CREATING *the* CULT *of* ST. JOSEPH

CREATING *the* CULT *of* ST. JOSEPH

ART *and* GENDER *in the* SPANISH EMPIRE

CHARLENE VILLASEÑOR BLACK

PRINCETON
UNIVERSITY
PRESS

PRINCETON *and* OXFORD

Front cover: Bartolomé Esteban Murillo, *Holy Family with the Little Bird*, before 1650. Plate 4

Published by
Princeton University Press,
41 William Street, Princeton, New Jersey 08540
In the United Kingdom:
Princeton University Press,
3 Market Place, Woodstock, Oxfordshire OX20 1SY
www.pupress.princeton.edu

Publication of this book has been aided by a grant from the Millard Meiss Publication Fund of the College Art Association.

MM

Designed and composed by Sam Potts Inc.
Printed by Data Reproductions Corporation

Printed and bound in the United States of America

1 3 5 7 9 10 8 6 4 2

Library of Congress Cataloging-in-Publication Data

Black, Charlene Villaseñor, 1962–
Creating the cult of St. Joseph : art and gender in the
Spanish empire / Charlene Villaseñor Black.
p. cm.
Includes bibliographical references and index.
ISBN 0-691-09631-7 (cloth : alk. paper)
1. Joseph, Saint—Art. 2. Joseph, Saint—Cult—
Spain. 3. Joseph, Saint—Cult—Mexico. 4. Sex role
in art. 5. Art, Spanish. 6. Art, Spanish Colonial—
Mexico. 7. Spain—Relations—Mexico. 8. Mexico—
Relations—Spain. I. Title.
N8080.J67B53 2006
704.9'4863—dc22 2005052163

British Library Cataloging-in-Publication Data Is Available

This book has been composed in Adobe Jenson
Printed on acid-free paper. ∞
pup.princeton.edu

ASDASD

For Joseph, *mi santo niño*

CONTENTS

ACKNOWLEDGMENTS

ACKNOWLEDGING THOSE who offered assistance during the process of writing this book, as well as the various institutions that provided financial backing and other aid, is a highlight of the writing endeavor. I am grateful to the following organizations for their support of this study: the Millard Meiss Publication Committee of the College Art Association, the Andrew W. Mellon Foundation, the UCLA Humanities Consortium and Center for Medieval and Renaissance Studies, the National Endowment for the Humanities, the Charlotte W. Newcombe and Woodrow Wilson National Fellowship Foundations, the American Society for Hispanic Art Historical Studies, the Program for Cultural Cooperation between Spain's Ministry of Culture and United States' Universities, and the Fulbright Agency. My home institution, the University of California, Los Angeles, provided Academic Senate and Assistant Professor Initiative Grants. While at the University of New Mexico I received two travel subsidies and a Research Allocations Committee Faculty Grant. Michigan State University's Department of Art and Center for Latin American and Caribbean Studies provided research travel support. Several awards from the University of Michigan supported my research during the dissertation phase, including the Rackham Merit Fellowship, the Rackham Predoctoral Fellowship, the Nathan T. Whitman Fellowship for Excellence in Graduate Studies in the History of Art, and a year-long residency at the Institute for the Humanities.

This project would not have been possible without the expert help of museum personnel, archivists, and library staff in Spain and Mexico. Individuals at the following institutions in Madrid facilitated my research: the Museo del Prado; the Biblioteca Nacional; the Consejo Superior de Investigaciones Científicas, Centro de Estudios Históricos, Departamento de Historia del Arte; the Archivo Histórico Nacional; and the Biblioteca Francisco de Zabálburu y Basabe. My work in Seville was a pleasure due to knowledgable and helpful staff at the Museo de Bellas Artes de Sevilla, the Archivo General del Arzobispado, the Archivo de la Catedral, the Biblioteca de la Universidad de Sevilla, and the Archivo Municipal. Several

individuals stand out in my mind for their interest in my project, including Manuela Mena and Mercedes Orihuela of the Museo del Prado; Margarita Estella Marcos, Isabel Mateo Gómez, Amelia López, and Enrique Anglés of the C.S.I.C.; Alfonso E. Pérez Sánchez; Rocío Izquierdo of the Museo de Bellas Artes de Sevilla; Enrique Valdivieso González and Juan Miguel Serrera of the Universidad de Sevilla; María Isabel González Ferrín of the Cathedral archive; and Carmen Calderón Berrocal of the Archivo del Arzobispado. I was granted access to the private collection of the Conde de Ibarra and allowed to view the spectacular *retablo* of Juan Martínez Montañés in the Monastery of San Jerónimo in Santiponce, thanks to Fernando Alberto Álvarez de Toledo Mencos and the Fundación Casa Álvarez de Toledo. I extend my heartfelt thanks to Matilde Melgarejo Ochoa of Seville for her help in these matters. Montserrat Blanch and Eulàlia Almuzara of the Institut Amatller d'Art Hispànic (Arxiu Mas) of Barcelona have been a tremendous help in locating photographs on my behalf. In Valladolid, Teófanes Egido, whose pioneering studies of St. Joseph have served as an inspiration, kindly provided access to the Biblioteca del Centro de Estudios Josefinos in the Convento de San Benito.

I enjoyed no less generous and expert help in Mexico, in particular at the Biblioteca Nacional de México, the Biblioteca de México, the Archivo General de la Nación, the Pinacoteca Virreinal de San Diego, the Museo Virreinal de Tepotzotlán, the Universidad de las Américas, and the Universidad Nacional Autónoma de México's Instituto de Investigaciones Estéticas. In Mexico City, the former director of the Pinacoteca Virreinal de San Diego, Virginia Armella de Aspe, and her staff provided expert help. In Puebla, Miguel Celorio offered me both his warm hospitality and sage counsel. In Mexico City, José Carlos Carrillo Ojeda, M.J., director of the Centro Mexicano de Estudios Josefinos and noted historian of the cult of St. Joseph, opened his archive's doors to me.

Several specialists in the field in the United States provided useful commentary at various stages of this project. I benefited from excellent training as a graduate student at the University of Michigan. My dissertation advisor, R. Ward Bissell, was an exemplary mentor who guided me with wisdom and respect. The other members of my dissertation committee, Celeste Brusati, Nathan Whitman, and Louise Stein, also deserve my gratitude for their judicious advice and support, as does Luisa López Grigera, professor emerita of the University of Michigan's Spanish Department, who assisted me in reading Josephine texts. A number of art historians took the time to comment on my project, helping me to refine its direction. They include Jonathan Brown, Marcus Burke, Claire Farago, Valerie Fraser, David Kowal, Mindy Nancarrow, Steven Orso, Jeanette Peterson, Edward Sullivan, Janis Tomlinson, the late Eleanor Tufts, and Christopher Wilson. I benefited from the advice of several historians, namely Jodi Bilinkoff, J. H. Elliott, Linda Hall, Richard Kagan, Mary Elizabeth Perry, and

Javier Pescador. My former colleague and comrade-in-arms at the University of New Mexico Geoffrey Batchen asked important theoretical questions that sharpened my thinking. My friend, mentor, and colleague Cecelia Klein, whose groundbreaking work on gender in pre-Columbian art has been an inspiration, posed challenging questions about the exact links between art and social contexts. I also owe debts of gratitude to my students, whose enthusiasm for art history inspires me. Two former students at the University of New Mexico, now professionals in their own right, made important contributions to this project: Felipe Mirabal and Kelly Donahue-Wallace. Four outstanding graduate student research assistants at UCLA, Elena Shtromberg, Maya Stanfield-Mazzi, Lauren Grace Kilroy, and Yasmine Beale-Rosano helped me complete this project.

Working with Princeton University Press has been a great pleasure. My editors, Hanne Winarsky and Nancy Grubb, combined scholarly acumen with a warm personal touch. I am also grateful to the other members of the art group at Princeton: Cynthia Grow, Sarah Henry, Sara Lerner, Devra K. Nelson, Ken Wong, and Kate Zanzucchi. Through them I was able to work with a wonderful copyeditor, Jonathan Munk. I would like to extend special thanks to the two scholars who read my manuscript, the historian Mary Elizabeth Perry and the art historian Mindy Nancarrow. I was honored that two such distinguished readers evaluated my work, especially since their own pioneering research on gender in Spain has been so formative with regard to my own development. Their helpful critiques significantly improved the final product.

Several friends provided support, editing, and advice. In Ann Arbor, they included Jane Chung, Carmen Lord, Julia Perlman, Mayra Rodríguez, and Laurie Winters, as well as my dissertation group, Katharine Burnett, Molly Lindner, and Rita Goodman. I would also like to thank several fellow researchers and friends in Madrid, including Paul Allen, Loli Bajo, Javier Durán Barceló, Marisa Fernández del Amo López Gil and her family, Larry Furr, Liz Lehfeldt, Felipe Pereda, and Marina Pinto. During my two-year tenure in Albuquerque, Connie Baca enriched my life in manifold ways. In Los Angeles, Helene Bernstein, George Gluz, and their family provided endless diversion as we explored southern California. Sharon Gerstel's arrival at UCLA enriched my life immeasurably. How fortunate I am to be able to share the joys and challenges of single motherhood with her. I would also like to thank my family, and especially my sisters, for their patience, humor, and support during this long process.

I owe my greatest debt of gratitude to my son Joseph, born during the genesis of this book. Thanks, *mi chiquito*, for keeping me focused on the important things in life. Your love, unbridled joy, enthusiasm, inquisitiveness, creativity, and boundless energy delight me every day. May you grow up to share the virtues attributed to your name saint.

INTRODUCTION

IN 1555 St. Joseph—humble carpenter, earthly spouse of the Virgin Mary, and foster father of Jesus—was made patron of the Conquest and conversion in Mexico, a position he held until 1746, when the Virgin of Guadalupe was elevated as his co-patroness. In 1679 King Charles II of Spain named St. Joseph patron of his kingdom, toppling Santiago, or St. James, traditional protector of the Spanish realms for over eight hundred years, from his honored position. In Spain, St. Joseph became a national icon and emblem of masculine authority in a society plagued by crisis and social disorder. In the Americas, the saint—as model father, caring spouse, and hard-working provider—became the perfect paradigm of Spanish colonial power. The visual arts played key roles in the creation of these discourses, as this study demonstrates through examination of numerous images, period print sources, and documents in Spanish, Latin, Náhuatl, and Otomí. A study of the imagery of the most important saint of the period, *Creating the Cult of St. Joseph: Art and Gender in the Spanish Empire* investigates the manipulation of the rich coded language of Catholicism to construct gender discourses in Spanish and Mexican art of the sixteenth through the eighteenth century.

After languishing in obscurity for centuries, the cult of St. Joseph became the central saint's cult of the early modern period, and Josephine devotion spread throughout Spain and its colonies. Spanish and Mexican churches prominently displayed depictions of Joseph, sacred plays praised him, and engravings popularized his image. As the most commonly rep-

resented saint in early modern Spain and colonial Mexico, Joseph appears in the oeuvres of countless artists, including the Spanish painters El Greco (1541–1614), Bartolomé Esteban Murillo (1617–82), and Francisco de Zurbarán (1598–1664), and the Mexican artists Baltasar de Echave Ibía (1583–1650), Juan Correa (1646–1716), and Miguel Cabrera (1695–1768). Seventeenth-century Spanish and Mexican artists reconceptualized Joseph as an important figure, and they gave him an increasingly substantial role in their images, placing greater compositional importance on his figure and representing him as the youthful, physically robust, diligent head of the Holy Family.

Despite the wealth of Hispanic depictions of St. Joseph, despite their unusual qualities, and despite the importance attached to his cult, no comprehensive study has previously focused on the topic. Although regularly singled out for their importance by art historians, Spanish and Mexican Baroque images of St. Joseph have not received the scholarly attention that, by virtue of both their scope and their interpretive richness, they so obviously demand.[1] A partial explanation for the neglect of Hispanic Josephine images may be found through critical examination of the historiographies of Spanish Golden Age and Mexican colonial art. Hispanists have long been engaged in recovering archival documents, producing monographic studies, and documenting artistic patronage. To date, very few thematic studies of Spanish or Mexican art have been produced. Furthermore, despite the fact that most Spanish and colonial Latin American art is religious in nature, religious subjects have, in general, been neglected. Whereas Spanish court art, mythology, still life, and collecting practices have been explored in depth, less scholarly attention has been directed to the thousands of Madonnas, Crucifixions, saints, and martyrs represented in Spain and the Americas.[2]

As a newer field, colonial Latin American art history has inspired more innovative scholarship. Recent studies have focused on the survival and transformation of native visual practices in the wake of the Conquest and on the related issues of indigenous agency, cultural hybridity, and the multidialectical nature of colonial visual languages. Much stimulating research has centered on the sixteenth-century contact period, but by emphasizing artworks in which the native hand can be discerned, scholars have left much seventeenth– and eighteenth-century colonial art ripe for investigation. Furthermore, with the exception of the Virgin of Guadalupe, few religious personages have undergone systematic analysis.[3] In light of James Lockhart's recent demonstration of the centrality of Catholic saints in post-Conquest Mexican society, and given the fact that they attained far greater importance in Mexican Catholicism than did the figure of Christ, it is clear that additional study of saints' cults in the Americas is urgently needed.[4]

Several traits inherent in Hispanic Catholic imagery may have disguised the richness and complexity of Joseph and Holy Family depictions. For example, once their forms were determined, the images changed little in the course of the period. Many representations seem homely or awkward to modern eyes, while others appear sweet and sentimental. This book argues that the repetitive nature of much Hispanic religious imagery results from the censorious power of the Spanish Inquisition, which discouraged experimentation in religious art, and from the use of the images as didactic tools to teach Catholic worshippers.[5]

This study proposes to connect study of Spanish and Latin American religious imagery of the sixteenth through the eighteenth century instead of studying these visual cultures in isolation. Inspired by postcolonial theorists, who have correctly insisted that colonialism occurred not just in the colonies but also in the mother country, this approach challenges the traditional division between Europe and the "New World."[6] Such a comparative approach makes particular sense in the case of seventeenth– and eighteenth-century religious art produced in Spain and Mexico. Artists on both sides of the Atlantic frequently depicted the same subjects. Artistic production in both locales was governed by identical Inquisition guidelines and functioned in conjunction with similar kinds of religious texts.

Comparative analysis of images of St. Joseph and the Holy Family has revealed striking similarities between art produced in the metropole and that made in the colonies—dramatic testimony to the censorship power of the Spanish Inquisition. The differences uncovered, however, are also striking and raise issues of colonialism, indigenous influence, and hybridity in colonial art. Furthermore, this study opens up the possibility, suggested by postcolonial theory, that colonial art may at times have informed Spanish visual culture. Certain developments in the cult of St. Joseph seem to have occurred first in the Americas, and then traveled back to the Old World. Admittedly, though, not all kinds of imagery necessarily benefit from this comparative approach; for example, knowledge of pre-Columbian cultures may be more illuminating than knowledge of Spanish art in studies of some Mexican colonial visual practices.[7]

This study also argues for renewed attention to the image through close description and semiotic analysis. Such careful visual readings of Spanish and Mexican images of St. Joseph and the Holy Family led me to question the usefulness of the rigid stylistic framework typically employed for such painting. The neat categories of Baroque Realism, Baroque Classicism, and Dynamic Baroque, originally defined for Italian art, do not adequately characterize Spanish or Mexican colonial art.[8] Many "Realist" paintings contain elements of idealization; "Classical" works are marked by the inclusion of naturalistic detail; and the

"Dynamic" style, though exhibiting fluid brushwork, is often characterized by notable reserve and the obvious use of live models for figure types. The problem is confounded by the existence of numerous regional schools of painting and by the persistence of Baroque Realism in Spain.[9] The inherent problems of transferring stylistic labels proposed for European art are exacerbated when applied to New World visual systems. Traditionally, scholars have been stymied by the mixed, or so-called *mestizo*, nature of colonial Mexican art, as well as by what have been described as tenaciously lingering medieval and Mannerist traits. Rejecting racialized characterizations such as "mestizo," I attempt to view the new, hybrid nature of Mexican colonial cultural production on its own terms, not as a degraded provincial reflection of art in the mother country.

I began research for this study by compiling and examining as many Spanish and Mexican Baroque images of St. Joseph and the Holy Family as possible. After I viewed numerous art works, the images' unusual characteristics emerged. From around 1600, Spanish and Mexican artists began depicting St. Joseph and the Holy Family more frequently than before and they significantly altered the composition of Holy Family imagery as well as St. Joseph's demeanor from that of an unimportant, at times comical older man to a young, handsome, virile husband and father. The rise of a new saint's cult to prominence necessitated the invention of new images. How did Spanish and Mexican artists create these new pictorial types? By comparing Josephine paintings to analogous representations of other saints—an approach, inspired by semiotics, that frames the images within the larger context of Hispanic visual culture—I discovered that in almost all cases, artists constructed the imagery of St. Joseph by using previously existing archetypes. In particular, artists followed pictorial models formerly employed in depictions of the Madonna and female saints.

This repurposing of prototypes used for depictions of female holy persons inspired my consideration of gender as an important category of analysis.[10] As Mikhail Bakhtin has suggested, linguistic signs are intertextual; that is, they possess what Norman Bryson has described as a "ready-made quality."[11] Artists, like writers, choose pictorial devices or words based on knowledge of the sign's established meaning. I explored how Josephine imagery was used to encode gender ideologies and, specifically, how important the cult of St. Joseph was in articulating new ideals of virtuous masculinity, which valorized caring husbands and doting fathers.

Because they function as exemplars of behavior for Catholic beholders, saints' images are a rich resource for revealing gender ideals.[12] According to period textual and visual sources, as the model husband and father St. Joseph even helped with domestic chores and childcare, tasks then being recommended to Hispanic men. One of a small hand-

ful of masculinity studies of the early modern period, this study attempts to correct the simplified view of Hispanic societies as hotbeds of *machismo*, by suggesting that multiple discourses of ideal masculinity existed. It also examines the particularly complex nature of gender discourse in Spain, notorious for the traditional rigidity of its gender-role prescriptions. In the Americas, with input from indigenous cultures, gender concepts became even more heterogeneous.[13]

My examination of the wider context of religious imagery led to the realization that, as the number of images of Joseph as tender, nurturing father increased, depictions of the Madonna in her maternal mode decreased, replaced by images of the Virgin of the Immaculate Conception. Indeed, seventeenth-century Spanish and Mexican devotees claimed that St. Joseph was more important than his holy wife. The downgrading of Mary's position seems especially surprising in the context both of "Marian" Spain, where for centuries the Madonna had enjoyed a position of honor within the saintly pantheon, and of Mexico, a country that still today professes fervent devotion to the Virgin of Guadalupe. In the end, I demonstrate that as St. Joseph's cult rose to ascendancy in the seventeenth century, Mary declined in importance.

Because works of art never exist as autonomous signs, but always function within a larger cultural system, this study incorporates numerous sixteenth–, seventeenth–, and eighteenth-century printed texts, manuscripts, documents, and records of popular devotional practices. To frame religious images simply as aesthetic objects, wrested from their public, ritual functions, would be anachronistic and ahistorical.[14] Thus, this study combines a commitment to excavating the past with concerns from critical theory and an interest in framing images politically.

Printed and manuscript sources of the period (in Spanish, Latin, Náhuatl, and Otomí) on the topic of St. Joseph and the Holy Family exist in abundance and have been a valuable resource. Care was taken to read a wide variety of texts, including those by the most famous hagiographers and theologians of the period—Alonso de Villegas, Pedro de Ribadeneira, Jerónimo Gracián de la Madre de Dios, and Antonio Pastrana—as well as other, lesser-known authors. Because this study examines imagery produced both in Spain and the Americas, it was important to establish the circulation of specific texts or ideas on both sides of the Atlantic. Art treatises, devotional works, sacred plays, religious poetry, and sermons reveal how the hagiography of Joseph was constructed and spread in early modern Spain and colonial Mexico, disclosing the significance of his life for period beholders. Art treatises, for example, provide valuable information on the existence of images of St. Joseph and Inquisition guidelines regulating their depiction. For the construction of the life of

Joseph, I have looked to hagiographies of the saint, devotional literature, poetry (including epic poetry and *romances*), sermons, Gospel commentaries, song texts (including *villancicos* and an oratorio), theatrical works (*comedia bíblica*), and prayers. Texts dedicated to other subjects—including the Virgin Mary, the Flight into Egypt, the Betrothal, the Nativity, the Circumcision, the Epiphany, and other saints—reveal additional information. Joseph is also invoked in treatises on carpentry, architecture, and matrimony. The *Brief Compendium of Carpentry* by Diego López de Arenas of 1633 opens with a print of the Flight into Egypt featuring St. Joseph in his role as family protector. Sermons and devotional texts promote the power of the saint's intercession and reveal the devotions performed before his image. Accounts of miracles wrought by depictions of Joseph testify to the power of religious imagery throughout the Spanish Empire.

My methodology questions traditional iconographic approaches to religious art, which rely on erudite writings such as the Greek or Latin patristics as their main sources.[15] In the case of St. Joseph and the Holy Family, neither the Bible nor the Church Fathers conveyed much information. No medieval hagiographies exist, and apocryphal tales, such as Jacobus de Voragine's *Golden Legend*, were firmly rejected as historically unreliable in the wake of the Council of Trent (1545–63).[16] The study of Hispanic Josephine imagery is further complicated by the fact that the images and the texts were produced during the same period, and thus it is difficult to establish the texts as the source for the works of art. Both images and texts co-existed in the same cultural system, dependent on each other to produce and reinforce meaning.

Church and government promoters intended St. Joseph to be a universal saint, protector of all in the Spanish Empire, and evidence indicates his widespread appeal. Documents from several archives in Spain and Mexico—including royal decrees, papal briefs, chronicles, various manuscripts, and the records of guilds, confraternities, convents, and churches, plus city and ecclesiastical councils—describe the celebration of Joseph's cult and the role of the visual arts in it. Investigation into patronage revealed that a variety of organizations and individuals commissioned images of St. Joseph and the Holy Family in Spain and Mexico. The promotion of St. Joseph's cult thus cannot be ascribed solely to a particular religious order, the Spanish monarchy, or a particular patron, although social welfare organizations such as hospitals, charitable confraternities, and orphanages, as well as artisanal guilds, seem to have been particularly interested in Josephine imagery.

Throughout, this study attempts to recapture the original importance and authority of images of St. Joseph and the Holy Family produced in Golden Age Spain and colonial Mexico. The variety of these images and the varied discourses in which they participated

testify to the power of religious imagery in the period and, more specifically, to the potency of the depictions of St. Joseph and the Holy Family in the Spanish Empire. This book introduces the images, documents their popular and theological underpinnings, and frames them within wider social discourses. In the process, it attempts to recapture some of their original power.

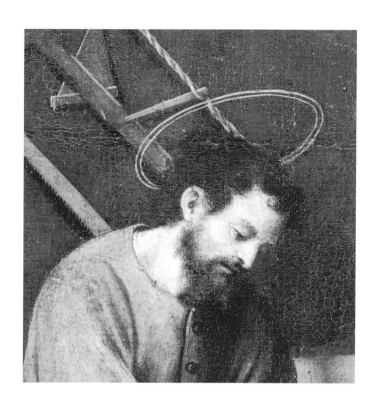

Joan de Joanes, *St. Joseph in the Carpenter's Workshop (detail of fig. 2)*

CHAPTER

ONE

CREATING *the* CULT *of* ST. JOSEPH

After Our Lord Jesus Christ and His most holy
Mother, the greatest saint, and the one that shines
most in grace and glory, is my lord St. Joseph.

I N THE EYES of seventeenth-century Hispanic theologians, St. Joseph was the most pow-
erful saint of the Catholic church. In status and holiness he ranked second only to his holy
wife, Mary, and his foster Son, Jesus. Since Joseph intervened on behalf of worshippers with
both his foster Son and his wife, and since neither refused anything for which Joseph asked,
theologians considered him the mightiest intercessor of the saintly pantheon. According to a
sermon delivered in Granada in 1677 by the famous Spanish preacher Joseph de Barcia y
Zambrana, St. Joseph was the first saint of the New Testament.[1]

Although for Hispanic Counter-Reformation theologians Joseph was Catholicism's
most powerful saint, his privileged status was achieved only after long centuries of neglect.
The New Testament Gospels report little information on Joseph, and patristic texts rarely
address him, focusing instead on the Virgin and on major doctrinal issues. Not until the late
medieval period can the first indications of Josephine devotion be documented. In the six-
teenth century St. Joseph's cult was elaborated, and it rose to prominence in the seventeenth
century. This chapter traces the creation of the cults of St. Joseph and the Holy Family and
the construction of imagery in their service. It proceeds from the assumption that all saints'
cults—even those based upon documentable lives—constitute acts of creation.[2]

St. Joseph is mentioned only eight times in the New Testament Gospels. The geneal-
ogy of Christ that opens the Gospel of Matthew describes him as the spouse of Mary (1:16).
Matthew's infancy narrative relates Joseph's response to Mary's pregnancy (Matthew
1:18–25), the Flight into Egypt sequence, and the family's return from Egypt (Matthew
2:13–15; 2:19–23). The Gospel of Luke mentions Joseph's presence at Jesus' birth in Bethlehem

and again at the Presentation in the Temple (Luke 2:4–7; 2:22–38). The Gospel of John twice describes Christ as the "Son of Joseph" (John 1:45 and 6:42). No mention of St. Joseph is made at all in the Gospel of Mark. Although meager in details, the information contained within the Gospels is significant since it establishes Joseph as the husband of the Virgin Mary and the earthly father of Jesus.

During the early period of patristic exegesis, St. Joseph remained a shadowy background figure. None of the Church Fathers wrote sermons or tracts exclusively dedicated to him, expounding instead upon Catholicism's major mysteries—the Trinity, the Incarnation, and the Sacraments. Fourth- and fifth-century Church Fathers, writing in response to attacks on the idea of Mary's virginity, mention St. Joseph tangentially: St. Jerome, St. Augustine, St. Ambrose, and St. John Chrysostom. In the process of affirming Mary's virginity, these theologians were forced to define the nature of her marriage. They postulated that, like Mary, Joseph was a virgin—a debate that lingered until the Council of Trent, when theologians declared that Joseph, like his spouse, was a virgin, had never been married, and had not previously fathered any children—still the Church's official position today.[3]

The lack of emphasis on St. Joseph in the patristics finds a parallel in the sphere of popular devotion. Apparently, the saint attracted little attention in the early Church. He did not appear in a Western martyrology until the eighth century and rarely appears in Early Christian art.[4] Despite the scant attention accorded Joseph by the Gospels and by the Church Fathers, apocryphal tales about him flourished in the early centuries of Church history. They would play an important role in influencing depictions of Joseph in medieval art, expanding Joseph's small role in the canonical Gospels with imaginative details.[5] Although varying in specifics, these different texts related that Joseph was of very advanced age at the time of his marriage to the Virgin (estimates ranging from eighty-nine to ninety-one years old), that he had been married before, had fathered other children, and married the Virgin only reluctantly.[6] The Counter-Reformation Catholic church later rejected this version of Joseph's life.

Several late medieval texts were instrumental in paving the way for the rise of Josephine devotion. The thirteenth-century *Meditations on the Life of Christ* by an anonymous Franciscan (the so-called Pseudo-Bonaventure), amplified Joseph's role in the Gospels. The *Vita Christi* by Ludolf the Carthusian (died 1378) elaborated upon the daily life of the Holy Family.[7] These texts manifest the spread of the *devotio moderna*, a late medieval movement to humanize Mary and Jesus, one by-product of which was greater attention to the role of St. Joseph in their lives.

In the art of the Middle Ages St. Joseph was rarely depicted, appearing for the most

part only in scenes of the Nativity or Adoration of the Magi. When artists did represent him, it was usually as an unimportant figure asleep on the sidelines, or as a comical figure.[8] An anonymous thirteenth-century Spanish *Nativity* perfectly illustrates his marginal role (fig. 1). Joseph appears here as a subsidiary character, with head resting on hand, unaware of the miraculous birth. In other examples, artists show him preparing the gruel or washing the baby's diapers.[9] According to St. Bridget of Sweden (c. 1303–1373)— whose *Revelations*, based on her visions of Christ's life, had an important effect on the visual arts—St. Joseph was not even present at the Nativity. Depictions of him returning to the scene with a candle in his hand, the glow of which is overshadowed by light radiating from the Christ Child, can be traced to her influence.[10]

Fig. 1. Anonymous, *Nativity*, 13th century. Tempera on panel, 37 $^2/_5$ x 32 $^1/_3$ in. (95 x 82 cm). Museo Diocesano de Solsona, Palacio Episcopal, Lérida, Spain

After centuries of such obscurity, the cult of St. Joseph rose to prominence in the late fourteenth and early fifteenth centuries. In Italy, St. Bernardino of Siena (1380–1444) preached sermons praising Joseph's special privileges (derived from having lived with Jesus and Mary) and asserted that Joseph was next to the Virgin in importance in the pantheon of saints.[11] Perhaps the most significant figure to promote devotion to Joseph was Jean Gerson, chancellor of Notre Dame and the University of Paris. At the Council of Constance in 1416, Gerson urged the institution of a feast day honoring the Betrothal of Mary and Joseph, for which he wrote an office. In a sermon delivered on the birthday of the Virgin Mary, he extolled Joseph as Christ's earthly father. His three thousand–line Latin poem, the *Josephina*, laid the foundations of modern Josephine theology.[12]

St. Bernardino and Gerson significantly modified the traditional view of St. Joseph. Whereas Joseph had previously been regarded as a subsidiary figure, old and unimportant,

they asserted that, as the head of the Holy Family, the saint had to have been young and robust in order to support, protect, and exercise authority over Mary and Jesus. Gerson further proposed that, like the Virgin, Joseph was assumed to heaven after his death. Their valorization of St. Joseph was to have profound influence on theologians and artists in the early modern Spanish Empire.

Despite considerable efforts on behalf of St. Joseph, a feast day in honor of the saint was not instituted in the Western church until fifty years after Gerson's death, by Pope Sixtus IV in 1479.[13] Its observance, however, on March 19, was not mandated. The faithful slowly began to respond to the cult. The first documents indicating the use of "Giuseppe" as a first name appear before 1500 in Italy.[14] In Spain, "Josef" and "Joseph," early variants of "José," began to appear in documents around 1580, at first as a name for abandoned children. By the early 1600s the name became popular throughout Spain.[15] If we look across the Atlantic to Mexico, however, we find the saint's name commonly given to native converts beginning in the 1520s.[16]

In the fifteenth century a few Netherlandish images of Joseph cast the saint in a favorable light. The *Mérode Altarpiece* (The Cloisters, New York, c. 1425) by Robert Campin (1375–1444), the so-called Master of Flémalle, exemplifies the new dignity given to St. Joseph in the wake of Gerson's efforts. The main scene of the Annunciation is flanked by a left panel in which the commissioning patrons appear and by a right panel dedicated to St. Joseph—the most noble medieval rendering of the saint. He appears seated at his carpenter's bench, an older but dignified man, drilling holes in a mousetrap. On one level, it is a respectful representation of a hard-working artisan, laboring on behalf of his family. Another interpretation suggests that the painting served as a marriage model.[17] On a symbolic level, the depiction of Joseph working on a mousetrap has been related to St. Augustine's commentary on the marriage of the Virgin and Joseph. Because its purpose was to conceal Jesus' birth from the devil, St. Augustine described their marriage as "bait" for Satan. Therefore, the mousetrap symbolically refers to the marriage as a trap to fool the devil.[18] As a result, Joseph is no longer cast as the unimportant figure of earlier periods, but rather is seen to have played a key role in protecting Christ and thus in furthering the Redemption. Despite his new dignity, however, Joseph still appears as an old man and is relegated to a side panel, clearly separated from the main Annunciation scene.

Sixteenth-century efforts to promote St. Joseph in Europe were centered in the monastic world. In 1522 the Milanese Dominican Isidoro de Isolani wrote the first scholarly essay on Josephine theology, his *Summa de donis sancti Joseph* (*Summa of the Gifts of St. Joseph*), which was profoundly influenced by Gerson.[19] Isolani's text argued that Joseph was

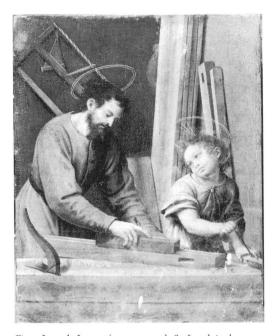

Fig. 2. Joan de Joanes (c. 1523–1579), *St. Joseph in the Carpenter's Workshop*, 1550s. Oil on canvas, dimensions unknown. Gemäldegalerie, Berlin

youthful, functioned as the head of the Holy Family, and was assumed bodily to heaven after his death. Isolani urged Pope Adrian VI to institute a mandatory Josephine feast day for the entire Church.[20] Worship of the saint by the European populace, however, did not occur until after the Council of Trent, when Joseph became one of the most important saints of the Counter-Reformation.

European Renaissance depictions of St. Joseph embody the saint's new elevation as Carolyn Wilson's recent study demonstrates.[21] In Michelangelo's *Doni Tondo* (1475–1564; Galleria degli Uffizi, Florence, c. 1503), the artist retained a compositional focus on the Virgin as well as the characterization of Joseph as an older, gray-haired man, but he did fully integrate the saint, represented as a physically powerful figure, into the Holy Family. In Raphael's *Marriage of the Virgin* (1483–1520; Pinacoteca di Brera, Milan, 1504), Joseph appears a willing partner in the marriage, youthful and handsome.[22] A painting by the Valencian artist Joan de Joanes dating from the 1550s depicts St. Joseph and the Christ Child at work in the carpenter's shop (fig. 2). Despite the new dignity given to Joseph in these paintings, numerous Renaissance examples continued to picture the saint as a subsidiary character. Leonardo da Vinci's *Adoration of the Magi*, begun in 1481 (1452–1519; Galleria degli Uffizi, Florence), positions the saint in the background, a hunched, aged figure peering over a wall separating him from the main scene of the Virgin and Child.[23] A painting of the Holy Family by the Spaniard Vicente Macip (c. 1475–c. 1545), father of Joanes and founder of a Valencian painting dynasty, depicts St. Joseph as a marginalized sideline figure in hieratic scale (fig. 16). It was not until seventeenth-century Spanish and Mexican art that Joseph would be consistently depicted as a young, dignified personage.

Although in sixteenth-century Europe Joseph's cult was concentrated in the monastic world, in the Americas, Spanish conquistadores and Franciscan missionaries had been fomenting Josephine devotion as a tool of conversion since the 1520s. Hernán Cortés, the

Spanish leader of the Conquest of Mexico, which began in 1519, reportedly brought the first image of the saint to the Americas. Cortés also founded a chapel dedicated to St. Joseph in what is now Mexico City—the former Aztec capital of Tenochtitlán—which fell to the Spanish in 1521.[24]

By 1527 Franciscan missionaries under the direction of Fray Pedro de Gante (c. 1480–1572) had established the very first native parish and dedicated it to Joseph, San José de Belén de los Naturales (St. Joseph of Bethlehem of the Natives) in the heart of Tenochtitlán. As the head parish of the four native barrios, or *calpullis*, of Tenochtitlán (Moyotlán, Teopan, Cuepopan, and Atzacualco), San José de los Naturales served as the major native church in the former Aztec capital throughout the colonial period.[25] It stood in the patio of the city's major Franciscan monastery, San Francisco.

The chapel's original configuration has occasioned much scholarly debate. According to the most widely accepted interpretation, the original St. Joseph of the Natives was a large open chapel with an arcaded facade, one bay deep, that opened onto an atrium for outdoor worship.[26] In the 1530s and 1540s, a series of earthquakes destroyed the original structure, and a new, larger chapel was erected in the 1550s. It retained the arcaded facade and facing atrium, but the chapel itself was enlarged. John McAndrew has likened the new configuration to Spanish mosque plans, which are characterized by a similar box-like space filled with rows of columns opening onto a patio planted with trees. Indeed, the rebuilders of San José may have consciously evoked the mosque at Córdoba with a low stone arcade across its facade.[27]

Apparently, San José was not the only native chapel to employ a mosque-like plan. The Royal Chapel at Cholula—possibly built in the 1540s and a direct copy of San José—as well as similar structures in Jilotepec, Toluca, and Etzatlán employed comparable configurations.[28] These borrowings cannot have been haphazard. The memory of the Spanish *Reconquista* of Islamic Spain, which had come to an end in 1492 with the fall of the Nasrid kingdom of Granada, was fresh in everyone's minds. By 1525 all Spanish mosques had been converted into churches. In that year, the very first church in Spain dedicated to St. Joseph was built on the former site of the Mosque of the Hermits in Granada. Proselytizing of the Hispano-Islamic population, however, continued throughout the sixteenth century. Not surprisingly, in the Americas missionizing friars conceived of natives as Muslims, describing indigenous temples as *mesquitas*, or mosques.[29]

San José de los Naturales thus appears to have constituted a unique hybrid creation of Hispano-Islamic mosque form combined with native and European influences. Some scholars have likened the open chapel model to indigenous temples, or *teocalli*. Similarly, the atrium, a space for outdoor worship, easily compares to native temple precincts. A recent re-

evaluation of early Mexican mission architecture has demonstrated that the friars intended these open chapels and outdoor worship sites as stages for the enactment of liturgical dramas and sacred plays.[30]

San José de los Naturales suffered earthquake damage again in 1622, after which the open chapel was enclosed. Today, nothing of the previous structures stands. In 1745 an author lamented the chapel's state of disrepair: "The most ancient, and to say it better, oldest chapel of St. Joseph of the Natives in Mexico . . . today is not all that it was in the beginning."[31] By 1769 the chapel seems to have been torn down, leaving only its tower still standing.[32] Documentary evidence indicates that the tower was under demolition in 1781. In 1784 San José's parish priest petitioned money to rebuild the chapel and was awarded 2000 pesos by the Franciscans.[33] By 1861 all remnants of San José were destroyed during the expropriation of Church holdings.[34] Writers throughout the colonial era eulogized "this First Church of all Churches" named in St. Joseph's honor.[35]

Twenty-eight years after the founding of San José de los Naturales, in 1555, at the first meeting of the Provincial Mexican Council of the Catholic Church, delegates proclaimed St. Joseph the patron of New Spain, his patronage extending throughout modern-day Mexico, Nicaragua, Costa Rica, Panama, Guatemala, El Salvador, and the Philippines. For the first time ever, observance of St. Joseph's feast day was mandated.[36] Numerous missions, chapels, villages, ranches, haciendas, farms, orchards, mines, and other locales throughout Mexico were named after St. Joseph, including, in 1559, one of the five Franciscan provinces targeted for conversion, San José de Yucatán.[37] Missions, in particular, were frequently dedicated to the saint, including some of the earliest and most important churches and chapels in Tlaxcala, Cholula, Cuernavaca, and Tula. In 1556 another large native parish was founded in St. Joseph's name in Puebla.[38] In 1585, at the Third Provincial Mexican Council, delegates reaffirmed the importance of St. Joseph's patronage of New Spain, noting how "truly extraordinary the devotion with which the most chaste Patriarch our lord St. Joseph, spouse of most holy Mary, is honored, treated, and revered in this province, through whose merits and intercession one can piously believe that New Spain has been favored by God with particular benefits."[39]

Throughout the colonial era, sermons and devotional texts lauded St. Joseph as the "universal Patron" of New Spain and Mexican clerics routinely attributed their country's Christianization to St. Joseph's help.[40] The saint played a key role in the conversion of Mexico's indigenous population.[41] According to the first published Náhuatl sermon dedicated to Joseph, issued in Mexico City in 1577, "Here in New Spain, St. Joseph has been appointed its venerated advocate and protector." In 1583 St. Joseph's feast day appeared in Fray Bernardino de Sahagún's *Christian Psalmody and Sermonary*. Another Náhuatl sermon was published in

1614.[42] In 1778 an anonymous author reported, "Since this New World was conquered, together with the true Religion, the first Fathers established in it devotion to Lord St. Joseph."[43] One sermonist praised the saint as a second conquistador:

> O Mexico, how you were before! You neither felt, nor understood, nor saw, because your inhuman barbarity and blind paganness had you in such a state . . . St. Joseph took you as his duty . . . and then, then, you felt with his Protection your consolation. . . . This kingdom had, Lord, two conversions. The first, due to the unequaled valor, industry, and affability of Don Fernando Cortez: The other, due to whom? To the zeal of those first parish priests? To the spirit of those first religious? Of this I speak not: I only say that if Fernando Cortez, with his arms, and industry, converted the Indians, with the vassals of his Catholic Emperor, St. Joseph Patriarch converted them so that through his Protection, they were baptized, leaving for our true God all the various multitude of their false gods.[44]

Not surprisingly, the Church reported numerous miracles worked by St. Joseph on behalf of the native, African, and mestizo populations in the Americas.[45] Further evidence of St. Joseph's role as the protector of ethnic minorities in Mexico is provided by a villancico, or carol, penned in 1690 by the illustrious Sor Juana Inés de la Cruz. It concludes with two verses sung by an "Indio" and a "Negro." The native character comments on the numerous images of St. Joseph in Mexico (singling out one in Xochimilco), which sets the stage for the Afro-Mexican character to suggest that "Our Lord St. Joseph might have been black!"[46] European friars' attempts to promote Joseph as the special protector of ethnic minorities in the Spanish colonies apparently attained success.

St. Joseph's close link to native conversion is further demonstrated by his inclusion in a print depicting friars preaching to the native population, which forms the frontispiece of an Otomí dictionary published in Mexico City in 1767 (Luis de Neve y Molina, *Reglas de Orthographia, Diccionario, y arte del Idioma Othomi, Breve Instruccion para los Principiantes*). A painting by an unnamed artist represents St. Joseph arriving in the New World on a raft in the

Fig. 3. Anonymous, *St. Joseph Arrives in the New World*, 18th century. Oil on canvas, dimensions unknown. San Martín, Texmelucan, Puebla, Mexico

company of Franciscan friars (fig. 3).[47] According to the Franciscan chronicler Gerónimo de Mendieta, so many native chapels were named in the saint's honor that natives called all open chapels "San Josés."[48] In 1727, in Mexico City's Corpus Christi convent, established for noble indigenous nuns, a new altar was dedicated to St. Joseph "because the Conquest of the Indies is due to his sworn Protection." A writer reported that in the eighteenth century in Mérida, Yucatan, St. Joseph's image was processed in a triumphal car and special festivities were held in the cathedral because Joseph had helped put down an indigenous uprising.[49] Another author, writing in 1778, reported of St. Joseph that "many magnificent and curious temples have been dedicated to his name in this America; many altars in which his high cult shines."[50]

Although it was not until the seventeenth and eighteenth centuries that St. Joseph's image became frequent in Mexico, a number of important early images of him date from the sixteenth-century contact period. The native artist Marcos Cipac de Aquino, whose name has been put forth as the possible author of the *tilma* of the Virgin of Guadalupe, created an image of St. Joseph for the main altar of San José de los Naturales sometime before 1564.[51] Similar images probably adorned other early Josephine churches, including those in Puebla, Cuernavaca, and Tula. A representation of the saint on the facade of Cuernavaca's St. Joseph Chapel, as well as its titular image, have been dated to the sixteenth century, as have depictions of the saint on the main altar and facade of San José in Tula. Numerous images from the contact era, however, particularly those used in the conversion process, have probably been lost. Extant portable animal hide paintings produced during the seventeenth- and eighteenth-century conversion efforts

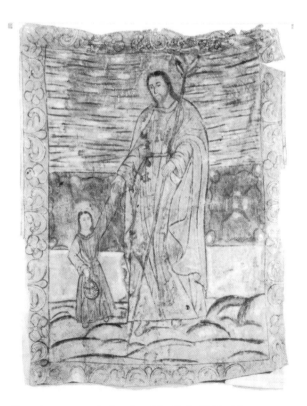

Fig. 4. Anonymous, *St. Joseph and the Christ Child*, 18th century. Painting on hide, dimensions unknown. Fred Harvey Collection of the International Folk Art Foundation, Museum of International Folk Art, Santa Fe, New Mexico

in New Mexico, several of which depict St. Joseph, may give an idea of the types of images created in the sixteenth century, as do a handful of extant feather paintings (fig. 4 and pl. 1).[52]

The centrality of St. Joseph's *cultus* in native conversion leads one to wonder about the reception of his image by native viewers and about the possibility of indigenous influences infiltrating his cult. Whereas friars intended religious imagery to teach Christian concepts, in some cases native viewers may have imposed their own messages, based on indigenous religious practices, onto the works, a phenomenon that has been described as "visual bilingualism."[53] One wonders, in particular, about Joseph's main attribute, the flowered staff, since flowers played important roles in religious worship.

The presence of flowers may have facilitated associating Joseph with one of the major Mexican deities at the time of the Conquest, Tlaloc, called the "god of the rains" in early colonial sources.[54] In fact, in Mexico Joseph appears to adopt Tlaloc's attributes and powers, most notably control over fertility and agriculture, as witness the countless farms, haciendas, orchards, and gardens named after St. Joseph, as well as the saint's reputation as the patron of married couples, families, and the infertile. Furthermore, celebration of Joseph's and Tlaloc's respective feast days overlapped in the month of March.

Flowers played a key role in the celebration of Tlaloc's feast, according to an early description of the native celebration: "The third month begins on March 14 and is called Toçoztontli, and in it they celebrate the feast of Tlaloc, God of the waters, who they say lives in the Earthly Paradise that they call Tlalocan; they offer these days the first flowers and roses of that month and year at a native temple on a high hill called Jupico, and no one can smell flowers before the first blooms are offered."[55] Additional associations between Tlaloc and flowers can be found in Náhuatl poetry.[56]

Furthermore, in colonial Mexico St. Joseph became associated for the first time with weather and seismic events, occurrences previously under Tlaloc's domain in ancient Mesoamerica. A colonial manuscript image of Tlaloc from the Codex Ixtlilxóchitl represents the god standing on a stylized cloud, thunderbolt in hand (pl. 2). In Mesoamerican cosmology, Tlaloc presided over Tlalocan, a heavenly paradise for people who died of drowning, illnesses associated with water, or as a result of rainstorms, thunder, or lightning strike, as reported by Fray Bernardino de Sahagún:

> They are the ones on whom thunder bolts fall
> They are the ones who are struck
> The Tlalocs desire them
> Eagerly want them
>
>

For indeed those who enter Tlalocan
Who are taken away
Are those who are struck by the bolt
There they fall in
Forever they live in the springtime
Nothing ever fades
All is ever blooming
All is freshly green
All is ever green[57]

Numerous primary sources document that in the colonial period Mexicans sought Joseph's protection as patron of rainstorms and lightning—roles the saint did not play in Spain.[58] In Puebla in 1556 the city council elected St. Joseph patron against storms and lightning after experiencing years of devastating weather that had left the city "struggling, frightened, and almost ruined."[59] During one terrible storm, lightning struck the cathedral and, according to witnesses, would have killed the cathedral chapter members and hundreds of other persons had it not been for St. Joseph's miraculous intervention. According to another report, lightning struck a large tree in the patio of the native parish of St. Joseph. The tree was later carved into an image of the saint by the sculptor Andrés Hernández de Saavedra, reportedly the parish's titular image today.[60] Another document from 1600 memorialized St. Joseph's role as protector from storms in Puebla: "In 1600, the most illustrious Señor Romero erected many parishes, among them that of St. Joseph in Puebla. Since this city was greatly tormented by storms and lightning, he proceeded to the choice of Patron against such calamities and the Most Chaste Patriarch Our Lord St. Joseph was chosen."[61] In 1611 Puebla's city council repeated the action, after experiencing more storms and bad weather. On St. Joseph's March 19 feast day mass was celebrated to prevent additional storms from ravaging the city and surrounding area.[62] According to a 1637 document, the city celebrated a novena in Joseph's honor the week of September 24 with a sermon and procession as an offering of thanks for protection during storms.[63] In 1688 the townspeople singled out May 23 as yet another special feast day dedicated to celebrating St. Joseph's role as the "Sworn Patron against storms and lightning," according to a sermon preached in the city.[64] The sermonist provided a dramatic account of how Joseph saved the city:

The city found itself in the horrors of a tempestuous night, in the horrors of a gloomy confusion, clouded by the hearts' dread, fearful with the souls' horrors. . . . It found itself embattled by lightning, when in the middle of such a

> dark night light dawned in the protection of St. Joseph, because for the con-
> solation of this city he appeared as the morning star, to announce the happi-
> nesses of the desired day: . . . When the People (*el Pueblo*), the City of Puebla
> found itself afflicted by the calamities of storms and lightning that attacked
> it: with the anguish of horrifying thunder that terrorized it day and night,
> by the dark shadows, with which the darkness was made darker by its
> clouds . . . Joseph, the morning star, appeared to console us.[65]

St. Joseph continued to be honored as the protector against storms in Puebla in the late eigh-
teenth century, as revealed by a 1779 report of a procession of the saint's image from the
parish church to the cathedral, where it remained for seven days every October.[66]

In addition to his association with rainstorms and lightning, events previously linked
to Tlaloc, St. Joseph also achieved renown in Mexico for his protection against earthquakes,
which had also been under Tlaloc's domain. In 1681 the saint reputedly saved Mexico City
from a devastating temblor. In 1732 the city and ecclesiastical councils elevated St. Joseph as
patron against "the continuous strong earthquakes" that the city was experiencing.[67] In 1734 a
sermon was preached in Mexico City's cathedral in honor of Joseph's powers against such
events. Published the following year, its title page, which included a print of St. Joseph hold-
ing the Christ Child in his arms, described Joseph as the "Earth's Firmness, Our Lady Mary's
Protection, and God's Tranquility and Quietude."[68] Additionally, Mexicans began to associate
St. Joseph with mines, possibly a variation on Tlaloc's connection to caves.[69]

Two additional parallels between Tlaloc and St. Joseph may have facilitated confla-
tion of the two figures. Tlaloc's pre-Columbian political significances could have easily been
transferred to the figure of St. Joseph. As the oldest indigenous deity, Tlaloc had been wor-
shipped throughout Mesoamerica. Significantly, as a rain and fertility deity he was one of the
gods honored at the main Aztec twin temple in Tenochtitlán, along with Huitzilopochtli, the
sun and war god. In addition to serving as an emblem of "settled civilization," the Aztecs also
associated Tlaloc with rulership and political transitions.[70] He was reportedly the only deity
honored by all the native rulers in an annual pilgrimage.[71] As I contend in chapter 6, St.
Joseph similarly became associated in colonial Mexico with concepts of rulership and notions
of civil society. Furthermore, according to Aztec legend, Tlaloc acted as a surrogate father to
Huitzilopochtli, much as St. Joseph was cast as Christ's foster father. In the manner of the
Incarnation, Huitzilopochtli's conception and birth were miraculous: his mother conceived
him after she found a miracle-working feather. Tlaloc later welcomed Huitzilopochtli to
Tenochtitlán "as his son."[72]

That a Catholic saint would be grafted onto, or conflated with, a pre-existing native cult is not surprising. Although much investigation remains to be done in this area, initial evidence seems to indicate that this was not uncommon in colonial Mexico. Other studies have suggested Huitzilopochtli's conflation with Christ, that of St. Anne with the goddess Toci, and the Virgin of Guadalupe with Tonantzin.[73] By melding together Catholic saints and indigenous deities, native converts were able to transform imported European Catholicism into their own hybrid religion.[74]

Investigation into the development of Josephine devotion in both Old World and New thus reveals that Mexico was an early locus for the flowering of St. Joseph's cult. Initially, the Spanish deployed St. Joseph as a tool of conversion. He seems then to have been conflated with one of the most important pre-Columbian deities, Tlaloc, the god of the rains. Later the promotion of the saint's cult became linked to the imposition of a Spanish ideology of family on the colonies. Although now overshadowed by the Virgin of Guadalupe, St. Joseph remains one of the top three saints celebrated in Mexico today.[75]

In Europe, it was not until after the Council of Trent (1545–63) that St. Joseph's cult gained in popularity. In 1563, at one of its last sessions, the Council addressed the issue of religious images, relics, and the saints, affirming the importance of saints' cults, which had been attacked by the Protestants. Afterward, Josephine devotion spread dramatically, fostered by such key figures as St. Francis de Sales, St. Ignatius Loyola, and St. Teresa de Ávila. Texts dedicated to him proliferated.

The person most responsible for spreading Josephine devotion in Spain was St. Teresa de Ávila, the renowned mystic, author, and Carmelite reformer. In her autobiography she disclosed that St. Joseph had cured her of a crippling illness during her childhood. As a result, she took the saint as her patron and was visited throughout her life by visions of Joseph. As an adult, she dedicated all her convents to the saint, and in 1621 her order, the Reformed Carmelites, officially selected Joseph as their patron.[76] Teresa had a direct influence on many important religious figures of the period. The Franciscan St. Peter Alcántara, one of her associates, was also instrumental in increasing devotion to Joseph. In 1561 Joseph was made the protector of the Friars Minor, to which St. Peter Alcántara belonged.[77] In 1597 Teresa's spiritual director, Father Jerónimo Gracián de la Madre de Dios, wrote an important devotional work, the *Josefina*, which circulated throughout the Spanish Empire and was translated into French and Italian.[78] Gracián's work, one of the most widely read early modern Josephine texts, directly affected artistic representations of the saint in Spain and Mexico.

The importance of St. Joseph in the early modern period is also demonstrated by the number of countries that took him as their official patron. After Joseph was made the protec-

tor of Mexico in 1555, other countries quickly followed suit, including Canada in 1624, Bohemia in 1655, France in 1661, Spain in 1679, and Belgium in 1689. During the conversion efforts in China and elsewhere in the East, Spanish Jesuits translated Joseph's life and related devotional books into Chinese and Tagalog; in 1678 he was made the patron of the missions in China.[79] Thus, St. Joseph became the protector of the entire far-flung Spanish Empire.

By 1621, when Pope Gregory XV established March 19 as a universal feast day mandatory for the entire Church, Joseph's popularity had been clearly established in Spain for at least sixty years and in Mexico for one hundred. The first celebrations of the "fallas de San José" (bonfires of St. Joseph) in Valencia, Spain—perhaps the best-known Josephine feast today—date to this era.[80] In 1624 Pope Urban VIII reissued Gregory XV's decree, and in 1670 Pope Clement X elevated the feast day's ranking.[81] A number of additional Josephine feasts were celebrated throughout the Hispanic world, including the Betrothal of Joseph and Mary (November 26), the Flight into Egypt (December 28), the Holy Family (January 19), the Return from Egypt (March 7), St. Joseph's Seven Joys and Seven Sorrows (March 26), St. Joseph's Protection (the third Sunday after Pentecost), and St. Joseph's Death, or *Transitus* (July 20 or March 19).[82] By the end of the seventeenth century, Joseph was honored the nineteenth of every month in Mexico's churches.[83] Yet another feast day was observed in Mexico City in October, celebrating Joseph's sanctification in the womb before his birth. In the mid-1720s the viceroy of New Spain, the Marqués de Valero, paid for an altar dedicated to St. Joseph in Mexico City's Corpus Christi convent to commemorate the holiday.[84]

After sixteen hundred years of obscurity, Joseph suddenly rose to the top of the saintly hierarchy. This early modern efflorescence of Josephine devotion provides a unique case study of the promotion of a new saint and the creation of art in the service of the Church. How did artists and theologians in the Spanish Empire create new imagery to illustrate the life of St. Joseph? What choices were made, and what do these choices reveal of Joseph's significance? As noted, neither the Bible nor the Church Fathers provided much information on Joseph. No medieval hagiographies existed, and apocryphal tales, such as the *Golden Legend* of Jacobus de Voragine and others, were firmly rejected in the wake of the Council of Trent. In essence, the Spanish were free to construct his figure as they wished, unrestricted by an established discourse.

Although Spanish artists had access to the more dignified renderings of Joseph by fifteenth-century Northern artists, which were brought to Spain by painters in the employ of the Catholic Monarchs Ferdinand and Isabella, Spanish and Mexican artists seem to have rejected these Netherlandish examples. Instead, they created a new type of Joseph—young, handsome, and virile—who starred in scenes of the Holy Family's domestic bliss and

assumed a major role in the Gospel narrative. Inspired by the dignified Joseph first described by Gerson, Hispanic artists and theologians championed the humble carpenter and developed a new hagiography featuring him as the manly protector of the Holy Family and the teacher of the young Jesus.

Around the year 1600 imagery of Joseph began to proliferate in Spain and Mexico. This sudden increase in Josephine imagery is remarkable because of the paucity of previous depictions of this saint. Spanish and Mexican artists took the first step by expanding the saint's role in the Gospel narratives. No longer a sideline figure, they fully integrated Joseph into images of the Nativity, the Adoration of the Shepherds, and the Epiphany. Artists also gave him new prominence in scenes such as the Circumcision, the Visitation, and Christ in the Temple with the Doctors, and expanded his role in the Flight into Egypt sequence. Joseph became the focus in images of the Betrothal, Joseph's Dream, the Holy Family, the Earthly Trinity, the Christ Child, the Carpenter's Workshop, his Death, and his Coronation—which in turn are the focus of this book.

One of the earliest Josephine altarpieces was by El Greco (1541–1614), whose *St. Joseph and the Christ Child* of 1593 was painted on commission for a private patron in Toledo. It is not surprising that some of the earliest full-scale paintings valorizing the saint appeared in Toledo, since in the sixteenth century, Cardinal Jiménez, Archbishop of Toledo, Regent of Spain, and Chancellor of the Realms, celebrated St. Joseph's feast in the city's cathedral.[85] In El Greco's painting, St. Joseph and the Christ Child lovingly clasp hands in front of a view of Toledo. The composition was evidently a success, given the existence of at least two other versions (fig. 46).

Joseph's new character and importance in seventeenth-century Spanish and Mexican painting stands in contrast to his depiction in most sixteenth-century art. Two paintings by Vicente Macip and Andrés de la Concha (d. 1612) typify respectively the Spanish and Mexican Renaissance interpretation of the Holy Family (fig. 16 and pl. 5). Both artists placed the compositional emphasis on the Madonna and Child, relegating St. Joseph to the second plane as a spectator who does not participate in the main action (his secondary role in both scenes is underscored by his small stature). Macip completed his characterization by rendering Joseph as an aged, bearded man who leans heavily on his walking stick for support.

Finally, artists began to utilize Joseph in other scenes in which he had never before figured, such as the Mystic Marriage of St. Catherine, the Vision of St. Teresa, the Immaculate Conception of Mary, and the Vision of St. Anthony. In a painting of St. Luke by the Spaniard Juan de Valdés Leal (1662–1690) the artist-saint is represented painting St. Joseph and the Christ Child rather than the customary portrait of the Virgin.[86] And, for the first

and embraces them, is fully incorporated into the composition. In contrast, St. Joseph is a marginal, additive personage who stands behind the main figures on the right, peering over the Virgin's shoulder at the Christ Child.[87]

Italian Baroque artists painted relatively few images of St. Joseph. The saint appears in Caravaggio's *Rest on the Flight into Egypt* (fig. 6)—an unusual rendering in which St. Joseph, seated on the left, holds up a book of music from which an angel plays. One prominent scholar has aptly characterized Caravaggio's Joseph as a "simple, elderly man," further noting the saint's akward, unshod feet and the juxposition of his head with that of the Holy Family's ass.[88] The artists Guido Reni (1575–1642) and Guercino (1591–1666) rendered the saint in a more dignified manner. Reni singled out St. Joseph and the Christ Child in a moving devotional canvas from 1638–40 (private collection, Houston). In it, St. Joseph, who appears as an older man with a wrinkled face, gray hair, and white beard, tenderly embraces the Child. Guercino depicted the saint in similar devotional works on three occasions, which include two canvases of Joseph holding the Christ Child and one of the saint alone.[89] In all three, however, the saint is rendered as an elderly man.

Because devotion to Joseph was nearly nonexistent in France until after 1650, when Carmelite reformers influenced by St. Teresa de Ávila promoted his cult there, very few images of St. Joseph appear in French seventeenth-century painting.[90] St. Joseph was, however, the subject of an unusual work by Georges de La Tour (1593–1652) of about 1638–40, his *St. Joseph the Carpenter* (Musée du Louvre, Paris). The image, which looks like a genre scene, depicts Joseph boring a hole in a beam of wood as the Christ Child holds a light for His foster father. An earlier scholar has suggested that Joseph's action alludes to the preparation of the cross for Christ's Crucifixion.[91] *The Dream of St. Joseph*, a unique canvas by Philippe de Champaigne (1602–1674), executed for a chapel of St. Joseph in the convent of Minims of the Place Royale in Paris, presents the saint as a young and handsome figure (National Gallery, London, seventeenth century). Other images of the saint by the same artist, however, represent the saint as the more familiar older man.[92]

The European images just examined by Rubens, Caravaggio, Reni, Guercino, La Tour, and Champaigne demonstrate that representations of St. Joseph were not standardized in seventeenth-century European painting. His placement in the picture, his age, and the dignity conferred upon his figure varied considerably from image to image. These variations suggest that Joseph was an ambivalent figure. In some instances artists ennobled him as Christ's loving earthly father, while in other images he is clearly marginalized by his placement or by being rendered as an ineffective old man. Seventeenth-century Spanish and Mexican images are unusual in their unanimously positive and absolute view of St. Joseph as a significant member of the Holy Family.

assumed a major role in the Gospel narrative. Inspired by the dignified Joseph first described by Gerson, Hispanic artists and theologians championed the humble carpenter and developed a new hagiography featuring him as the manly protector of the Holy Family and the teacher of the young Jesus.

Around the year 1600 imagery of Joseph began to proliferate in Spain and Mexico. This sudden increase in Josephine imagery is remarkable because of the paucity of previous depictions of this saint. Spanish and Mexican artists took the first step by expanding the saint's role in the Gospel narratives. No longer a sideline figure, they fully integrated Joseph into images of the Nativity, the Adoration of the Shepherds, and the Epiphany. Artists also gave him new prominence in scenes such as the Circumcision, the Visitation, and Christ in the Temple with the Doctors, and expanded his role in the Flight into Egypt sequence. Joseph became the focus in images of the Betrothal, Joseph's Dream, the Holy Family, the Earthly Trinity, the Christ Child, the Carpenter's Workshop, his Death, and his Coronation—which in turn are the focus of this book.

One of the earliest Josephine altarpieces was by El Greco (1541–1614), whose *St. Joseph and the Christ Child* of 1593 was painted on commission for a private patron in Toledo. It is not surprising that some of the earliest full-scale paintings valorizing the saint appeared in Toledo, since in the sixteenth century, Cardinal Jiménez, Archbishop of Toledo, Regent of Spain, and Chancellor of the Realms, celebrated St. Joseph's feast in the city's cathedral.[85] In El Greco's painting, St. Joseph and the Christ Child lovingly clasp hands in front of a view of Toledo. The composition was evidently a success, given the existence of at least two other versions (fig. 46).

Joseph's new character and importance in seventeenth-century Spanish and Mexican painting stands in contrast to his depiction in most sixteenth-century art. Two paintings by Vicente Macip and Andrés de la Concha (d. 1612) typify respectively the Spanish and Mexican Renaissance interpretation of the Holy Family (fig. 16 and pl. 5). Both artists placed the compositional emphasis on the Madonna and Child, relegating St. Joseph to the second plane as a spectator who does not participate in the main action (his secondary role in both scenes is underscored by his small stature). Macip completed his characterization by rendering Joseph as an aged, bearded man who leans heavily on his walking stick for support.

Finally, artists began to utilize Joseph in other scenes in which he had never before figured, such as the Mystic Marriage of St. Catherine, the Vision of St. Teresa, the Immaculate Conception of Mary, and the Vision of St. Anthony. In a painting of St. Luke by the Spaniard Juan de Valdés Leal (1662–1690) the artist-saint is represented painting St. Joseph and the Christ Child rather than the customary portrait of the Virgin.[86] And, for the first

time in the history of art, St. Joseph became the frequent subject of major altarpieces.

St. Joseph's new position of importance in seventeenth-century Spain is given perfect pictorial form in Bartolomé Esteban Murillo's *Holy Family with the Little Bird* (1617–1682; pl. 4). Murillo painted Joseph as a handsome young man in his thirties, with long, wavy hair, even features, and a powerful physique. The saint tenderly watches over the Christ Child, his impressive figure filling the horizontal canvas. The artist also drew attention to Joseph's role as provider by positioning the saint's carpentry tools, including his bench, saw, adze, and chisel, in the foreground. The Virgin is visible in the background, demurely attending to her spinning. The artist's representational choices—such as the inclusion of abundant naturalistic

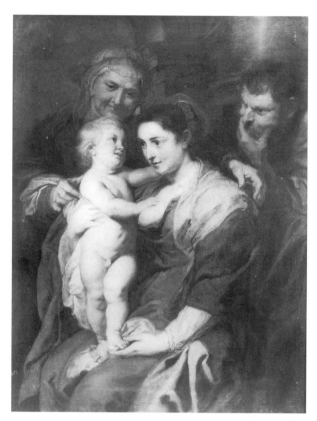

Fig. 5. Peter Paul Rubens (1577–1640), *Holy Family with Saint Anne*, c. 1628. Oil on canvas, 45 ¼ x 35 ½ in. (115 x 90 cm). Museo del Prado, Madrid

details, the dependence on live models, and the earth-tone palette—create an image that is humble, human, and mundane. The Mexican Baroque artist Cristóbal de Villalpando (c. 1649–1714) characterized St. Joseph in a similar manner in a depiction of the Holy Family dating from late in the century (fig. 29). St. Joseph now appears in the foreground on equal footing with the Madonna and Christ Child. In fact, the saint leans over his foster Son protectively, a pose designed to valorize Joseph's role as Christ's earthly father and mitigate his earlier marginalization.

Although the growth of St. Joseph's cult was a pan-European phenomenon, Josephine devotion appears to have attained particular intensity in Spain and the Americas. Compared to seventeenth-century depictions of St. Joseph by artists in Italy, France, and Flanders, Spanish and Mexican works give greater emphasis to the saint. Spanish and Mexi-

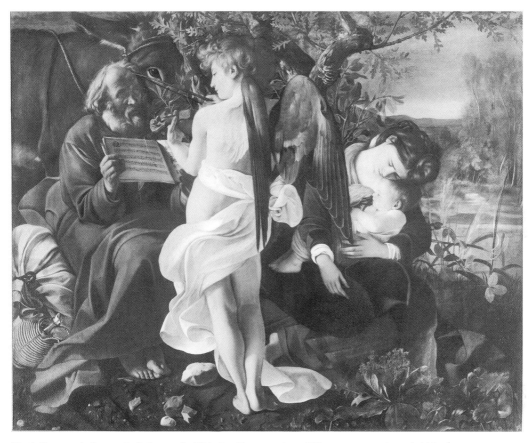

Fig. 6. Caravaggio (1573–1610), *Rest on the Flight into Egypt*, 1596–97. Oil on canvas, 52 /12 x 65 ¹/₂ in. (133.5 x 166.5 cm). Galleria Doria-Pamphilij, Rome

can artists also routinely depicted Joseph as a young and vigorous husband and father, whereas elsewhere in Europe the saint still generally appeared as an older or middle-aged man. A few comparative examples make this point clear.

Even though Peter Paul Rubens (1577–1640) routinely included St. Joseph in depictions of the Holy Family, the renowned Flemish artist invariably assigned the saint to the paintings' margins. This can be seen in several of the artist's Holy Families painted in the 1620s and 1630s. His *Holy Family with Saint Anne* (fig. 5), which in the seventeenth century hung in the Escorial and currently is housed in the Museo del Prado, uses the same configuration favored by the artist in all his other renditions of the theme. The scene is focused on the Virgin and Child, seated in the foreground. Saint Anne, who stands behind the figures

and embraces them, is fully incorporated into the composition. In contrast, St. Joseph is a marginal, additive personage who stands behind the main figures on the right, peering over the Virgin's shoulder at the Christ Child.[87]

Italian Baroque artists painted relatively few images of St. Joseph. The saint appears in Caravaggio's *Rest on the Flight into Egypt* (fig. 6)—an unusual rendering in which St. Joseph, seated on the left, holds up a book of music from which an angel plays. One prominent scholar has aptly characterized Caravaggio's Joseph as a "simple, elderly man," further noting the saint's akward, unshod feet and the juxposition of his head with that of the Holy Family's ass.[88] The artists Guido Reni (1575–1642) and Guercino (1591–1666) rendered the saint in a more dignified manner. Reni singled out St. Joseph and the Christ Child in a moving devotional canvas from 1638–40 (private collection, Houston). In it, St. Joseph, who appears as an older man with a wrinkled face, gray hair, and white beard, tenderly embraces the Child. Guercino depicted the saint in similar devotional works on three occasions, which include two canvases of Joseph holding the Christ Child and one of the saint alone.[89] In all three, however, the saint is rendered as an elderly man.

Because devotion to Joseph was nearly nonexistent in France until after 1650, when Carmelite reformers influenced by St. Teresa de Ávila promoted his cult there, very few images of St. Joseph appear in French seventeenth-century painting.[90] St. Joseph was, however, the subject of an unusual work by Georges de La Tour (1593–1652) of about 1638–40, his *St. Joseph the Carpenter* (Musée du Louvre, Paris). The image, which looks like a genre scene, depicts Joseph boring a hole in a beam of wood as the Christ Child holds a light for His foster father. An earlier scholar has suggested that Joseph's action alludes to the preparation of the cross for Christ's Crucifixion.[91] *The Dream of St. Joseph*, a unique canvas by Philippe de Champaigne (1602–1674), executed for a chapel of St. Joseph in the convent of Minims of the Place Royale in Paris, presents the saint as a young and handsome figure (National Gallery, London, seventeenth century). Other images of the saint by the same artist, however, represent the saint as the more familiar older man.[92]

The European images just examined by Rubens, Caravaggio, Reni, Guercino, La Tour, and Champaigne demonstrate that representations of St. Joseph were not standardized in seventeenth-century European painting. His placement in the picture, his age, and the dignity conferred upon his figure varied considerably from image to image. These variations suggest that Joseph was an ambivalent figure. In some instances artists ennobled him as Christ's loving earthly father, while in other images he is clearly marginalized by his placement or by being rendered as an ineffective old man. Seventeenth-century Spanish and Mexican images are unusual in their unanimously positive and absolute view of St. Joseph as a significant member of the Holy Family.

As a result of the choices ultimately made by Spanish and Mexican theologians and artists, St. Joseph assumed a position of extraordinary centrality and importance within the Spanish Empire. This book demonstrates that in Spain the construction of the imagery of St. Joseph was bound up with the pervasive perception of social and political crisis during the so-called Golden Age.[93] The images, texts, and documents indicate the existence of distinct but overlapping discourses of Josephine devotion in Mexico and Spain. In Mexico, Joseph initially played a key role in the conversion efforts. In addition, the promotion of his cult was intimately linked to the imposition of a Spanish ideology of family on the colonies, as the remainder of this study will show.

Jusepe de Ribera, *Dream of Jacob (detail of fig. 14)*

CHAPTER

TWO

LOVE *and* MARRIAGE

IN A 1633 SERMON dedicated to the difficulties of marriage, the Spanish preacher Diego
Niseno compared having a wife to being crucified: "[I]t is the same for a man to marry as
to be crucified; it will be the same to give him a cross as a wife."[1] In seventeenth-century
Betrothal paintings, which imaged the union between the Virgin Mary and her earthly hus-
band, St. Joseph, as the consummate loving alliance, artists in the Spanish Empire portrayed
a rather more ideal expression of marriage (figs. 7–12). These Spanish and Mexican paintings,
produced in unprecedented numbers in the seventeenth century, feature St. Joseph, the high
priest, and the Virgin Mary enacting the Catholic marriage ritual by joining hands.[2] Joseph
holds his major attribute, the flowered staff. The dove of the Holy Spirit appears, indicating
the event's sacred nature. The basic components vary little throughout the century, attesting
to the Inquisition's success in imposing conformity in cultural production throughout the
Spanish Empire. Annunciation and Visitation scenes similarly celebrated Joseph as the ideal
husband. Images of St. Joseph's Dream, also known as "Joseph's Doubts" or "Jealousy," depict-
ing Joseph's anguished discovery of his wife's inexplicable pregnancy, represented the saint as
a sensitive and understanding spouse (figs. 13, 15, and pl. 3).

Seventeenth-century representations such as the foregoing, in conjunction with ser-
mons, hagiographies, devotional texts, and sacred plays, shaped societal discourses on mar-
riage in the Spanish Empire. These images presented to Spanish and Mexican beholders the
source of Joseph's glories: his status as the husband of the mother of God. Such depictions
celebrated Joseph as the perfect spouse, articulated the Church's position on adultery, and
otherwise provided models for men to imitate, thus helping define a Spanish Catholic vision

of gender roles in marriage. In so doing, these works of art gave visual form to a specifically Catholic marriage ideology defined at the Council of Trent and designed to challenge Protestant critiques. In the New World, these paintings of holy matrimony performed the additional cultural work of colonialism.

Like most religious imagery, these paintings were visible to worshippers in such public venues as parish churches and cathedrals. For example, Francisco Ribalta (1565–1628) and his workshop were commissioned to execute two different versions of the Betrothal, one destined for a series of paintings on St. Joseph's life for the saint's chapel in Santiago Apóstol, the parish church in Algemesí (1605–10), and another for the parish church of Andilla as part of a series of eight canvases on the life of the Virgin Mary (1621). Other Betrothal images can be documented in cathedrals in the seventeenth century, including a canvas by Andrés de Vargas (1613–1674) which formed part of an altarpiece grouping in the Sagrario Chapel of Cuenca Cathedral (1652–53); Juan de Valdés Leal's 1667 painting for the St. Joseph Chapel of Seville's Cathedral (1662–90; fig. 7); and a sculpted relief by Gregorio Fernández (c. 1576–1636) for the *retablo mayor* of the Cathedral in Plasencia (Cáceres). The Spanish monarchy also seems to have been interested in depictions of the subject, as witness two paintings traceable to royal commission, one from the early 1600s and one from the end of the century: a Betrothal painting by Vicente Carducho (fig. 8), originally part of a series in the oratory of the royal hunting lodge, the Torre de la Parada, and a later work by Lucca Giordano (1632–1705) commissioned by Charles II illustrating the life of the Virgin Mary for the *camarín* of the *Monasterio* in Guadalupe, Extremadura. Although similar documentation for Mexico is only now being recovered, one imagines that such paintings were similarly accessible to viewers in a variety of locales.[3]

Because neither the Bible nor patristic texts reveal substantial information about the marriage between Joseph and the Virgin, the contemporary system of cultural signs serves as a point of departure. The Gospels disclose only that Joseph was Mary's husband and thus the father of Jesus.[4] The paucity of information perplexed Spanish theologians, who therefore assumed that the Gospel's description of Joseph as Mary's husband encompassed all his glories, and that Joseph's holiness derived from his status as the husband of the mother of God.[5]

Although artists in the Spanish Empire only began to depict the Betrothal with frequency in the seventeenth century, the subject had long been the focus of Church celebration. In 1479, Pope Sixtus IV placed it on the liturgical calendar. In 1621, Pope Gregory XV added a second feast day in honor of St. Joseph on March 19, when the Betrothal was also celebrated. On this day, Spanish preachers delivered sermons extolling the virtues of the marriage.[6] In the later seventeenth century, Pope Innocent XI singled out November 26 as yet a

third feast day to commemorate the Betrothal. So esteemed was St. Joseph in Spain that King Charles II urged the pope to mandate observance of the feasts for the entire Spanish kingdom. To bolster such a demand, Spanish theologians maintained that the Virgin Mary herself had celebrated the Betrothal.[7]

Fig. 7. Juan de Valdés Leal (1622–1690), *Betrothal*, 1667. Oil on canvas, 5 ft. 11 in. x 9 ft. 6 in. (1.8 x 2.9 m). Chapel of St. Joseph, Catedral, Seville, Spain

The Inquisition's careful regulation of Betrothal depictions further testifies to the image's importance. *The Art of Painting*, written by Francisco Pacheco (1564–1644), a painting censor for the Holy Office in the first third of the seventeenth century, and Fray Juan Interián de Ayala's *The Christian Painter* of 1730 carefully prescribe the image.[8] The two books, issued approximately one hundred years apart, serve as the beginning and end points for the Spanish and Latin American Baroque, summarizing the century's approach to religious art. The great number of writings dedicated to the Betrothal in the seventeenth century, knowledge of which expands understanding of the paintings, further documents the subject's importance. The most accessible text, known throughout the Spanish Empire, was the enormously popular sacred play *El Mejor Esposo, San José* (The Best Husband, Saint Joseph) by the Spanish Golden Age dramatist Guillén de Castro.[9]

Castro's *comedia bíblica* implies that the paintings allude to an unexpected sexual innuendo. Conditioned by Castro's play, viewers would have understood that Joseph's main attribute, the flowering staff, referred to a ribald event in the narrative, the choice of St. Joseph in act I (figs. 7, 8, 9, and 12). According to the stage directions, Joseph and the other young Jewish men enter the scene with staffs in hand. God's voice then explains that the lucky man who sees his "dry staff" transformed into a "fresh bouquet" will be Mary's "chosen spouse."[10] Suddenly, Joseph's staff bursts into bloom, and he exclaims: "What do I see? Woe is me! It seems that the fresh mist that blows forth moistens my dry staff. Now new leaves burst forth, now white flowers

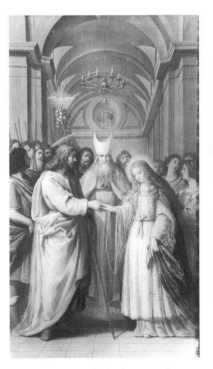

Fig. 8. Vicente Carducho (1576–1638), *Betrothal*. Oil on canvas, 44 1/2 x 23 3/5 in. (113 x 60 cm). Palacio Real, Madrid

bloom!" At this moment white flowers burst from Joseph's rod as a dove appeared.[11] To the modern reader, the allusion to ejaculation could hardly be less subtle.

Accordingly, the contrast between Joseph's long, blossoming rod and the rejected suitors' short, plain staffs, an obvious reference to the scene described above, often served as a key component of Betrothal paintings. In some canvases the rejected suitors appear on the sidelines, holding their staffs, whereas in others they angrily break the rods over their knees, a detail from medieval apocryphal stories. Significantly, their staffs do not flower and are generally shorter than that of Joseph. Both Pacheco and Interián emphasized that Joseph's staff must be "full of flowers."[12] Pacheco contended that the flora represented Joseph's virginity while Interián interpreted the blooms as symbolic of the saint's "most pure continence."[13] According to a sermon preached in Granada in 1672, the flowering staff and dove indicated God's signs that Joseph was Mary's chosen spouse.[14] Despite the Inquisition's proclamations of purity, however, Joseph's flowering staff resonates with obvious phallic connotations, associations that Castro emphasized in his play.

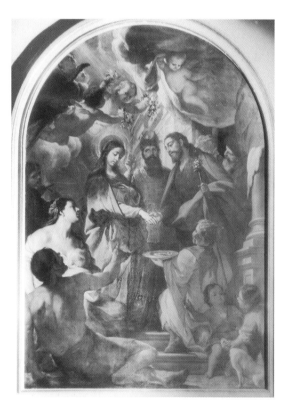

Fig. 9. Acisclo Antonio Palomino (1655–1726), *Betrothal*, 1695. Oil on canvas, 9 ft. 9 in. x 6 ft. 4 in. (3 x 1.9 m). Museo Nacional de Escultura, Valladolid, Spain

Erotic allusions are, in fact, common elements of betrothals and weddings, which are, after all, fertility rites.[15] The inclusion of such elements, however, in the context of the virginal marriage between Joseph and Mary is perhaps surprising and paradoxical. Surely, some Spanish viewers found it comical as well as ironic that such an obvious phallic symbol— the "dry" staff, which when moistened, bursts into white blooms—represented a man who never used his phallus to procreate, who remained ever virginal, and who did not father his wife's child.

In this way, the seemingly simple attribute of Joseph's staff points to a conspicuous contradiction in these paintings. How could Joseph simultaneously personify the perfect husband and yet remain a virgin? Were his blossoming staff and superior size meant to mitigate his lack of sexual prowess, the traditional marker of masculinity? Did their inclusion not draw attention instead to his demonstrated lack of sexual expertise? Such contradictions seem particularly obvious as well as perplexing in the context of Hispanic society, where sexual performance has traditionally been a significant component of masculinity.[16] As I discuss

below, the obvious contradictions seem to point to the valorization of new modes of masculine behavior.

The Inquisition guidelines demonstrate a similar, although less paradoxical, preoccupation with gender ideologies in their prescription for Mary's figure. Interián instructed artists to adorn the Virgin "with great modesty."[17] Artists apparently took special care to follow his instructions. The Virgin nearly always looks down as Joseph takes her hand (figs. 7–12). Other gestures of modesty accompany her downcast eyes. In some paintings, the Virgin places her hand over her heart to signal self-effacement, while in others she shyly pulls her mantle about her body. In

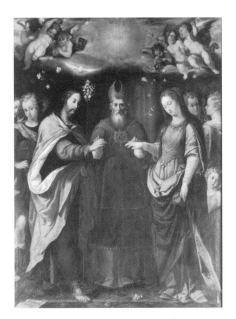

Fig. 10. Sebastián López de Arteaga (1615–1652), *Betrothal*, between 1645–52. Oil on canvas, 88 x 66 in. (224 x 167 cm). Museo Nacional de Arte, Mexico City

Fig. 11. Luis Juárez (active 1609–1639), *Betrothal*, between 1610–38. Oil on canvas, 98 ¹/₂ x 59 in. (250 x 150 cm). Parish church, Atlixco, Puebla, Mexico

some images she wears a knotted cord below her breasts, a traditional symbol of chastity dating back to classical times when it was worn by the virgin goddess Diana (fig. 8).

The most potent emblem of the Virgin's modesty was, however, her hair. Although traditionally artists represented the Virgin wearing a veil, in nearly all Betrothal paintings she appears bareheaded. Artists drew attention to her long hair, which falls in soft waves over her shoulders. Period devotional texts explain why. According to one, women have an obligation to grow their hair long, to be "pleasing to divine eyes."[18] Their tresses serve as a natural veil. Furthermore, long hair symbolizes women's subjugation to men: the longer the hair, the more submissive the woman. Flowing locks bear witness to women's "soft and delicious slavery."[19] Thus, it is not coincidental that Spanish and Mexican artists depicted the Virgin with long, flowing hair in the Betrothal, as in that by Luis Juárez (fig. 11). The strategy alerted the beholder to her subjugation to her husband, St. Joseph.

The Church's censors and commentators also carefully regulated the depiction of St. Joseph's demeanor. On the subject of the saint's attire, Interián wrote, "I readily confess that he should be painted in common costume, and more in the style of low class people than in that of the grandees."[20] Although Joseph was poor, artists had not the license to paint the

saint in a demeaning way, as Interián pointed out: "but this does not mean that he can be painted deformed, with an ugly appearance, and his hair so little cared for that it falls almost into slovenliness: especially because modesty, which is concerned with caring for and moderating the toilet of the body and dress, is a virtue."[21] Interián reiterated his stance by warning against the depiction of the just and dignified Joseph "as if he were a rude little man, of almost no estimation" who "did not know his right hand from his left."[22]

Conversely, Interián cautioned artists against erring by painting Joseph as overly attractive and prettified. He warned against painting Joseph "in the manner of a very well coifed young man and lover of cosmetics," offering his opinion that "sensible men should remain very far from similar childish excesses." He elaborated: "Nor can I approve of the indiscretion of others, who on the contrary paint the most holy Patriarch and most chaste spouse of Mary more handsome and adorned than is just, those who represent him with a very smiling face, his beard too carefully arranged, his hair half-curled and fanned out over his shoulders, and finally, adorned in a manner that it seems that his clothing serves more to adorn than to cover him."[23] Joseph must be represented as "a serious man without any affectation," "commendable in all respects for his modesty and gravity."[24] Interián's concern with Joseph's masculinity is unmistakable.

Rendering St. Joseph's age correctly became artists' vital task in Josephine imagery. According to Interián, many a painter and learned person had fallen into the error of thinking Joseph old when betrothed to the Virgin.[25] The Inquisition held that artists should not depict Joseph as too young nor as a decrepit old man. Some theologians had claimed erroneously that Joseph had other children from his first marriage, a version of the saint's biography that the Church firmly rejected on account of its implication that Joseph was not a virgin his entire life. This concern with Joseph's age forms the centerpiece of discussions regarding imaging the saint. According to Pacheco, the saint should be represented as "a little more than thirty" years of age.[26] As a result, Joseph always appears as a youthful man between the ages of thirty and forty in Spanish and Mexican seventeenth-century Betrothal paintings.

The art theorists Interián and Pacheco were not alone in debating the age of St. Joseph, for this polemic was the major controversy surrounding him in the Spanish Empire. Traditionally, artists had depicted Joseph as an older man; indeed, in medieval paintings and apocrypha Joseph appears as a white haired octogenarian stooped over with age. Often artists rendered him in hieratic scale, a smaller figure in relation to the Virgin. Such strategies attempted to assuage doubts about Mary's virginity, as presumably an old man would be incapable of seducing her. These tactics, however, also characterized Joseph as a cuckold, albeit a cuckold of God, downplaying his importance. This practice began to change in the sixteenth century, when some theologians and artists represented Joseph as a middle-aged man of

about fifty years old. By the seventeenth century, artists and clerics in the Spanish Empire argued that, at the Betrothal, the saint was a "most handsome young man."[27] And so he appears in Spanish and Mexican art.

Neither Pacheco nor Interián envisioned any need to depict Joseph as an old man in order to remove doubts about the Virgin's purity, for in their opinion her virginity was beyond question. Theologians concurred, arguing that Joseph's youth and handsomeness made their abstinence all the more impressive.[28] Furthermore, theologians argued that only if Joseph were young could he have convinced both the devil and the Jews that he was Mary's legitimate husband, thereby preventing discovery of the Messiah's identity. If Joseph were old, people would suspect that he was not the true father of the Christ Child. Indeed, as an octogenarian Joseph would have been incapable of defending his wife's honor from the accusation that she had given birth to a child out of wedlock.[29] Finally, the Spanish appealed to common sense, stating that large age differences between husband and wife were potentially problematic. Eighty-year-old men, it was thought, were incapable of protecting, supporting, or defending their families. Joseph required youth and physical strength to support his family as a carpenter and protect it on the Flight into Egypt. To conform to this ideal of the perfect husband, Pacheco asserted that, at the time of the Betrothal, Joseph was in his thirties, the perfect age of man. Interián more or less concurred, suggesting that the

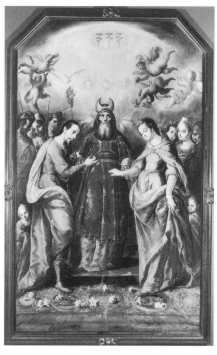

Fig. 12. Cristóbal de Villalpando (c. 1649–1714), *Betrothal*, 1690s?. Oil on canvas, 64 ½ x 56 ⅔ in. (164 x 144 cm). Museo Nacional de Arte, Mexico City

saint was "around forty years old," the time in life when a man's bodily strength and virtues reach perfection.[30]

Additional instructions governed the compositional arrangement of the scene, further evidence of the Inquisition's interest in Josephine imagery and an indication that the Church did not consider the subject a mere artistic matter. The Church required Spanish and Mexican artists to focus on the joining of the Virgin's and Joseph's hands in the Betrothal. According to Pacheco, the Virgin and Joseph must be painted "giving their right hands to each other with great honesty and, in the middle, the priest blessing them."[31] Accordingly, Spanish and colonial Mexican Betrothal paintings feature the handclasp as the scene's central focus. The High Priest stands between the couple, joining together their hands. An unusual painting by the Mexican artist Cristóbal de Villalpando depicts Joseph placing a ring on Mary's index finger, in accordance with Jewish custom (fig. 12).

The Inquisition intended that its artistic instructions give visual form to the Catholic marriage ceremony as standardized at the Council of Trent. At its twenty-fourth session on

November 11, 1563, the Council considered the marriage sacrament and prepared to refute Protestant critique of the institution. Luther, in *The Babylonian Captivity* (1520), had stated that matrimony was a civil contract, and not one of the seven sacraments. He also maintained that for a marriage to be valid, it had to be consummated physically, an assertion clearly at odds with the Church's insistence that Joseph and Mary had a true marriage.[32] In reaction to the Protestant critique, the Church reasserted matrimony's status as a sacrament and insisted that all marriages be sanctioned ecclesiastically. In addition, the Council of Trent condemned secret betrothals and clandestine marriages, requiring that a priest perform all marriages, that both parties publicly declare their intent to marry, and that the couple seal the contract with a handclasp.[33] Despite historicizing "Hebrew" details (such as the Jewish priest, the Solomonic columns in the temple, or the inclusion of Hebrew text), all seventeenth-century Betrothal images in the Spanish Empire depict or imply the foregoing elements.

Betrothal images thus served as vital tools in the Church's campaign to promote a Counter-Reformation marriage ideology. In conjunction with texts, such images also played a central role by defining and shaping Church-sanctioned gender roles in marriage. Theologians outlined the duties of husbands and wives via sermons, treatises, devotional texts, and in the confessional. Priests delivered sermons on the feast of the Betrothal directed at newly married couples, whom theologians instructed to emulate Mary and Joseph.[34] Devotional writers heartily recommended Mary and Joseph's marriage as "true and most perfect," further noting that Mary "loved Joseph as she loved herself, and had him always in her eyes and in her mind." Joseph served as a loving husband who treated his wife to "soft and loving words."[35]

Josephine devotional writers often personalized stories of Joseph's life to offer practical advice to the worshipper. For example, a 1609 life of St. Joseph by Andrés de Soto includes extended passages of marital advice in the chapters on the Holy Family. Soto asserted that although Mary was the mother of God, Joseph was her equal (a truly extraordinary claim), a necessary prerequisite for a happy marriage. Indeed, it was preferable in a marriage for the husband to be greater than the wife, or the resulting marriage would be unhappy. This was because men were "worth more," "more perfect," and had more "reason."[36] Like all earthly wives, the Virgin derived her status from her husband Joseph, whose valor and virtue were her most precious jewels; women "take as their own the virtues and perfections of their husbands."[37] Castro's comedia, discussed above, also included practical admonitions to the viewer. After the marriage scene, Mary declared her subjugation to her husband: "My master, beloved spouse . . . I am so much yours, that unworthy of being your wife, I am always contemplating the flowering dry staff in your miraculous hand, where the royal dove took its place, that declares to me your value; I should to the best of my abilities prefer you, esteem you, aggrandize you, obey you as a father and serve you as my master."[38]

Thus, marriage was a major preoccupation in the seventeenth-century Spanish Empire, as witness the Spanish Church's careful regulations of Betrothal depictions. The Church designed such prescriptions to elevate St. Joseph to a level of dignity and importance after centuries of being cast in an ignoble light. They also embodied gender ideologies revealing contemporary standards of behavior for seventeenth-century men and women. So timely was marriage as a topic of deliberation that two additional images pictorialized Joseph's exemplary conduct as a husband—the Visitation, and more particularly, Joseph's Dream. As we shall see, such scenes image Joseph as the perfect husband as they explicate the Church's position on adultery.

These two scenes, along with the Annunciation to the Virgin, constitute one of the most important narratives in the Gospels, the story of the Redemption (Luke 1:26–38). Although Western artists had depicted the Annunciation for centuries, seventeenth-century artists in the Spanish Empire elaborated on scenes of the Visitation and especially St. Joseph's Dream. Similarly, devotional writers expanded on the meager information provided about St. Joseph in the New Testament. Such writers reported that after the Annunciation and Incarnation, Joseph and Mary embarked on a four-day journey to the house of Mary's cousin Elizabeth and her husband Zacharias. Joseph, although ignorant of Mary's condition, sensed a change in his wife. Upon their arrival, St. Elizabeth embraced her cousin, immediately recognizing Mary's miraculous state. Joseph remained unaware.[39] Such is the scene represented by the Visitation.

Visitation paintings traditionally depict the figures of Mary and Elizabeth embracing. In seventeenth-century Spain and Mexico, however, artists began to add the figures of Joseph and Zacharias to the image, which evolved into the "double Visitation." According to Pacheco's instructions, artists must depict Mary and Elizabeth embracing in the foreground, while their husbands, Joseph and Zacharias, echo the greeting in the second plane.[40] Thus, seventeenth-century double-Visitation images valorized Joseph and Zacharias by providing them a role in the episode. The image also demonstrated Joseph's care for and protection of his wife. According to seventeenth-century Hispanic standards of comportment, no honorable husband would allow his wife to make such a journey by herself. Pacheco assured his readers that Joseph accompanied the Virgin on this expedition, as it would not have been proper for his beautiful young wife to attempt it alone.[41] Like Betrothal scenes, images of the Visitation visualized the saint's new status and provided a model of masculine behavior.

The scene of Joseph's Doubts (or Dream), the episode following the Visitation, offered Spanish and Mexican married couples a didactic model for coping with jealousy or adultery (figs. 13, 15, and pl. 3). One of the central scenes of their married life together, it represents Joseph's response upon discovering his wife's unexpected pregnancy. Spanish and

Mexican artists depicted Joseph's Doubts with great frequency in the seventeenth century, often pairing it with the Betrothal.[42] It, too, became the subject of numerous devotional texts, poems, prayers, and theatrical works. Spanish and Mexican authors seemed to delight in filling in the details only hinted at in the Gospels.

As with the Betrothal, the Inquisition censor Pacheco described Joseph's Doubts (or Dream) with great precision, employing his own painting of it, executed for the Chapel of the Annunciation of the College of St. Hermengild in Seville, as a model (fig. 13). Thus, in Spanish and Mexican colonial paintings Joseph appears asleep on a bench, his head resting on his right arm, exhausted from his worries about his wife; his knapsack, walking stick, and carpentry tools are at his side. Slightly behind Joseph a beautiful angel appears, extending its right hand to touch the saint's head and pointing to the house. It is Gabriel who has come to reveal the secret of Mary's pregnancy.[43]

Like the Betrothal, Joseph's Dream was the subject of numerous texts, which expand our knowledge of the scene. The

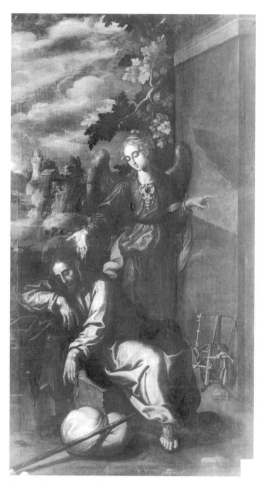

Fig. 13. Francisco Pacheco (1564–1644), *Dream of St. Joseph*, 1604. Oil on canvas, 58 ⅓ x 33 in. (148 x 84 cm). Academia de San Fernando, Madrid

paintings additionally produced meaning through their relationship to other images. For example, Joseph's sleeping gesture—head resting on hand—enjoyed a long history in Western art. In medieval Nativities Joseph appeared asleep in the same pose to indicate his lack of awareness of Christ's miraculous birth (fig. 1).[44] In the seventeenth century, Spanish and Mexican Baroque artists reclaimed the exact gesture to denote divine revelation (figs. 13 and 15).

One finds the same gesture in other scenes of divine revelation produced in the seventeenth-century Spanish Empire. The Old Testament patriarch Jacob appears in the same pose in Jusepe de Ribera's *Dream of Jacob* as he dreams of the stairway to heaven (fig. 14). As

recounted in Genesis 28:16–17, Jacob exclaimed upon awakening, "Truly the Lord is in this place and I did not know it.... This is none other than the house of God; this is the gate of heaven." In the seventeenth century, theologians gave Jacob's revelation a typological gloss that likened the door of heaven (*porta coeli*) to the Virgin Mary, for through her the worshipper finds Redemption: "the Virgin is the celestial door, because she opened the heavens to us, and the ladder to heaven, since through her descended God in human form."[45] The episodes of Jacob's Dream and Joseph's Doubts (or Dream) present compelling similarities. In fact, Joseph has nearly the same dream, that of Redemption made possible by the Incarna-

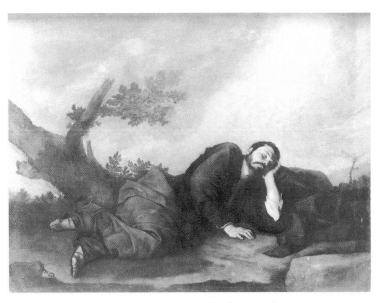

Fig. 14. Jusepe de Ribera (1591–1652), *Dream of Jacob*, 1639. Oil on canvas, 70 ¹/₂ x 91 ³/₄ in. (179 x 233 cm). Museo del Prado, Madrid

tion. Jacob's declaration ("This is none other than the house of God; this is the gate of heaven") could have easily been uttered by Joseph, whose humble house literally *was* the house of God.

St. Joseph's Dream also produces meaning by its relation to images of the Liberation of St. Peter, another popular seventeenth-century theme, wherein an angel frees St. Peter from the jail in which Herod had imprisoned him for following Christ (Acts 12:1–11). As seen in a painting by José Antolínez (1635–75; National Gallery of Ireland, Dublin), the components of the scene—an angel approaching a sleeping male figure—are similar to depictions of Joseph's Dream. Like Peter, who was imprisoned for his Christian beliefs, Joseph, too, has suffered because of Christ. The angel frees them both.

Scenes of Joseph's Dream also resemble the Annunciation to the Virgin. Indeed, Joseph's Dream represents a second Annunciation, since the angel Gabriel appears in both to reveal the Church's mystery of Redemption. Artists often paired paintings of Joseph's Dream and the Annunciation to underscore their relationship. In at least one instance, a painting of Joseph's Dream was commissioned for a chapel dedi-

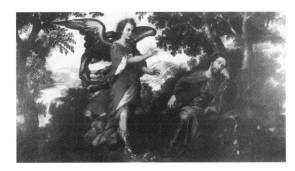

Fig. 15. Juan Correa (1646–1716), *Dream of St. Joseph*, 17th century. Oil on canvas, 37 ¹/₂ x 78 in. (95 x 198 cm). Fototeca del Departamento de Restauración del Patrimonio Cultural del Instituto Nacional de Antropología e Historia, Churubusco, Mexico City

cated to the Annunciation to the Virgin (fig. 13).[46] The two events were also linked in Catholic devotional practice. In the prayer series known as the Seven Joys and Seven Sorrows of St. Joseph and the Seven Joys and Seven Sorrows of the Virgin, the joy of Joseph's Dream corresponds to that of the Annunciation.[47] Structuring the episodes of Joseph's life in imitation of the Virgin's was typical in Josephine imagery and intended to valorize the saint by association. This strategy was also intended to encode new gender ideologies.

The meanings produced by these Josephine images reinforced to the beholder several important points. Their resemblance to images of the Annunciation to the Virgin highlighted Joseph as the recipient of divine revelation. After the Virgin herself, Joseph next comprehended the mystery of the Incarnation. Thus, he acquired a role in the process of Redemption. The sleeping gesture further demonstrated the shift in Joseph's status. Whereas earlier it indicated Joseph's ignorance, in seventeenth-century images of Joseph's Doubts (or Dream), it came to signify his divine knowledge.

Although the Gospels are nearly silent on Joseph's response to his bride's unexpected pregnancy, Hispanic devotional writers did not hesitate to fill in details. They reported that Joseph first began to suspect a change in his wife during the Visitation episode. Then, he noticed her abdomen growing larger every day. When she was in her fifth month of pregnancy, the truth was too obvious to deny: his pure, virginal wife was pregnant, and he was not the father. The realization was devastating, as reported in one hagiography: "But when Joseph realized that he could no longer deny the truth, his soul leapt in a somersault, and although satisfied that some accident had occurred to his wife, he could not deny what his eyes saw, because he was a holy and upright man. Although he knew what he saw, he suspended judgment of the cause; because if he had been persuaded that his wife was guilty, without a doubt the saint would have died of the pain."[48]

Joseph's anguish intensified when he recognized the great dishonor that would befall his wife. By law he was required to condemn her as an adulterer, after which she would surely be stoned to death.[49] Joseph's only recourse was to pray to God:

> Most high God and Eternal Master . . . I turn over to you the wife that I received from your hand. Of her great sanctity I am sure, and the new signs that I see in her cause me great pain and fear. . . . But it is impossible to deny what my sight sees. . . . Reason finds her innocent, but my senses condemn her. She hides from me the cause of the pregnancy. I see it, what am I to do? . . . I suspend judgment, and find myself ignorant of the cause of what I see. I leave my afflicted spirit in your care: Oh God of Abraham, of Isaac, of Jacob![50]

Despite the terrible doubts and torments that Joseph experienced, he never uttered an accusation, but instead suffered in silence. As he observed the continued growth of Mary's belly, he contemplated accepting the child as his own, but did not want to commit such a sin. He concluded that he was incapable of understanding what had transpired. The mystery being too great for his limited understanding, he humbly decided to leave his wife, and prepared by packing a few clothes and money in a knapsack.[51]

Observing the suffering of her beloved husband, the Virgin prayed for his relief. God sent the angel Gabriel to reveal to Joseph the mystery of the Virgin's pregnancy. Gabriel's words paralleled the Annunciation ("Do not be afraid, Mary, for you have found favor with God"): "Do not be afraid, Joseph, son of David, to take to thee Mary thy wife, for that which is begotten in her is of the Holy Spirit. And she shall bring forth a Son, and thou shalt call His name Jesus; for He shall save His people from their sins."[52] Thus, Joseph became the second person on earth after Mary to know the mystery of the Incarnation, and, the holy messenger Gabriel revealed it to him, as to her. With this knowledge, two months of torment, doubts, and jealousy finally came to an end. According to theologians, Joseph had suffered more than any human had ever suffered, and thus should be considered a martyr.[53]

Devotion to Joseph the troubled husband was widespread throughout the Spanish Empire. The episode gave preachers the opportunity to praise the saint as the perfect spouse, who, despite damning evidence, never accused, confronted, nor defamed his pregnant wife. Just like other married couples, Joseph and Mary had faced the "jealousies of love." Joseph, however, had restrained his normal human passions.[54]

Because seventeenth-century narratives and images of Joseph's Dream (or Doubts) contain at their core anxiety about women's uncontrollable sexuality, the saint's predicament resonated in a particularly potent way in the Hispanic world, where adultery was tied to concepts of honor and shame, and thus served as a central component in the construction of masculinity. Since at least the Middle Ages, honor had been a central social preoccupation in Spain. In the thirteenth century, during the rule of King Alphonse X ("the Wise"), Castile's *Siete Partidas* gave honor and dishonor legal definitions. Such laws identified female adultery as the cause of dishonor or infamy (*enfamamiento*).[55] The obsession with honor escalated in the early modern period when, in the sixteenth century, treatises on the subject first appeared. Although the constituents of honor could be religious, political, financial, or sexual, women's sexual behavior was both its most important element as well as its most dangerous enemy. Masculine honor did not simply depend on the individual male's behavior, but was intimately linked to his family's comportment and especially his wife's behavior. In other words, a man's honor depended on his wife's purity. Honor, along with authority over family, formed the basis of Hispanic masculinity.[56]

Honor obliged men to defend female virtue by preventing their wives' contact with outsiders. When a wife committed adultery, it meant that the husband—not she—had failed.[57] Part of the reason for Joseph's great distress lay in the realization that if Mary were carrying another man's child, it was because he had failed to protect her. In a strange twist, however, after the miraculous nature of the pregnancy was revealed, Joseph's honor may have increased dramatically. Since his honor and status depended directly on her sexual purity, did the fact that her impregnation occurred without human sexual penetration render Joseph the husband with the most honor of all?

Not surprisingly, priests routinely advocated Josephine devotion for married couples facing sexual temptation or jealousy within their marriage. One theologian recommended: "Married couples take my master St. Joseph as a patron if they want to have peace and conformity in their marriage. Especially when they see themselves afflicted with jealousy, they reach to this spouse of the Virgin for a remedy."[58] Reported cases of Joseph's helpful intervention abound. In the Spanish city of Zaragoza, a priest sent a jealous husband to pray to a statue of St. Joseph. The husband knelt before the image, and said: "My father, you know well the terrible torment of jealousy. I don't need to tell you what has happened to me, since you know it well. In your hands I place my remedy."[59] In Lima, Peru, prayers to a statue of St. Joseph were reputed to free husbands from jealous rages.[60]

If, however, despite prayers to St. Joseph, wayward spouses still succumbed to adultery, priests recommended that the couple "go to Joseph" to learn forgiveness.[61] Chapels dedicated to the saint often housed paintings of Christ and the adulterer, giving explicit visual form to Joseph's role in mediating adultery.[62] While the Church did not condone illicit affairs, it urged couples to forgive their spouses' transgressions, an inevitable strategy in view of the divorce prohibition. Such beliefs stood in stark contrast to Protestant teachings, which permitted divorce but harshly condemned adultery. Some Protestant sects even advocated the death penalty for adulterers.[63]

In the Spanish Empire, St. Joseph became the patron saint of marriage. In a touching case in rural Spain, a young woman forced to marry against her will an older, unattractive man imagined her husband to be St. Joseph during intimate moments. She reported, "And with this I felt new love for him, because I was greatly devoted to Saint Joseph."[64] Joseph was also renowned for finding husbands for women eager to marry. As an extension of his duties as the patron of married couples, the saint acquired a reputation for easing pregnancies and for aiding couples having difficulty conceiving. Certain statues of Joseph acquired reputations for assuaging labor pains. In one remarkable case, a statue of the saint reportedly miraculously impregnated a woman. Thus, in addition to his power to help devotees achieve the

virtue of chastity, combat the dangers of sensuality, and fight the torments of jealousy, Joseph was also thought to guarantee familial succession.[65]

The attention focused on marriage by artists and the Catholic church reflects more general consideration of the family in Golden Age Spain and colonial Mexico. In early modern Spain, the status of the institution of marriage was a major concern to the Church and monarchy. According to Spanish commentators, decreases in the rates of marriage and procreation threatened the future of the nation. Concomitant with Spain's depopulation, Spanish family size in the seventeenth century decreased from an average of five in the previous century to scarcely four people as the rate of marriage and procreation declined.[66] The status of the institution of marriage became a major concern. Period commentators lamented cohabitation without benefit of the sacrament. Theologians expressed anxiety about adultery, a topic the Church was debating with Protestant reformers. Period documents detail the public humiliation of adulterous couples at the hands of the Inquisition.[67] During this time, interest in marriage was at an all-time high, part of wider European consciousness of social welfare and institutions described by Michel Foucault.[68] Images such as those discussed in this chapter served as visible, tangible reminders of the perfect marriage, upholding the ideal in the face of a perceived social crisis.

In the American colonies, the Spanish specifically manipulated Joseph's cult as they tried to impose a European marriage model on the colonies. Their chief goals were to eradicate the indigenous practice they deemed "polygamy," put an end to native divorce (el repudio), and convince the converts to accept Christian marriage. The acceptance of Christian marriage was Church theologians' major concern in the sixteenth century, several of whom penned treatises on the subject.[69]

Marriage was a major issue at the 1585 Third Mexican Provincial Council convened by the Mexican bishops. When their findings were published, one of the five volumes was dedicated solely to the subject of marriage. In addition to affirming the Council of Trent's positions, the Mexican Council elaborated specific guidelines for Indian marriage. Key among these were prohibitions against "polygamy," living together before marriage, and repudiation of one's spouse.[70] Following the Tridentine Council's example, the Mexican bishops stressed the indissoluble nature of matrimony, restating the divorce prohibition. Significantly, however, the Mexican church did sanction a form of de facto divorce for Indian couples: if one of the spouses refused to convert to Christianity, the Christian spouse was free to marry again after a six-month waiting period.[71] In addition, the Church insisted that Indians, like its European subjects, be allowed to marry freely. Freedom in marriage choice was similarly upheld by the Laws of the Indies (leyes de Indias), which governed the New World. While on

the surface "freedom of choice" sounds empowering, these laws robbed the indigenous family of its traditional power to select mates for children and establish alliances.

Thus, after 1585, the Church played a major role in destroying traditional indigenous family and community structures, a colonizing strategy that hastened Hispanization in the New World. Its Counter-Reformation ideology of marriage was taught and enforced in the Americas in a variety of ways. Images such as the ones examined in this chapter served as a prime mechanism. The Spanish church also spread betrothal and marriage laws through catechism, preaching, and confession.[72] Sermons on St. Joseph in Náhuatl presented the saint as the perfect husband and urged native men to imitate him by practicing sexual continence.[73]

The Church's colonialist intentions are made clear by contrasting its discourse on Indians with what is known of actual native marriage and sexual practices. Of course, it is impossible to recover pure and intact indigenous culture after the point of colonial contact.[74] Through careful and critical examination of both colonial chroniclers as well as the work of anthropologists, however, it is possible to glean some understanding of precontact native social practices. European cries of widespread "polygamy" notwithstanding, indigenous polygyny seems to have been rarely practiced, and then only by members of the noble class. Instead, native men were taught to value monogamy, chastity, and fidelity in marriage. Adultery was strictly censured since it dishonored not only the guilty party, but also his or her family and ancestors. In some cases it was punishable by death. Similarly, repudiation of one's spouse (a form of divorce in Christian eyes), occurred rarely, and was carefully regulated by law and social custom.[75]

The rupture between what is known of actual social practice and the Church's view of that practice alerts us that much more than marriage was at stake for the Spaniards. By accusing the Indians of polygamy and divorce, the Church characterized them as sexually voracious. During the Conquest of the Americas, sexual voracity, which in colonial discourse was a signifier of lawlessness often linked to reports of cannibalism, became a common justification for the need for European colonization. As cannibals and sexually voracious predators, reasoned the Spanish, Mexican Indians would benefit from the civilizing effects of imposed European power.[76]

Thus, images of the Betrothal and Joseph's Dream (or Doubts) played a vital role in the colonization and Hispanization of New Spain by giving visual form to a specifically European Counter-Reformation ideology of marriage. By upholding Church-sanctioned monogamy as the only alternative, these images helped extend Church control over indigenous converts' lives. Christian marriage thus became a form of colonialism.

Did Spanish and Mexican husbands follow Joseph's example and treat their wives to

"soft and loving words"? Were they as kind and understanding as St. Joseph? Did they restrain their normal human passions when faced with the possibility that their wives had committed adultery? Archival information seems to indicate not. The figure of Joseph remained for most men an unattainable, nearly superhuman ideal. Both Spanish and Mexican archives are full of documents detailing domestic violence, bigamy, adultery, secret betrothals, broken engagements, clandestine marriages, and other acts testifying to human weakness.[77] Like earthly wives, unable to measure up to the perfect standard of the Virgin Mary, earthly husbands frequently found themselves unable to match Joseph's perfections.

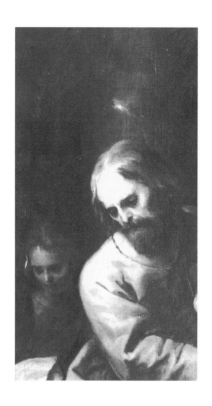

Alonso Cano, *Circumcision of Christ (detail of fig. 25)*

HAPPY FAMILIES

O<small>N THE SURFACE</small>, early modern Spanish and colonial Mexican images of the Holy
Family, which depict Mary, Joseph, and Jesus engaged in the apparently mundane tasks
of daily life, seem to proclaim the joys of domestic bliss. The representational strategies
employed, such as the attempts to replicate the effects of reality, encourage the beholder to
naturalize and identify with the blessed family. Many of these tranquil images of familial hap-
piness, however, are predicated on a surprising displacement: in numerous examples Joseph
takes center stage, figuratively and at times literally pushing the Virgin, the traditional focus of
such paintings, to the background. This remarkable reversal of the figures of Mary and Joseph,
and the implied downgrading of the former's importance, seems especially notable in the con-
text of Marian Spain, where the Madonna had for centuries enjoyed a place of honor within
the pantheon of saints, and in Mexico, home to the most important contemporary Madonna
cult, that of the Virgin of Guadalupe. This chapter suggests that reasons for the proliferation
of Spanish and Mexican Holy Family images may be found by situating the works of art
within the social, devotional, and political contexts of their production and consumption.

 Although the historical record remains incomplete, patronage documents that have
come to light demonstrate that most documentable works were commissioned for churches.
These include El Greco's *Holy Family with Saints Anne and John the Baptist* (1541–1614; Museo
de Santa Cruz, Toledo, c. 1590–95), originally painted for Toledo's Church of Santa Ana; and
Alonso Cano's intriguing *Holy Family* painted for the Franciscan Convento del Ángel Custo-
dio in Granada (fig. 24). At least three other versions of the latter painting have been identi-
fied, demonstrating the popularity of this particular rendition by Cano. The *Holy Family* by

Diego Valentín Díaz, signed and dated 1621, was commissioned by the monastery of San Benito el Real in Valladolid for its Capilla del Cristo de la Luz. The Benedictine monks of Madrid's Church of San Martín commissioned Juan Carreño's *Earthly Trinity* for its Capilla del Santo Cristo (1614–85; San Martín, Madrid, 1649). The Las Palmas Cathedral chapter charged the Sevillian painter Juan de las Roelas (c. 1560–1625) with painting the *Holy Kinship* of 1607 (Catedral, Las Palmas, Canary Islands). An important *Holy Family* painting by Claudio Coello, today in a museum, was probably originally created for a church (fig. 34). A sculpted relief of the Earthly Trinity attributed to the Sevillian sculptor Juan Martínez Montañés (c. 1568–1649; San Ildefonso, Seville, 1609) was commissioned for the burial chapel of a private patron, the Licenciate Lucas Pérez. Two other Spanish works were commissioned for *colegios*: a *Holy Family* by Francisco Ribalta (1565–1628) and his workshop, part of a large *retablo* in the Colegio of Valencia (c. 1610); and Sebastián de Herrera Barnuevo's *Earthly Trinity*, the major canvas in an altarpiece dedicated to the Holy Family commissioned by the Colegio Real of Madrid (1619–71; San Isidro, Madrid). A *Holy Family* by Eugenio Cajés (1574–1634), signed and dated 1619, may have originated in the royal collections of El Escorial.[1] Unfortunately, the commissions for some of the most important Spanish Holy Family depictions have not been recovered. Art historians have yet to clarify the circumstances surrounding the creation of Bartolomé Esteban Murillo's *Holy Family with the Little Bird* (pl. 4), the most compelling image of its type in the history of Spanish art.

Even less documentation has come to light for colonial Mexican art. The surprising circumstances surrounding the creation of Simón Pereyns's *Virgin of Mercy with the Holy Family* are detailed by Inquisition records (d. 1589; formerly Catedral, Mexico City, 1568). Pereyns, a Flemish émigré artist who had worked in Spain and Portugal before arriving in Mexico with the viceroy's entourage, was arrested by the Inquisition after boasting that he would rather paint portraits than saints and claiming to be a Lutheran, among other such assertions. On December 4, 1568, he was sentenced to paint a retable of Our Lady of Mercy for Mexico City's Cathedral.[2] One can safely assume that most other Holy Family depictions were commissioned under less dramatic circumstances but were similarly destined to hang in churches. Cristóbal de Villalpando's *Holy Family* as the *Cinco Señores* likely belonged to a Life of the Virgin series in Zacatecas (fig. 33). Friar Miguel de Herrera's depiction of the same subject probably formed an altarscreen (active 1725–1780; Palace of the Governors, Santa Fe, New Mexico, 18th century).[3]

Since its creation in the late Middle Ages, the theme of the Holy Family had always demonstrated flexibility in configuration. Unlike scenes from the infancy or Passion cycles, the subject enjoyed relative freedom from the dictates of long-standing visual tradition; moreover, textual sources did not circumscribe its depiction. Thus, the theme's changing form

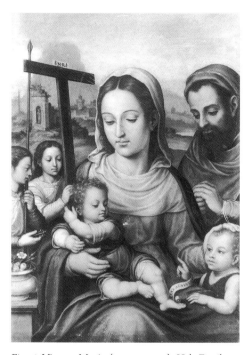

Fig. 17. Joan de Joanes (1523–1577), *Holy Family*. Oil on canvas, 30 ²/₃ x 25 ²/₅ in. (78 x 64 cm). González Martí Collection, Valencia, Spain

Fig. 16. Vicente Macip (c. 1475–1545), *Holy Family*. Oil on canvas, 35 ⁴/₅ x 26 ²/₅ in. (91 x 67 cm). Academia de San Fernando, Madrid

articulated and responded to a variety of social discourses. In the earliest depictions, dating from the fifteenth century, the Holy Family took the form of the Holy Kinship, or the extended Holy Family, and included not only the Virgin and Child, St. Joseph, and St. Anne, but also Mary's apocryphal sisters, as well as their husbands and six children.[4] Typically, the Virgin, Christ Child, and St. Anne are represented on a throne in the foreground attended by St. Anne's other daughters and their children. The various husbands of Anne, Mary, and her sisters, all rendered as diminutive forms in hieratic scale, are clustered together in the background peering over the throne. A Spanish print version, in the style of Albrecht Dürer (1471–1528), can be dated to 1511: the frontispiece to a life of St. Anne by Juan de Robles, *La*

Fig. 18. José Juárez (1617–1660), *Holy Family of the Doves*, 1655. Oil on canvas, 76 ¹/₅ x 59 ³/₅ in. (195.5 x 152.8 cm). Museo Universitario Benemérita Universidad Autónoma de Puebla, Puebla, Mexico

vida y excelencias y miraglos de santa Anna y de la gloriosa nuestra señora santa maria fasta la edad de quatorze años: Muy deuota y contenplatiua nueuamente copilada (Seville: Jacobo Cromberger, 1511). A painting by Hernando de Esturmio (c. 1515–56) of 1549 in the parish church of Santa María de la O in Sanlúcar de Barrameda also depicts the subject.

The Renaissance witnessed the creation of the nuclear Holy Family, comprised of the Virgin, the Christ Child, and Joseph, although many artists continued to include members of the extended tribe such as Saints Anne, John the Baptist, Elizabeth, and Joachim. In sixteenth-century Spanish and Mexican examples, by such artists as Vicente Macip, Joan de Joanes, Diego de Pesquera (active 1563–1580), and Andrés de la

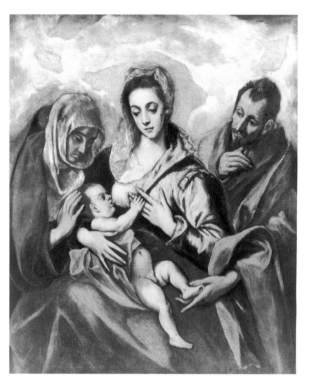

Fig. 19. El Greco (1541–1614), *Holy Family*, c. 1590–95. Oil on canvas, 50 x 41 ³/₄ in. (127 x 106 cm). Hospital de Tavera, Toledo, Spain

Concha (figs. 16, 17, and pl. 5), Joseph plays a minor role; in many cases he is not depicted at all, is cast as a marginal figure, or appears slightly comical.[5] His physical appearance varies from that of a balding, old graybeard to a middle-aged man. Frequently, artists persisted in relegating Joseph to the margins, thereby valorizing the bond between Mary and Jesus. Often they included the child St. John the Baptist recognizing the young Jesus as the Messiah as related in the Gospel of John (1:36). Indeed, scenes of Mary, Jesus, and John the Baptist are by far the most frequent type of Holy Family depicted in sixteenth-century Spanish painting. The type also appears throughout the colonial period in Mexico, as witness examples by Andrés de la Concha dating from the late sixteenth century (Museo Nacional de Arte, Mexico City), José Juárez's version of 1655 (fig. 18), and a 1795 painting by Andrés López (1768–1813; private collection).

In the last decades of the sixteenth century Spanish and Mexican Holy Family imagery experienced a transitional phase. Initially, artists relegated St. Joseph to the sidelines,

an onlooker to the standard Madonna and Child composition. Paintings from the last third of the sixteenth century by Andrés de la Concha, a Spanish-born artist who worked in Mexico after 1563, and El Greco of about 1590–95 are representative (fig. 19 and pl. 5).[6] The experimental nature of this transitional phase in the depiction of Joseph is also indicated by its variety. In the 1590s theologians were still debating Joseph's age and physical features. Thus, although the saint is usually depicted as young and handsome, he occasionally appears as the old man of times past, as in another canvas by El Greco datable to about 1595–1600 (National Gallery of Art, Washington, D.C.).

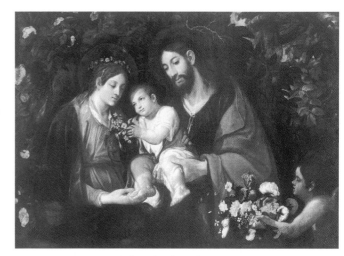

Fig. 20. Juan de las Roelas (1560–1625), *Holy Family*, c. 1620. Oil on canvas, 41 ¹/₃ x 57 ¹/₂ in. (105 x 146 cm). Casa Cuna, Seville, Spain

During this transitional period and into the first two decades of the seventeenth century, artists took the first steps toward moving Joseph to center stage by animating and integrating him into the Holy Family scene. In a painting by El Greco of about 1590–95 (The Cleveland Museum of Art), Joseph offers a bowl of fruit from which Mary has plucked an apple (symbolic of Original Sin) to hand to the Christ Child. In a painting of 1615 by another *toledano* artist, Luis Tristán (c. 1590–1624), St. Joseph stands and presents a dove, symbol of chastity, to the Madonna and Child (Contini Bonacossi Collection, Florence). Despite such attempts to involve Joseph in the main action of these images, the saint still appears as an added appendage to the main dyad of Madonna and Child.

A dramatic change occurs in the 1610s and 1620s. At this time, Joseph emerged from the shadows and began to share the compositional foreground with his holy wife and foster Son. A *Holy Family* attributed to the Mexican artist Baltasar de Echave Ibía of about 1620 (1583–1650; San Felipe, Mexico City) and a canvas of about 1614–16 by the Madrid artist Domingo de Carrión (fig. 22) illustrate this compositional shift. A similar painting by Seville's Juan de las Roelas of about 1620 copies Carrión's composition, but reverses the figures of the protagonists. Not only is Joseph positioned in the foreground in the same plane as the Madonna, but now *he* holds the Christ Child (fig. 20). Roelas similarly focused attention on Joseph in another variant from 1624, which depicts the saint leading the Christ

Fig. 21. Attributed to Juan Sánchez Salmerón (active 1661–1697), *St. Anne, St. Joachim, and the Virgin Mary*. Oil on canvas, dimensions unknown. Tlalmanalco, Puebla, Mexico

Child by the hand as Mary follows behind (Collection of the Duquesa de Medina Sidonia, Sanlúcar de Barrameda, Spain). These paintings exemplify the general trend in Spanish and Mexican Baroque paintings of the Holy Family to give St. Joseph greater prominence and authority.

In seventeenth-century Spain and Mexico, as artists heightened emphasis on St. Joseph in Holy Family paintings, they concurrently focused on the nuclear family. In the sixteenth century, the members of the extended family frequently appeared in Holy Family scenes, including Saints John the Baptist, Anne, Joachim, and Elizabeth, vestiges of the medieval Holy Kinship. In seventeenth-century images, Mary's relatives appear less frequently, and only in the first half of the century in Spanish examples.[7] Instead, artists diverted Mary's family to a new image depicting the Virgin with her parents, a type modeled on the Earthly Trinity. An example by Roelas of Saints Anne and Joachim with the enthroned Virgin and Child presents the new prototype. Depictions of Mary's family also enjoyed popularity in Mexico, as witness a painting attributed to Juan Sánchez Salmerón (fig. 21), several anonymous works (private collection, Calimaya; Philadelphia Museum of Art), a 1795 painting by Andrés López (private collection), and others. New Holy Family images even more dramatically valorized St. Joseph. These include depictions of the Double or Earthly Trinity, which were particularly prevalent in Mexico,

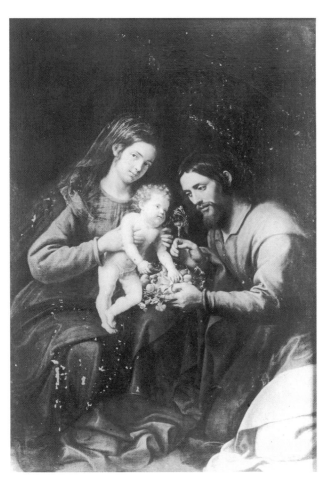

Fig. 22. Domingo de Carrión (active 17th century), *Holy Family*, c. 1614–16. Oil on canvas, 69 ²/₃ x 53 ¹/₆ in. (177 x 135 cm). San Jerónimo el Real, Madrid

the inverted Holy Family, and scenes of the men of the Holy Family, the latter two subjects more frequent in Spain.

St. John the Baptist was the only other family member to be depicted with any regularity by Spanish and Mexican Baroque artists. He appears most notably in a series of Holy Family scenes by Murillo from the 1660s and 1670s (Museo de Arte Colonial, Havana, 1665–70; Collection of the Marquis of Lansdown, Calne, England, 1670; Collection of the Duke of Rutland, Grantham, England, 1670; The Wallace Collection, London, 1670; Fogg Art Museum, Harvard University, Cambridge, Mass., 1670–75; and A. G. Nicholson, London). The foregoing examples, set in landscapes, take as their subject an episode from the Flight into Egypt when the Holy Family stopped to visit with Saints Elizabeth, Zacharias, and their son, the young Baptist. They depict John's recognition of his cousin Jesus as the Messiah, and accordingly, John bears a banderole inscribed with the legend "*Ecce agnus dei*" ("Behold the lamb of God"; John 1:36). The Mexican artist José Juárez executed a version of the theme almost exactly contemporaneous (fig. 18). In 1795 Andrés López created a loose copy (private collection) after Murillo's Wallace Collection painting, also incorporating details from Francisco de Zurbarán's 1662 version of the same subject (1598–1664; Museo de Bellas Artes, Bilbao), demonstrating the influence of these artists in Mexico.

The early decades of the seventeenth century thus witnessed a dramatic transformation in artistic depictions of the Holy Family in Spain and Mexico. For the first time in the history of art, St. Joseph became their major focus; by 1620, Joseph was supplanting the Virgin's position and role. Roelas's aforementioned Holy Family demonstrates the metamorphosis (fig. 20). In contrast to its probable pictorial source, Carrión's canvas of 1614 (fig. 22), and their likely mutual point of origin, Albrecht Dürer's widely circulated print of the *Madonna and Child with Monkey* (c. 1497–98), Roelas's painting positions Joseph in the center of the composition with the Christ Child in his arms, reaching for His mother. Félix Casteló (before 1600–1652) adopted a similar course in his *Holy Family* (formerly Santa Isabel, Toledo, before 1656), also clearly based on Dürer's print. Not only has Joseph co-opted the Virgin's traditional position and activity, he has also replaced St. Anne. In Murillo's *Holy Family with the Little Bird* of about 1650 (pl. 4) the Virgin retreats to the background, while father and Son assume center stage. Joseph similarly dominates a canvas of 1646 by Alonso Cano (fig. 24). Likewise, in many Mexican examples, St. Joseph moves into the foreground with Mary (Baltasar de Echave Ibía, *Holy Family/Earthly Trinity*, San Felipe, Mexico City, c. 1620).

The shift in Spain and Mexico to the nuclear Holy Family reflects the wishes of Spanish church reformers. The Inquisition painting censor, Francisco Pacheco, explicitly banned representations of the Holy Kinship because such images included the apocryphal

"sisters" of Mary from St. Anne's second and third marriages. Not only was Pacheco concerned about the historical "authenticity" of these sisters, a typical concern following the Council of Trent, he was also troubled by the existence of Anne's second and third husbands. Since it might have been unclear to worshippers what had happened to the former spouses (death? divorce?), and in any case, Anne's desire to remarry seemed improper, Pacheco and others were eager to quash the notion that Anne had been thrice married. In the final account, Anne's multiple marriages seemed to cast doubt on the sanctity of matrimony and its status as a sacrament, another issue on which Catholics and Protestants were in vehement disagreement. The Church thus struck such past marriages from hagiographies.[8] Pacheco expounded upon the problem in his treatise *The Art of Painting*:

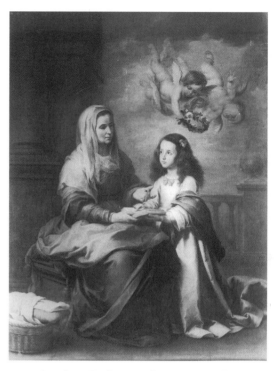

Fig. 23. Bartolomé Esteban Murillo, *St. Anne Teaching the Virgin to Read*, c. 1650. Oil on canvas, 86 ¼ x 65 in. (219 x 165 cm). Museo del Prado, Madrid

A Painting of St. Anne No Longer in Use:
At one time, the painting of the glorious St. Anne seated with the most holy Virgin and her Child in her arms and accompanied by her three husbands, her three daughters, and many grandchildren, as it is found in some old prints, was very valid, which today the most learned do not approve of and which the most judicious painters justly reject, because, as Tertulian said: "Time increases wisdom and uncovers truths in the Church." Thus, today we see favored as certain and secure truth the single marriage of St. Anne and St. Joachim.[9]

Murillo's *Holy Family with the Little Bird* (pl. 4) exemplifies Joseph's new status in the reconfigured Holy Family. In it we behold the powerful figure of the young saint keeping a

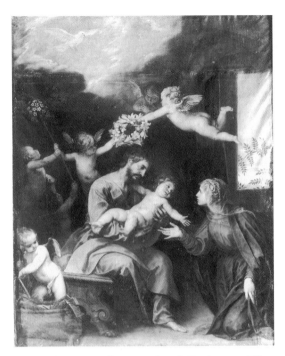

Fig. 24. Alonso Cano (1601–1667), *Holy Family*, 1646. Oil on canvas, 96 ⁶/₇ x 29 ¹/₂ in. (246 x 201 cm). Convento del Ángel Custodio, Granada, Spain

Fig. 25. Alonso Cano, *Circumcision of Christ*, 1645. Oil on canvas, 74 x 47 ²/₃ in. (188 x 121 cm). La Magdalena, Getafe, Madrid

vigilant eye on the divine toddler, at play with the family dog. The demure Virgin, seated at her spinning, looks on modestly from the left background. A virtuous wife, she weaves and sews. The innovation of this painting is best appreciated by comparison to earlier, sixteenth-century examples of the theme, such as its probable compositional source, the so-called *Holy Family with a Cat* (National Portrait Gallery, London) by the late sixteenth-century Italian artist Federico Barocci (1526–1612).[10] While scholars have observed the similarities of the two works, no one has commented on Murillo's striking transformation of his source, a transformation that reveals the new importance of Joseph in the Holy Family. Whereas Barocci's composition revolves around the seated Virgin, Murillo's painting features St. Joseph, who retains Mary's posture and downward glance. Christ supplants the young Baptist, and a white dog replaces Barocci's cat.

Compelling pictorial analogues for the scene that further demonstrate artists' elevation of St. Joseph at Mary's expense can also be found in Madonna and Child imagery. In fact, Spanish and Mexican artists often appropriated the pictorial conventions reserved for the

Virgin to depict Joseph, a tactic that valorized him by association. These borrowings, and especially the reuse of poses previously reserved for the maternal Madonna, associate Joseph with parental love, thus making claims for his earthly fatherhood of Christ. For example, Joseph's seated pose in many Holy Family images is identical to countless Madonna and Child depictions. Murillo's own *Holy Family with St. John the Baptist* (The Wallace Collection, London, 1670) offers the same pose, as does his *Madonna and Child with St. John the Baptist* (Art Gallery and Museum, Glasgow). Furthermore, Spanish and Mexican artists commonly utilized this same posture to depict another model parent, the Virgin's mother, St. Anne. Murillo's painting of *St. Anne Teaching the Virgin to Read* (fig. 23) assumes a nearly identical configuration. These sensitive images of Anne, the ideal mother, teaching her virtuous daughter to read, present

Fig. 26. Workshop of Bartolomé Esteban Murillo, *Holy Family*. Oil on canvas, 80 x 62 ¹/₅ in. (203 x 158 cm). Ringling Museum of Art, Sarasota, Florida

compelling similarities that by association strengthen the image of Joseph as the ultimate attentive father.

In a painting of the *Holy Family* by Alonso Cano, St. Joseph similarly dominates the scene, as he lovingly holds the holy Infant in his arms (fig. 24). The Virgin assumes a position of subservience before her husband, kneeling in deference at his feet, as she reaches for her Child. The unorthodox placement of the Virgin at Joseph's feet initially shocks the viewer. Cano depicted Mary in the exact same pose in his *Circumcision of Christ* (fig. 25). Several Holy Families by Murillo and his workshop depict the Madonna in a similar posture seated on the floor before her carpenter husband, reaching up to receive the Child (fig. 26), a position evocative of Madonna of Humility imagery.

Other pictorial analogues for Cano's kneeling Madonna, visionary scenes of kneeling saints, underscore Mary's surprising displacement. Murillo's *Vision of St. Felix of Cantalice* (fig. 27), and Cano's *Vision of St. Anthony* (National Gallery, London), both of which image saints kneeling before apparitions of the Virgin and Child, are typical examples.[11] Cano's *Holy Family* inverts the compositional hierarchy: now it is Mary who kneels to receive Jesus, while Joseph claims the privilege of presenting the Child. A final comparison with a scene of the *Coronation*

of the Virgin by Cano (National Gallery, London) highlights Joseph's and Mary's shift in status. Whereas in the Coronation, Mary kneels before the figures of Christ and God the Father, in Cano's *Holy Family*, Joseph the humble carpenter assumes the position of the divinity.

As the foregoing examples demonstrate, in the seventeenth century, Spanish and Mexican Holy Family imagery underwent a dramatic reconfiguration. Whereas previously, artists had cast St. Joseph as a marginal personage, beginning around 1600 Spanish and Mexican artists moved the blessed carpenter to center stage. These changes in visual depictions of the Holy Family suggest that a new campaign was underway in the Hispanic Catholic church. In fact, a fertile cache of primary source texts demonstrates that the Church was actively promoting the importance of St. Joseph as paterfamilias. In period sermons and other devotional texts, preachers elevated the Holy Family as an exemplum for

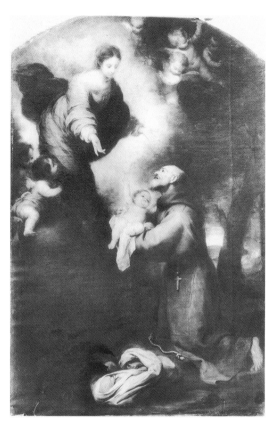

Fig. 27. Bartolomé Esteban Murillo, *Vision of St. Felix of Cantalice*, 1670s. Oil on canvas, 53 x 46 in. (135 x 117 cm). Museo de Bellas Artes, Seville, Spain

Catholics throughout the Spanish Empire to emulate. In his role as the chaste and industrious head of the Holy Family, Joseph became a model of the perfect spouse and father, his image reaffirming the sanctity of marriage, family, and procreation.

As artists moved Joseph from the shadowy background to share the foreground equally with his holy wife, Spanish and Mexican devotional writers also began to assert the spouses' equality. According to the Spanish church, a peaceful marriage required two partners of equivalent social status. One of the era's most important hagiographers, Pedro de Ribadeneira, proclaimed in his life of St. Joseph that for a marriage to be "strong and peaceful" it must be enacted between "equal persons"; that is, people of "equal lineage, state, condition, and habits."[12] Other writers concurred, remarking upon the couple's similar saintliness and virtues.[13]

Despite being the mother of God, the Virgin Mary, like all earthly wives, was subor-

dinate to her husband Joseph. Numerous Hispanic writers proclaimed Joseph's superiority to and power over Mary as her husband and the "head of the household," a claim repeated countless times in Spanish and Mexican texts.[14] According to Ribadeneira, "God chose him [Joseph] to be the spouse and true husband of the Virgin and thus to be the head of the family and the superior of our Lady the Virgin Mary."[15] According to the Mexican sermonist Juan de Villa Sánchez, Mary obeyed Joseph "as her master."[16]

In fact, according to Spanish law, Mary possessed the legal status of a minor. Joseph was her master; she belonged to her husband: "According to the marriage rules and laws, Mary belonged to Joseph; because we have proved that there was a true marriage between the two, and according to the Apostle (1 Corinthians 7:4): Woman is not mistress of her own body, which belongs to the husband."[17]

Church writers even argued that, as her husband, Joseph legally possessed the right to impregnate Mary, a claim he refused on divine orders.[18] Furthermore, because Mary's body was her husband's legal property, Joseph was responsible for the preservation of her virginity. As a result, "[S]he (Mary) is obligated to him because he was the guard of her virginity, because he supported her with the sweat of his brow, because he accompanied her on their trips, because he consoled her and alleviated her burdens, because he served her with fidelity, because he loved her most tenderly with pure, holy, and chaste love, because he helped her raise her most holy Son."[19]

By positing Mary's subordination to her husband, St. Joseph, the Josephine author Gracián drew the conclusion that all wives were subordinate to their husbands:

> The husband is the head of the wife. . . . God Himself, as His apostle says (Ephesians 5:23), ordered that the husband be the head, that he order and govern, and women, as St. Peter says (1 Peter 3:1), were to be subordinated, obedient and inferior to their husbands; and that in all they must obey, respect and reverence them, and do their will. . . . And so he ordered that Joseph be Mary's husband, and from His divine will it proceeded that she would obey him, and that he would govern and order her as a father would a daughter . . . as tutor to his pupil and lesser . . . as husband and wife.[20]

The numerous Spanish and Mexican paintings that feature Joseph more prominently than his wife pictorialize Mary's subordination. Devotional writers thus worked in tandem with artists to promote the ideal of the patriarchal nuclear Holy Family in which Joseph was the head of the household, its protector, and provider.

As master of his house and family, Joseph was the source of authority in his family;

his wife and Child were obligated to obey him.[21] Obedience thus constituted another major theme of Holy Family paintings and devotional texts. According to Gracián, both Mary and Jesus obeyed the master of the house with humility.[22] Jesus, as his Son, "obeyed, respected, and revered Joseph as His father, and Joseph exercised command, superiority, and government as Jesus' father."[23] Christ was reported to have been "obedient to Joseph in everything, as children are with their parents."[24] In Mexico, the Dominican friar Martín de León, in a 1614 sermon in Náhuatl preached to native converts, praised Jesus' obedience to His earthly foster father, presenting Him as an example to other children, who must also obey their parents.[25] That Jesus was subject to Joseph increased the latter's dignity, in the same way that any father's standing was increased by his family's obedience, in the words of Ribadeneira.[26] Another author suggested that Christ's position at Joseph's side, as pictorialized in numerous Spanish and Mexican paintings, testified to His obedience to Joseph as a father as well as to Joseph's role as His guardian (pl. 4).[27] Depictions of the Virgin Mary on her knees before her husband, waiting to receive her Child (an interpretation unthinkable in Italian or Flemish art) seem to give visual form to Joseph's absolute authority over the mother of God (figs. 24 and 26). As the early modern Spanish Catholic church emphasized fatherly authority and familial obedience, exemplified in both paintings and texts, Hispanic theologians insisted that Jesus' lineage be reckoned through Joseph, not Mary, as had been done in the Middle Ages.[28]

As the loving protector, defender, and supporter of the Holy Family, its source of authority and discipline, St. Joseph represented the perfect paterfamilias in the early modern Hispanic world. He was a virtuous man, his wife's "lustrous crown," and the honor of the Holy Family: "The honor of the father is honor of the son and of the wife, and thus the honor of Joseph is the honor of Jesus and Mary."[29] "[W]hat married woman has there been in the world who has received from her husband more good works than Mary received from Joseph?" asked Gracián.[30]

Hispanic writers cast the Virgin in the corresponding role of humble, virtuous wife. As "the most holy wife that there has ever been and will ever be in the world," the "most holy and perfect wife," and the "perfection of a married woman," Mary properly complemented her faultless husband.[31] Because she was an exemplary wife, Mary "loved and served her husband, and was in all things most perfect . . . after Christ Our Lord, the Virgin did not love any other person as much as she loved St. Joseph."[32]

Josephine texts frequently specify Mary's wifely duties. Gracián recounted a conversation between Mary and St. Bridget of Sweden, the medieval mystic, in which Mary professed her dedication to her family: "Although I was predestined from the beginning of time for the highest and most exalted throne of eternal bliss, and for the greatest glory and honor that any creature could attain, with all this I was humble and I never thought it was beneath

me to serve and prepare food to eat for Joseph and for my Son; because my Son also served Joseph."[33] According to a poem of the period, "[t]he pure Virgin served her spouse and beloved master with such love and humility that it is impossible to extol it enough"—a sentiment repeated in numerous Josephine texts.[34] If Mary, the perfection of womanhood and mother of God, so selflessly served her family, so, too, should mere mortal wives. Theologians and religious writers called upon women in the Spanish Empire to help their husbands, noting that in a marriage "[t]he woman serves to help the man."[35] "Help him (your husband) bear the weight of marriage: serve him in his duties and household tasks: each one should help and aid the other," advised one author.[36]

In addition to caring for her husband and son, writers identified Mary's other major occupations as sewing and

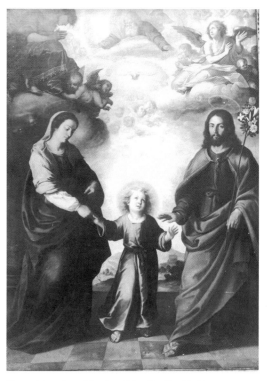

Fig. 28. Bartolomé Esteban Murillo, *Earthly Trinity*, 1640. Oil on canvas, 87 ²/₅ x 63 ⁴/₅ in. (222 x 162 cm). National Museum, Stockholm

weaving, activities frequently depicted in Holy Family paintings and which both Spanish and Mexican cultures recognized as appropriate wifely activities.[37] Josephine authors inform us that the Virgin busied herself making clothes for the Christ Child and Joseph, the activity depicted in Murillo's *Holy Family with the Little Bird* and Claudio Coello's *St. Joseph and the Christ Child/Holy Family* (pl. 4 and fig. 34).[38] Marriage manuals of the period, such as *The Perfect Wife* by Fray Luis de León, recommended these tasks to exemplary wives, in addition to praying, another activity in which Mary is commonly engaged.[39] "[H]ow many times did Joseph dress himself in clothing not only given him by the Virgin, but also sewed and adorned by her very own hands and with such loving care?" wondered one author.[40]

As Joseph's humble, virtuous wife and the Mother of God, Mary defined Hispanic standards for perfect womanhood. Selflessly, she busied herself with household duties, serving her husband, cooking, and sewing for her family. This idealized vision of femininity, however, concealed deep misogyny. One seventeenth-century Josephine author expounded upon women's "natural evil": "Only the woman, who is of nature evil, and of depraved habits, is an

untamable animal, in whom is inactive all the concern that is intended to subdue her, because there is no empire to whom she yields herself, nor advice which subdues her, nor brake that humbles her, nor yoke that tames her, nor fear that frightens her, nor punishments that reform her."[41]

He concluded by likening woman to "an eel in the hands of a fisherman": "if he tightens his grip the eel slips away, and if he loosens his grip, it escapes." Similarly, a sermon preached on St. Joseph's feast day in Puebla, Mexico took as its topic women's "natural inferiority" to men.[42] These sources and others reveal profound anxieties about women's untamable, uncontrollable nature.

While on the surface, elevating the Holy Family as the ideal family seems like an easy task, in reality it was an exacting endeavor. Whereas the aforementioned Holy Family paintings posited Joseph as the Virgin Mary's head and superior, depictions of the Earthly or Double Trinity (fig. 28), seemed to heighten Joseph's importance to such a degree that they likened him to God the Father. Comprised of Joseph, Mary, and Jesus, these images provided an earthly manifestation of the Divine Trinity of God, the Holy Spirit, and Christ. According to traditional understanding of the subject, Christ connected the celestial and earthly realms, Joseph assumed God's role, and the Virgin symbolized the Holy Spirit on earth. Some early modern commentators suggested that these two trinities were equal, an assertion that dramatically valorized the Holy Family but raised doctrinal problems: "As there is in heaven a Trinity of persons of divine nature, so there is also another Trinity of persons of human nature, who are Christ, the Virgin, and St. Joseph," said one friar.[43]

Fig. 29. Cristóbal de Villalpando (1649–1714), *Holy Family/Earthly Trinity*, 1680s. Oil on panel, 9 ft. 3 in. x 5 ft. 9 in. (2.8 x 1.7 m). Catedral, Puebla, Mexico

Spanish and Mexican artists visualized these encomiums of the Earthly Trinity in compositions that encouraged beholders to equate Joseph with God. Such visual strategies brought into relief the contradictory dual nature of the Holy Family as simultaneously earthly and divine. The following carol from 1618 proclaims the Earthly Trinity's superiority to the Celestial Trinity:

> *To Joseph / Carol. / On Jesus, Mary, and Joseph*
>
> The best that my soul sees / although it rise to heaven itself /
> is to look at on our earth / Jesus, Mary, and Joseph.
>
> In the celestial city / God one encloses three, / but our earth also /
> enjoys another Trinity.

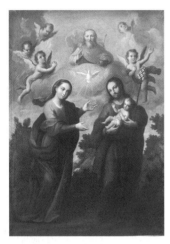

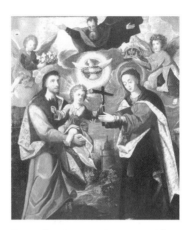

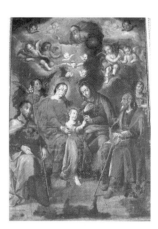

Fig. 30. Anonymous, *Holy Family/Earthly Trinity*, 18th century. Oil on canvas, dimensions unknown. Museo Regional, Guadalajara, Mexico

Fig. 31. Anonymous, *Coronation of the Holy Family*, 18th century. Oil on canvas, dimensions unknown. Museo del Carmen, Mexico City

Fig. 32. Juan Correa (1646–1716), *Holy Family/Cinco Señores*, 17th century. Oil on canvas, dimensions unknown. Museo de Arte Colonial, Antigua, Guatemala

> The Trinity that is seen / outside that of heaven itself, /
> is to look at on our earth / Jesus, Mary, and Joseph.[44]

So effective were the Double Trinity paintings in their elevation of Joseph, in fact, that some worshippers confused Joseph and God the Father, leading the Inquisition to censor references to the Earthly Trinity in devotional texts.[45] The Church was particularly sensitive to the possibility of confusion among new native converts in the New World. An early seventeenth-century Náhuatl sermon carefully explained that although Joseph was Jesus' earthly custodian, protector, and teacher, he was not technically His true father.[46]

Despite the Inquisition's attempts to discourage the proliferation of the Double Trinity cult, however, popular devotion to the trio remained fervent, especially in Mexico. Artists continued to produce images, devotees reported experiencing visions of the Earthly Trinity, and writers sang its praises.[47] In Mexico, in fact, it appears to have been the most frequently depicted Holy Family variant. Baltasar de Echave Ibía's *Holy Family/Earthly Trinity* (San Felipe, Mexico City) of the 1620s represents an early statement of the subject, and a rare example set indoors, as does Cristóbal de Villalpando's version in Puebla's Cathedral (fig. 29). Other artists staged the scene in an outdoor landscape, among them Juan Correa (1646–1716; private collection, seventeenth century), Juan de Villalobos (La Compañía, Puebla), and Juan Sánchez Salmerón (private collection), as well as anonymous artists (fig. 30). Even when not the explicit

subject of the painting, Mexican colonial artists frequently included allusions to the Double Trinity in Holy Family scenes. This is demonstrated by an anonymous eighteenth-century *Coronation of the Holy Family* (fig. 31), as well as by numerous depictions of the "Cinco Señores," or the five lords or masters, including those by Juan Correa (fig. 32; and Nuestra Señora de la Soledad, Mexico City); Cristóbal de Villalpando (fig. 33); Fray Miguel de Herrera (Palace of the Governors, Santa Fe, New Mexico, 18th century); and various unidentified artists (Bodega del Museo Regional, Guadalajara, eighteenth century). In fact, nearly every Mexican colonial depiction of the Holy Family alludes to the idea of the Double or Earthly Trinity.

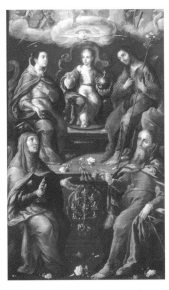

Fig. 33. Cristóbal de Villalpando, *Holy Family/Cinco Señores*, 17th century. Oil on canvas, 74 ⁴/₅ x 44 ⁹/₁₀ in. (190 x 114 cm). Museo Regional de Guadalupe, Guadalupe, Zacatecas, Mexico

One wonders if the tendency to suggest St. Joseph's divinity may be linked to the conflation of his figure with the indigenous deity Tlaloc, previously discussed in chapter 1.

Fig. 34. Claudio Coello (1642–1693), *St. Joseph and the Christ Child/Holy Family*, 1666. Oil on canvas, 72 ¹/₂ x 40 ¹/₂ in. (184.2 x 103 cm). Toledo Museum of Art, Toledo, Ohio

Around the mid-seventeenth century, Spanish artists elevated St. Joseph's status to new heights by inventing completely new Holy Family scenes. The inverted Holy Family by Claudio Coello from 1666 (fig. 34) and another by Juan Montero de Rojas (c. 1613–1683) of 1668 (private collection, Madrid) are representative. On first glance, the images appear to depict only St. Joseph and the Christ Child, but further inspection reveals the inclusion of the Virgin as a small background figure. Montero's intriguing painting, which depicts St. Joseph helping the Christ Child eat, an activity traditionally associated with the Madonna or female saints, demonstrates the surprising gender reversals that characterize much Josephine imagery.[48]

The Virgin Mary disappears completely in scenes by Angelo Nardi (fig. 35) and Antonio Pereda (1611–1678; Palacio Real, Madrid, 1654), leaving only the male members of the family—Joseph, Jesus, and St. John the Baptist. In Nardi's canvas, Joseph stands with the sleeping Christ Child clasped on his shoulder against the backdrop of his carpenter's shop,

which is filled with an encyclopedic display of tools. On the right, the Baptist kneels in homage. In Pereda's painting, the seated St. Joseph holds the Child on his lap as St. John the Baptist looks on. Comparison to sixteenth-century images of the Virgin, Child, and St. John the Baptist—the apparent sources of these depictions of the men of the Holy Family—dramatizes St. Joseph's rise to prominence in the seventeenth century.

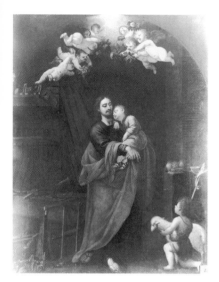

Fig. 35. Angelo Nardi (1584–1665), *St. Joseph and the Christ Child*, mid-17th century. Oil on canvas, 9 ft. x 7 ft. 3 in. (2.7 x 2.2 m). Museo de Bellas Artes, Huesca, Spain

In addition to suggesting to the beholder that Joseph possessed the authority to act as Christ's father, Spanish and Mexican paintings and texts also claimed that Jesus *looked* like His father. In the minds of Church officials, it was incumbent that Joseph resemble his foster Son to mislead the Jews and the devil into thinking that he was the Virgin's true spouse and the real father of Jesus, a clever bit of sleight of hand since he obviously could not—or should not—be the procreative father. The resemblance between father and Son also made the Holy Family a more efficacious model for earthly families, where father and son would more likely resemble each other.[49] Thus, seventeenth- and eighteenth-century artists constructed Joseph's physical features in imitation of those of the adult Christ. For example, in Murillo's *St. John the Baptist and Christ* (fig. 36) the figure of Jesus looks very much like Joseph in the *Holy Family with the Little Bird* (pl. 4), or in countless other depictions. Both have wavy, long, dark hair, neat beards, dark, expressive eyes, and sculptural, heart-shaped faces. In colonial Mexican art, the familial resemblances are even more striking. Comparison of Mexican renditions of the Trinity, which often employ the device of identical triplets to render the abstract idea of a triune God, to depictions of St. Joseph suggest an even closer familial resemblance: Jesus and Joseph, as well as God the Father, often look identical. An eighteenth-century painting by Andrés López of the *Divine and Earthly Trinities* thematizes familial resemblance (Museo Nacional del Virreinato, Tepotzotlán, Mexico, 18th century).[50] Such similarities hint that Joseph played a procreative part in fathering Christ, a role clearly at odds with the official Church stance on the miraculous birth through Incarnation. Artists and writers were so successful in their attempts to make Joseph seem like Jesus' real father that some worshippers began to believe that that the two were indeed biologically related, leading the Inquisition to censor with care references to Joseph as the "father of Christ" in devotional texts.[51]

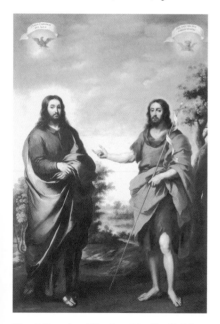

Fig. 36. Bartolomé Esteban Murillo, *St. John the Baptist and Christ*, c. 1655. Oil on canvas, 8 ft. 10 in. x 6 ft. 1 in. (2.7 x 1.8 m). The Art Institute of Chicago

Spanish and Mexican artists employed other representational strategies to encourage the beholder to naturalize and identify with the

blessed family. Murillo's *Holy Family with the Little Bird* (pl. 4) perfectly exemplifies pictorial choices designed to replicate the effects of reality. On first glance, the painting appears to be a genre scene, and indeed, Murillo employed various genre painting strategies here, such as the simplified composition, shallow spatial setting, earthtone palette, broad, sculptural drapery, as well as the inclusion of telling details—the family dog, carpentry tools, and spinning accessories. Other pictorial choices accentuated St. Joseph's humanity. Artists often based their renditions on human models. At times, however, the depiction of Joseph verges on the awkward or the homely. Juan de las Roelas particularized Joseph's features—including large, clumsy ears—to the point of coarseness (fig. 20). Murillo usually depicted the figure of St. Joseph with wrinkled brow. Artists frequently focused on Joseph's large, ungainly feet. These stylistic awkwardnesses were intended to create an intentionally "low" or humble style to express rhetorically Joseph's humanity and humility. These various strategies came to constitute a pictorial shorthand for denoting "reality." When employed in saints' images, such strategies were designed to encourage beholder identification with and induce emulation of the scenes depicted.

Other visual clues alerted the beholder that Holy Family scenes did not depict just any ordinary family. One of the most frequent hints is selective idealization, particularly of the figures of Mary and Christ. Artists usually represented the Christ Child with blond hair, ruby red cheeks, and pale white skin, a rhetorical formula drawn from literary descriptions of Christ that, in the context of the Hispanic world, marked Him as distinct from most of the population.[52] In Murillo's *Holy Family with the Little Bird*, the Virgin's idealized face clearly draws upon Raphaelesque prototypes. Thus, in contrast to the particularized features of Joseph, artists' depictions of his wife and Child stress their idealized, superhuman qualities. The contrast between the carefully observed features of St. Joseph and the idealized features of mother and son are obvious in Echave Ibía's rendering of the *Holy Family/Earthly Trinity* of about 1620 (San Felipe, Mexico City). Spanish and Mexican artists employed other visual tactics to reference the family's divinity. Halos, or, more frequently, diffuse golden glows of light, sometimes appear around the Christ Child's head, or angels infiltrate the scene (figs. 24, 28, and 35). The members of the Holy Family typically wear generalized biblical clothing based on the classical toga and appear in their traditional colors: Mary in red and blue, symbolic of her role as the Queen of Heaven, and Joseph in green and gold, colors associated with spring and fertility. Artists' skillful combination of idealizing and realist pictorial strategies refers to the paradoxical concept of "Holy Family," a kinship group simultaneously divine and mundane. The careful balance that Spanish and Mexican artists negotiated between the human and divine also parallels the precarious balancing act that the Church faced in promoting this cult. The resulting eclectic combination of styles visible in Holy Family scenes, much criticized as a failing of Spanish and colonial Mexican art, thus functioned purposefully.

Because Joseph's saintly status derived from his domestic life, Josephine texts and paintings sanctified even the most mundane aspects of the Holy Family's everyday existence. For example, they depicted Mary, Joseph, and Jesus engaged in quotidian tasks, thereby raising familial life to the level of the divine. In images by Vicente Carducho (c. 1576–1638; private collection, London) and Montero (1668; private collection, Madrid), the holy parents feed their divine Child. Artists imbued images of the Virgin nursing the Infant (fig. 19) as well as images of the Child eating fruit with symbolic meaning. Depictions of Christ sleeping often alluded to His future Passion. Other canvases by Murillo, Casteló, Cano, López, and others depict St. Joseph handing the holy Child to His mother (figs. 24 and 26). Murillo depicted St. Joseph protectively watching over his foster Son at play with the family dog (pl. 4). Friar Gracián reported that Joseph "took the Child in his arms and carried Him singing little songs, hushed Him if He cried, rocked Him so that He would sleep in the cradle, gabbled to him, and gave Him childish gifts, and he never left the house without finding little birds or apples or similar things which children usually enjoy to bring to the Child Jesus."[53] Thus, in addition to the standard christological reading usually mapped onto the goldfinch in Murillo's painting, which was probably inspired by this very text, the bird also signifies Joseph's attentive fatherhood.[54]

In eighteenth-century Mexico, artists thematized the saintliness of daily life in scenes of the Holy Family at the dinner table. Two examples of the *Blessing at the Table*, one by José de Alcíbar (Museo Nacional de Arte, Mexico City, 18th century) and another by José de Ibarra (1685–1756), depict the Holy Family seated at a food-laden table, the scene enlivened by the inclusion of such realistic details as Mexican *poblano* ware. While at first glance these paintings simply seem to pictorialize descriptions of the Holy Family's daily life, a closer look confirms their sacramental quality. This family is not simply eating dinner, but witnessing the Christ Child's blessing of the food, a premonition of His transformation of bread and wine into His body and blood at the Last Supper. His parents, Joseph and Mary, humbly bow their heads in reverence. What tremendous benefits Joseph derived from having lived so many years with Mary and Jesus, "eating at the same table, and from the same bread, and living in the same house," posited the author Fray Antonio Joseph de Pastrana.[55]

The variations in Holy Family depictions examined in this chapter suggest that the concept of "family" does not correspond to any "natural" kinship structure, but is always politically and socially constituted. Indeed, from 1500 to 1700 in Europe, the paradigm of the ideal family was in flux.[56] Previously, in the Middle Ages, the family unit comprised all people living in a house, including an extended network of relatives, household servants, and apprentices.[57] Correspondingly, medieval images of the Holy Kinship represented the Virgin's full tribe of relatives. Such depictions, which focus on the women of the Holy Family, have been linked to late medieval attempts to trace Christ's genealogy through his mother, an emerging

concept of the family as matriarchal, and the construction of the family as a tribe.[58] Another study has suggested that in the medieval period, there were same-sex unions that were sanctioned and accepted by the Church.[59]

In the wake of the Council of Trent, theological pronouncements, devotional texts, and religious images suggest that the Church narrowed its definition of the ideal family to the nuclear unit of father, mother, and children. The configuration of the Holy Family comfortably shifted to fit this emerging model. Additionally, shifts in Hispanic family ideology can be linked to the effects of the Protestant Reformation. Protestantism shifted religious practice from the public space of the Church to the private home, and from the hands of the official hierarchy to the individual. Protestant cultures valorized the patriarchal, nuclear family, giving fathers new control over the actions of wives and children.[60] The Spanish monarchy and Church, on the front lines of the battle against Protestant heresy, and fearful of losing more souls to Luther's appealing democratic religion, may have reformed its ideology of family in response to the Protestant threat. New depictions of the Holy Family were intended to encourage the formation of similar kinship structures amongst the populace.

Early modern historians have linked the shift in the concept of family to the rise of the modern state. Historians posit that as the state took over many of the social and economic roles previously performed by families, the importance of kinship declined in society, replaced by loyalty to sovereign and state. The patriarchal nuclear family better served the state because it encouraged authority and obedience.[61] The Spanish founder of the Jesuits, St. Ignatius Loyola, recognized the connection between patriarchal families and obedience to authority. According to him, this was one of the major benefits of devotion to the Holy Family.[62]

In Spain, political ideology was conveniently enacted against a backdrop of social crisis, producing a complex matrix of social conditions within which images of the Holy Family functioned. Hard economic times and familial separations caused by the numerous wars and emigration to the New World exacerbated the perception that the family was in crisis.[63] Amidst cries that the family was in jeopardy, King Philip IV passed a series of decrees to encourage the formation of Spanish families, such as reduced taxes for married couples with children.[64] Theologians promoted Joseph's power to work miracles in troubled families.[65] The attention focused on marriage by artists and the Hispanic Catholic church thus reflects more general consideration of the family in Golden Age Spain and colonial Mexico.

Spanish period commentators also professed alarm at their perceptions of a shortage of men. As the population of men in Spain decreased—the result of war, emigration to the Indies, and vast missionary efforts abroad—Spanish women gained new opportunities in the home, the Church, and the marketplace. According to Mary Elizabeth Perry, Spanish notarial documents reveal women's increased ability to buy property, transact business, and con-

duct other types of legal affairs in the period.[66] Chroniclers of the time decried women's increasing influence, leading one visitor to comment that Seville had fallen into "the hands of women."[67] Cries that the family was in crisis may have been intended to deflect attention from what has been identified as the real problem: the patriarchal social order itself was in crisis.[68] The rise of St. Joseph's cult, with its emphasis on patriarchy and authority, must be analyzed within the context of these fears.

According to period sources, the countless orphans on the streets provided irrefutable proof that the Spanish family was in crisis. A Jesuit chronicler from Murcia, in a 1649 letter, blamed increasing child abandonment on the plague's devastating effects: "The plague raged so that there were no fathers for the children, and the men left [the city] fleeing like wild animals for the countryside. . . . The orphaned children roamed the streets bleating like little lambs until a hospital was built to shelter them."[69] As Michel Foucault has demonstrated, issues such as child abandonment only came to be perceived as social problems in the early modern period.[70]

Golden Age Spain witnessed the creation of numerous orphanages. In the sixteenth century, Madrid, Valladolid, Salamanca, Toledo, Seville, Córdoba, and Santiago de Compostela all founded orphanages.[71] In 1627, the nobleman Andrés Gutiérrez de Haro spearheaded a national campaign to place all orphans under the protection of St. Joseph, and they came to be known as the *hijos de San José* (children of St. Joseph).[72] A painting of the Holy Family protecting abandoned babies hung in the church of Seville's Casa Cuna, or cradle house.[73] Roelas's *Holy Family* (fig. 20) of about 1620 may have hung in the same orphanage. A polychromed wood sculpture of the Holy Family by Gregorio Fernández (c. 1576–1636) was placed in the chapel of a Josephine confraternity dedicated to caring for foundlings in Valladolid. Joseph was also honored on the facades of orphanages, which displayed sculptures of him.

A number of orphanages were also founded in colonial Mexico. By the 1530s, the first native parish, San José de los Naturales, on the grounds of the monastery of San Francisco in Mexico City-Tenochtitlán, included an orphanage. In 1560 Pope Pius IV granted a plenary indulgence to all who visited the Chapel of St. Joseph and donated money to the orphans.[74] Other Josephine institutions include St. Joseph's Royal House of Abandoned Children in Mexico City (Real Casa del Señor San José de Niños Expósitos).[75]

Colonial writers boasted of St. Joseph's importance in Mexico. According to the Jesuit José Ignacio Vallejo, "These cults of Our Lord St. Joseph are not only seen in churches, they are frequent and flourish in almost all families, so that in their domestic devotions families invoke the most holy Patriarch as their renowned protector."[76] Another author claimed in 1778 that "from the churches Josephine devotion has spread to the interiors of houses, where mothers with their families affectionately invoke the protection of the Most Holy

Patriarch on his day."[77] A number of Mexican churches were dedicated to St. Joseph and the Holy Family, such as Puebla's parish of St. Joseph, originally founded in the mid-sixteenth century as a native congregation. Rebuilt between 1628 and 1653, its seventeenth-century decoration celebrates the Holy Family. The central nave was dedicated to the saint himself, the right nave to the Holy Family, and the left to the family of the Virgin Mary.

By giving visual form to Spanish Counter-Reformation ideologies of family that promoted patriarchal authority, images of St. Joseph and the Holy Family played a vital role in the colonization and Hispanization of New Spain. Like their counterparts in Spain, Mexican church and government officials professed alarm at what they perceived as a crisis of "family values" that only colonization and conversion could remedy. The cults of St. Joseph and the Holy Family thus became important tools in attempts to Hispanize native family structures.

In some ways, precontact indigenous families and gender roles therein approximated medieval European ideals. Because native kinship groups were large and varied in composition, consisting of extended family plus other non-blood-related persons, they differed substantially from the early modern Spanish norm of the patriarchal nuclear family. The Náhuatl word for "family"—*cemithualtin*, or "those of one patron"—corresponds to the people who share a living space, not a particular kinship group.[78] Male and female gender roles within the family also differed significantly from Spanish standards. In contrast to the model of male authority and female submission promoted by the Spanish colonizers, native Mexican gender roles have been described as complementary in nature. In other words, native women enjoyed special status in the domestic sphere.[79] For this reason, Spanish missionary friars were particularly worried about native women's power and status in the home, viewing the native household as "a potential locus of subversion and resistance," according to Louise Burkhart.[80]

While, in general, many Mexican colonial Holy Family images follow the development of Spanish Holy Family images and seem to produce similar meanings (like much Josephine imagery), Mexican artists' notable departures from Spanish norms merit further investigation. Examination of these differences provides a more nuanced view of religious art production in the Spanish Empire. Most notably, in contrast to Spanish images, which almost without exception characterize the Holy Family as patriarchal and nuclear in nature, many Mexican Holy Family images persisted in constructing the Holy Family as matriarchal by placing the women of the family in positions of prominence, and continued to depict the extended family throughout the seventeenth and eighteenth centuries, with special importance accorded Saints Anne and Joachim. In fact, only about half of extant colonial Mexican Holy Family depictions privilege St. Joseph as paterfamilias in the manner of Spanish representations. Such differences in Holy Family imagery are particularly curious since artists on

Fig. 37. Nicolás Rodríguez Juárez (1667–1734), *Holy Family/Cinco Señores*, 18th century. Oil on canvas, dimensions unknown. Museo Regional, Querétaro, Mexico

Fig. 38. Cristóbal de Villalpando, *Holy Family/Cinco Señores*, late 17th–early 18th century. Oil on canvas, 71 ¹/₄ x 86 ¹/₄ in. (181 x 219 cm). Museo de Bellas Artes, Toluca, Mexico

Fig. 39. Nicolás Rodríguez Juárez, *Holy Family/Cinco Señores*, 1722. Oil on canvas, dimensions unknown. Museo Regional, Querétaro, Mexico

both sides of the Atlantic were beholden to the same Inquisition pronouncements, read many of the same religious texts, and received similar artistic influences. Do Mexican images reveal native responses to colonization?

Mexican colonial patrons' and artists' taste for the continued depiction of the Holy Family as an extended clan is demonstrated by the great popularity of representations of the Holy Family as the "Cinco Señores," or "the five lords or masters," which depict the nuclear Holy Family of Mary, Jesus, and Joseph joined by Jesus' maternal grandparents, Saints Anne and Joachim. Important seventeenth-century versions include paintings by such Mexican luminaries as Juan Correa (fig. 32; and Nuestra Señora de la Soledad, Mexico City) and Cristóbal de Villalpando (fig. 33). Artists depicted several different variations of the scene. Correa, Villalpando, Miguel de Herrera, and others (anonymous, Bodega del Museo Regional, Guadalajara), for example, attempted to valorize the nuclear family by placing St. Joseph, Mary, and the Christ Child in the center of the composition and the holy grandparents on the periphery.

Other images of the Cinco Señores privileged the women of the Holy Family, including works by such artists as Nicolás Correa, Nicolás Rodríguez Juárez (fig. 37), as well as

examples by anonymous artists (Catedral, León, Mexico, eighteenth century; and Bodega del Museo Regional, Guadalajara, eighteenth century), and another version of the theme by Villalpando in Toluca (fig. 38). In the latter's version of the *Cinco Señores*, the artist privileged the women of the Holy Family by placing them front and center, a compositional type articulated in the sixteenth century by Andrés de la Concha (pl. 5). In a 1722 version of the theme by Nicolás Rodríguez Juárez, St. Anne, Christ, and Mary appear in the center elevated on clouds, with Saints Joachim and Joseph flanking (fig. 39).

Mexican devotion to the Cinco Señores appears to have been quite vibrant in the colonial period, a phenomenon unmatched in Spanish culture. In a sermon published in 1726, a Oaxacan friar claimed to have delivered the very first sermon dedicated to the Cinco Señores in November of 1725 in the Discalced Carmelite Church of St. Sebastian in Mexico City. He also revealed that the Holy Family in this guise enjoyed its own feast day, on January 19, which had been celebrated for the first time in 1725.[81] Continued devotion to the Cinco Señores is demonstrated by the founding of a church named in their honor in Tehuaca, Mexico in 1783.[82]

The prevalence in colonial Mexican art of images of the extended Holy Family such as the Cinco Señores, which by their very definition diminish St. Joseph's importance, as well as images of the Holy Family as matriarchal, raises intriguing questions. Why do nearly half of extant colonial Mexican Holy Family depictions seem to privilege the women of the Holy Family? Was the Spanish Church less successful in promoting its vision of the patriarchal nuclear Holy Family in the American colonies? These questions are especially puzzling since after 1555 New Spain boasted St. Joseph as its patron and protector.

Conventional wisdom suggests that the persistence of such Holy Family imagery is typical of the *retardataire* style and iconography of art in the Spanish colonies. Specialists in the field have long characterized Mexican colonial art as medieval in nature, and thus, the continuance of an older iconographic type would not be surprising.[83] Others would view this trait as indicative of the lower quality of Mexican art as well as a lack of sophistication on the part of Mexican patrons and artists.

Other avenues of investigation beckon. The great variety of colonial Holy Family images and the persistence of types discouraged by the Spanish church and Inquisition seem to suggest that oversight of religious imagery was less zealous in Mexico than in Spain. Preliminary research on Mexican colonial art suggests that this hypothesis will benefit from additional investigation. A recent study of print production in New Spain revealed little Inquisition oversight of Mexican printmaking. Similarly, a study of the imagery of St. Philip of Jesus, the first Mexican-born saint and patron of Mexico City, found negligible Inquisition involvement in the regulation of the visual arts.[84] Even without widespread direct intervention, though, the Inqui-

sition still fostered an atmosphere that discouraged radical departure from Church-approved imagery.[85]

The preference for the extended matriarchal family in Mexican Holy Family images may also be traceable to the influence of indigenous family structures, which were more matriarchal in nature and frequently composed of extended kin networks. Despite concerted attempts to impose European family ideals, centuries of indigenous attitudes toward family did not disappear easily.[86] Even today, contemporary Mexican culture values the extended family and accords a special place of honor to its matriarchs. Some additional evidence to support this hypothesis can be found in images that represent St. Joseph on his knees before Mary, such as two from the seventeenth century, one by Cristóbal de Villalpando (private collection) and the other by Juan Rodríguez Juárez (fig. 40). The scene, which represents Joseph's realization of the sacred nature of his wife's pregnancy, contrasts dramatically with Spanish representations of Mary on her knees before her husband.

Fig. 40. Juan Rodríguez Juárez (1675–1728), *St. Joseph before Mary*, 18th century. Oil on canvas, dimensions unknown. La Concepción, San Miguel de Allende, Guanajuato, Mexico

Further evidence to support the hypothesis that colonial Mexican taste for the extended matriarchal Holy Family can be traced to indigenous influence may be found in the Mexican development of the cult of St. Anne. Throughout the sixteenth, seventeenth, and eighteenth centuries, St. Anne, believed by Catholics to have been the mother of the Virgin Mary and grandmother of Jesus, was the object of remarkable devotion in Mexico. Numerous hagiographies, sermons, and devotional texts, as well as countless visual images lauded her as the "Mother of the Mother of God" and the "most holy Grandmother of Jesus."[87] The widespread celebration of Anne's cult in colonial Mexico is striking, particularly when compared to contemporaneous Spanish culture.

In Spain, after reaching an apogee in the sixteenth century, St. Anne's cult then diminished in importance.[88] Some evidence suggests that Spanish church reformers attempted to suppress Anne's cult, possibly to promote Joseph's instead. The Spanish Inquisition censor Francisco Pacheco expressed his displeasure at popular enthusiasm for the blessed matriarch. Despite being "beloved and admired by the faithful," the subject of St. Anne teaching Mary to read (fig. 23) had, in Pacheco's estimation, no basis in historical fact. Pacheco also critiqued depictions of the extended Holy Family, as discussed earlier in this chapter.[89]

One wonders if Pacheco's aversion to St. Anne's cult may have been linked to its focus on Anne's maternality, to use a psychoanalytic term denoting fantasies of idealized

motherhood.[90] The cult's surge in the late medieval period coincided with the rise to prominence of an unparalleled number of female saints' cults. Social historians have posited that these cults testify to European women's increased power in the family and within society or fantasies thereof.[91] The early modern era, in contrast, witnessed the promotion of a number of important male saints, as well as frequent attempts to contain and control European women. Feminist historians have demonstrated these trends in sixteenth- and seventeenth-century Spain.[92]

In fact, in early modern Spain, Spanish Church reformers and Josephine devotees reassigned to St. Joseph all of the functions previously under the domain of the grandmother of Jesus. Like Anne, he became a universal saint, recipient of all manner of petitions. He took over Anne's previous patronage of woodworkers. Most incredibly, St. Joseph also appropriated St. Anne's role as patron of infertile women and even women in childbirth. In place of Anne, the powerful thrice-married matriarch of the Virgin Mary's large extended family, the early modern Church favored St. Joseph, beneficent emblem of fatherly authority. The shift in emphasis from St. Anne to St. Joseph can be clearly detected in images of the Holy Family from sixteenth- and seventeenth-century Spain.[93]

In contrast to Spain, however, in colonial Mexico artists continued to privilege St. Anne in Holy Family depictions. A late sixteenth-century painting by Andrés de la Concha (pl. 5) valorizes the women of the Holy Family, relegating Saints Joseph and Joachim to the margins. Simón Pereyns's sixteenth-century *Virgin of Mercy with the Holy Family* (formerly Catedral, Mexico City, 1568) places St. Anne in the foreground on equal footing with St. Joseph. Representations of the Double or Earthly Trinity, which in Spain focus closely on the patriarchal nuclear family of St. Joseph, Mary, and Jesus, in Mexico frequently include the Holy Grandparents, Anne and Joachim.

Images of St. Anne—including the Triplex, St. Anne as teacher, and the Birth of the Virgin, among others—were, in fact, plentiful in colonial Mexico. Mexican artists dedicated entire series of paintings to the Holy Grandparents Saints Anne and Joachim, examples of which can be found in San Juan Bautista in Coixtlahuaca, the church of the exconvento of Churubusco in the Federal District (originally from La Piedad), San José in Puebla, and Mexico City's La Profesa. These altarpieces demonstrate the intensity of Mexican devotion to the Holy Grandparents, a devotion that embodied the continued valorization of the extended family and the importance of matriarchs in Mexican culture.

Furthermore, compelling evidence indicates that native Mexicans favored the cult of St. Anne because it allowed them to continue religious practices to a revered Aztec deity, Toci, or "Our Grandmother," matriarch of the indigenous pantheon. The Franciscan friar Bernardino de Sahagún reported in the 1580s that native neophytes conflated Santa Ana with Toci in the village of Santa Ana Chiautempan. In 1611 the Dominican friar Martín de León

repeated the complaint, protesting that native converts in Tlaxcala continued to worship Toci while feigning devotion to St. Anne. He explained that they came to the Church of Santa Ana to worship "a goddess they called Tocitzin, 'Our Grandmother,' and even today they say that they celebrate the fiesta of Toci, or that they're going to Toci's temple."[94]

Frequent depictions of St. Anne in colonial art combined with the textual evidence suggest that there was a limit to the colonizers' success in imposing a Spanish family ideology on Mexico. Although the Spaniards could split up indigenous households, forcing them to conform to the model of the patriarchal nuclear family, Mexicans continued to elevate grandparents—and grandmothers in particular—to positions of honor as they had done for centuries. The cult of St. Anne may thus hint at Mexican resistance to Spanish colonial authority.

In conclusion, the rich variety of Holy Family imagery produced in Spain and Mexico testifies to the malleability of the theme and its signifying potential. The vast increase in the production of such imagery in the seventeenth-century Spanish Empire affirms the subject's popularity in the early modern era.[95] After a period of experimentation in the 1580s and 1590s, artists conferred greater and greater importance on Joseph. In many examples, Joseph replaced the Virgin as the focus of attention. Concurrently, depictions of the extended Holy Family virtually disappeared from the repertoires of Spanish artists, although they persisted in Mexican art. In Spain, these reconfigured Holy Families demonstrate four distinct traits. First, they almost exclusively depict the nuclear family, placing the greatest visual attention on the figure of Joseph, who often takes over the Virgin's traditional position or customary activities; second, some paintings further develop this strategy, placing the Virgin in a position subservient to her husband; third, Spanish artists clearly modeled Joseph's physical characteristics on those of the adult Christ; and finally, Spanish Baroque images of the Holy Family attempt to sanctify the most mundane tasks of daily life. Mexican images demonstrate many similarities, but with two distinct differences: first, although in general St. Joseph is valorized as the head of the family, Mexican images often depict the extended family; and second, almost all Mexican Holy Family images are also Earthly or Double Trinity images. As noted above, these differences are evidence of the different developments of this cult in Spain and the colonies and may point to the influence of indigenous culture on a Catholic saint's cult.

Critical readings of Spanish and Mexican Holy Family paintings in conjunction with period religious texts greatly expand understanding of the ideal family promoted by the Spanish Catholic church and clarify early modern Hispanic gender prescriptions. As the ideal father and husband, St. Joseph was presented as the head of his household in numerous paintings and texts. Mary was characterized as the perfect wife, subservient and industrious. Changes in the positions and poses of Joseph and Mary in Spanish and Mexican paintings, as well as the representation of specific tasks such as sewing, are more fully understood as visual

manifestations of the patriarchal nuclear family promoted by the early modern Spanish church. Whereas the Church actively promoted fathers' authority and power, it also encouraged fathers to be kind and loving. Not only did sermons and other religious writings attempt to codify wifely duties within marriage, but the duties of responsible husbands, too.[96] The coexistence of discourses of patriarchal authority and love in St. Joseph's cult points to the complexity of gender ideologies. Such religious scenes thus demonstrate the visual arts' participation in significant social and cultural discourses.

How efficacious were Holy Family images in the Church's promotion of the patriarchal family? Historians' studies of court documents in Spain and the New World paint a dismal picture of life for many women in the period. Spanish writers deemed husbands' authority in the family "natural" and unquestionable, since it arose from men's inherent superiority to women, as the author Juan Ginés de Sepúlveda wrote: "In wisdom, skill, virtue and humanity, men surpassed women just as Spaniards exceeded Indians and adults children."[97] Furthermore, men held legal power over women's bodies and dowries. Domestic violence perpetrated against women was rampant. Confessional manuals advised priests just how far husbands could go in beating and disciplining their wives.[98] These various sources testify to the effectiveness of the Catholic church's campaign to increase men's authority over women.

In this climate, St. Joseph seems to have enjoyed great popular success. Theologians recommended Josephine devotion to troubled families and the saint became the patron of married couples and children. Joseph also became known for his ability to guarantee familial succession by helping women achieve pregnancy. In one case in Lima, Peru, St. Joseph purportedly appeared to a woman, placed his hand on her stomach, and miraculously impregnated her.[99] Finally, St. Joseph was hailed as the special protector of children. Explained the friar Antonio Joseph de Pastrana, "Parents recommend their children to my lord St. Joseph, procuring from childhood to imprint on their children devotion to St. Joseph, in order to assure his protection through all their lives, because to whom could they better recommend their children, than to he to whom the eternal Father recommended His only begotten Son?"[100] The new elevation of St. Joseph as the perfect father will be discussed in detail in the next chapter.

Francisco de Zurbarán, *St. Joseph and the Christ Child, (detail of fig. 48)*

CHAPTER

FOUR

MOTHERING FATHERS

SPANISH AND MEXICAN RENDITIONS of St. Joseph and the Christ Child depict the
Holy Foster Father tenderly cradling the baby Jesus in his arms or protectively holding
Him. Father and Son lovingly gaze into each other's eyes, embrace affectionately, kiss each
other. In some images, the young Jesus obediently follows His earthly father, His small hand
enveloped by Joseph's protective clasp, or gazes up at him with a son's admiration and love.
Other scenes depict Joseph in the humble tasks of child-rearing, such as feeding the Child or
tending to Him in the cradle. These intimate, endearing works clearly captivated beholders,
as witness the great numbers of them produced throughout the Spanish Empire in the sev-
enteenth and eighteenth centuries.

A partial explanation of the theme's importance can be found in a 1597 text by the
most influential Josephine writer in the Spanish Empire, Fray Jerónimo Gracián de la Madre
de Dios. He explained: "I am very sure that if you were to measure all the love that natural
fathers have had for their sons against Joseph's love of Jesus, you would find Joseph's love to be
greater."[1] He went on to praise the father-son relationship between Joseph and Jesus as ideal,
suggesting that Joseph's love for his foster Son exemplified "the deepest love a father could
have for his son."[2] Gracián enumerated Joseph's fatherly responsibilities, among them not
only raising, supporting, and defending Christ, but also carrying Him in his arms.[3] On the
authority of Gracián and others, images of St. Joseph holding the Christ Child were to
become potent signifiers of Joseph's earthly fatherhood of Christ.

Such imagery played a key role in an early modern campaign sponsored by the Span-
ish Catholic church urging men to become involved in the daily life of their families. For the

first time in its history, the Church advocated that fathers directly intervene in child-raising and even housework. This valorization of involved fathers and attentive husbands constitutes a new discourse of ideal masculinity. It suggests the need to re-examine easy assumptions about Hispanic society as a hotbed of *machismo*. When these new constructions of ideal masculinity and fatherhood were spread by Church representatives in Mexico, as part of colonization, gender concepts became even more heterogeneous with input from indigenous cultures. The cult of St. Joseph thus provides a lens through which to view the complex nature of gender discourse in Spain and its empire.

The visual and textual evidence suggests that Hispanic theologians, worshippers, and artists recognized several different scenes under the rubric of "St. Joseph and the Christ Child" in seventeenth- and eighteenth-century Spain and Mexico. These various types encoded different messages for period beholders, as further analysis below will reveal. Devotees distinguished between the itinerant, standing, and seated St. Joseph, as well as between scenes of Joseph embracing or guiding Jesus; Jesus seated on the saint's knee; Jesus kissing Joseph; Jesus with His arms around His earthly father's neck; the Child caressing Joseph's face or grasping his tunic; the Child asleep; St. Joseph in ecstasy; and scenes that alluded to Christ's future Passion.

One of the earliest Spanish portrayals of St. Joseph and the Christ Child was that of the "itinerant St. Joseph," which represents St. Joseph leading the Christ Child through a landscape.[4] It is distinguished from most other images of St. Joseph and the Christ Child by the latter's age. In these images Christ appears as an older child, aged between three or four to eight or nine years, not as an infant or toddler.

Several important early renditions date from the late sixteenth century, including two examples by El Greco (fig. 46; and Capilla de San José, Toledo, 1597–1599). One of these paintings was commissioned for a private chapel in Ávila, which, as St. Teresa's birthplace, was a major locus of Josephine devotion. Sevillian examples include Francisco Pacheco's painting for the parish church of Santiago in Seville (1564–1644); Pablo Legot's example probably dating from the first third of the seventeenth century (1598–1671); and Francisco de Zurbarán's altarpiece for Seville's Descalced Convent (fig. 48), now in France. Several Castillian artists produced paintings of the theme, including Diego de Aguilar (d. 1624; first third of the seventeenth century), Felipe Diriksen (1590–1678; 1627–29), and Angelo Nardi (1584–c. 1665), whose 1634 painting was executed for the Convent of Las Bernardas in Jaén. A painting by Pedro Orrente (1580–1645) from 1629 for the *retablo de San José* in the parish church of Yeste represents the School of Toledo. Later versions of the subject include the canvas datable to about 1700 by the Sevillian follower of Bartolomé Esteban Murillo (1617–1682), Esteban Márquez de Velasco (d. 1696; Museo de Bellas Artes, Seville), and another by

Vicente Berdusán (1632–97) from the early eighteenth century (Museo de Bellas Artes, Zaragoza).

Although documentation for Mexico is less abundant, the itinerant St. Joseph was also an early theme to be elaborated in the Americas. Important examples date from the late seventeenth century, including paintings by such artists as Juan Correa (fig. 49), as well as works by artists whose identities remain unknown (fig. 41).

Spanish and Mexican artists later turned to images of the standing St. Joseph holding the infant Christ Child. The earliest such seventeenth-century depiction known to the author is by the Spaniard Juan Sánchez Cotán (1560–1627; San José, Toledo), most likely created before 1603. It represents

Fig. 41. Anonymous, *St. Joseph and the Christ Child*, 17th century. Oil on canvas, dimensions unknown. Santo Domingo, San Cristóbal de las Casas, Chiapas, Mexico

Fig. 42. Vicente Carducho (c. 1576–1627), *St. Joseph and the Christ Child*, 1632. Oil on canvas, 86 ¹/₅ x 54 ¹/₃ in. (219 x 138 cm). Musée des Beaux-Arts, Narbonne, France

Joseph as a three-quarter–length figure with the Child in his arms, looking out at the beholder as he stands in a landscape. Jesus holds a stalk of lilies, one of Joseph's main attributes, as He looks to His earthly father, grasping at his tunic. The open sky above reveals the dove of the Holy Spirit and a heavenly *gloria*.

A notable change occurs in Vicente Carducho's 1632 rendition of the theme: Joseph is now a full-length figure (fig. 42). Framed by classical columns and an archway, he looks to the Holy Child, not out at the viewer. Joseph's flowered staff replaces the more emblematic lilies, but as in the painting by Sánchez Cotán, the sky opens to reveal the dove and a glory of angels. Because of its size and monumentality, Carduchos's 1632 painting, now housed in a museum in Narbonne, France, may have been a church altarpiece; a copy of it can be found in the parochial church of Muruzábal in Navarra.[5]

Spanish canvases produced in the 1640s and 1650s continued to depict Joseph full-length, but placed more emphasis on the emotional bond between foster father and Son. Alonso Cano's two paintings from the 1640s are perhaps the most endearing renditions of the theme: the canvas executed for the Church of the Magdalene in Getafe (near Madrid) from 1645 which remains in situ (fig. 50) and a similar version of about 1646, originally painted for

a retablo in the St. Joseph Chapel of Madrid's Church of San Ginés (fig. 56).[6] In the Getafe painting Joseph turns his head to kiss the Child as the latter looks lovingly into the saint's eyes, clutching his robe. In the San Ginés version, one sees included for the first time a carpenter's bench and full panoply of woodworking tools. Both figures directly address the beholder. A later version of the theme by Francisco Camilo presents an intimate variation; it depicts the holy baby asleep in Joseph's arms (fig. 64).[7] A canvas by Murillo of 1665–68 (fig. 47) does not neatly fit into either category outlined above, but presents a remarkable modification. Here the Child—now about three years old—stands on a classical pedestal next to His foster father, who embraces his divine Son with one arm while steadying Him with the other. The Child clutches a branch of flowers, an imaginative reworking of Joseph's traditional attribute.

In Mexico, the standing Joseph and Christ Child is the most frequent of all Josephine images. Examples can be found in nearly every church in the republic today. The theme's popularity dates to the colonial era, as witness numerous seventeenth- and eighteenth-century examples in both painting and sculpture. Paralleling artistic developments in Spain, the image was elaborated slightly later than the itinerant Joseph images. Documentable early representations include examples attributed to and/or by Juan Correa (figs. 43 and 58) and Cristóbal de Villalpando (figs. 52 and 55), which date from the late seventeenth century. A number of images by unidentified artists can also be cited. The subject continued to be popular into the eighteenth century, as witness paintings by Ignacio Ayala Prieta, Fray Miguel de Herrera (active 1725–c. 1780), and Andrés López (fig. 66). In contrast to Spanish examples, Mexican artists frequently represented the figures in a landscape setting, or in a celestial ambient, often with God the Father looking on (fig. 43; as well as anonymous, private collection, seventeenth century; anonymous, San Jacinto, Mexico City, eighteenth century; anonymous, Adams Collection, Philadelphia; and anonymous, private collection, second half of the eighteenth century). The emotional intensity of the Mexican works, though, is similar to Spanish examples. Often the two figures gaze lovingly into each other's eyes; at other times, the Holy Child affectionately touches His foster father's chin or clutches his tunic. In many images, the Christ Child makes eye contact with the viewer as His foster father humbly looks to Him. A variation on the scene can be found in an anonymous eighteenth-century painting in the antesacristy of Mexico City's Santo Domingo, in which St. Joseph leans over to embrace the seated Christ Child. Numerous other Mexican paintings document Murillo's influence in the Americas (Philadelphia Museum of Art, eighteenth century).

One particular type of image depicting the standing Joseph and Child seems to be peculiar to Mexico, that of St. Joseph holding the baby in an offering pose (fig. 43). In some images, Joseph lifts the Child up to God the Father, who makes an appearance in the top right

corner. The Heavenly Father does not always appear in the scene, although Joseph retains a similar offering or presentation pose, as in an eighteenth-century New Mexican sculpture attributed to Bernardo Miera y Pacheco (d. 1785; Museum of International Folk Art, Santa Fe, New Mexico). These images draw attention to Joseph's role as God the Father's proxy.

The subject of the seated St. Joseph with the Child in his arms seems to appear first in the early 1620s in Seville. Juan de las Roelas's *St. Joseph and the Christ Child* of about 1620–24 (c. 1560–1625; Palacio de San Telmo, Seville) and Juan del Castillo's version datable to about 1622 (c. 1590–1657; Espíritu Santo, Seville) are the first known extant depictions.[8] It was not until the 1640s that Spanish artists took up the theme in earnest. Some paintings present an interesting thematic innovation: Christ holds objects that presage His Passion, as in a painting by Francisco Herrera the Elder (fig. 59).

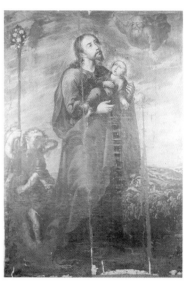

Fig. 43. Attributed to Juan Correa (1646–1716), *St. Joseph and the Christ Child*, 17th century. Oil on canvas, 39 ²/₅ x 27 ¹/₂ in. (100 x 70 cm). Church of Guadalupito, Zacatecas, Mexico

In the 1660s, production of images of the seated Joseph and Child increased dramatically in Seville, all by Murillo and his workshop, as depictions of the standing saint began to decrease in frequency (pl. 6 and fig. 67).[9] Whereas in earlier versions of the scene the production of meaning was localized in signifiers such as attributes, now the intimate interactions between the two figures serve as the locus. Murillo simplified the compositions and curtailed the depiction of extraneous objects in order to create highly affective devotional images. In their tender characterization of the father-son bond, sense of intimacy, and profound realistic effects, these devotional works epitomize the relationship between Joseph and Jesus as it was constructed in the period.

Images of the seated St. Joseph and Christ Child present particular patronage problems since, of all the images discussed in this chapter, the least amount of documentation has been recovered for these paintings. The original location of only one can be securely determined: Castillo's aforementioned painting of about 1622 for the Sevillian church of the Espíritu Santo. But the lack of information itself may be revealing. The frequency of these paintings, the lack of commission documents and unknown provenance, their intimate size, plus current locations in private, gallery, and museum collections suggest that some of these works were painted for the open market and were therefore destined for private patrons' devotions. Certainly, the large number of these paintings turned out by Murillo's workshop indicates that a market existed in Seville.

One final image type, although rare, merits attention because of its extraordinary nature—depictions of St. Joseph at the cradle of the Christ Child. A Spanish drawing by Alonso Cano from the seventeenth century and an eighteenth-century Mexican painting by

José de Alcíbar demonstrate that the scene was represented on both sides of the Atlantic (fig. 62). Unfortunately, Cano's drawing, which is thought to have been a sketch for an altarpiece, so far has not been linked to any extant painting. Alcíbar's version, however, suggests that perhaps a Spanish painted precedent did exist. No scene so perfectly captures a father's love as these depictions of St. Joseph kneeling before his foster Son's cradle.

Although documentation for the Americas is much less abundant, speaking generally, the development of colonial Mexican Josephine imagery paralleled that in Spain, but with a few noteworthy exceptions. Most significantly, St. Joseph imagery developed later in the Americas than in Europe, reaching its full efflorescence in the late seventeenth and eighteenth centuries. As in Spain, the itinerant St. Joseph was an early theme to be elaborated, with important examples dating from the late seventeenth century. Colonial Mexican artists frequently preserved two key traits from early Spanish sources, representing the figures in a landscape setting and including a heavenly gloria in the scene.

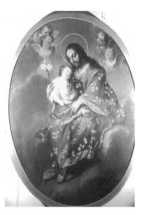

Fig. 45. Miguel Cabrera (1695–1768), *St. Joseph and the Christ Child*, 18th century. Oil on canvas, 63 x 48 ²/₅ in. (160 x 123 cm). Museo Nacional de Historia, Mexico City

Finally, Mexican images reveal Murillo's pervasive influence in Mexico, as witness in particular examples by Miguel Cabrera, the "Mexican Murillo," and others (figs. 45 and 44).

Patronage information for Mexico is sorely lacking, not only because much archival work remains to be done on Latin American art, but also due to centuries of war, revolution, and anti-Church violence.[10] The lack of documentation makes it difficult to pinpoint original locations for many works of art, a number of which are now housed in private collections. Of the paintings discussed above, four may remain in their original locations: Correa's painting in Coyoacán's *convento* (fig. 58); Villalpando's paintings in Tlalpan's seminary and San Ángel's former Carmelite convent, now the Museo del Carmen (figs. 52 and 55); and the anonymous eighteenth-century painting in the parish church of San Jacinto in Mexico City. The provenance of other paintings, many by unidentified artists and often in private collections, remains unknown. Still, in general, large size often indicates public display, perhaps as church altarpieces. A significant number of sculptures of St. Joseph with the infant Christ in his arms, mostly dating from the eighteenth century, still today can be found in Mexican churches. Several examples in the

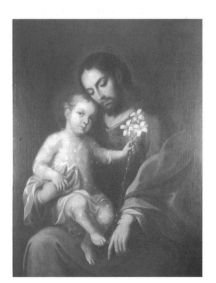

Fig. 44. Anonymous, *St. Joseph and the Christ Child*, late 17th century. Oil on canvas, 62 ¹/₅ x 36 ³/₅ in. (158 x 93 cm). Museo Nacional de Arte, Mexico City

ex-colegio, now Viceregal Museum, of Tepotzotlán remain in situ.

The visual evidence suggests that after the late 1500s and early 1600s, when the first depictions of St. Joseph and the Christ Child appeared in Spain, the images' components and attributes operated within relatively narrow limits. This tendency to preserve the status quo and eschew iconographic change is typical of Spanish and Mexican Baroque art, in large part due to the censorious control of the Inquisition and the power of ecclesiastical patronage. The major change that occurs in these images is the intensification of the emotional bond portrayed. The evidence of the artworks further suggests that several different scenes under the rubric of "St. Joseph and the Christ Child" were widely recognized in seventeenth- and eighteenth-century Spain and

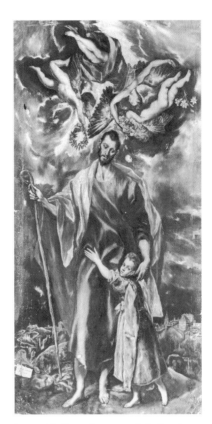

Fig. 46. El Greco (1541–1614), *St. Joseph and the Christ Child*, c. 1597–99. Oil on canvas, 43 x 22 in. (109 x 56 cm). Museo de Santa Cruz, Toledo, Spain

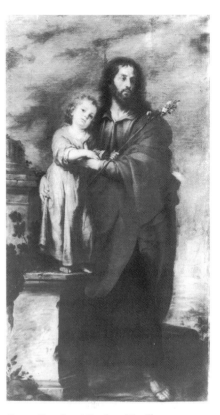

Fig. 47. Bartolomé Esteban Murillo (1617–1682), *St. Joseph and the Christ Child*, c. 1665–68. Oil on canvas, 88 ½ x 49 ⅕ in. (225 x 125 cm). Museo de Bellas Artes, Seville, Spain

Mexico. Within the larger category of Joseph as Christ's earthly father, these different types encoded different messages for beholders of the period, as further analysis will reveal.

The earliest Josephine images to be elaborated in Spain and Mexico, the "itinerant" St. Joseph guiding Christ, demonstrate several subtle variations, which, according to textual evidence, produced different meanings. In El Greco's memorable renditions, Joseph and Jesus have stopped to embrace against the backdrop of the city of Toledo (fig. 46). Murillo reiterated the idea by depicting Christ standing on a classical pillar at Joseph's side (fig. 47). More commonly, these compositions focus on the joining of the two figures' hands, usually in the center of the canvas, as in the examples by Pacheco, Diriksen, Orrente, Legot, and Nardi, cited earlier, as well as in two by Zurbarán and Correa (figs. 48 and 49). Typically, Joseph wears traveling costume, consisting of a cloak, tunic, and staff, as does Christ, and both figures appear

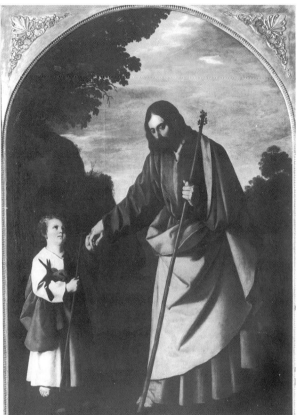

Fig. 49. Juan Correa
(1646–1716), *St. Joseph and
the Christ Child*, 17th century.
Oil on canvas, dimensions
unknown. Art Market
(Galerías La Granja), Mexico
City

Fig. 48. Francisco de Zurbarán (1598–1664), *St. Joseph and the
Christ Child*, c. 1635–40. Oil on canvas, 93 $^2/_3$ x 67 $^2/_3$ in. (238 x
172 cm). St. Médard, Paris

either completely unshod or wear sandals. While flowers traditionally crown Joseph's walking
stick, in several instances he carries a crooked shepherd's staff, symbolic of the saint's duties as
the guide, protector, and mentor of Christ.[11] The staff associates Joseph with other pastoral
images, such as Christ as the Good Shepherd or Jacob guarding his flocks.

 The image of the itinerant St. Joseph leading the Christ Child by the hand provided
fathers with a model to emulate in guiding their children. In 1686 the renowned preacher
Joseph de Barcia y Zambrana dedicated a sermon to that very theme. He delivered it in
Toledo, the location of El Greco's altarpiece of the subject in the Capilla de San José, and a
major center of Josephine devotion. Barcia asked his audience to visualize the painted image:
"I don't know if you have ever stopped to think of the image of our saint. How do they paint
him? Of course: a venerable man who leads the Child Jesus by the hand. By which hand? By

the left."[12] Barcia interpreted the image as emblematizing Joseph's role as the earthly father of Christ.[13] It also represented Jesus' respect for Joseph, who appears at His left hand, while the Virgin appears on the right. It thus demonstrated that Joseph occupied "the first place after most holy Mary his wife."[14] The handclasp, usually the compositional focus of these scenes, additionally signified Joseph's "singular excellence," because it demonstrated that Joseph had God in his hand.[15] Fathers were to imitate Joseph and assume power over their own families.

The pictorial roots of itinerant St. Joseph representations further suggest the saint's roles as the Holy Family's leader and protector. Close pictorial analogues are to be found in depictions of the Flight into Egypt sequence, which represent Joseph leading the Holy Family to safety, as in Murillo's *Flight into Egypt* of about 1650 (The Detroit Institute of Arts). A *Holy Family* by Juan de las Roelas seems to depict an intermediate stage in the development of the subject, wherein Joseph appears in the foreground leading the Christ Child by the hand as the Virgin follows behind (Duquesa de Medina Sidonia Collection, Sanlúcar de Barrameda, Spain, 1620). The closest contemporary analogues are in images of the Guardian Angel (Murillo, Catedral, Seville), which present nearly identical configurations of a child being led by the hand through a landscape by a guardian figure. The similarities between Guardian Angel and itinerant St. Joseph images were not coincidental. Both devotions date to the sixteenth century, the period of the Catholic Reformation, and both feast days were extended to the Church by papal decrees in the seventeenth century. The compositional correspondences reinforced the similarities between the two figures, both of which were thought to walk with and protect the worshipper.[16] Seventeenth-century Josephine texts further explained that not only was Joseph the guide and protector of Christ, but also that he was by extension the guide of the Catholic worshipper. In a vision of St. Joseph granted to "the venerable servant of God Josepha de la Madre de Dios" in 1684, the saint appeared with his staff, signifying his protection of her.[17]

Consistent with his role as the guide of Christ and the Holy Family, numerous miracles were reported in the Spanish Empire in which Joseph aided lost travelers, a job previously performed by St. Christopher, the traditional patron of wayfarers, whose cult was suppressed after the Council of Trent.[18] St. Joseph seems to have taken over this task in the seventeenth century, and apparitions of him leading the Christ Child or the Holy Family (as on the Flight into Egypt) commonly appeared to lost travelers.[19] Joseph was also reputed to rescue people from drowning and shipwreck, duties performed previously by St. Christopher. In one case, Joseph appeared to pull a drowning man from a river by the hand.[20] The saint similarly aided shipwreck victims, pulling them from the water by the hand, as related in a sermon preached in Mexico City on St. Joseph's feast day.[21] Devotional texts, in fact, frequently described Joseph in terms previously used for St. Christopher. One author described the saint as the

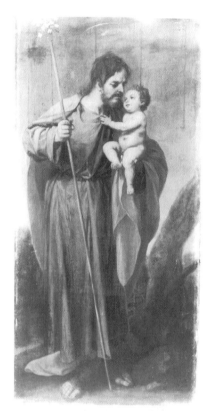

Fig. 50. Alonso Cano (1601–1667), *St. Joseph and the Christ Child*, 1645. Oil on canvas, 65 ¾ x 31 in. (167 x 79 cm). La Magdalena, Getafe, Madrid

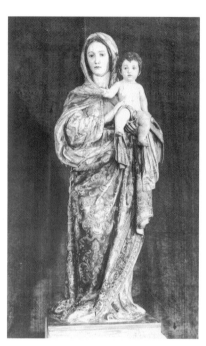

Fig. 51. Alonso Cano, *Madonna and Child*, 1629–31. Polychromed wood sculpture, height 72 in. (183 cm). Santa María de la Oliva, Lebrija, Seville, Spain

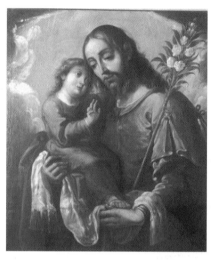

Fig. 52. Cristóbal de Villalpando (c. 1649–1714), *St. Joseph and the Christ Child*, late 17th century. Oil on canvas, 34 ¼ x 28 ⁷⁄₁₀ in. (87 x 73 cm). Museo del Carmen, San Ángel, Mexico City

new Christ-bearer and giant, both key words in earlier descriptions of Christopher: "Joseph was the lustrous carriage, alive, and magnificent, who carried everywhere the eternal word of God made man. Only this first giant of grace was allowed this duty."[22]

With their roots in Flight into Egypt, Guardian Angel, and St. Christopher imagery, images of the itinerant St. Joseph and the Christ Child were unique in Spanish and Mexican art. All other depictions of St. Joseph and the Christ Child were constructed by borrowing Marian pictorial strategies. Such strategies were designed to articulate new Spanish ideologies of fatherhood. Depictions of the saint standing as he holds the Christ Child shall serve as a point of departure for the present discussion. Comparisons between Cano's two paintings of the subject from the 1640s (figs. 50, 56) and depictions of the Madonna and Child reveal compelling similarities. For the latter, an example by Cano as sculptor, his poly-

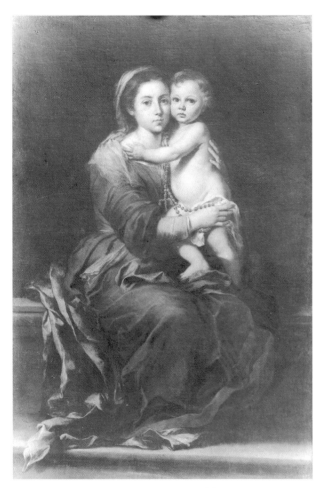

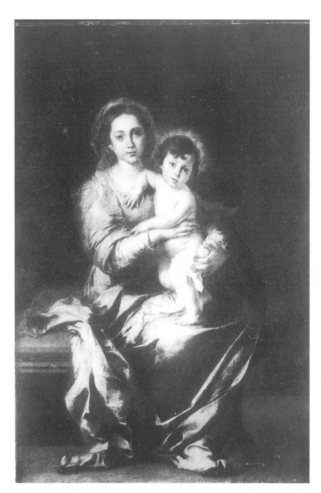

Fig. 53. Bartolomé Esteban Murillo, *Virgin of the Rosary*, c. 1650–55. Oil on canvas, 64 ½ x 43 ⅓ in. (164 x 110 cm). Museo del Prado, Madrid

Fig. 54. Bartolomé Esteban Murillo, *Madonna and Child*, c. 1650–55. Oil on canvas, 65 x 43 in. (165 x 109 cm). Palazzo Pitti, Florence, Italy

chromed wood *Madonna and Child* (fig. 51), and a painting by Murillo from 1673 (Walker Art Gallery, Liverpool, England) may be introduced. Indeed, the compositions are so similar that they appear to be cut from the exact same mold: all four works depict full-length figures in nearly identical postures who stand and hold the Child (age three or four months) in their proper left arms. Similarly, images of the seated St. Joseph and Christ Child, such as examples by Murillo or Villalpando (figs. 67, 52, and pl. 6), produce meaning by association with depictions of the Madonna and Child. Murillo's own *Virgin of the Rosary* (fig. 53) of about 1650–55 presents remarkable correspondences. Jesus is shown in almost exactly the same posture,

Fig. 55. Cristóbal de Villalpando, *St. Joseph and the Christ Child*, 17th century. Oil on panel, 62 ³/₅ x 36 ³/₅ in. (159 x 93 cm). Seminario Conciliar, Tlalpan, Mexico City

Fig. 56. Alonso Cano, *St. Joseph and the Christ Child*, c. 1646. Oil on canvas, 55 x 39 in. (140 x 99 cm). Collection of Manuel Gullón, Granada, Spain

standing, with one leg bent and firmly planted on His mother's thigh. One of His hands rests on her proper left shoulder, while the other reaches toward her right. Their heads are placed close together. In another example by Murillo, his *Madonna and Child* (fig. 54), also datable to 1650–55, Jesus again stands on His mother's lap, their arms touching.

By associating St. Joseph with the Madonna in such a readily recognizable manner, Spanish and Mexican artists dignified him, at times seeming to claim the saint's equal status with the Mother of God (fig. 55). They also posited new gender discourses. Pictorial devices that once visualized the loving mother-child bond between Mary and the Son of God came to signify the intimacy of the relationship between Joseph and his foster Son.

In fact, theologians interpreted St. Joseph carrying Christ as proof of his paternal love. In a seventeenth-century sermon on the topic, the preacher Joseph de Barcia y Zambrana asked his audience to consider "How many times . . . did Joseph carry Christ in his arms, singing lullabies, quieting Him if he cried, rocking Him so that He would sleep, cooing to Him, and giving Him little gifts and trinkets?"[23] According to one life of the saint, the scene demonstrated Joseph's helpfulness in the home: "[M]any times the Divine Wife put Christ in Joseph's arms, when it was necessary to do some task. . . . such as cook the food, prepare the diapers, or sweep the house. On these occasions, St. Joseph held the Child . . . and the Child Jesus always looked happy, and He inclined His head on the Saint's chest, and . . . caressed him with great feeling, as other infants are accustomed to do to their fathers."[24] These passages call to mind any number of Spanish or Mexican images.

Numerous other Josephine paintings similarly adapted existing Marian pictorial strategies to emphasize the physical contact between Joseph and Jesus. Spanish and Mexican artists rendered the two figures in countless paintings kissing, embracing, caressing, and holding each other. For example, in a painting by Juan Bautista Maino (1580–1641) of the *Adoration of the Shepherds* (Museo Balaguer, Villanueva y Geltrú, Spain, 1613), Joseph kisses Jesus' tiny hand. In Cano's Getafe painting (fig. 50), Joseph is about to kiss the Child. Many other images represent Joseph and Jesus embracing.

Pictures portraying Jesus with His arms around His foster

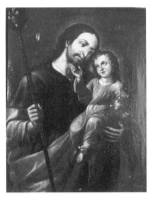

Fig. 58. Juan Correa, *St. Joseph and the Christ Child*, 17th century. Oil on canvas, 36 ⅗ x 28 ⁷⁄₁₀ in. (93 x 73 cm). Church of San Juan Bautista, Coyoacán, Mexico City

Fig. 57. Francisco de Zurbarán, *Madonna and Child*, 1625–30. Oil on canvas, dimensions unknown. Collection of Émile Huart, Cádiz, Spain

father's neck, which similarly thematize bodily proximity, also derive from Marian tradition. Three of the paintings previously mentioned by Cano (figs. 24, 50, 56), as well as other artworks, specifically depict this variant of the scene. The motive has a long history in Marian imagery dating to the late Middle Ages. Pictorial analogues from the seventeenth century, however, are difficult to find. Nevertheless, in Murillo's *Madonna and Child* of about 1650 (Collection of Mrs. George Lane, Elsfield, England), Jesus tenderly embraces his mother, while an example by Francisco de Zurbarán of 1625–30 (fig. 57) employs essentially the same gesture. Related scenes that show Jesus caressing Joseph's chin can also be traced to Marian precedents. In Antonio Pereda's painting of *St. Joseph and the Christ Child* from 1654 (1611–1678; Palacio Real, Madrid), the Holy Child lovingly reaches up to touch His earthly father's face, as He does in Mexican works by Juan Correa (fig. 58), Nicolás Enríquez (private collection), and others. The gesture first appears in images of the Virgin, with Spanish examples dating from the thirteenth century (Junyent Collection, Barcelona). After the spread of the *devotio moderna* and such texts as the Franciscan *Meditations on the Life of Christ* in the fourteenth and fifteenth centuries, the theme gained greatly in popularity.[25] In the seventeenth century, as St. Joseph assumed this particular Marian guise, representations of Jesus caressing His mother's chin virtually disappear in Spanish and Mexican art.

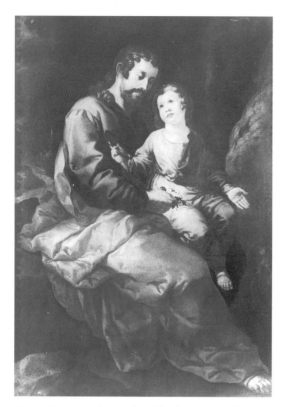

Fig. 59. Francisco Herrera the Elder (c. 1590–1654), *St. Joseph and the Christ Child*, 1648. Oil on canvas, 63 ⁴/₅ x 45 ²/₃ in. (162 x 116 cm). Museo Lázaro Galdiano, Madrid

Fig. 60. Bartolomé Esteban Murillo, *Madonna and Child*, 1655–60. Oil on canvas, 74 x 54 in. (188 x 137.5 cm). Rijksmuseum, Amsterdam

Paintings of the Christ Child seated on His foster father's lap or knee resonated with allusions to the Virgin as the throne of wisdom, or *sedes sapientiae*. Francisco Herrera the Elder's image of 1648 (fig. 59) seems to be an explicit visualization of the theme. The rather awkward rendering of Joseph's body, its highly sculptural presence, the stiff forty-five degree angle at which it is bent, and its architectonic form seem to suggest quite literally that Joseph's body was Christ's throne. Such representations, which produce meaning through their association with related Madonna and Child imagery, were derived from the centuries-old tradition of the Virgin as *Maria Thronus*: "The blessed Virgin Mary is the throne of the true Solomon / In which resided Jesus Christ, the true wisdom."[26] Artists traditionally rendered the scene as an enthroned Madonna and Child, with lions at the figures' feet alluding to

King Solomon. In other examples, the lions appear as carvings on the Virgin's throne. An anonymous Spanish sculpture from the fifteenth century (Monasterio, Carracedo) represents the first variant, Robert Campin's much-studied *Madonna of the Firescreen* the second (1375–1444; National Portrait Gallery, London, 1420s). Even without explicit lion references, images of the Child on Mary's lap resonate with throne allusions, as demonstrated by Murillo's *Madonna and Child* (fig. 60), which represents Jesus standing on His mother's lap, the shape of which resembles a throne for the divine Child, against a celestial setting.[27] Depictions of the seated Joseph with the Child on his knee similarly characterize Joseph as Christ's throne.

Indeed, numerous seventeenth-century sermons described Joseph as "the chosen throne of God," or characterized him as "he who was formed to be the throne of the only Son of God Christ Jesus."[28] Upon this throne, Joseph placed Jesus "to caress Him a thousand times, as if he were His father."[29] If Joseph appeared as a throne when he sat and held the divine Child, when he stood he became a "lustrous carriage, alive and magnificent, who carried everywhere the eternal word of God made man."[30]

Spanish and Mexican representations of Jesus sleeping on St. Joseph's knees or shoulder also derived from Marian motives. Murillo's rendition in St. Louis (pl. 6) typifies the scene. Set against a Spanish landscape of trees, rocky outcroppings, and mountains, the Child lays asleep on Joseph's knees, His head resting against the saint's left arm. Devotional texts inform us that Jesus routinely slept in Joseph's arms. These naps produced mystical ecstasies in the saint: "Joseph would safeguard His sleep, contemplating the mysteries hidden within Christ, his

Fig. 61. Alonso Cano, *Virgin of Providence*, c. 1646–50. Oil on canvas, 63 ⁴/₅ x 42 in. (162 x 107 cm). Museo del Prado, Madrid

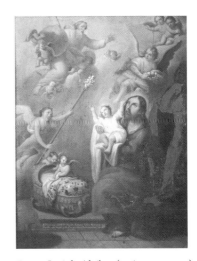

Fig. 62. José de Alcíbar (active 1751–1801), *St. Joseph and the Christ Child*, 18th century. Oil on copper, 29 ⁹/₁₀ x 22 ⁴/₅ in. (74 x 58 cm). Museo Nacional del Virreinato, Tepotzotlán, Mexico. CONACULTA-INAH-MEX

love becoming more fervent; and with the greatness of such high prayer, Joseph would arrive at . . . ecstasy or rapture."[31] The scene is obviously based on Marian models, such as Alonso Cano's *Virgin of Providence* (fig. 61), a canonical interpretation of the subject.

A unique subset of the sleeping Christ Child type represents St. Joseph kneeling at the Holy Child's cradle. A seventeenth-century drawing by Alonso Cano demonstrates the Spanish approach to the scene, wherein Joseph prostrates himself before the cradle, head bowed and hands clasped in prayer. An eighteenth-century oil on copper painting by José de Alcíbar (fig. 62) represents a later Mexican variation in which Joseph has just removed the Child from His crib, and holds Him up as an offering to God the Father. The touching, intimate scene appears to have been inspired by descriptions of the Madonna kneeling at Jesus' cradle in the fourteenth-century anonymous Franciscan manuscript, *Meditations on the Life of Christ*, or paintings of the scene such as those by Juan Sánchez Cotán (Cartuja, Granada).

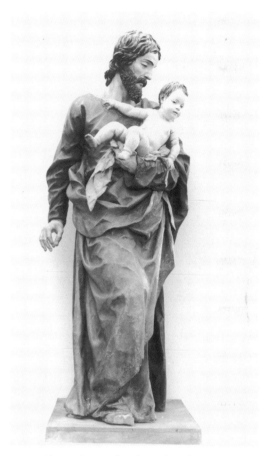

Fig. 63. Alonso Cano and Pedro Roldán (1624–1699), *St. Joseph and the Christ Child*, c. 1656. Polychromed wood sculpture, height 80 ⅓ in. (204 cm). Museo de Bellas Artes, Granada, Spain

Paintings by Francisco Herrera the Elder, Antonio Pereda, Jusepe de Ribera (1591–1652), and Juan Correa, as well as numerous others, contain an additional layer of meaning alluding to Christ's future Crucifixion. These paintings imply that Joseph, like Mary, played a role in human salvation. In such works, Christ holds an attribute of the Passion. For example, in Pereda's canvas of 1654 (Meadows Museum, Dallas), Christ meditates on a miniature cross held in His right hand. In Francisco Herrera the Elder's painting of 1648 (fig. 59), Christ holds a small crown of thorns while Joseph looks on sadly.[32] Other Josephine works evoke the Passion in a subtler manner. For example, the carpentry tools, which appear in Ribera's canvas, could be considered not only as Joseph's attributes, but also as allusions to the

Fig. 64. Francisco Camilo (d. 1673), *St. Joseph and the Christ Child*. 17th century. Oil on canvas, 92 x 68 in. (234 x 173 cm). Museo de Bellas Artes, Huesca, Spain

Fig. 65. Francisco de Zurbarán, *Holy House at Nazareth*, 1639. Oil on canvas, 65 x 90 ¹/₂ in. (165 x 230 cm). The Cleveland Museum of Art

Passion. In El Greco's *Disrobing of Christ* (Catedral, Toledo, 1577–79) this association of wood-working tools and the Crucifixion is made explicit in the bottom right corner where a carpenter hews Christ's cross. In two paintings by Juan Correa, the holy Child holds a basket of carpentry tools; in another image, He holds in His hand a miniature cross. Murillo's *St. Joseph and the Christ Child* (pl. 6), in which the Christ Child sleeps on Joseph's lap, adumbrates the moment when Christ returns to the Virgin's lap in the pietà. In other works of art, such as the polychromed sculpture of *St. Joseph and the Christ Child* by Alonso Cano and Pedro Roldán (fig. 63), Joseph gazes sadly at the tiny Child, presumably thinking of the future sacrifice. A subtle reference to Christ's mission as the world's redeemer can be found in images wherein the Child Jesus holds a staff crowned by a cross and the orb of the world , as in Camilo's *St. Joseph and the Christ Child* (fig. 64), attributes more usually found in depictions of the adult Christ as *Salvator Mundi*.

Associating Joseph with Christ's Passion raised its own dilemmas for, as hagiogra-

phers noted, Joseph did not live to witness his foster Son's sacrifice. No matter how greatly theologians valorized Joseph, he could never attain Mary's privilege of having been present at the Crucifixion. Nevertheless, many Josephine paintings make claims for Joseph's participation in the Passion by indicating that he witnessed Jesus' childhood meditations on it (a topic discussed more fully in chapter 5). They parallel similar Marian paintings, such as Francisco de Zurbarán's *Holy House at Nazareth* (fig. 65), which depicts the Madonna sadly watching as her Son pricks His finger on a miniature crown of thorns.

In the absence of an established visual tradition for Josephine imagery, most Spanish and Mexican Baroque depictions of St. Joseph and the Christ Child consciously borrowed poses, gestures, and compositions previously reserved for images of Mary, ennobling the saint by implying his association with the Virgin. Countless images depict the saint holding, carrying, kissing, or caressing Jesus. These images were designed to valorize Joseph's earthly fatherhood of Christ, characterizing it as tender, nurturing, and intimate. As Joseph began to take on Mary's role as the nurturer of Jesus, paternal devotion replaced maternal love.

While the similarities between depictions of Mary and Joseph with the Christ Child are striking, several thought-provoking differences, which seem to demonstrate anxieties about reusing Marian pictorial strategies to image Joseph, merit attention. For example, in contrast to the Madonna, Joseph rarely meets the beholder's gaze, but instead looks to Christ, as if directing our attention to Him.[33] This underscores Joseph's humility, as it suggests to the viewer that Christ and Mary are the more appropriate objects of devotion. Nuances in the conceptions of Joseph and Mary can also be seen in their different postures relative to Jesus. For example, in contrast to Marian images, Christ is rarely depicted *on* Joseph's lap; instead, He almost always stands in close proximity next to His foster father.

The strong association of the Virgin's lap with the throne of wisdom (*sedes sapientiae*) or the throne of Solomon, both emblematic of her role in humanity's Redemption, may have made artists uneasy about co-opting this particular strategy without adaptation, as it implied a similar role for Joseph.[34] Furthermore, the other lap-*cum*-throne associated with Christ belongs to God the Father, as we see in El Greco's *Holy Trinity* of 1577–79 (Museo del Prado, Madrid); it may have proved an even stronger deterrent to depicting the Holy Child on Joseph's lap. Although artists and theologians wished to aggrandize Joseph by imaging him like the Virgin, they could not completely suppress their anxieties about seeming to equate Joseph with Mary and God.

Other contradictions arose when Spanish and Mexican artists reused Marian visual strategies to construct new Josephine imagery. Scenes of Jesus caressing His mother's chin, the so-called chin-chuck images, present an interesting case. According to the latest interpretation, these images should not be read as charmingly naturalistic representations of mother-

son love, but as signs of "erotic communion" that characterize the Infant as the Heavenly Bridegroom and His mother as His bride.[35] Seemingly, this gesture lost this specific dimension of meaning in seventeenth-century representations of St. Joseph and the Christ Child, leaving behind the suggestion of the tenderness of His relationship with His foster father.[36]

The inherent contradictions involved in reusing the Virgin's imagery for St. Joseph come to the fore most strongly in images that show Jesus clutching at Joseph's tunic. The gesture appears in one of the earliest renditions of the scene, Sánchez Cotán's painting for Toledo's convent of San José, which depicts Jesus grasping the neckline of Joseph's tunic with His right hand. In Cano's Getafe painting of 1645 (fig. 50), the Infant makes a similar gesture, as He does in a painting by Murillo from the 1670s (Pushkin Museum, Moscow) and in a related workshop piece (Inskipp-Hawkins, Woodburn, England). When artists employed this gesture in depictions of St. Joseph, they seemed to imply that the saint could lactate, since historically, this pose was associated with Spanish depictions of the breastfeeding Virgin Mary. Like scenes of Jesus touching Mary's chin, these became popular in Spain in the fourteenth century, with the spread of the *devotio moderna*. After the Council of Trent, however, Spanish church reformers discouraged depictions of the actual breastfeeding, decreeing them indecorous and disrespectful to the mother of God.[37] As a result, artists substituted the more decorous gesture of Jesus placing His hand inside the Virgin's tunic, or on its neckline, for the actual nursing, replacing the breastfeeding with the more seemly depiction of Jesus hungrily searching for His mother's breast.[38] Murillo's *Virgin of the Rosary* of about 1650–55 (fig. 53) and Zurbarán's *Madonna and Child* (fig. 57) illustrate the switch. Images of Jesus sleeping on Joseph's chest may also represent a displacement of the breastfeeding gesture, according to textual accounts such as the following, which related that "countless times Jesus would fall asleep on Joseph's chest, His divine mouth pressed to Joseph's heart."[39]

How are we to interpret this breastfeeding gesture in Josephine imagery? Did artists intend to portray St. Joseph as a lactating father? Is it possible that artists reused the pose without intentionally referencing its origins?

While such images can be considered part of a general trend to Marianize St. Joseph's figure, textual evidence suggests that the borrowed breastfeeding gesture cannot be dismissed as a thoughtless reuse of a standard compositional type. Artists, in fact, employed it intentionally. Devotional writers routinely characterized Joseph as Jesus' "padre nutricio," or "nourishing father."[40] Other texts called Joseph Jesus' "amo de leche," a variation of "ama de leche," or "wet nurse." Gracián endeavored to define the term in 1597: "Amo de leche.—The husband of she who raises the child at her breast, who is customarily called *amo de leche*, has the duty and love of a father, and the child openly calls him this. This duty, says St. Bernard, St. Joseph did extremely well; because as *amo de leche* he took the Child in his arms and carried

Him singing lullabies, he quieted Him if He cried, rocked Him so that He would sleep, cooed to Him, and gave Him little gifts and trinkets."[41]

By characterizing St. Joseph as the "amo de leche" and imaging him as a lactating father, Hispanic theologians and artists attempted to construct Joseph as a maternal, nurturing figure. Thus, not only did St. Joseph assume a new, more important role as the paterfamilias of the Holy Family, and take over such tasks as holding, carrying, caressing, and kissing the Christ Child, but these images suggest that Joseph appropriated the role biologically reserved for mothers only—breastfeeding the Child. Other works of art, such as the inverted *St. Joseph and the Christ Child/Holy Family* of Juan Montero de Rojas (c. 1613–1683) examined in the last chapter, depicted quite literally Joseph's role as nourisher and nurturer when they showed the saint actually feeding the holy Child (1668, private collection, Madrid). Sermons of the period proclaimed that not only did Joseph earn the money to provide food for Christ, but that he fed Him himself with his own hands.[42]

How are we to interpret these images? What social meanings did they construct? By framing images of the lactating St. Joseph within early modern debates over maternal breastfeeding, it is possible to suggest how these images produced meaning.

Maternal lactation was a topic of major concern in Europe amongst both Catholic and Protestant church reformers and Humanist philosophers in the sixteenth and seventeenth centuries. Such notables as St. Thomas More, Martin Luther, Erasmus, Juan Luis Vives, and others undertook an energetic campaign to encourage women to nurse their own children.[43] They hoped to discourage mothers from placing their infants with wet nurses for the first two years of their lives, as was customary in Europe. Vives warned of the dangers of ingesting "the milk of strangers," and others cautioned against bad habits imbibed from morally suspect wet nurses.[44] Because it was believed that babies ingested morals and character traits from their milk's source, maternal lactation supporters thought animal or foster milk unsuitable for human consumption.

When depictions of the lactating St. Joseph are interpreted in conjunction with contemporaneous breastfeeding discourses, the images seem to propose more specifically that Joseph had a formative influence over Christ's personal development. Because breast milk was thought to affect the formation of a child's character, images that implied that Joseph breastfed Christ posit his direct influence. They also liken their father-son bond to the relationship between mother and son, suggesting that paternal love and affection equaled maternal devotion.

Many images, in fact, seem to suggest the greater tenderness of the father-child relationship by stressing the warmth and physical contact between Joseph and Jesus. Frequently the two figures look lovingly into each other's eyes as the Child affectionately clings to His

foster father. In contrast, seventeenth-century depic-
tions of the Madonna and Child seem unusually
detached at times. Mary often appears as a cool, regal
figure displaying the Son of God to the beholder.
Artists constructed the physical relationship between
mother and Son as more formal in character. The two
figures do not look at each other; nor does Jesus try to
embrace His mother. The warm, nurturing bond so
apparent in Cano's two paintings of St. Joseph (figs. 50,
56) is strangely absent in many Marian depictions.
Joseph has become the more "maternal" figure accord-
ing to Hispanic gender constructs.

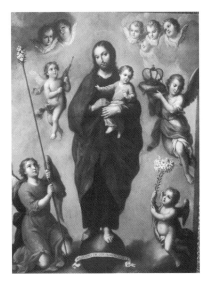

Fig. 66. Andrés López (1768–1813),
St. Joseph and the Christ Child, 1797. Oil
on copper, 33 x 24 ⁴/₅ in. (84 x 63 cm).
Museo Nacional del Virreinato,
Tepotzotlán, Mexico

 The construction of St. Joseph as more tender
and nurturing, traits conceived of in European cultures
as more "feminine" in nature, may have resonated in
unexpected ways in Mexico. In contrast to the strict
binary construction of male and female found in West-
ern societies, indigenous Mesoamerican gender role
constructs have been described as "ambiguous" in nature,
combining both masculine and feminine traits.[45] Perhaps this explains what I perceive as an
odd feminization of St. Joseph in colonial Mexican art, whereby the saint's features are soft-
ened, sweetened, and made delicate such that he becomes difficult to distinguish from the
Virgin Mary at times (fig. 66 and pl. 7).

 As if in response to St. Joseph's greater feminization, depictions of the standing
Madonna and Child decrease dramatically in the repertoires of many seventeenth-century
Spanish and colonial Mexican artists. The examples previously discussed by Cano and
Murillo, in fact, are unique in their oeuvres (fig. 31). Admittedly, artists depicted greater num-
bers of images featuring the seated Virgin and Child, but even these decline in number unex-
pectedly in the period. Instead, Spanish and Mexican artists represented Mary in images of
the Immaculate Conception, elevating her as the archetype of pure, chaste womanhood.

 The doctrine of the Immaculate Conception, which was not officially made dogma
until 1854, maintains that Mary was conceived in the womb of her mother, St. Anne, without
the stain of Original Sin. The belief enjoyed widespread favor in Spain, which sent tireless
delegations to various popes to pressure the Church to declare it dogma, culminating in the
oft-described Immaculate Conception riots in Seville in 1619.[46] This shift in emphasis in the
cult of the Virgin brought out the inherent tensions and contradictions of Marian devotion.

How could Mary be both a loving, earthly mother (whose features in paintings were based on actual women) and the untouchable, unsullied embodiment of purity? The answer to this question is readily apparent in works of art: Only with great difficult could Mary simultaneously fulfill both of these functions in Hispanic society.

The tensions are apparent in Spanish depictions of the Madonna and Child, which began to emulate images of the Immaculate Conception. When viewed together, Murillo's *Madonna and Child* of 1673 (Walker Art Gallery) and his *Immaculate Conception* of about 1670–80 (Museo Ferré, Ponce) look remarkably similar. In both images the monumental, full-length figure of the Madonna stands majestically in *contrapposto*. Closer inspection reveals that the *Madonna and Child* contains several spe-

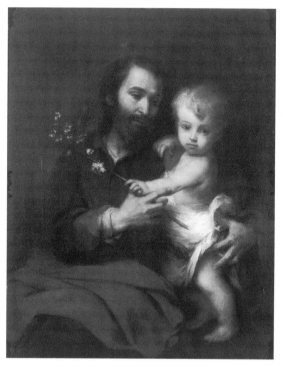

Fig. 67. Bartolomé Esteban Murillo, *St. Joseph and the Christ Child*, c. 1670–75. Oil on canvas, 34 ²⁄₅ x 31 ¹⁄₅ in. (95 x 81 cm). Ringling Museum, Sarasota, Florida

cific traits usually reserved for depictions of the Immaculate Conception. For example, Mary stands in the clouds with putti at her feet as a gloria of angels surrounds her, and a halo of light crowns her head. There is little interaction between the figures of Mary and Jesus. Thus, even images that purported to represent the Madonna in her maternal mode lost many of their nurturing, mothering qualities. The reasons for this change in attitude, which demonstrate Spaniards' increasing need to imagine Mary as pure and untouchable and Joseph as warm and mothering, will be treated in the final section of this chapter.

With this shift in the Virgin's role, the cultural work performed by her as mother was left undone. Theologians and artists then assigned this duty to the figure of Joseph, who became the model of the nurturing, parental saint. As a result, Spanish and Mexican artists went out of their way to depict Joseph and Jesus in close physical proximity, thematizing the motive of their bodily contact. Murillo's painting of *St. Joseph and the Christ Child* (fig. 67), now in Sarasota, Florida, best encapsulates the physical and emotional intimacy between the two figures. In this moving devotional work, we see Joseph seated in three-quarter length with the

Child seemingly standing on his lap. He looks to his foster Son, as if directing the beholder to do the same, and the blessed Child looks out directly at us. Christ hands Joseph a flower, bestowed like a scepter. The focus of the painting is the joining together of their bodies in the center of the canvas. Although at first glance the Child appears to stand on His foster father's lap, he is actually positioned on an elevated surface (a carpentry bench?) adjacent to him. This in no way, however, diminishes the contact between them, and in fact serves to heighten it. His right leg slightly bent, Jesus leans into Joseph, His right hand and arm resting on Joseph's left shoulder. His foster father's left arm protectively wraps around Him, to rest on His hip. Their physical closeness is intensified in the center of the canvas, where Jesus reaches out to His earthly father, extending His left arm. Joseph, in turn, lightly touches the offered arm, as his thumb supports the tiny, dimpled hand. The types of contact depicted are multiple, and include Christ's hand on Joseph's shoulder, the joining of the two arms and hands, Joseph's hand on Christ's behind, and the joining of Christ's leg and side with Joseph's torso.

The pronounced physical contact represented in Josephine works of art and signaled in numerous religious texts made visible to seventeenth- and eighteenth-century beholders the source of Joseph's saintly powers. According to Spanish and Mexican theologians, Joseph's daily communication with Jesus was the source of his sanctity and proof of God's love for him. God loved Joseph so much that He allowed the blessed carpenter to live for thirty years with His only Son, Jesus, whereas the apostles were only with Christ for three.[47] The thirty years spent with Jesus indicated the saint's favored status: "How much did not only the words, but also the loving affection, sight, presence, and examples of the Son of God excite and inflame the breast and heart of the blessed St. Joseph for the space of 30 years?"[48] Of all the men on earth, only Joseph was allowed this contact with Christ; only Joseph enjoyed not just the embraces, but the kisses and caresses of the divine Child, and these innumerable times. Gracián expounded upon the many instances in which they touched: "[M]any times Joseph touched and washed and kissed Jesus' feet; and not only the feet, but His hands, chest, head and the mouth of the most sweet Jesus, who never said *Touch me not*, and Joseph was kissed innumerable times with ineffable love and tenderness by the eternal Child."[49]

Another devotional writer similarly enumerated the many different types of physical contact that occurred between Joseph and his divine foster Son: "The lucky eyes, that so many times saw Him, happy the ears, that so many times heard Him, the arms, that so many times embraced Him, the hands that so many times touched Him, the shoulders and chest that so many times supported Him."[50] The privileged embrace signified Joseph's privileged rank: "Because among the saints there was none, after the Virgin, who enjoyed on earth the privileges that St. Joseph enjoyed . . . he who took Jesus in his arms innumerable times, touched Him with his hands, and with his hands adored Him faithfully, and enjoyed

His thousand gifts of love and singular delights."[51] According to theologians, these embraces infused Joseph with Grace, and could only be surpassed by the embraces between God the Father and Christ.[52]

As a result, Joseph enjoyed special favor and influence with the Son of God. A hagiographer noted that "God never denies Joseph anything that he asks for, God does all that Joseph prays for, and all that Joseph implores him to do."[53] Worshippers believed that this physical contact made Joseph a good patron and efficacious intercessor, as one prayer of the period makes clear: "O glorious Patriarch St. Joseph, these petitions that I have prayed in devotion to you, I expressly offer you . . . that you may intercede for me, your unworthy devotee, before the presence of Christ's sovereign majesty, Redeemer of all humanity, whom you had in your lucky arms so many times, while He lived as a child in this world, in order that . . . through your intercession . . . I may enjoy His eternal bliss in your company. Amen."[54]

Given Joseph's power as an intercessor, it is not surprising that, beginning in the seventeenth century, miracles worked by the saint were reported in great numbers. Images were of supreme importance for these divine favors: in over half of the 140 cases reported in one source, images of St. Joseph worked the miracles. Most often devotees attributed these favors to paintings of Joseph holding the Christ Child in his arms.[55]

The numerous works of art and corresponding texts that characterize Joseph as an involved and nurturing parent valorize new modes of masculine behavior that support the increased involvement of fathers in the nuclear family. Indeed, these paintings do seem to document the emergence of many of the ideas we associate with modern families and sensitive husbands. Whereas recent analysis of literary evidence from the Spanish Middle Ages documents the valorization of aggressive, even violent, modes of masculine behavior, the images examined in this chapter seem to attest to new constructions of ideal manhood in the early modern Spanish Empire.[56] The visual and textual evidence also testifies to a concerted campaign in the Hispanic Catholic church to promote the importance of fatherhood. This evidence is particularly valuable because it offers a unique glimpse into the historical construction of fatherhood, a topic that, in contrast to motherhood, has been rarely analyzed by scholars. Little is known of the history of fatherhood in Spain and the Americas.

The cult of St. Joseph was not unique in Golden Age Spain. A number of similar "copycat" saints also ascended to prominence, demonstrating the spread of these new concepts of masculinity. Depictions of St. Joachim, for example, the grandfather of Jesus, also represented the saint tending to the child Mary. Seventeenth-century Spaniards persisted in celebrating Joachim's feast day on March 20, the day after St. Joseph's fiesta, despite the papal ban on Joachim's cult issued because of its doubtful historicity. Spanish and Mexican artists depicted several additional male saints embracing the baby Jesus. Representations of St.

Anthony and the Christ Child often show the saint in close physical contact with the baby Jesus, at times holding Him in his arms. They thus offer a novel reworking of the vision on which they are based. Reportedly, the Christ Child visited St. Anthony while he read the Bible, appearing on the pages of the open book, a visualization of Christ as the Word. Significantly, artists often neglected to represent the book that was the original focus of the vision, instead thematizing the tender physical contact between Anthony and the Christ Child.

Several other saints appear in similar guises in Spanish and Mexican art of the seventeenth and eighteenth centuries. The Sevillian artist Murillo depicted St. Felix of Cantalice embracing or about to embrace the Christ Child in a number of paintings, a scene inspired by a visionary experience. Murillo transformed this vision, in which a mysterious child approached the saint as he begged for alms and gave him a loaf of bread, into yet another image of a man tenderly embracing a baby (fig. 27). St. Cajetan, a new Theatine saint, also appeared in such scenes.[57] Murillo also depicted St. Francis of Assisi with the Christ Child in his arms, an image inspired by Francis's promotion of the Christmas creche, or nativity scene. Mexican artists routinely represented several additional male saints with babies in their arms, namely Saints Stanislaus of Kostka, John of God, and Aloysius Gonzaga.

Like much religious imagery, these Spanish and Mexican images were intended as models of behavior for worshippers. The Church encouraged Catholic men to emulate the protagonists, who frequently adopted attitudes previously reserved for women, such as holding infants, taking care of children, and even breastfeeding poses. These images thus problematize facile assumptions about gender in Hispanic cultures and preconceived notions about them as wellsprings of machismo. They also demonstrate a particular fascination in Spanish culture with crossing over what Judith Butler has called the "dimorphic divide" of gender, a fascination with gender as drag.[58] In addition to the lactating St. Joseph, and reports of lactating men in Spanish medical texts, Spain was the site of a cult to a bearded female saint, Santa Librada, centered in Sigüenza. Only Spanish culture recognizes portraits of bearded women as a distinct artistic genre, as witness paintings by Juan Sánchez Cotán (1590; Museo del Prado, Madrid) and Jusepe de Ribera (1631; Hospital of Tavera, Toledo). This fascination with the mutability of gender codings represents the flip side of rigid Spanish social norms—the instability, changeability, and ceaseless vacillation of gender categories.

Significantly, with the increase in portrayals of Joseph as the perfect father and related portrayals of other nurturing male saints, images of the maternal Mary decreased dramatically. As artists increasingly depicted her as the embodiment of purity in the Immaculate Conception, scenes of her as the earthly, loving mother declined in frequency, replaced by those showing paternal love and affection. This importance placed on fatherhood seen in the images of St. Joseph and in numerous period texts is paralleled by a striking de-emphasis on

motherhood in Spanish literature of the Golden Age. Writings on motherhood virtually disappear in sixteenth- and seventeenth-century Spain, and mothers are similarly absent in familial scenes in literature.[59] One of the most important treatises for women of the Golden Age, Juan Luis Vives's *De Institutione Foeminae Christianae* (*Formation of the Christian Woman*) of 1523 suggests that mothers should withhold all maternal, nurturing feelings and behaviors toward their children.[60] His admonishment of mothers, from chapter 11, "On Children and the Care that Mothers Owe Them," surprises with its severity: "[M]others should very much guard against indulging their children . . . I'm not saying here that the mother must stop loving her children, but I tell you that you should love them as it is right to love them . . . But I tell you that you should love them so that they do not feel it . . . Mothers: if you don't already know this, learn it from me—that every bad and wicked man there is in the world is your fault and the thanks for him are due to you."[61] In the opinion of Vives and others, formation and education of children was better left in the hands of fathers.

Sermons that valorized the authority and importance of fathers proliferated in the early modern Spanish Empire. Preachers compared fathers to kings presiding over the kingdoms of their families, to the Church Fathers, and to teachers.[62] According to these sermonists, children owed their parents not only love, veneration, and thankfulness, but also obedience.[63] Parents, in turn, were obligated to raise well their children. To that end, parents (and fathers in particular) were to provide their children with education, vigilance, and good example.[64] Thus, parents were obliged to teach their children reading, writing, counting, dancing, business, hunting, and other tasks. Most importantly, however, parents were responsible for their children's religious education.[65] Parents who neglected these duties risked not only eternal damnation, but threatened the social welfare of the state, according to one sermon.[66]

Should these images of St. Joseph and the Christ Child be read as social documents testifying to a change in men's roles in the domestic sphere? Are we to infer from them that Spanish and Mexican men began to take more responsibility for household chores and child-rearing?

Despite the numerous images of Joseph as the perfect father and countless sermons, prayers, and other texts that encouraged men to imitate him, statistics compiled by demographic historians point to increased numbers of families without fathers and to mothers' expanded domain in the domestic sphere.[67] Paintings of St. Joseph and the Christ Child may have primarily functioned to uphold an ideal of fatherhood in the face of perceived social crisis. In other words, the growth of the cult of St. Joseph in Spain and his increased importance in religious imagery may testify to a desire to improve the standing of men in the face of heightened power among Spanish women. The historian David Herlihy has demonstrated

that the sudden appearance of great numbers of female saints was a direct reflection of the enhanced power and standing of women in medieval society.[68]

Many of the issues raised in the images examined in this chapter—Joseph's contact with the divine, his mentoring role in Christ's life, and his role in the Redemption—receive fuller treatment in scenes of the carpenter's workshop, the subject of the next chapter. As they demonstrate Josephine theologians' arguments that Joseph played a key role in the salvation of humanity, they also dignify the ordinary lives of working families in early modern Spain and viceregal Mexico.

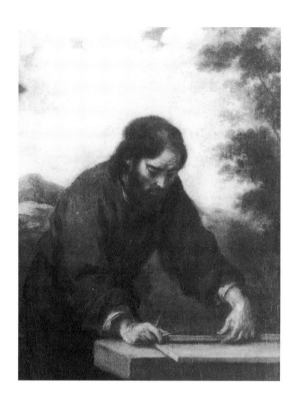

Bartolomé Esteban Murillo, *Holy Family in the Carpenter's Workshop (detail of fig. 68)*

CHAPTER

FIVE

MEN *at* WORK

*Mary and St. Joseph divided their days and
nights in half, always attending to work with
care and to prayer with feeling.*

MANY PAINTERS produced depictions of the carpenter's workshop in early modern
Spain and colonial Mexico, including such artists as Bartolomé Esteban Murillo,
Jusepe de Ribera, Juan de Valdés Leal (1662–90), Alonso Cano, Juan Tinoco (1617–88), and
others. The images featured St. Joseph in his role as hardworking artisan, representing the
saint toiling away at his carpenter's bench or working with his foster Son, Jesus. The popular-
ity that these paintings enjoyed is surprising to the modern viewer, as they do not follow the
typical canon for the representation of the divine. In addition, understanding the meanings
they produced for beholders of the period is problematic without knowledge of Spanish and
Mexican devotional practices that, fortunately, are recorded in contemporary literature on the
saint. As these sources demonstrate, paintings of the carpenter's workshop encode moral
philosophies of labor, sanctity, virtue, and true nobility, new ideas that were spread through-
out the Hispanic world by Josephine confraternities of carpenters. In conjunction with devo-
tional literature, these paintings argue that the aforementioned virtues, once the privileged
domain of the nobility, now pertain to the artisanal class. Finally, these images participated in
a theological debate that advocated a role for St. Joseph in the Redemption of humanity.
Thus, in seventeenth-century Spain and eighteenth-century Mexico, paintings of St. Joseph
in the carpenter's workshop became powerful symbols of the honor of manual labor.

Although many seventeenth- and eighteenth-century Spanish and Mexican images
of St. Joseph refer to his trade, paintings of the carpenter's shop constitute a distinct category
comprised of three different scenes. Spanish artists represented most frequently the Holy
Family in the workshop during its exile in Egypt. Typical examples include paintings by

Roelas, Orrente, Cano, Murillo, and Valdés Leal (figs. 68, 70, and 71). In an important variant of the scene, the young St. John the Baptist appears, as in paintings by Ribera (pl. 8) and Cano (fig. 72). The second most frequently depicted Spanish image is the Holy Family in the workshop in Nazareth, distinguishable from similar depictions set in Egypt by the age of the Christ Child, who moved with His family to Nazareth when He was seven or eight years old. Salient examples include paintings by Juan del Castillo (c. 1590–1657) and Valdés Leal (fig. 74). Finally, a handful of paintings completely omit the figure of the Virgin, representing only foster father and Son, as in Roelas's *Workshop in Nazareth* (Collection of the Duquesa de Medina Sidonia, Sanlúcar de Barrameda, Spain, 1624), or an unusual sixteenth-century version by Joan de Joanes (fig. 2). In Mexico, extant examples, most of which date from the

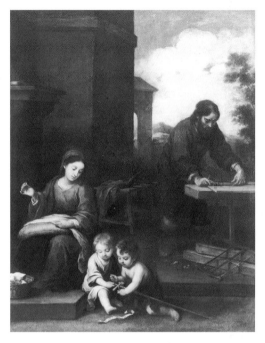

Fig. 68. Bartolomé Esteban Murillo (1617–1682), *Holy Family in the Carpenter's Workshop*, c. 1660–75. Oil on canvas, 78 ³/₄ x 69 ¹/₃ in. (200 x 176 cm). Szépmüvészeti Múzeum, Budapest

eighteenth century, indicate that colonial artists and patrons preferred the scene of the workshop in Nazareth, which featured the older Christ Child (figs. 69 and 73).

Many Mexican depictions were based on paintings by the Spanish artists Zurbarán (1598–1664), Cano, and Murillo. For example, Juan Tinoco's *Workshop in Nazareth* (fig. 73) reworks Zurbarán's moving image of the *Holy House at Nazareth* (fig. 65) by incorporating St. Joseph. Tinoco closely copied significant sections of Zurbarán's composition—the figures of Christ and the Virgin Mary, the sewing basket, the turtle doves, and the bowl—as well as its premonitional nature. The Christ Child, seated on the right, pierces His finger on a crown of thorns, as His parents look on sadly. Tinoco's figure of St. Joseph, planing wood at his carpenter's bench, appears to have been drawn from Cano's paintings (figs. 71 and 72), whereas the tools hanging on the workshop wall find their inspiration in Murillo's work (Chatsworth, Derbyshire, England, Duke of Devonshire Collection, c. 1670–75).

Two anonymous renderings of the workshop scene demonstrate the popularity of Zurbarán's painting in Mexico (figs. 69 and 70). Significantly, both adapt their sources to include St. Joseph (San Francisco; and Obregón Collection). Of these two, an eighteenth-

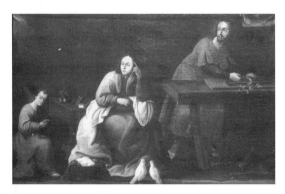

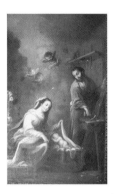

Fig. 69. Anonymous, *Workshop in Nazareth*, 18th century. Oil on canvas, dimensions unknown. Convento de San Francisco de Asís, San Miguel de Allende, Guanajuato, Mexico

Fig. 70. Anonymous, *Holy Family in the Carpenter's Workshop*, 18th century. Oil on canvas, dimensions unknown. San Francisco, Mexico City, Mexico

century Mexican painting of the workshop in Egypt (fig. 70), perhaps associated with the followers of Miguel Cabrera (1695–1768), displays the influence of Murillo as well as Zurbarán. The canvas closely copies the diagonal composition and numerous details of the aforementioned painting by Murillo from Derbyshire.

A treatise by Francisco Pacheco (1564–1644), *The Art of Painting*, carefully described the representation of the workshop in Egypt. As he was not only an art theorist and painter, but also sacred art censor for the Inquisition, his blueprint demonstrates the importance given to this image. He prescribed that it should be set in a humble house, with carpentry tools and woodshavings scattered on the floor, St. Joseph planing a plank of wood on his carpenter's bench, the Christ Child, one or two years old, sitting on the floor next to His mother gazing upon a cross made of two sticks, while the Virgin, with her sewing basket at her feet, works on her sewing cushion.[1] He also suggested that artists could vary these elements according to personal devotional considerations, thereby granting painters an unusual latitude in the depiction of the scene. This unprecedented concession to the artist's personal desires in the depiction of religious imagery probably reflects the novelty of the scene as well as the lack of an established textual source. The other two workshop scenes—depicting the workshop in Nazareth with and without the Virgin Mary—without benefit of explicit instructions from Pacheco nonetheless draw upon his formula.

Pacheco's instructions signal an important trait that characterizes all three versions of the workshop scene—the valorization of manual labor through the depiction of the Holy Family hard at work. This elevation of labor is inseparable from ideologies of gender and family. Thus, as Spanish and Mexican artists depicted St. Joseph working at his carpenter's

bench, planing, sawing, or measuring wood—labors that Church clergy characterized as noble, dignified, and useful— period texts described Joseph's role as the family's breadwinner as his "most singular glory."[2] A Mexican sermon for indigenous neophytes on the sacrament of marriage declared that husbands who depended on their wives to work were "shameful."[3] The Virgin Mary, acclaimed as "the best woman, wife, mother, and virgin," was constructed in the complementary role of humble, virtuous wife, submissive to, and respectful of, her husband.[4] Artists depicted her

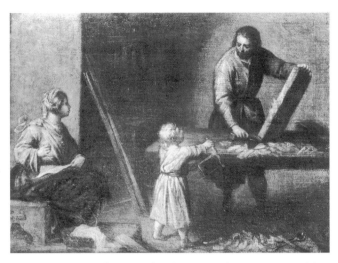

Fig. 71. Alonso Cano (1601–1667), *Holy Family in the Carpenter's Workshop,* 1650s. Oil on canvas, 65 x 89 ⅓ in. (165 x 227 cm). Art market (Sala Parés), Barcelona, Spain

weaving, sewing, praying, and tending to the Child, the perfect "wifely" activities according to Fray Luis de León's treatise *The Perfect Wife* and other texts, such as Pedro de Guzmán's *The Benefits of Honest Labor and the Dangers of Idleness* of 1614 and Gaspar Gutiérrez de los Ríos's *General Information for the Estimation of the Arts* (1600).[5] As the perfect child, Jesus can be seen in paintings lending a hand in the workshop, picking up wood chips from the floor, or assisting His foster father in the operation of the carpentry tools (fig. 71). One Josephine author glossed on the Child's helpfulness in the workshop: "Many times the Son of God lovingly guided my master St. Joseph, helping him in the manual tasks of his occupation, such as giving him the chisel, the adze, and other tools of his trade, helping him saw the wood, and making with him other things appropriate to the *persona* of Christ."[6] According to another writer, Jesus' labors were a demonstration of "His obedience to His parents."[7]

These paintings and texts of the Holy Family hard at work helped create the Hispanic ideal of the artisanal family in the seventeenth and eighteenth centuries. In so doing, they gave visual expression to surprising new Spanish philosophies of manual labor. Treatises on work maintained that labor was dignified, honorable, and noble, and recommended it for the preservation of human nature. Work was natural for humans, whom, according to the Book of Genesis (3:19), God had created to labor.[8] Idleness, in contrast, was a dangerous vice, the origin and source of all evil and corruption. According to the Josephine theologian, Andrés de Soto, God favors "those who eat from the work of their hands" and grants them

happiness.[9] These new early modern conceptions of manual labor provided a means for men of the artisanal class to achieve honor and dignity.

This insistence upon St. Joseph's status as a laborer was in contradiction to the fact that the saint was said to have descended from a rich, noble family of the House of David.[10] So Josephine authors had to explain carefully their position on this point, holding that while Joseph did not *have* to work, he chose for the sake of virtue to do so. One author wrote that Joseph "exercised the trade of carpenter more for virtue than for necessity, and to occupy time honestly."[11] Thus, they elaborated a theory of true nobility that used his figure as an exemplum.

Josephine writers urged impoverished nobles to follow the example of St. Joseph. The friar Antonio Joseph de Pastrana, asserting that manual work was noble, recommended that the nobility imitate St. Joseph and practice trades "to live life laudably, and free themselves from the poison of laziness, which was so contrary to virtue and holiness, that is the true nobility."[12] Significantly, the number of poor hidalgos, the lowest members of the nobility, was on the rise in the seventeenth century. Many left their native villages for the cities.[13] Nobles who found themselves impoverished should emulate Joseph: "If they find themselves in poverty, stripped of their kingdoms and estates, it would not be a case of amounting to less to support themselves with the art or occupation that they had learned, but rather a cause for praise; thus also was my lord St. Joseph, supporting himself honestly in the state in which he found himself, so far from the grandeur of his grandparents, with the occupation that he had chosen, converting physical labor to the merit of patience."[14]

The case for work was supported by historical precedents. Soto and others noted that in old times it was customary for the nobility, as well as kings and their children, to learn trades. The emperor Constantine practiced the art of painting. Ulysses, the first king of the Greeks, had practiced carpentry, according to no less an authority than Homer.[15] One author implied that Spain's current king had revived the practice: "Although the patrimony of my lord St. Joseph was very important, and his parents were very rich and noble, he practiced the occupation of carpenter, because it was the custom that all the descendants of kings learn some occupation, in order to free themselves from idleness, and whatever misfortune of the times, as we see kings do today with their children."[16]

The promotion of manual labor associated with St. Joseph's cult is surprising in the context of early modern Spain, particularly given the obsession with personal honor and corresponding disdain for physical labor, which scholars have oft remarked upon and which period sources readily document.[17] The French visitor Barthélemy Joly, who traveled throughout Spain in 1603 and 1604, condemned Spanish artisans' prideful scorn for work: "As for the small handicraftsmen, unable to do anything else but work for their living, they do it as a matter of form. Most of the time they sit disdainfully outside their shops and, for two or

three hours in the afternoon, they parade up and down wearing swords. If they manage to amass two or three hundred reals, they suddenly become noblemen. There is no reason for them to do anything until, having spent it all, they have to go back to work to earn some more money to enable them to show themselves off again."[18]

In 1640, the Spanish political theorist Diego Saavedra Fajardo lamented the damaging effects of an exaggerated sense of honor on the Spanish economy: "In the country, agriculture is neglected, and the same applies to the exercise of mechanical skills, to business, and to commerce. The spirit of the nation is so haughty and vainglorious that even the common folk are not satisfied with their natural state. They long for ennoblement and scorn every occupation which seems to be contrary to their aspiration."[19] The centrality of honor as a social concern is also reflected in its importance as a major theme in much Golden Age literature, including such works as Cervantes's *Don Quijote*, *Lazarillo de Tormes*, Calderón de la Barca's *El Médico de su Honra*, Baltasar Gracián's *El criticón*, and Lope de Vega's *Las comendadoras de Córdoba* and *La estrella de Sevilla*.[20]

These textual sources notwithstanding, scholars seem to have overemphasized the inflexibility of Spanish honor codes. Scholarship on the topic leaves the impression that no alternative discourses, such as those that might elevate manual labor and which are readily apparent in Josephine literature, even existed. According to St. Joseph's devotees, honest work provided its own path to an honorable life.

Despite its admirable devotion to work, the Holy Family never grew rich, as personal wealth raised ethical concerns in the eyes of the Church. Instead, they had to remain poor as testimony to their immense humility. So, Joseph, Mary, and Jesus refused to take money for their work: "[A]lthough Joseph and his divine wife worked with their hands, they never asked a price for the work, nor said 'This costs such and such,' nor 'You must pay me,' because they did their jobs, not for the money, but for obedience and charity."[21] According to another author, "although the house of St. Joseph was poor and small, in it dwelled the King of the Heavens and the Queen of the Angels, and thus it was for Joseph the Kingdom of the Heavens."[22] A prayer from 1650 noted that while Joseph's house may have been poor, it was "rich in divine gifts."[23] Furthermore, although they were not rich, the Holy Family generously gave alms, all their excess money going to the poor. "It came about on more than a few occasions that the divine lady and her spouse St. Joseph found themselves poor and deprived of the necessary succor to live, because they were most generous with the poor," related Pastrana.[24]

Poverty itself was not a problem. God had specifically chosen the honest carpenter to be the earthly father of His Son precisely because he was poor. This demonstrated the humility and charity of the Son of God, as well as the humility and devotion of Joseph. One of the major Spanish hagiographers of the Counter-Reformation, Pedro de Ribadeneira, summed

up the virtues of Joseph's low station in life and his poverty: "God wanted Joseph to be a poor carpenter, so that we would understand that poverty is not lowliness, nor so bad as the deceived world believes; and just as He chose a poor mother, and a poor country, so also He wanted the foster father to be poor . . . His divinity was what had converted and transformed the world, and brought it to His understanding and love."[25]

The goodness of St. Joseph resided precisely in the fact that he preferred "innocent poverty" to "dangerous wealth."[26] Poverty, in clearly testifying to humility, obedience, and sincerity, increased the sanctity of the Holy Family, a point reiterated repeatedly in Josephine texts.[27]

In light of these concerns with the poverty of the Holy Family, it is now obvious why painters chose a humble style to represent them in the carpenter's workshop. This style, featuring a restricted palette of earth tones and strong contrasts of chiaroscuro, is in contrast to what one expects in representations of the divine. A painting of St. Joseph and the Christ Child by an Italian émigré to Spain, Angelo Nardi, gives an idea of the more typical representational strategies used to present the divine (fig. 35). Although Nardi clearly followed Pacheco's instructions for the scene by including the details appropriate to the carpenter's shop, his sweet and graceful style contrasts with the austerity and humility seen in other Spanish and Mexican examples. Nardi's St. Joseph stands in perfect contrapposto, his sandal-clad feet and smooth hands elegantly posed, in a tunic and mantle reminiscent of a Roman toga. His posture, costume, and handsome face give him the appearance of a classical divinity. In contrast to Nardi's sweet idealization, Spanish painters and their Mexican compatriots employed different representational devices that were more appropriate to the Holy Family's lowly station. They depicted Joseph, Mary, and Jesus engaged in manual labors, and emphasized St. Joseph's rude tunic, furrowed brow, work-gnarled hands, and poorly shod feet, which, according to an art theorist of the period, symbolized his poverty.[28] His rough hands were also singled out by the Josephine theologian, Francisco de Jesús María, as signifiers of the saint's manual labors on behalf of his foster Son. The author imagined St. Joseph pleading with his Son on worshippers' behalves: "[H]ow much I worked on Your behalf, the paths that I walked to protect You; look at the scars of my wounds and the calluses on my hands caused by the continuous work, with which I earned the bread to sustain You. Look at this face, which was browned by the sun, weathered by the winds, and furrowed by the weather, since I toiled, worked, and traveled in Your service, and don't deny me what I ask You, since I didn't refuse any task to serve You."[29]

Hispanic theologians thus located the sanctity of Joseph in his hard work on behalf of his family, which made him an efficacious intercessor: "In order to achieve what he asks for, he shows his hands, with which he worked to rescue Christ and His Mother, and the sweat that he shed to sustain them, and the feet injured from the paths that he walked to protect and defend them."[30]

On the surface, these representations of this poor family do not seem to be appealing devotional images. Their pictorial strategies do not invoke the divine in an obvious manner. But their power and efficacy result especially from the employment of this naturalistic low style, and the ideas of labor, family, and goodness that it conveys. The "lowness" of the style reinforces the sublimity of the idea.

Devotees of Joseph elevated poverty to a remarkable degree. Some Spanish and Mexican writers even claimed that the saint's humble labors made him similar to God the Father, as they equated St. Joseph, the earthly carpenter, with God, the divine artisan. Pastrana wrote that the saint's occupation "was a representation of his dignity, because it represented him as similar to God, the Universal Artificer of all created things."[31] Similarly, Jerónimo Gracián compared Joseph's labors to the Creation itself, writing that God had created the world "utilizing the trade of artisan or carpenter."[32] In a sermon preached in Valencia in 1645, as part of a celebration of St. Joseph sponsored by a group of turners who took the Holy Carpenter as their patron, God was described as utilizing the skills of their trade to create the heavens, earth, and elements, "those perfect, beautiful spheres, columns of the elements, the round globe of the earth."[33]

The Church Fathers, however, did not unanimously agree on Joseph's occupation. While some patristic texts posited that the saint was a carpenter, others argued that he was an artisan (faber) in the broad sense of the term. That St. Joseph had practiced the trade of carpentry was not taken for granted during the early modern period either, and his occupation had, indeed, been the object of much debate. The fact that in seventeenth-century Spanish and colonial Mexican paintings he always appears as a carpenter signals the participation of art in this polemic. The dispute arose from the meager information provided by the Gospels, which simply called him "faber," that is, worker or artisan. Thus, some Church Fathers had claimed that Joseph was not a carpenter, but rather an ironworker or blacksmith. For example, St. Hilarius of Poitiers, St. Anselm, and the Venerable Bede asserted that Joseph was an ironworker, while St. Augustine posited that the saint was a bricklayer. St. Ambrose was of the opinion that Joseph was both an ironworker and a carpenter.[34]

This controversy seems to have come to an end in 1597, when Gracián, a major authority on St. Joseph, suggested that although the saint was skilled in all of the mechanical arts, his principal occupation was that of carpenter.[35] A Náhuatl sermon published in 1577 preached to indigenous neophytes also described St. Joseph as a carpenter.[36] This seems to have been the official position of the Inquisition's painting censors, as evidenced by Pacheco's art treatise, and became the most common opinion in the seventeenth century. Pacheco defended it according to the Gospels and Church custom. Moreover, St. Joseph had always

appeared as a carpenter in Spanish art, surrounded variously by an encyclopedic array of carpentry tools, such as planes, saws, braces, compasses, squares, rules, levels, adzes, axes, chisels, pliers, calipers, augers, mallets, and hammers.[37]

The controversy over Joseph's occupation and the dispute over the translation of "faber," was, however, much more than a pedantic philological debate. By arguing that Joseph was a carpenter, Hispanic Josephine writers advocated the saint's active participation in the Redemption of humanity. This is one of the most important innovations in the imagery of St. Joseph in early modern Spain and colonial Mexico. While traditionally theologians had cast the Virgin Mary in a major role as co-Redemptor, they had credited Joseph with only a minor part in the Salvation.[38] Seventeenth-century Josephine advocates sought to expand the saint's involvement in the Redemption by explaining that his occupation as carpenter symbolized the Crucifixion of Christ. According to Pastrana, "Joseph had to be a carpenter . . . because this occupation was more appropriate than any other . . . it is a representation of the Son of God, Who on a wood beam achieved the Redemption of humanity."[39] Gracián insisted that Christ had chosen Joseph to be His earthly father precisely because he was a carpenter, and dedicated an entire chapter of his *Josefina* to teasing out the "mysteries" hidden within Joseph's trade.[40] Pastrana singled out Joseph's planing and polishing of lumber as laden with significance: "Joseph had to be a carpenter, he who had to be Coadjutor in the building of the Church of God. He had to be a carpenter, he who had to plane and polish the trees of God (which are men) with his words, examples, and protection."[41] Thus, according to Pastrana, the wood depicted in paintings of the carpenter's shop represents humanity, and Joseph's planing and polishing of it symbolizes his words, examples, and protection.[42] These two tasks are the activities most commonly depicted in the workshop paintings, with examples by Cano (two), Murillo, Ribera, Valdés Leal, and Tinoco among others. Planed and polished tree limbs leaning against the workshop wall appear in two significant works by Ribera (pl. 8) and Cano (fig. 72). Similarly, St. Joseph can be seen planing wood in several Mexican paintings.

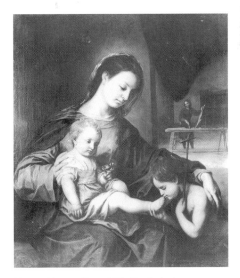

Fig. 72. Alonso Cano, *Holy Family in the Carpenter's Workshop*, 1650s. Oil on canvas, 40 1/2 x 31 in. (103 x 79 cm). Marquesa de la Guardia Collection, Madrid

Because these paintings contain clear allusions to the Passion of Christ, their main theme is the Salvation of humanity and St. Joseph's role in the Redemption. On first glance, Ribera's canvas appears to be a straightforward depiction of the Holy Family in a humble interior. On the right, St. Joseph works at his carpenter's bench, smoothing a tree limb with his adze. The Virgin Mary as the Madonna of Humility

sits on the floor. Between them stands the infant St. John the Baptist. The Christ Child, asleep on the Virgin's lap, offers the first clue to the painting's principal message. His slumped posture, with His head resting against His mother, left arm slung back, and left leg hanging down, exactly replicates His usual position in depictions of the pietà, as do the gestures of the Virgin as she clutches His side. Furthermore, Christ rests on a white cloth, which Mary lifts to display His body. This cloth symbolizes both His shroud and the altar cloth on which the Eucharist rests.[43] Finally, the intense light focused on His figure renders His body an eerie, deathly white, further alluding to the future sacrifice. The beholder is thus reminded of Christ's future Passion.

St. John the Baptist, placed in the center of the composition and looking out at the beholder, plays a pivotal role in the scene. He holds his customary attribute, the reed cross, which occupies the middle of the painting and, significantly, is much larger than normal. As Cynthia Hahn has noted in her study of late medieval imagery, John the Baptist frequently appears in scenes of the Holy Family as the precursor of Christ, calling the worshipper to repentance, as described in Matthew 3, where he admonishes the Pharisees and Sadducees: "Even now the ax lies at the root of the trees. Therefore, every tree that does not bear good fruit will be cut down and thrown into the fire (3:7–10)."[44] Similarly, in Ribera's painting the Baptist warns the beholder to repent. His proximity to Joseph trimming the tree reminds the worshipper to be shaped by the Holy Carpenter's example, or risk being "cut down and thrown into the fire." As Joseph cuts the branches from the log, shaping the "trees of God," he looks down at the Christ Child, the source of Redemption.

As in Ribera's canvas, Cano's painting also makes explicit references to Christ's Passion (fig. 71). In the foreground, the seated Madonna holds the Christ Child on her lap, the latter clutching a goldfinch in His hand, a well-known symbol of His Passion.[45] The infant St. John the Baptist leans over to kiss the foot of his younger cousin, indicating his acceptance of Christ as the Messiah. In the background, St. Joseph strips branches from a limb with an adze. Significantly, St. John's reed cross points to and is perfectly aligned with St. Joseph in the distant background. This alignment between the cross and the adze connects the saint with the foreground, reinforcing the idea that Joseph participated in the Redemption of the world.

Ribera's and Cano's depictions provided inspiration for several Mexican versions of the scene, including Juan Tinoco's *Workshop in Nazareth* of 1702 (fig. 73). Tinoco's St. Joseph stands at his carpentry bench planing wood, much like the saint in Spanish examples. The rest of the scene, which revolves around the adolescent Christ, Who has pricked His finger on a crown of thorns, is based on Zurbarán's *Holy House at Nazareth* (fig. 65). Joseph's inclusion

in the scene, which in Zurbarán's original depicted only the figures of Mary and Jesus, was intended to link Joseph to the Salvation. This interpretation can also be applied to two other anonymous paintings of the same subject (fig. 69; and Obregón Collection).

While the paintings of Ribera, Cano, Tinoco, and others posited that St. Joseph's role in the Redemption was to serve as an example, other Spanish and Mexican works of art proposed a more active involvement. That is, they asserted that Joseph participated directly in the planning of the new Church. This planning took place while the Holy Family worked together in the carpentry shop, as Gracián explained: "by being together sawing, planing, and exercising the crafts of carpentry, Joseph and Jesus were able to communicate, speak of, and discuss the new building of the Church in the presence of the Virgin herself." During these discussions, St. Joseph "helped with the sketches, models, and designs of our Redemption."[46] Gracián metaphorically

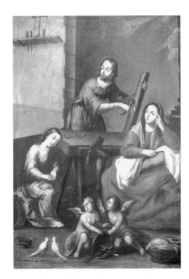

Fig. 73. Juan Tinoco (1641–1703), *Workshop in Nazareth*, 1702. Oil on canvas, dimensions unknown. San Martín Texmelucan, Puebla, Mexico

equated the building of the new Church with Joseph's carpentry work, and in the same manner extended the carpentry metaphor to the rest of the Holy Family, asserting that Jesus, Mary, and Joseph were all carpenters, who designed and built the Church, thereby opening the path to the Redemption. Previously, theologians had considered the Virgin to be the path, the door, or window to Salvation. Now, in addition, to Jesus and Mary, Joseph, too, offered the way to Salvation.

Despite the desire on the part of Spanish and Mexican authors and artists to make these new claims, they faced one great obstacle: St. Joseph did not live to witness the Crucifixion. The date of his death was, in fact, the object of much polemic. Had he lived to witness the Crucifixion, then why had Christ, when He was suffering on the cross, commended His mother to the care of St. John the Evangelist? But if Joseph had died before the Passion, when exactly had this occurred? Was it possible that the blessed carpenter had only lived a few years with the Christ Child, as some had claimed? To all these questions, Hispanic theologians produced ready answers, concluding that St. Joseph had lived with Jesus for thirty years.[47] Thus, according to their calculations, he must have died three years prior to the Crucifixion.

Despite the fact that Joseph was not present at Christ's Passion, Hispanic theolo-

gians claimed that the honest carpenter witnessed the event *vicariously*, while he worked with Jesus in the carpenter's shop. With reference to this, Gracián explained that during His childhood, "Christ enjoyed very much to make and see the cross, and He asked the saint to make Him many. He contemplated it, recreated it with His vision, and with this representation hastened the long wait. The continued representation of the Passion and death of his most holy Son caused my master St. Joseph great pain."[48]

Therefore, he added that "although Joseph was not found in the company of the Virgin beneath the cross when Christ was crucified, he received the same gifts as if he had been present."[49] A sermon preached in Puebla, Mexico, in 1749 posited that the water that issued from Christ's side at the Crucifixion was, in fact, the perspiration shed by St. Joseph as he labored to support his foster Son. The mysterious transformation was explained by the sermonist: "When it costs one much work to subsist, it is customary to say that one eats from the sweat of his labor; inasmuch as lord St. Joseph worked all day shedding perspiration so that from his sweat he could support his beloved Son Christ . . . the food of Jesus was that perspiration, and since it was found in the blood and lymph that Christ had as a true man, at the time of His death the blood and the lymph went straight to His heart, as if to protect it, and there was found the sweat of Joseph."[50]

St. Joseph's vicarious participation in the Crucifixion is represented in numerous seventeenth- and eighteenth-century Spanish and Mexican paintings. In some scenes the saint appears constructing what seems to be the arms of a cross. The Sevillian painters Roelas and Castillo, as well as an anonymous Mexican master, depict the foster father and adolescent Son working together sawing long rectangular beams that project dramatically beyond the picture plane (Collection of the Duquesa de Medina Sidonia, Sanlúcar de Barrameda, Spain, 1624; and Museo de Bellas Artes, Seville, Spain, 1635–36). In another canvas, Roelas represents the Christ Child carrying a miniature cross—presumably constructed in Joseph carpenter's shop—in His basket of wood chips (private collection, Valladolid, Spain, 1620s). In a variation of this theme by Murillo, the Holy Child and His cousin John play together fashioning a cross (fig. 68). Jesus' childhood premonition of the Passion is shared by St. Joseph in a canvas by Valdés Leal (fig. 74). The Christ Child stands transfixed before an elaborate celestial vision of angels bearing the Cross and the other instruments of the Passion. St.

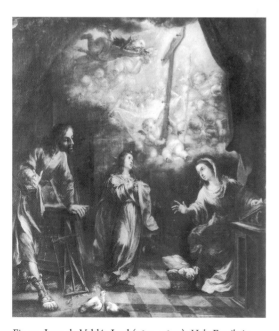

Fig. 74. Juan de Valdés Leal (1622–1690), *Holy Family in the Carpenter's Workshop*, c. 1665–69. Oil on canvas, 61 x 56 ²/₃ in. (155 x 144 cm). Private collection, Seville, Spain

Joseph has stopped his work, his hand outstretched in wonder, to look at the Child. A pair of turtledoves at their feet reminds the beholder of the saint's sacrificial offering at the Presentation in the Temple. They recall the prophesy pronounced by Simeon, proclaiming Christ as the Messiah, and warning that His sacrifice would pierce His mother's heart (Luke 2:22–35). Valdés Leal paints St. Joseph in a similar meditative mood in another canvas (Catedral, Baeza, Spain, 1673–75). As Jesus holds up a small cross and gazes upon a vision of God the Father represented above, Joseph protectively lays a hand on his foster Son's shoulder, his expression of sadness revealing his awareness of the future Passion. The Virgin, on the left, momentarily stops working on her embroidery to look over at her Child. Several Mexican paintings re-elaborate Mary's premonition of Christ's Passion to include St. Joseph. All of these images of the carpenter's workshop, whether depicting St. Joseph planing and polishing wood, planning the new Church, or vicariously witnessing Christ's Passion, credit Joseph with a new major role in Salvation.

This valorization of Joseph the saintly carpenter had important implications for the status of worldly carpenters, who along with other members of the artisanal class manifested widespread devotion to the saint. One preacher in Valencia proclaimed "this most noble saint, the greatest after Mary, was a carpenter, which is a glorious honor for all of this art."[51] For a general idea of the diffusion of the cult, we can look to the records of Josephine guilds, confraternities, and brotherhoods, which were important patrons of works of art. Documents demonstrate that the number of confraternities dedicated to Joseph increased dramatically in the late sixteenth and seventeenth centuries, with important congregations in major cities such as Badajoz, Granada, Valladolid, Madrid, and Seville, the latter home to several such confraternities.[52]

For example, in 1566 in Badajoz, carpenters founded a Brotherhood of St. Joseph, as they also did in late sixteenth-century Valladolid. Another Josephine confraternity could also be found in Valladolid, which cared for abandoned children.[53] A confraternity of "San Josef de los Carpinteros" founded a hospital in Seville in 1578. The nearby town of Utrera also boasted a Josephine brotherhood, founded in 1628.[54] A confraternity of carpenters in Valladolid, whose rule was approved in 1614, commissioned a life-size polychromed wood sculpture of St. Joseph with a saw in his hand for their chapel in the church of Nuestra Señora de las Angustias.[55] Other brotherhoods were attached to the churches of St. Mary Magdalene in Ciempozuelos, the Assumption in Barco de Ávila, and Seville's Convento de Nuestra Señora de la Victoria.[56] In 1693, two new brotherhoods were established under Joseph's patronage, one in the parish church of St. Ildefonso in Seville, and another in Santa María de la Almudena in Madrid.[57] Seville's largest and seemingly most wealthy Josephine confraternity, the Carpenters' Brotherhood of St. Joseph, built a new Chapel of St. Joseph in the eighteenth century.[58]

Josephine confraternities can also be documented throughout colonial Mexico. Probably the first such brotherhood was located in San José de los Naturales, the native parish founded by Fray Pedro de Gante in 1527, on the grounds of the monastery of San Francisco in Mexico City-Tenochtitlán. The parish included a native school under Fray Pedro's direction, a hospital, and an orphanage. Reportedly, the Josephine confraternity was attached to the hospital, its members comprised of "Indios de Mechoacan," who served as *enfermeros*, or nurses to the sick.[59] A number of other confraternities dedicated to St. Joseph were founded in colonial Mexico, including an "esclavitud del glorioso Patriarca Sr. S. José," founded in Puebla in 1631. In 1639 a chapel and confraternity dedicated to the saint could be found in Morelia. The sculptor Nicolás de Vergara of Mexico City was commissioned in 1677 to build an altarpiece dedicated to St. Joseph for the "Cofradía del Señor San José" in Pachuca's parish church of La Asunción. In 1735 Pope Clement XII granted indulgences and perpetual graces to the men and women of the confraternity "Esclavitud del Glorioso Patriarcha Señor San Joseph" located in the convent church of San José de Gracia in Mexico City.[60] The Cofradía del Señor San José attached to the Cathedral of Saltillo commissioned and paid for an Ultrabaroque retablo, which included images of the itinerant St. Joseph and Child, the Death of St. Joseph, a Holy Family by José de Alcíbar (active 1751–1801), a Holy Family attributed to Antonio Sánchez, and a Virgin of Carmen attributed to Miguel Cabrera, which was finished in 1806.[61]

In addition to his protection of carpenters, St. Joseph also seems to have been associated with other artisans, and especially with those involved in the building trades. Thus, confraternities of bricklayers, ironworkers, blacksmiths, steelworkers, and turners (or lathe operators) were also founded in his name. In at least one instance, gardeners took Joseph as their patron. St. Joseph also became the patron of professional men such as pharmacists, lawyers, and medical doctors.[62]

According to the testimony of devotees, the saint worked a number of miracles on behalf of members of these confraternities. Pastrana, in his aforementioned work, records seventy-five miracles performed by images of St. Joseph. Miracles worked for carpenters are numerous. For example, in Peru in 1662, a painting of the saint was credited with helping overworked carpenters constructing a new church by bringing about the miraculous arrival of twenty-four extra laborers. When the master architect's saw broke, this same painting caused a new saw to appear. During a dangerous storm, it was reputed to have saved the church from damage, and in 1666 in the cloister of the church, a short plank miraculously grew. The miraculous power of St. Joseph's image is further attested by a sculpture of St. Joseph in Peru's Cathedral of Lima that was reputed to have saved the life of the master carpenter's son in a building accident.[63]

The ennoblement of Joseph's occupation as a carpenter may have also had implica-

tions for Spanish seventeenth-century racial politics. Certain artisanal trades had long been associated in Spain with *moriscos*, or Christianized Muslims.[64] In the sixteenth century, moriscos came under increasing attack in Spain, culminating in the 1609 order promulgated by King Philip III that forced their expulsion from the country. Art works were commissioned to commemorate this tragic event, including a large-scale twenty-nine compartment altarpiece dedicated to Santiago as "Moor-slayer" by Francisco Ribalta (1565–1628) and his workshop for the parish church of Algemesí, Valencia, in 1609.[65] Apparently, St. Joseph's figure was marshalled among the Spanish Muslim population after the forced conversion to Christianity in 1492, just as the saint was elevated as the perfect convert in the New World. The very first church dedicated to the saint in Spain was, in fact, consecrated in the city of Granada in 1525, when the former Mosque of the Hermits was renamed in honor of St. Joseph.[66] Only thirty-three years earlier, the last remaining Muslim stronghold in Spain, Granada's Nasrid dynasty, had fallen, bringing the Reconquest to an end.

The promotion of work and family visible in depictions of the carpenter's workshop was related to the pervasive perception of social and political crisis during Spain's so-called Golden Age, an issue discussed throughout this book. Worrisome economic problems plagued Spain and her empire throughout the period. Widespread poverty, high unemployment, and skyrocketing inflation threatened to destroy the social fabric. By valorizing poverty and manual labor, images of St. Joseph, the humble carpenter, became icons of hope. They also became tools of social control. As Foucault has argued, the moralized work ethic of the early modern period was a useful tool to maintain societal order because it sought to suppress indigence, a major cause of unrest.[67] Historians such as Mary Elizabeth Perry have convincingly demonstrated that government regulations to control poverty in Spain were clearly designed to pacify the population.[68] The Spanish state additionally responded by creating and regulating institutions of social welfare such as orphanages, halfway houses, and hospitals, which enclosed and controlled the destitute by feeding, housing, and clothing them.

Seventeenth-century Spaniards themselves clearly perceived a link between work and social order according to tracts on poverty penned by social reformers such as Juan Luis Vives, Miguel Giginta, and Cristóbal Pérez de Herrera.[69] Advocating Church and government control of poverty through the licensing of beggars, such social critics also advocated that the poor be taught trades, as labor was the cure for poverty.[70] Commentators such as Guzmán feared that idleness, which had destroyed the most powerful empires of the ancient world, now threatened to bring down Spain.[71] Because "[l]aziness is the cause of the vice of lust, and destroyer of empires," work was necessary to preserve social order, he reasoned.[72] In addition, period texts prescribed emulation of the hard working Holy Family as an antidote to the idleness threatening to destroy the family unit. "How many families and houses have

been ruined and destroyed by the laziness of their proprietors!" lamented one author.[73] By sanctifying manual labor, representations of St. Joseph the honest carpenter thus assumed central importance in Church– and government-sponsored strategies of social control.

The emphasis on labor seen in images of St. Joseph in the carpenter's shop finds a parallel in the cult of another saint, St. Isidore the Farmer, who was chosen as the patron of Madrid in the seventeenth century, and who became St. Joseph's rural counterpart. Born about 1070 in Castile, Isidore was a peasant laborer, the patron of farmers and the harvest, who died in 1130. He was made a saint in 1622 by Pope Urban VIII in the festivities that also witnessed the canonizations of Saints Teresa de Ávila, Ignatius Loyola, Philip Neri, and St. Frances Xavier. In the seventeenth century a new tomb for Isidore was constructed in Madrid's Cathedral. The Golden Age dramatist Lope de Vega penned a comedia, *San Isidro Labrador*, in his honor. Like Joseph, Isidore was reputed to pray as he worked, and angels appeared to help him with the plowing.[74] According to Alonso de Villegas, one of the most influential hagiographers of the era, Isidore, a landless peon who labored as a sharecropper, "always supported himself by the sweat of his brow, was always occupied by physical labor."[75] In addition, Isidore was the hardworking head of his family (fashioned in imitation of the Holy Family), which consisted of a saintly wife, St. María de la Cabeza, and their one extraordinary son.

Like depictions of St. Joseph, San Isidro's image promoted the sanctity of the industrious nuclear family and provided a model for men with families to emulate. Images of the saint include a painting by Alonso Cano executed for Santa María de la Almudena, the Cathedral of Madrid (Museo del Prado, Madrid, 1645–50), which features the saint's farm implements, and a relief sculpture by Pedro de Mena (1628–1688; Catedral, Málaga, Spain). Like representations of St. Joseph, Cano's St. Isidore painting utilizes a "low" style that employs an earthy palette and rough brushwork, challenging customary notions about depicting the divine. These images are also important because they challenge current wisdom about early modern masculinity. Several of the most important scholars theorizing masculinity today have suggested that the role of family provider originated in the nineteenth century, an assertion that these seventeenth-century images challenge.[76] Worker saints and holy husbands were clearly fashionable in the period.

To have been effective tools of social control, however, these images must have first functioned as efficacious objects of religious devotion. Therefore, we must ask ourselves if Spanish and Mexican beholders shared the moral and devotional ideas that informed Josephine paintings and literature. If so, they would have believed that when poverty resulted from charity, and not from laziness, it was a virtue, the exercise of which constituted the only true nobility. They sought the divine in the humble and lowly, and believed that to work was

to pray. They looked to St. Joseph as a model and identified closely with him. Instead of searching for the divine in sweet, light-filled, celestial images, they looked to the poverty, humility, and sadness visible in paintings of St. Joseph in the carpenter's workshop to understand the path to honest labor and Redemption.

In summary, the canvases by Roelas, Castillo, Ribera, Orrente, Cano, Valdés Leal, Murillo, Tinoco, and others belong to a new tradition of representations of St. Joseph in Golden Age Spain and colonial Mexico. These paintings, in conjunction with Josephine texts, elevated the saint as a model artisan and honest laborer. The importance given to these ideas on work is demonstrated in the proposal that Joseph played a major role in the Redemption and Salvation through his vicarious participation in the Passion of Christ. The two ideas are intimately linked: work is devotion, and it is through work that we achieve Salvation.

Francisco de Zurbarán, *Coronation of St. Joseph (detail of fig. 80)*

CHAPTER
SIX

The GOOD DEATH

INSTEAD OF DYING a glorious martyr's death, Catholicism's most exalted fate, St. Joseph instead expired from natural causes. Spanish and Mexican images of St. Joseph's last moments depict the aged, bed-ridden saint during his final illness with Mary and Jesus at his side. These images gave visual form to the new post-Tridentine conception of the "good death" in the Catholic Church. To die a good death was to die peacefully and with the proper preparations for Salvation, such as the last rites. Paintings of the saint's demise not only pictorialized the exemplary Catholic death, they also elevated St. Joseph as its patron (figs. 75, 76, and 78). While death scenes offered hope to devotees in death, Spanish and Mexican renditions of St. Joseph's coronation and protection offered hope on earth. Such paintings, to be discussed in the second half of this chapter, explicated Joseph's role as the Spanish monarchy's protector in times of crisis and emblem of social welfare. All three image types—St. Joseph's Death, Coronation, and Protection—enjoyed particular popularity in Mexico.

Since the Bible revealed nothing on the subject of the saint's demise, theologians deliberately constructed the exact narrative sequence of Joseph's final illness and death. Hagiographies, sermons, prayers, poetry, songs, and other devotional texts expounded upon the sequence of events and their importance. The widely performed play (*comedia bíblica*), *El Mejor esposo, San José (The Best Husband, Saint Joseph)* by Guillén de Castro, re-enacted Joseph's death in the final scene of the last act. These sources, as well as the evidence of reported miracles, confraternity documents, and descriptions of rituals associated with Josephine feasts elucidate the meanings produced by these paintings as they suggest cultural attitudes toward death in Spain and Mexico.

Textual sources consistently characterize the saint's final illness and death as commonplace, even humble, in nature. Many authors reported that in his old age, St. Joseph began to weaken and grow tired. Then, one day, he fell ill while at work in his carpenter's shop, his saw dropping from his hands.[1] Because of his special saintly status, he knew that the hour of his death was approaching.[2] This foresight allowed St. Joseph to prepare calmly for the momentous event. Such preparations constituted a model of the good death.

According to Hispanic authors, God tested the saint's patience to increase his sanctity in his final days by sending fevers, headaches, and aching joints.[3] The art theorist and Inquisition official Friar Juan Interián urged the painter to keep in mind that not only was Joseph old at the time of his death, but that his physical strength had been "broken" by the many "tribulations" that had befallen him.[4] The artist Juan del Castillo, and others, drew attention to the ravages wrought on Joseph's body by illness. In his painting, Joseph's drawn face is lined with worry as he clutches his stomach in pain (Museo de Bellas Artes, Seville, early 17th century).

Most Spanish painters represented the saint as an old, gray-haired man, a logical characterization in the context of the scene. In paintings by the disciples of Francisco Ribalta and Pedro Orrente, Joseph's hair and beard are speckled with gray, although the saint is not overly aged or infirm (Santiago Apóstol, Algemesí, Spain, 17th century; and El Carmen, Valencia, Spain). According to one of the most widely known sources, Valdivielso's epic poem, Joseph had never been seriously ill before, and as a result, was old but not aged when he died. Valdivielso recounted how St. Joseph was spared aging's process of physical decline: "His grave eyes never became muddy / nor did his strength weaken, / his cheeks never faded / nor did his teeth ever rot; / illnesses never bothered him / nor did pains affront him: / with his health always happy he worked, / and his wife and his beloved Son he supported."[5] Most Mexican painters took pains to depict the saint as aged, almost uniformly characterizing him as sickly and near death.

A few artists characterized the dying St. Joseph as unnaturally youthful. The odd strategy probably constituted an attempt to describe the effects of a visionary experience that occurred right before St. Joseph's expiration. A painting by a follower of Francisco de Zurbarán seems to visualize

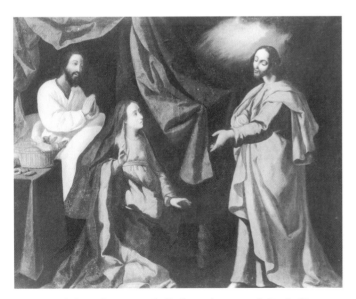

Fig. 75. Workshop of Francisco de Zurbarán (1598–1664), *Death of St. Joseph,* 17th century. Oil on panel, 39 x 22 ¼ in. (99.5 x 56.5 cm). Ex-Colegiata, Olivares, Seville, Spain

the moment when, after entering into an ecstasy, Joseph asked his wife and Son for a blessing (fig. 75). In it, a youthful St. Joseph sits up in bed with his hands clasped in prayer, and looks to his Son, as Mary kneels in prayer at the bedside. A small gloria appears above Christ's head, as if to differentiate Him from His foster father, who looks remarkably similar. One author described the event: "St. Joseph returned from this rapture his face full of admirable light and beauty, and speaking with his most holy wife he asked for her blessing, and she asked her most blessed Son to give it and His divine Majesty did it."[6] According to another text, in the seconds before Joseph's death, the saint entered into a "most high ecstasy": "and in this grandiose rapture he saw and knew what faith had created (as well as the incomprehensible Divinity), such as the Mystery of the Incarnation, and human Redemption and the militant Church, with all the sacraments that belong to it."[7] St. Joseph appears similarly young and remarkably akin to his foster Son in the Mexican artist Miguel de Herrera's 1751 Death of St. Joseph (fig. 76).

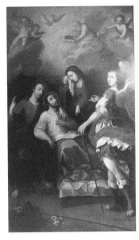

Fig. 76. Miguel de Herrera, (active 1725–c. 1780), Death of St. Joseph, 1751. Oil on canvas, dimensions unknown. Estudiantado Mayor Josefino, Mexico City

Because the Bible was silent on Joseph's age at death, the matter occasioned much theological deliberation. The Bible only revealed that Joseph was still alive when Christ left His family to remain in the temple debating the doctors at age twelve (Luke 2:41–51). Most theologians were almost certain that the saint had died, however, before the Crucifixion, since Christ had recommended His mother to the care of St. John the Evangelist—not Joseph—as He died on the cross. So, Hispanic theologians calculated that Joseph must have fallen ill and died at age seventy, when Christ was twenty-nine years old.[8] At least one Spanish theologian, however, asserted that the saint was only sixty when he died.[9] Interián opined that Joseph was at least seventy years old.[10] In any case, most Spanish and Mexican artists depicted the saint as aged, suggesting that this was the approach preferred by the Spanish church and the Inquisition.

When considered within the wider context of images of saints' deaths, Spanish and Mexican artists' renditions of St. Joseph's lowly demise are remarkable for their humble, quotidian quality. Artists' emphasis on naturalistic details and the everyday nature of the scene's setting encourage viewers to identify with the event depicted. It is as if we have been granted the privilege of witnessing one of the Holy Family's most personal, private moments together. To emphasize the intimacy of the moment, artists positioned Joseph's bed prominently, and provided plentiful details. For example, Castillo carefully described such particulars as Joseph's patterned pillow and night clothes (Museo de Bellas Artes, Seville, early 17th century). Pedro

Orrente's painting (El Carmen, Valencia, Spain) appears to recreate the interior of a seventeenth-century Spanish house. Joseph lies in a canopied bed, a lap tray on his knees as the Virgin and her angel assistants bring plates of food to succor him. Similar quotidian details enliven Mexican paintings. Mary spoon-feeds soup to the ailing saint in a canvas by José de Ibarra, and bowls of comestibles can also be seen in Ramírez El Mozo's rendering (private collection). No death could be further from the glorious drama of martyrdom, the traditional heroic fate of Catholicism's most exalted individuals.

The composition of the death scene, like much Josephine imagery, can be traced to depictions of the life of Mary. Even in death, St. Joseph's life was modeled on that of the Virgin. Representations of Mary's death, called her "dormition" because, according to the Church, she did not truly die, but rather was asleep for three days before her Assumption, commonly show the Virgin peacefully reclined on a bed, surrounded by the apostles, as demonstrated by an example by the Mexican artist Juan Correa (Museo Nacional de Arte, Mexico City, last third of the 17th century). The composition of the death of St. Joseph, although with fewer figures, is quite similar. The differences in mood, however, are significant. The scene of Joseph's passing appears less formal, less peaceful, and ultimately, less dignified.

The humble nature of St. Joseph's demise can also be seen in comparison to other images of saints' deaths, which, although akin in compositional arrangement, are different in expression. A similar diagonal arrangement can be found in Zurbarán's *Saint Bonaventure on His Bier* (fig. 77), which depicts the learned doctor lying in state, important personages in attendance, and the same artist's *Burial of Saint Catherine on Mount Sinai* (Collection of the Conde de Ibarra, Seville, c. 1630–40). Despite the obvious compositional similarities that unite these works, Josephine scenes represent the saint as still alive—albeit dying—not deceased. Furthermore, instead of being costumed in finery, St. Joseph wears night clothes and lies amidst the crumpled blankets

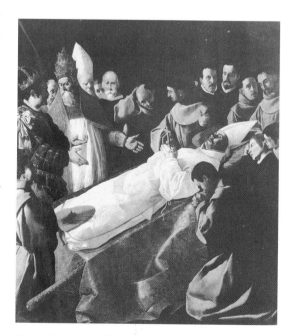

Fig. 77. Francisco de Zurbarán, *Saint Bonaventure on His Bier*, 1629. Oil on canvas, 96 ¹/₂ x 86 ²/₃ in. (245 x 220 cm). Musée du Louvre, Paris

of his disheveled bed. Artists calculated such undignified details to emphasize the saint's humility.

Paradoxically, scenes of St. Joseph's death also call to mind representations of the Nativity of the Virgin, which depict St. Anne shortly after giving birth. The latter is also organized around a bedridden figure. The analogous relationship of these images, which represent the suffering at life's beginning and its end, suggests the continuities between life and death. In addition, the adoption of this compositional type in Josephine imagery may provide further evidence that the Spanish promoted St. Joseph's cult at the expense of St. Anne, a topic discussed in greater detail in chapter 3.

Fig. 78. Attributed to Juan Correa, *Death of St. Joseph*, 17th century. Oil on canvas, 51 x $^{3}/_{5}$ x 67 $^{1}/_{5}$ in. (131 x 171 cm). Museo Regional, Querétaro, Mexico

While emphasizing the quotidian aspects of St. Joseph's suffering, artists and religious writers simultaneously suggested its extraordinary nature: Joseph died in the presence of Jesus and Mary. The stage directions for the final scene in Guillén de Castro's sacred play summed up the event's essentials: "The curtain opens; Joseph appears in a bed, with Jesus on one side and Mary on the other."[11] Some authors related that Joseph died in Jesus' arms. According to one, as he lay dying, Joseph asked his Son for His blessing, a moment frequently depicted by Spanish and Mexican artists: "Give me your arms beloved Son . . . and although it is the duty of the father to give a blessing at this moment, I ask for Yours, so that protected by it, the furies of hell will not harm me."[12] In a painting by Castillo, for example, Christ grasps Joseph's hand and blesses him while the Virgin prays for his soul (Museo de Bellas Artes, Seville, early 17th century). In paintings by Ribalta and Herrera, Christ places one hand on His foster father, while raising the other in blessing (Santiago Apóstol, Algemesí, Spain, 17th century; and fig. 76). In other examples, such as in a painting attributed to Correa and another by José de Alcíbar, Joseph dies in his foster Son's arms (fig. 78; and Catedral, Aguascalientes, Mexico, 18th century). Artists also rendered the Holy Family's care for, and prayers on behalf of, the dying saint. Often, the Virgin leans over Joseph's bed with concern, praying for her perishing husband. In a touching version by the Mexican Fray Miguel Herrera, tears course down Mary's face.

As further proof of the extraordinary nature of the event, most artists represented angels visiting Joseph during his final illness. In Castillo's painting, the ceiling of the room opens to display a heavenly gloria of musical angels who serenade the saint, as described in Josephine texts: "In these nine days the holy angels gave celestial music to the lucky sick one

with canticles of praise to the almighty and blessings for the saint himself" (Museo de Bellas Artes, Seville, early 17th century).[13] Musical angels also make an appearance in Orrente's painting (El Carmen, Valencia, Spain), one playing the shofar, the other plucking a harp. *Angelitos* float above the bed. One pulls back the canopy to reveal God the Father and the dove of the Holy Spirit, while another one bears a martyr's palm and crown for Joseph. This crown appears in paintings associated with Ribalta and Correa, as well as in a work by Alcíbar (Santiago Apóstol, Algemesí, Spain, 17th century; fig. 78; and Catedral, Aguascalientes, Mexico, 18th century). In works by Mexican artists, the numbers of angels is mul-

Fig. 79. Follower of Pedro Orrente (1580–1645), *Blessing of Jacob*, 17th century. Oil on canvas, dimensions unknown. Art market, Barcelona, Spain

tiplied. In canvases by José del Páez and Miguel Herrera, angels bear the saint's carpentry tools (fig. 76). In paintings by Correa and Alcíbar, putti crown the saint with flowers or present martyr's palms. The poet Valdivielso described these events in his epic Josephine poem, recounting that, at the moment of death, angels crowned Joseph with a wreath of roses, lilies, and jasmine, emblems of his purity.[14] An angel also appears with a floral crown and stalk of lilies for Joseph in a painting by the Ribalta workshop, while in the right corner the archangel Michael stands holding his customary spear and shield. The inclusion of Michael is unusual, but perfectly apropos, since, as the protector of the Israelites and thus of Joseph, he appears in the Book of Daniel.[15] Michael also frequently played a role in scenes of the Last Judgment, where he weighs Christian souls, thereby assessing the life of the deceased, and appears here in the same capacity.

A different innovation can be found in a canvas by a disciple of Pedro Orrente (El Carmen, Valencia, Spain), which depicts Christ offering the bread of the Eucharist to Joseph. A flask of wine, a chalice, and a cluster of grapes sit on a low table covered with a white altar cloth. The scene thus represents the last communion of St. Joseph. God the Father and the dove of the Holy Spirit appear above Joseph's head, sanctifying the moment. While Christ attends to His father's spiritual needs, the Virgin tends to his physical ones. In this painting, she stands at the foot of the bed with a plate of food and stirs the contents of the bowl with a

spoon as she looks to her angel helper. Numerous devotional texts described how Mary "helped him and served him on her knees throughout his entire illness."[16]

The goodness of Joseph's death can be appreciated in contrast to the analogous Old Testament scene of the Blessing of Jacob. A painting by a follower of Pedro Orrente presents a compelling comparison (fig. 79). Here Jacob dupes his blind, infirm father, the patriarch Isaac, into bestowing on him Esau's birthright. Isaac's wife Rebecca prompts Jacob (Genesis 25:19–34; 27; 28:1–5). Through the open door on the left, the unsuspecting Esau can be seen hunting (of all things) a turkey. A telling detail in the left foreground, which provides the key to the entire scene, emblematizes the deceptive behavior of Isaac's wife and son. There, a cat eats furtively from a plate left on a table, taking what does not belong to him. While the compositional arrangements of the two scenes are quite similar (both depict dying men attended by their wives and sons), their messages differ dramatically. In contrast to this scene of familial deception, depictions of St. Joseph's demise represent Jesus blessing him, his wife praying for and comforting him.

According to Josephine hagiographers, after nine days of suffering, Joseph died in the presence of his beloved Son and wife. One writer described the moment:

> Well, what will I say of the happy and lucky death that Joseph had, finding at his most happy transitus his most holy spouse, who helped him and served him on her knees throughout his entire illness, and also his most holy Son, in Whose arms he died and to Whom he turned over his soul, so that thousands of angels—who also were present at his illness and death— brought it to the bosom of Abraham; and this same God closed his eyes and mouth and ordered the angels to anoint his body; He prepared his tomb and accompanied him to his burial.[17]

Overcome with grief, Jesus and Mary donned their mourning clothes. With the help of the angels, Mary prepared Joseph's body for burial. It was entombed in the Valley of Josephat, next to the Virgin's eventual resting place.[18] Joseph's soul went to Limbo (as Christ's Passion had not yet occurred) to await his Son's descent after the Crucifixion. Four years later, Jesus retrieved Joseph during His descent into Limbo. Joseph's body and soul were then assumed to heaven where he was crowned by his adopted Son.[19]

St. Joseph's death was the object of widespread veneration throughout the Hispanic Catholic world, despite the fact that there was considerable disagreement over its exact date. According to Pastrana, seventeenth-century Spaniards celebrated Joseph's transitus on his March 19 feast day.[20] In 1658 in Puebla, Mexico, devotees celebrated the "Day of the Transitus

of St. Joseph" on July 20. One hundred years later, in the 1760s, the Oratorians of Mexico City's La Profesa Church also observed the transitus feast in July.[21] Eighteenth- and nine-teenth-century Mexican authors attempted to clarify the confusion over the date. One argued that "the feast of his death, or transitus to the other life" should be celebrated on March 19, which date, as the oldest Josephine feast, commemorated the saint's death. He blamed the confusion on the Eastern church, which had mistaken the July 20 feast of St. Joseph Barnabus for one honoring the death of the Patriarch St. Joseph.[22]

Congregants in the Hispanic world honored St. Joseph's transitus in a number of ways. One account reported that nine days before the feast, worshippers in some churches and convents, particularly those of the Discalced Carmelites, placed a wood sculpture of Joseph in a bed "as if sick, attended by Christ Our Lord and his Most Holy Spouse, sur-rounded by angels."[23] They waited at Joseph's bedside night and day for nine days, bringing offerings such as food and flowers to the saint. On the tenth day, the saint "died." The wor-shippers then distributed the offerings to the city's poor in Joseph's name. A similar novena was observed in eighteenth-century Mexico: "The saint's novena is observed the nine days preceding his first fiesta (i.e., March 19) in churches as well as private homes, after the rosary that the entire family usually prays together on their knees at night. The same venera-tion that is manifested in the cities is also common in small villages, and even on rural haciendas."[24]

A Mexican writer in 1845 reported on a transitus devotion "from long ago" in the vil-lage of Atlixco, in the state of Puebla:

> There was then an association of twelve principal persons who, in addition to meeting the nineteenth day [of every month] at mass, accompanied a worthy image of the saint with candles in their hands, which was translated with music at night from the house of the devotee whose turn it was to have the image that month, until the next nineteenth day when it was led in the same manner to another devotee's house, each in his turn taking pains to have it piously lit at night, and all attending the nice festivity on March 19.[25]

In 1760 the Oratorians of Mexico City's La Profesa established a special celebration of the transitus with hopes of ending a rash of unfortunate deaths. A lengthy inscription on a painting of St. Joseph memorialized the events: "This congregation, having experienced for the space of twelve years the sad calamity that no year passed without mourning some of the few subjects who composed it, decided that our venerable founders would recognize as patron the most glorious patriarch lord St. Joseph."[26] The campaign was a great success, for

since seven years have passed without a single congregant dying, piety has persuaded us that God, through the intercession of the most holy Patriarch, has conceded this benefit to us, confirming for us the hope of achieving that which we principally desire and request, attaining a blessed transitus to eternal life."[27]

The existence of confraternities dedicated to Joseph as the patron of the Good Death further documents the importances of Joseph's transitus in the Hispanic world. Madrid's Convent of St. Mary Magdalene housed one in the seventeenth century, while another confraternity of St. Joseph and the Good Death could be found in Vitoria.[28] In the Mexican city of Saltillo, in Coahuila, an Association of the Most Holy Patriarch, housed in the cathedral, also honored Joseph's death.[29] Other Josephine confraternities, while not specifically named in honor of this advocation, also commemorated the saint's transitus. One Mexican confraternity observed a special mass at the altar of the souls of the dead (las Almas de los Fieles Difuntos) every Wednesday, plus on Day of the Dead (el dia de la commemoracion de los Difuntos) for which Pope Clement XII granted the members fifteen years of indulgence. This same confraternity dedicated itself to burying the dead and praying for souls.[30]

By pictorializing Joseph's demise, these images provided Catholic beholders with examples of the good death to emulate. They thus participated in the Counter-Reformation's promotion of this new approach to dying.[31] St. Joseph died content because he died redeemed, and in the company of Christ and the Virgin, to whom he entrusted his soul. Prayers to the saint took note of this.[32] These scenes also give pictorial form to a death within the Catholic church preceded by the last sacraments of penance, extreme unction, and Holy Communion.[33] To ensure a "good, happy, and lucky death," devotees were instructed to partake of all the holy sacraments, pray many acts of contrition, love God and for extra help place on the right side of their death bed a crucifix and on the other a statue of St. Joseph.[34] Upholding the last rites was a major task of the Counter-Reformation church, part of the plan to codify and promote the sacraments in the face of the Protestant attack.[35] Thus, paintings of Joseph's death carefully include references to extreme unction: in the paintings by Castillo and a follower of Ribalta (Museo de Bellas Artes, Seville, early 17th century; and Santiago Apóstol, Algemesí, Spain, 17th century), Christ lays His hands on Joseph; in examples by Ramírez El Mozo and Ibarra, Christ appears to bless His ailing foster father. In that by Orrente (El Carmen, Valencia, Spain), Christ presents the Eucharist to His dying father. The archangel Michael appears as a symbol of the Church militant, fighting heresy in a Ribaltesque painting.[36]

As an extension of his role as an exemplar of the Good Death, numerous sources reveal that devotion to Joseph was a help and comfort to Catholics on their deathbed. For Catholics, the hour of death was fraught with dangers—a sermon of the period described it as a "dangerous battle."[37] There were many things to fear at this moment, such as the pain or

fatigue of illness, but most significantly, Catholics feared dangers to the soul, and "the formidable judgment of God" which could grant salvation or eternal condemnation.[38] By representing Joseph dying, as opposed to dead, artists and theologians provided a model. One devotional writer wrote that "the Christian who has St. Joseph for a patron and advocate will come forth well from these fatigues, frights, and dangers."[39] Therefore, sermons advised Christians to "Go to Joseph" in their hour of their death in order to secure the passage of the soul to heaven: "Christian souls, who fear, and with reason, the dangers of death: do you want security in that unavoidable dangerous passage? Go to Joseph, who will remove the difficulties of the passage for you, so that you may arrive happily at the eternal country."[40] Another devotional writer urged his readers: "Let us put ourselves in the hands of my master St. Joseph all our lives and especially in the hour of death, and in order to turn over the soul to the hands of Jesus, let us take as patrons Joseph and Mary, because wherever Mary and Joseph are, Jesus must be there, too."[41] Joseph's help continued after death, when he achieved salvation for his devotees. "Ultimately, Catholics, the powerful efficacy of Joseph's patronage lasts until after death, because of the two keys to heaven that Jesus Christ Our Lord has, He gave one to His mother, the most pure Mary, and the other He gave to St. Joseph, as His legal father."[42] Thus, dying Catholics were directed to pray to the three personages depicted in the paintings examined in this chapter: Joseph, Mary, and Jesus, the "helpers" in the hour of death.[43]

Josephine devotees were particularly concerned about diabolical interference at the hour of death. At this vulnerable moment, demons were believed to persecute the soul. The devil himself might even appear to snatch away the soul of the dying person. "[T]he passage to eternity has to be most frightful; the devil, my common enemy, will fight me formidably with all the power of Hell, so that in the end I might lose God eternally," worried one devotee.[44] According to a sermon preached in 1717, St. Joseph was the "capital enemy of the devil."[45] Another author claimed that St. Joseph frightened the devil at these moments with his flowered staff.[46]

Devotional texts are replete with accounts of miracles worked by St. Joseph at the time of death. Images of the saint were extremely helpful during these critical moments and, additionally, provided solace.[47] Reports of deathbed visions of St. Joseph were numerous. A woman in Lima, Peru, who had kept an altar dedicated to the saint in her house, was visited by the saint as she lay dying.[48] In another case, Joseph appeared to a devotee to assure him of his salvation and to announce the exact hour of his death so that he could prepare for it.[49] Other similar occurrences are too numerous to recount here.[50]

Not only did Joseph appear to console his devotees, he also helped transport their souls to heaven. In one case, a charitable man was rewarded at his death by a vision of Jesus, Mary, and Joseph. Jesus took him by the hand, just as He holds the hand of Joseph in the paintings by Castillo, Correa, and others.[51] In other instances, Joseph reportedly visited the deathbed

Plate 1. Anonymous, *St. Joseph and the Christ Child*, 16th century.
Feather mosaic, 13 ½ x 9 ½ in. (34.3 x 24.1 cm).
Museo de las Américas, Madrid

Plate 2. Anonymous, *The Water God Tlaloc*, 16th century.
Polychrome and metal leaf on European paper, 12 ¼ x 8 ¼ in. (31.1 x 21 cm).
Codex Ixtlilxóchitl, Bibliothèque Nationale de France, Paris © BnF

Plate 3. Juan Montero de Rojas (c. 1613–1683), *Dream of St. Joseph*, 1660s.
Oil on canvas, dimensions unknown.
Church of Don Juan de Alarcón, Madrid

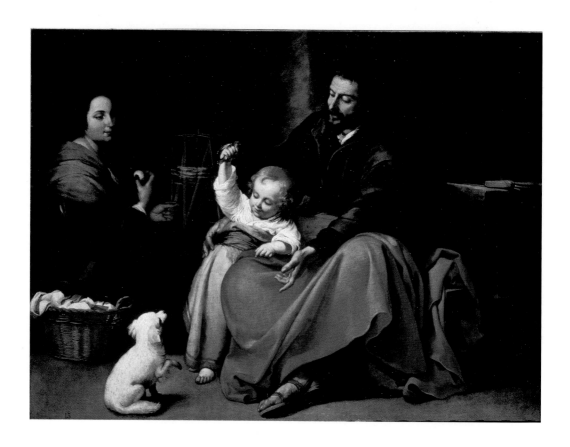

Plate 4. Bartolomé Esteban Murillo (1617–1682), *Holy Family with the Little Bird*, before 1650.
Oil on canvas, 56 ²/₃ x 74 in. (144 x 188 cm).
Museo del Prado, Madrid

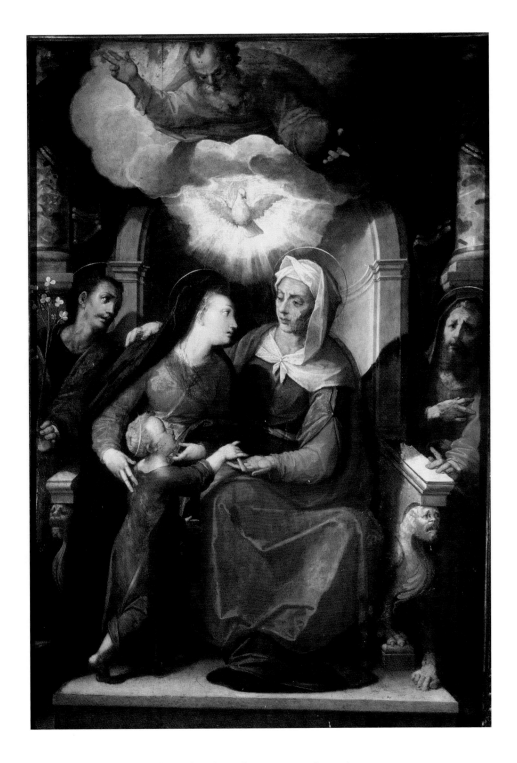

Plate 5. Andrés de la Concha (d. 1612), *Holy Family / Cinco Señores*, late 16th century.
Oil on canvas, dimensions unknown.
Catedral, Capilla de Nuestra Señora de la Soledad, Mexico City

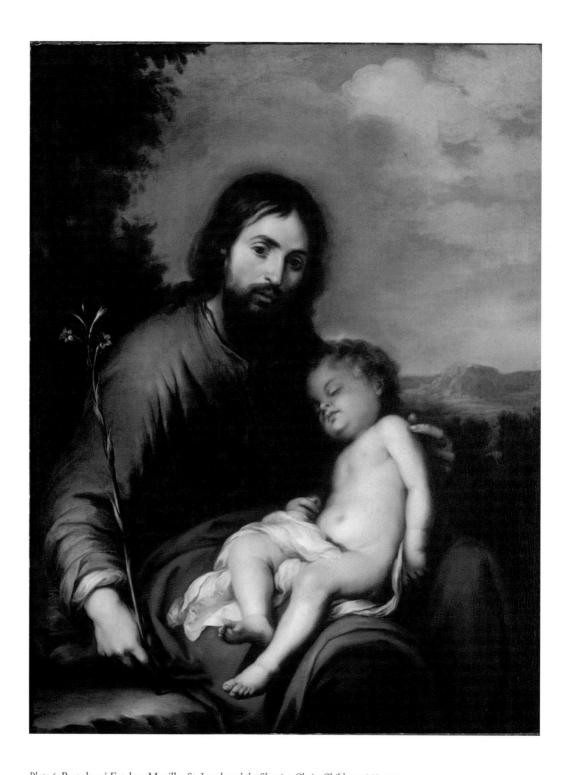

Plate 6. Bartolomé Esteban Murillo, *St. Joseph and the Sleeping Christ Child*, c. 1668–75.
Oil on canvas, 49 $\frac{1}{2}$ x 37 $\frac{5}{8}$ in. (126 x 95.5 cm).
Mildred Lane Kemper Art Museum, Washington University in St. Louis, Missouri. Gift of Leicester Faust and
Audrey Faust Wallace, 1941

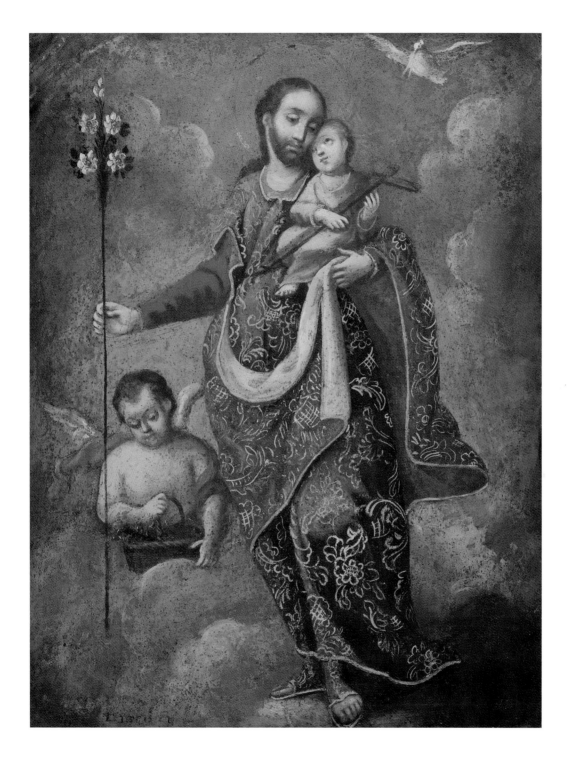

Plate 7. Nicolás Enriquez (1722–1767), *St. Joseph and the Christ Child*, 18th century.
Oil on copper, 16 ¹/₂ x 12 ¹/₂ in. (42 x 31.8 cm).
El Paso Museum of Art, El Paso, Texas; gift of Mr. and Mrs. Dorrance D. Roderick

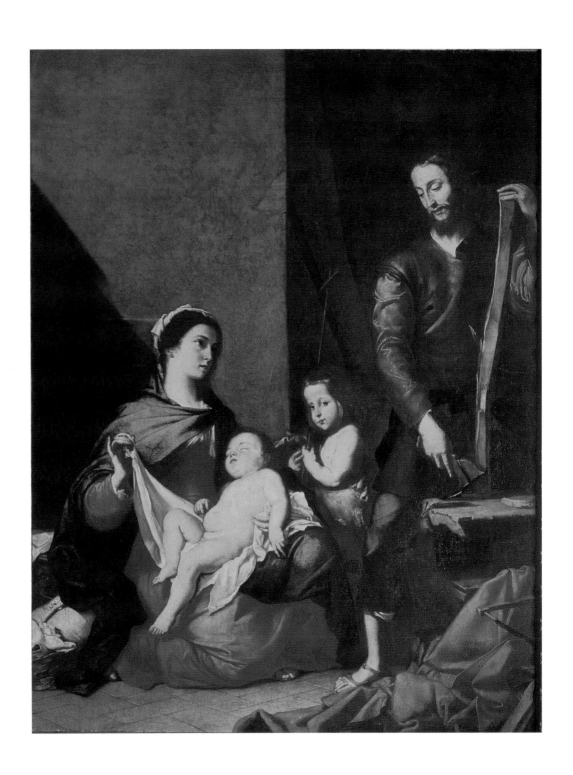

Plate 8. Jusepe de Ribera (1591–1652), *Holy Family in the Carpenter's Workshop*, 1639.
Oil on canvas, 6 ft. 6 in. x 8 ft. 4 in. (2 x 2.6 m)
Museo de Santa Cruz, Toledo, Spain

in the company of angels. People who owned images of the saint received special rewards at their death.[52] St. Joseph personally transported one devotee to heaven, according to Pastrana.

Joseph was also reputed to help those in danger of dying in sin. To die without the Church's last sacraments doomed one to eternal damnation. In one case, Joseph restored the speech of a dying man so that he could partake of the last rites.[53] In another instance, Joseph miraculously revived a member of a Josephine confraternity who had expired in mortal sin so that he could die with the proper sacraments.[54] People who prayed to images of the saint enjoyed special protection. A man in Venice who had an image of Joseph in his house became so gravely ill that he forgot about the sacraments: "He saw St. Joseph enter, the same figure as the image in his house," confessed to the saint, who absolved him of his sins, and then died within the Church.[55]

As an extension of his role as patron of the good death, in the early modern Hispanic world St. Joseph was also renowned for saving lives. Numerous accounts from the period testify to devotees' belief in his abilities to save people from accidents and illnesses.[56] In one instance, a painting of the Death of St. Joseph reportedly saved the life of an African man who fell into a well.[57] In another case, a priest saw a child drowning in a river: "The servant of God knelt before an image of my lord St. Joseph, who was the patron of the children's school, that was there on an altar . . . Thus, without knowing how, the child escaped."[58] In another case, a woman choking to death on a fish bone placed a medal of the saint on her throat, and her life was miraculously saved.[59] In 1666, an eleven-year-old boy dying of typhus was spared when his grandmother placed a canvas of St. Joseph on the boy's body.[60] A friar, also sick with typhus, was reputedly cured because he kept a print of the saint.[61] A print of Joseph was similarly credited with saving another man's life.[62] In another case, St. Joseph brought a little girl back to life after her distraught mother hugged an image of Jesus, Mary, and Joseph, and prayed to the latter.[63]

The evidence of miracle accounts and descriptions of devotional practices enriches our understanding of Spanish and Mexican representations of the death of St. Joseph. All religious art has a purpose; it cannot be studied separate from its original functions. Images of Joseph's death, as we have seen, provided beholders with an example of the good death to imitate. Their emphasis on dying a natural death was rather unusual. Saints were usually depicted as martyrs or in more dignified funeral scenes. This focus drew attention to Joseph's humility. The images were also designed to promote observance of the Catholic sacrament of the last rites, thereby upholding Church control over every aspect of its members' lives.

Because these images were produced in an era of almost unparalleled mortality from disease, depictions of St. Joseph's death took on special poignancy by suggesting the heroic potential of ordinary suffering. Death was ever present on both sides of the Atlantic. One of the major causes of Spain's drop in population in the early modern period was recurrent

outbreaks of plagues and epidemics. Social historians have maintained that after the Black Death of the fourteenth century, no other century had ever known such devastating disease as the seventeenth.[64] Beginning with a series of outbreaks in 1580, which struck northern and central Spain, one scholar has estimated that plagues took 1,250,000 lives in seventeenth-century Spain. After continuing epidemics (in 1599–1601 and 1629–31), the most serious plague broke out between 1647 and 1652, leaving in its wake over 500,000 victims. The city of Seville, which had been the third largest in the world after Paris and Naples, lost half its population in a three-year period. Plagues struck Spain again between 1676 and 1685, killing 250,000 people. Recurrent natural disasters such as floods that destroyed crops, thereby causing famine, worsened the devastation. The food shortages, caused by natural disasters and a paucity of workers, led to inflation, and the country additionally suffered currency deflation and political rebellion.[65] Spain's population, which in 1596 numbered 8.5 million people, sunk to 6.5 million by 1650. It would not reach sixteenth-century levels again until after 1700.[66]

During the continual plagues, worshippers could seek solace in images of Joseph's death. Like the victims of the epidemics, he, too, had died wracked by fever and pain. Devotion to him could ease the suffering at the hour of death.

Not surprisingly, Spanish seventeenth-century society seems to have been marked by a preoccupation with death, as previous scholars have noted.[67] The theme is taken up repeatedly in Baroque art and literature. Numerous texts pondered the subject, such as Luis de la Puente's *Meditaciones Espirituales* (1554–1624) which included two chapters entitled "Meditations on Our Last Days" (*Meditaciones de Nuestras Postrimerías*), Miguel Mañara's *Discurso de la Verdad*, Alejo Venegas's *Agonía del tránsito de la muerte* (1583), and Carlos Bundeto's *El espejo de la muerte* (1700). Paintings, too, took up these themes, including works like Bartolomé Román's *The Good Death* (1596–1659; active 1614–45; Museo Cerralbo, Madrid), or Juan de Valdés Leal's two canvases in the Santa Caridad in Seville, *In Ictu Oculi* and *Finis Gloriae Mundi* (1662–90; c. 1671).[68] Although paintings of the Death of St. Joseph are clearly part of this phenomenon, they seem to give voice to a new, alternative discourse about life's end. Instead of asking worshippers to meditate on such macabre thoughts as the pains of dying or the decaying of flesh, Josephine images and their corresponding devotional literature urged believers to prepare for their final moments calmly, so that they might pass to the other world in happiness.

This new approach to death may have resonated with particular force in Mexico. Scholars have commented on how, in comparison to Western attitudes, Mexican indigenous cultures seem more accepting of death's inevitability. The celebration of *Día de los muertos* (Day of the Dead) at the beginning of November, at which time Mexicans traditionally honor their departed loved ones with foodstuffs such as candy and *pan de muertos* (bread of the dead), illustrates Mexican culture's acceptance of death as part of life.[69] These distinctive

cultural attitudes, in fact, may explain the great popularity of Josephine death scenes in colonial Mexican art.

In the narrative of St. Joseph's life constructed by Counter-Reformation hagiographers, the saint's death was followed by bodily resurrection to heaven and coronation. While paintings of the Death of St. Joseph promised aid in the dangerous and fearsome passage from life to death, the scene of Joseph's Coronation held out the promise of protection on earth. Francisco de Zurbarán's *Coronation of St. Joseph*, datable to about 1636, is a rare example of the theme in Spanish Baroque art (fig. 80). It depicts Christ standing on Joseph's left with His cross, as the personification of the *vivo crucifijo*, or living cross, crowning His foster father with a wreath of flowers.[70] Joseph, shown as an older man with a graying beard and hair, kneels before his foster Son, flowered staff in hand. God the Father looks down from the top left corner and the dove of the Holy Spirit hovers over the center of the scene.[71]

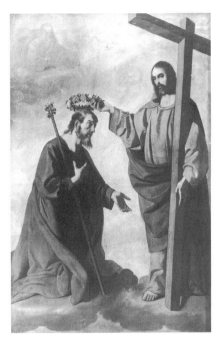

Fig. 80. Francisco de Zurbarán, *Coronation of St. Joseph*, 1639. Oil on canvas, 99 $^1/_5$ x 65 $^1/_3$ in. (252 x 166 cm). Museo de Bellas Artes, Seville, Spain

Zurbarán's *Coronation of St. Joseph* produces meaning through its similarities to images of the Coronation of the Virgin. A version by the studio of Alonso Cano of the 1630s is typical of Sevillian renditions of the theme (National Gallery, London). It depicts the Virgin kneeling before the seated figures of Christ and God the Father, the dove of the Holy Spirit above their heads. Christ reaches out His hand in blessing, about to touch His mother, behind whom putti bear a life-size cross. The *Coronation of Joseph* includes many of the same elements: the kneeling figure, Christ extending His hand, the life-size cross, the dove, and God the Father. Although images of Joseph's Coronation are rare in Spanish art, several other paintings imply the saint's heavenly coronation. In a painting by Bartolomé González (1564–1627; Palacio Real, El Pardo), for example, the saint appears enthroned in the heavens, holding the Christ Child in his arms.

Fig. 81. José de Ibarra (1685–1756), *Coronation of St. Joseph*, 1735. Oil on canvas, 6 ft. 11 in. x 10 ft. 3 in. (2.1 x 3.1 m). Museo Nacional del Virreinato, Tepotzotlán, Mexico. CONACULTA-INAH-MEX

The subject of St. Joseph's Coronation was much more frequent in Mexican art, especially in the eighteenth century. Colonial artists often combined it with scenes of Joseph's Protection or Patronage (*patrocinio*). These large-scale works were intended as explicit emblems of allegiance to the Spanish king. José de Ibarra's *Coronation* (fig. 81), signed and dated 1735, is typical. As God the Father looks on from above, Christ and the Madonna place a bejewelled gold crown upon the enthroned

St. Joseph's head in a compositional arrangement reminiscent of Coronation of the Virgin scenes. Since Joseph's facial features strongly resemble those of his foster Son, and because the figures of God, Joseph, and the dove of the Holy Spirit are aligned in the composition's center, the viewer's initial impression is that the main figures represent the Holy Trinity. On second glance, though, one realizes that the four figures and the dove are the members of the Double or Earthly Trinity, but with the positions of Joseph and Jesus reversed. Ibarra combined the Coronation and Double Trinity compositions with a third pictorial type designed to suggest the saint's protective powers, the representation of the saint as the "Joseph of Mercy." Ibarra's painting, which represents Church and civil authorities (including the pope and Spanish king) kneeling beneath St. Joseph's flowered cloak for protection, derives from depictions of the Madonna of Mercy. Amongst the group of civil officials on the right, Ibarra memorialized the patron of this work, commissioned for the St. Joseph reliquary chapel in Tepotzotlán, with the following inscription: "A Devocion de D. Diego Ruiz de Aragonez."[72] At St. Joseph's feet appear representations of the sun, moon, and seven stars, as well as biblical verses that refer to the Old Testament Joseph. The implications of such a comparison were clear to Josephine advocates: just as the first Joseph had served Egypt's pharaoh, St. Joseph now served Spain's king, a comparison made not just by artists, but one that also frequently appeared in Josephine texts.[73]

Whereas in Ibarra's painting the emphasis seems equally divided between the Coronation and Protection scenes, in other images, colonial artists subtly shifted the pictorial focus to St. Joseph's protective role, while retaining the coronation reference. In a painting attributed to Miguel Cabrera (fig. 82), two angels place a floral crown on the saint's head. Much more noticeable, however, are the legions of kneeling devotees sheltered below St. Joseph's cloak. Angels also crown the saint in an enormous eighteenth-century work by Miguel Jerónimo Zendejas (fig. 83) in Mexico City's cathedral. Like Alcíbar's work in Tepotzotlán, it, too, revolves around the conflation of the celestial and earthly trinities, suggested through the alignment of God the Father, the dove of the Holy Spirit, and St. Joseph with the Christ Child in his arms. Below, an impressive array of elaborately costumed Church and state officials seeks St. Joseph's favor. In some works, Mexican artists simply depicted the saint crowned, implying the act of coronation, as in another painting by José de Ibarra of the Co-Regents of Zacatecas (fig. 84), and other works. Mexican sculptors also executed portrayals of St. Joseph's protection. One, dating to the eighteenth century, adorns the facade of the Colegio de San Ildefonso in Mexico City.

Our understanding of the Coronation scene can be expanded by reference to Josephine texts. Because the story of Joseph's resurrection was not told in the

Fig. 82. Attributed to Miguel Cabrera (1695–1768), *Coronation of St. Joseph*, 18th century. Oil on canvas, 11 ft. 5 in. x 8 ft. 4 in. (3.5 x 2.5 m). Museo Regional, Guadalajara, Mexico

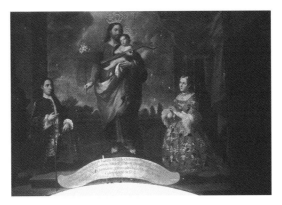

Fig. 84. José de Ibarra, *St. Joseph and the Co-Regents of Zacatecas*, 18th century. Oil on canvas, dimensions unknown. Museo Virreinal, Guadalupe de Zacatecas, Mexico

Fig. 83. Miguel Jerónimo Zendejas (1750–1815), *St. Joseph's Protection*, 18th century, dimensions unknown. Oil on canvas. Catedral, Mexico City

Bible, theologians had been debating it since the time of Jean Gerson. By depicting Joseph crowned in heaven, paintings of the Coronation participated in this debate, positing that, like Christ and the Madonna, Joseph, too, was assumed to heaven body and soul. This bold valorization of his figure was designed to elevate Joseph in the saintly pantheon.

According to Hispanic theologians, Joseph's body was resurrected four years after his death by Christ Himself at the moment of His own Resurrection. Thus the Holy Family was joyfully reunited.[74] On the day of Christ's Ascension, Joseph rose to heaven in the company of his divine Son to attain eternal glory, where choirs of angels and rejoicing saints greeted them.[75] With no biblical source supporting the idea that Joseph was resurrected, theologians justified it with several different explanations.[76] First, it was Christ's way of honoring Joseph as His earthly father. Second, the Earthly Trinity was needed in the heavens to complement the divine one. According to one devotional writer: "St. Joseph is in heaven in body and glorious soul: in order that, as there is one trinity of divine personages, so too there is another trinity of human people, who are Christ, the Virgin, and St. Joseph."[77] Third, Jesus wanted to honor Joseph in the same manner as He would later honor His mother, Mary.[78]

The fact that Joseph's body could not be located was taken as further proof that the saint had been resurrected. A major Counter-Reformation hagiographer, Pedro de Ribadeneira,

deduced that "[a]nd thus there is no doubt but that this most holy Patriarch is in heaven in a most eminent place: and some doctors say that he is there in body and soul; they say this because they don't know where his body is (and if he were on the earth, God would not want that he be hidden and lacking the honor that other minor saints have)."[79] The only existing Josephine relics were his staff, the ring from the Betrothal, and various cloaks. The Camaldulense Fathers of the Church of the Angels in Florence laid claim to St. Joseph's staff. The ring could be found in Perugia, Italy, a major center of Josephine devotion. Various churches in Europe and the New World professed to own pieces of St. Joseph's various cloaks. The Church of St. Cecelia in Trastevere, Rome claimed ownership of a piece of the cloak St. Joseph was wearing when he first held the newborn Christ Child. Another cloak was venerated in Rome's Church of St. Anastasia. This one, a "fabric of diverse colors," was St. Joseph's "other mantle," the one in which Jesus was wrapped as a newborn. The Discalced Carmelites also held pieces of this vestment in Antwerp. Two churches in Bologna, St. Joseph of the Market and St. Dominic, also preserved pieces of Joseph's clothing. In the Americas, Josephine relics were no less numerous. The Jesuits of Mexico City and Lima, Peru, also claimed pieces of St. Joseph's cloak. St. Joseph's Reliquary Chapel in Tepotzotlán, the Jesuit school for natives and a center for indigenous language instruction located on the outskirts of Mexico City, possessed "a very small piece" of the saint's mantle, evidently the same as that venerated in Antwerp, because both were the color of straw or saffron, according to reports.[80] Because they were thought to cure illnesses, these Josephine relics were widely venerated in the Spanish Empire.[81]

According to Josephine texts, not only did Christ swear to His foster father on his deathbed that he would ascend to heaven, but Christ also promised to crown him there.[82] Theologians maintained that Jesus honored His foster father by bestowing upon him the three crowns of Virgin, Martyr, and Doctor.[83] His crown was composed of nine stars, which stood for his excellencies: 1) his royal dignity as the head of the Holy Family and the father of Jesus; 2) his being chosen by God for these jobs; 3) his virtue of justice, the universal, perfect virtue that includes all of the others (obedience, perseverance, humility, devotion, patience, zeal, tears, constancy, fortitude, and purity); 4) his spotless virginity; 5) his love for the Virgin Mary; 6) his twenty-seven years of daily life with the Virgin; 7) his manual labor on behalf of the Holy Family; 8) his incomparable honor; and 9) his years in the presence of, and communication with, Christ.[84] The crown of flowers, which appears in several paintings, was specifically described by the poet Valdivielso as a wreath of roses, jasmines, and lilies, flowers traditionally associated with St. Joseph.[85] According to a sermon preached in Puebla, Mexico, the floral crown was an emblem of Joseph's "fragrant" virginity.[86]

In the opinion of the Josephine writer Pastrana, Joseph deserved his crown because

he was of royal blood. Passages in texts that discuss the Coronation routinely point out the saint's royal lineage as a descendant of the House of David: "Joseph is the son of a king, since he was a son of David: IOSEPH *fili David*. He was a royal person."[87] In fact, the saint should be called "king," because he was the husband of the Queen of the Heavens, the Virgin Mary, who herself wears a crown.[88] Because he was a king, whether through his position as the husband of the Queen of the Heavens or through his royal lineage, Joseph was routinely invoked as a special guardian of the Spanish kingdom. Joseph was a powerful protector of Spain because he was God's *privado*, or favorite minister.[89] In Mexico, he was designated "God's viceroy."[90] A sermon preached in Puebla, Mexico, to commemorate the "Festive Imperial Coronation of the Most Holy Patriarch Master St. Joseph" on September 6, 1788, lauded the saint as "viceroy of the Universe," "Sovereign Prince and Master of the Universe," and "Emperor of the Earth," key phrases that linked St. Joseph's Coronation to the idea of earthly rulership.[91] According to other authors, St. Joseph's crown symbolized civic and military virtues, as well as the triumph of just governments over "powerful enemies."[92] The crown being bestowed upon Joseph in various paintings therefore constitutes a synecdoche of all these excellencies. Prayers to Joseph were thus effective in the restoration of the monarchy, improvement of the well-being of the Spanish kingdom, and the attainment of peace.[93] Only through Joseph could the monarchy achieve success, the prince quietude and good health, and the kingdom well-being.[94] Particularly in the later seventeenth century, as Spain's political situation became more and more precarious, Spaniards offered prayers to Joseph on behalf of their monarchy. Thus, not only did Coronation paintings participate in theological debate on Joseph's saintly status, but they also functioned to valorize the Spanish monarchy.

In 1679, King Charles II named St. Joseph official patron saint of the Spanish realms, replacing the country's protector for over 800 years, Santiago (St. James). Pope Innocent XI affirmed the declaration by issuing a papal brief reiterating St. Joseph's position as Spain's patron. On March 19, 1680, the royal edict and accompanying brief arrived in the Mexican port city of Veracruz, occasioning a festive celebration and sermon preached in honor of the "oath of the new patronage."[95] According to copies of edict and brief, which circulated throughout Mexico, King Charles II ordered all viceroys, presidents, audiencias, governors, and city councils of the provinces of Peru and New Spain, as well as archbishops, bishops, and all church and cathedral ecclesiastical councils, to receive St. Joseph as guardian.[96] An entry in the Puebla town council's book of decrees records that the city observed the "Celebration of St. Joseph's Patronage of the Spanish monarchy" on May 12, 1680: "having sounded the bells at the hour of eight in the morning, a great number of persons of all stations joined together in the holy cathedral . . . they formed a procession to celebrate the designated fiesta this day to the glorious Patriarch St. Joseph in virtue of what was mandated by Royal

decree. . . . so that [St. Joseph] shall be venerated as guardian ["tutelar"] of the Monarchy of Spain."[97] A document dated May 2, 1680, describes Morelia's official response to the decree and brief, both of which had arrived the previous month. According to the book of resolutions, the ecclesiastical council ordered that the following Sunday "Señor St. Joseph be taken out of the holy church in procession, as is the custom" to commemorate the saint as patron and guardian of all the Spanish realms.[98]

St. Joseph's association with the Spanish monarchy earned him a featured position on the enormous Altarpiece of the Kings in Mexico City's cathedral. Built from 1717–37, the enormous gilt Ultrabaroque retable features a central painting of the Adoration of the Magi, surrounded by sculptures of king- and queen-saints. The Virgin of the Assumption, titular saint of the cathedral, ascends from the retable's upper reaches to the heavens to be named Queen of Heaven. St. Joseph flanks her on the right and Teresa de Ávila on the left.[99] St. Joseph was so closely associated with the official government that in 1871 he reputedly came to the aid of government forces during a battle between the army and insurgents in Saltillo, an act reminiscent of Santiago's miraculous appearances during key battles of the Reconquest and Conquest.[100]

The first documented celebration of a separate feast in observance of the Protection of St. Joseph can be dated to shortly after his elevation as protector of the Spanish Empire during the reign of King Philip V. In Mexico the feast was observed on the third Sunday after Easter.[101] A sermon preached in Mexico City on April 29, 1714, by the author Antonio de Mansilla, a Franciscan friar and Inquisition official, commemorated this day as the first official celebration of the Protection feast in the king's name.[102] The sermon, delivered in "the Parish of the Indians," the "first chapel" "in all of America"— that is, in San José de los Naturales—lauded Joseph as "Godfather (*Padrino*) of the Kingdom of the Indies, of this invincible King of the Spanish Realms, and of this First Church of the churches." As "godfather" of the Indies, who felt a "singular love" for the Spanish kingdom, St. Joseph had played a special role in the conversion of the indigenous population.[103] Indeed, according to Friar Mansilla, "Now there is no place in this kingdom without joy, since from the moment that St. Joseph offered himself as Godfather, the Indians and all parts of the Indies are happy; in the mountains, without idols; in the countryside, without crop failures; in the cities, without barbarians; in the villages, without gods; and on all the roads, without superstitions."[104]

Several additional descriptions of Mexican celebrations of St. Joseph's Protection have come down to us, indicating the importance of this feast in the colonial era. A "letter of slavery"—or proclamation of devotion—from a Josephine confraternity in Mexico City's church of San José de Gracia indicates that, in the eighteenth century, confraternity members gathered to pray for "concord between Christian Princes, the extirpation of heretics, and the

exultation of our Holy mother Church" on the feast of St. Joseph's Protection. This same group observed St. Joseph's Protection as their titular feast.[105] In 1767, the Congregation of Oratorians of St. Philip Neri in Mexico City's Church of La Profesa established a separate celebration of St. Joseph's Protection in addition to observance of his March 19 and July 20 feast days. That same year, on May 9, 1767, the Oratorians elevated Joseph as patron of La Profesa, commissioning a painting of St. Joseph's Protection to honor the occasion. Said painting was unveiled on September 12, 1767, during a special ceremony in which the Philippians sang Joseph's praises: "From Joseph favorable protection / Let us live without hurt or danger." The painting featured St. Joseph standing in the middle of the canvas, his outstretched cape protecting the kneeling Philippian fathers. The founder of the Oratorians, St. Philip Neri, points to a textual inscription that reads "Ite ad Joseph," or, "Go to Joseph" (Gen. 41:55).[106]

In 1788, the city of Puebla, Mexico, observed a special celebration of the "Festive and Imperial Coronation" of St. Joseph with a three-day holiday. The festivities included a citywide celebration, a procession, and fireworks. It culminated with the official crowning of an image of St. Joseph from the Puebla parish named after him. The sermon preached on the first day of the festivities, which was funded by a Josephine confraternity, was published in 1789 in order to "perpetuate through the centuries the Solemnity of your [St. Joseph's] Imperial Coronation." It describes the return of the crowned image to the parish of St. Joseph, reputedly the largest celebration ever held in the city: "Upon the arrival of your Sacred Image in the Atrium, the area was covered with a large multitude of doves which took off in flight, crowned with glittering crowns, covered with little colorful banners, and their breasts adorned with the respective escutcheons of the various neighborhoods. So numerous were the flowers that were thrown, that in but a minute no one was able to see your Image."[107]

According to reports, it was the most peaceful public gathering ever witnessed in Puebla. Despite the large assemblage of people of different social classes and neighborhoods, "who carried with them like original sin from the founding fathers a detestable, hateful envy that neither the wisdom of the shepherds [i.e., priests] nor all the rigor of justice had been able to extinguish," peace and harmony reigned: "I saw on that lucky day, with the greatest rejoicing, and with the greatest tenderness, inveterate enemies hug each other tightly." Indeed, the celebration of St. Joseph's Coronation was marked by "the general reconciliation of all the neighborhoods" of Puebla, leading the preacher to designate the crowned saint the "Rainbow of Peace."[108] Other Josephine devotees also promoted the saint's peacemaking powers. A Josephine confraternity in Mexico City urged its members to promote peace between enemies in honor of the saint.[109]

In the Americas, as proxy for king and viceroy, the figure of St. Joseph—the model father, caring spouse, hard-working provider—became the perfect paradigm of Spanish

colonial power. In Spain, St. Joseph's role as protector of the empire took on special meaning against the backdrop of the sustained economic crisis of the period. During this era of economic depression, currency devaluation, skyrocketing taxes, and the bankruptcy of the Spanish monarchy, St. Joseph was elevated as an emblem of social welfare by Church and state.[110] Establishments that tended to the needs of Spain's dispossessed, such as orphanages, hospitals, and charitable confraternities, sprung up all over Spain, many dedicated to the saint. These institutions commissioned paintings and sculptures of the blessed patriarch.[111] A hospital for the poor founded in the late sixteenth century in Getafe near Madrid, dedicated to "Señor San José," commissioned an altarpiece of St. Joseph for its chapel.[112] Josephine confraternities and orphanages also commissioned images of the blessed carpenter, as discussed in chapters 3 and 5. Cast as the saint of social welfare, St. Joseph and his images addressed the newly perceived problems in Spanish society.

Similarly, in colonial Mexico, a number of hospitals, orphanages, and confraternities dedicated to the saint were founded. One of the major purposes of these groups was to perform acts of charity, both for their members and the community at large. The constitutions of Josephine confraternities often spell out the charitable acts expected of members. In the Esclavitud del Glorioso Patriarcha Señor San Joseph in Mexico City's Church of San José de Gracia, members were urged to come to the aid of the poor, the sick, and the dying, as well as to pray for the souls of the dead.[113] A number of hospitals dedicated to the saint were also founded, including the Hospital Real de San José in Mexico City; the Hospital de la Virgen de Guadalupe y de San Joseph, founded in 1659 in "la Ciudad de Toluca de San Joseph;" the Hospital de San José de Gracia in Querétaro; and the Hospital de San José in Aguascalientes.[114] In 1560, Pope Pius IV granted a plenary indulgence to all who visited the chapel of St. Joseph and donated money to the hospital's poor and to the orphans.[115] The St. Joseph Chapel in Mexico City's Church of San Juan Letrán was home to a school for children. Thus, the figure of St. Joseph was strongly linked to institutions of social welfare both in Spain and in Mexico.

The evidence presented in this chapter suggests that the cult of St. Joseph was deployed as an emblem of the unified Spanish state. The assertion that Joseph was a national saint whose domain and protection extended throughout the Spanish Empire was one of the most striking of the many remarkable qualities attributed to St. Joseph. Prior to the seventeenth century, saints in Spain were associated with specific locales. They were, in the words of the anthropologist William A. Christian, Jr., "local saints," whose cults were tailor-made to reflect location-specific religious practices.[116] For example, the town of Cuenca promoted its own benefactor, St. Julian, and every village had its own patron, feast day, and procession.[117] Joseph, in contrast, was considered the universal saint of Spain and its empire. This metamorphosis from local to all-inclusive religious devotion finds an intriguing parallel in the shift

from the fragmented political structure of medieval Spain to the emergence of the modern bureaucratic state under the Habsburg kings.[118]

National unity was a timely subject. The seventeenth century witnessed the reconsideration of the fate of Spain's Jews, who had been ejected from the country or forced to convert to Catholicism in 1492 by the Catholic Monarchs Ferdinand and Isabella. In the sixteenth century, those who had chosen conversion were the object of intense persecution by the Inquisition.[119] During the reign of King Philip IV in the seventeenth century, Spain's prime minister, the Count-Duke of Olivares, conceived a plan to bring the Jews back to Spain. A descendant himself of a *converso* family, he fought to abolish the *limpieza de sangre* (purity of blood) statutes that prevented descendants of Jews from holding public office.[120] Theologians, writers, and artists drew attention to Joseph's Jewish heritage. In paintings depicting Joseph's participation in Jewish rituals such as the Circumcision, the Purification, or the Betrothal, artists took care to describe the rituals accurately. Joseph was heralded a model convert to Christianity, a saint for *converso*s to emulate. In other images, such as paintings of St. Joseph holding the Christ Child, and in devotional texts, the saint is held up as model convert to Catholicism, who although born Jewish, eagerly embraces Christ both literally and figuratively.

The Spaniards also attempted to present St. Joseph as an emblem of unity in the New World. In 1527, only six years after the death of the last Aztec ruler, Cuauhtémoc, the first Indian church was built in Mexico City dedicated to St. Joseph (San José de los Naturales).[121] In 1555, at the first meeting of the Provincial Mexican Council of the Catholic Church, St. Joseph was proclaimed the patron of New Spain, his patronage extending throughout modern-day Mexico, Nicaragua, Costa Rica, Panama, Guatemala, El Salvador, and the Philippines.[122]

Josephine imagery played a crucial role in the conversion of the indigenous population. Indeed, the construction of Joseph as a patriarchal but beneficent father figure defines the paradigm of Spanish colonialism. He was repeatedly invoked as the special protector of indigenous and African peoples in the New World. Miracles worked by him on behalf of the native population were reported in great numbers.[123] Presented to the Indians as a protective figure, Joseph was seen as the representative of God and the king in New Spain.[124] During the conversion efforts in China and the East, Spanish Jesuits translated Joseph's life and devotional books into Chinese.[125] Thus, St. Joseph became not just a national saint, but also the protector of the entire far-flung Spanish Empire.

The shift from geographically localized saints to Joseph's national domain finds a parallel in saints' shift from specific advocations to universal authority and power. This transformation is demonstrated by the many different roles played by St. Joseph in early modern Spain and Mexico. He was a universal saint who, because of his wide-ranging intercessionary

powers, could grant his devotees any kind of aid. Whereas other saints were thought to be effective in specific circumstances, seventeenth-century texts asserted that devotion to Joseph would help worshippers in all aspects of their lives. According to one of these works, St. Blas was reputed to cure people of throat illnesses; St. Lucy healed diseases of the eyes; St. Ramon Nonato aided women in dangerous births; St. Apollonia cured toothache; St. Gregory remedied stomach ailments; St. Liborio helped those afflicted with "bad urine"; and people with fevers directed their prayers to Saints Dominic, Hyacinth, and Nicolas of Tolentino. Businessmen facing bankruptcy prayed to Saints Diego of Bebaña and Dominic, while those involved in damaging lawsuits sought help from St. Henry. Saints Anthony of Padua and Elena helped locate lost items. In contrast, St. Joseph was said to help worshippers with everything: "But God has granted universal grace to my lord St. Joseph to remedy and console everyone who puts himself in his hands in all their necessities, illnesses, business transactions, and afflictions."[126]

The all-inclusive encomiums of St. Joseph penned by Hispanic theologians notwithstanding, the saint seems to have played three important roles in the early modern period. As I have argued in previous chapters, he provided an ideal of familial behavior, in the process defining new discourses of masculinity. The images examined in the final chapter pictorialized Joseph's two other roles: symbol of the unified Spanish Empire and emblem of social welfare. His image, which spoke to, and helped mediate, major concerns of the period, demonstrates the need to study religious art not only in terms of its aesthetics, but also as a key participant in, and articulator of, major discourses of the time.

CHAPTER
SEVEN

EPILOGUE

Τ HE SEVENTEENTH-CENTURY MOVEMENT to elevate St. Joseph as protector of Spain
reached its apex in 1679, when King Carlos II of Spain declared Joseph the patron of all
Spanish dominions. In Mexico, the news was reportedly greeted with widespread celebra-
tion. Only one year later, however, King Carlos rescinded the decree amidst fears that an envi-
ous Santiago, the former patron, might retaliate.[1] The King reinstated Santiago to his
position of honor. Faring better in the Americas, St. Joseph remained sole patron of Mexico
until 1746, at which time the Mexican Virgin of Guadalupe was elevated as his co-patroness.
While La Guadalupana's supporters reasoned that St. Joseph would be more than happy to
share his post with his wife, the event clearly marked an important and seemingly terminal
milestone for the cult of St. Joseph.[2] While St. Joseph remains co-patron of Mexico to this
day, his cult is now overshadowed by that of the Mexican Madonna, whose basilica on the hill
of Tepeyac, the site on which many Catholics believe she miraculously appeared to the native
convert Juan Diego, is one of the most important Marian shrines in the world.

Thus, at first blush, the Joseph phenomenon would appear to be a historical failure,
a temporary product of early modern Catholic church attempts at social control. Despite the
Spanish monarchy's official revocation, however, such events did not mark the end of St.
Joseph's cult in either Spain or Mexico. Artists continued to produce works depicting the
humble foster father (including such luminaries as Francisco de Goya, 1746–1828), devotional
writers continued to produce Josephine texts, and ordinary Catholics maintained steadfast
devotion to his figure, which they sustain even to this day.

In the nineteenth century the cult to St. Joseph witnessed two milestone events. On

December 8, 1870, Pope Pius IX declared St. Joseph patron of the Catholic church in the decree "Quemadmodum Deus," published during Vatican Council I. Nineteen years later, in 1889, Pope Leo XIII issued the most extensive papal document ever published in honor of St. Joseph, the encyclical epistle "Quamquam Pluries." It enjoined the faithful to combat attacks against the Catholic church by means of devotion to the saint.[3]

St. Joseph's *cultus* continued to be marshaled in defense of Catholicism in the twentieth century. Pope Pius XI invoked the saint as guardian against atheism. In 1955 his successor, Pope Pius XII, in response to mounting fears of communism, announced a new Josephine feast day, St. Joseph the Worker, to be celebrated on May 1 (May Day). Perhaps the most significant honor bestowed upon the saint in the twentieth century, however, was the declaration of St. Joseph as the patron of Vatican Council II, the most important ecumenical council since the Council of Trent, by Pope John XXIII. One year after his declaration, in 1962, the pope ordered St. Joseph's name inserted into the canon of the mass.[4]

Throughout the twentieth century and continuing to this day, Catholic bookstores, churches, and shrines still provide devotional literature promoting Joseph as model husband and father. The conservative Catholic lay organization, Opus Dei, founded in 1928 in Spain by José María Escrivá, elevates St. Joseph as its patron, taking as its dictum a belief in holiness through work and daily life. In the United States in 1999, "José" was the most common name given to newborn boys in the states of California and Texas, a reflection of the large numbers of Latino immigrants in the U.S. Southwest and their continued dedication to the blessed carpenter. At the popular level, St. Joseph enjoys widespread devotion as the patron of real estate transactions. People hoping to sell their homes bury his statue in their backyards to ensure a sale. Just as in the early modern era, St. Joseph's figure today proves to be not only a malleable political signifier of institutional elites, but also an object of great popular devotion.

NOTES

INTRODUCTION

1. Émile Mâle was perhaps the first to signal the need for an examination of the subject and to point out the importance and novelty of Josephine images in Spanish art: *L'art religieux du XVIIe siècle* (1954; reprint, Paris: Armand Colin, 1984), 282, 284. In a survey of Spanish Baroque painting, Alfonso E. Pérez Sánchez noted that no other saint enjoyed the popularity that St. Joseph did in the period: *Pintura barroca en España (1600–1750)* (Madrid: Cátedra, 1992), 50. Similarly, Santiago Sebastián López observed that a study of the theme of St. Joseph was long overdue in his preface to the exhibition catalogue, *Patron Saint of the New World: Spanish American Colonial Images of St. Joseph* (Philadelphia: St. Joseph's University, 1992), viii.

2. Two older studies of the iconography of Spanish religious art merit mention: Manuel Trens, *María, iconografía de la Virgen en el arte español* (Madrid: Plus-Ultra, 1947); and F. J. Sánchez Cantón, *Nacimiento e infancia de Cristo* (Madrid: Biblioteca de Autores Cristianos, 1948). Important recent studies include Mindy Nancarrow Taggard, *Murillo's Allegories of Salvation and Triumph: The Parable of the Prodigal Son and The Life of Jacob* (Columbia: University of Missouri Press, 1992), the only study of an Old Testament theme in Spanish art; Suzanne L. Stratton, *The Immaculate Conception in Spanish Art* (Cambridge, England: Cambridge University Press, 1994), with a focus on royal patronage; Susan Verdi Webster, *Art and Ritual in Golden Age Spain: Sevillian Confraternities*

and the Processional Sculpture of Holy Week* (Princeton, N.J.: Princeton University Press, 1998), which provides an unusual glimpse into popular patronage practices; and Victor Stoichita, *Visionary Experience in the Golden Age of Spanish Art* (London: Reaktion, 1995), one of the few studies of Spanish art that engages critical theory in its semiotic analysis of visionary painting.

3. On post-Conquest visual practices in Mexico, see the following studies, listed in chronological order: Donna L. Pierce, "The Sixteenth-Century Nave Frescoes in the Augustinian Mission Church of Ixmiquilpan, Hidalgo, Mexico," Ph.D. dissertation, University of New Mexico, 1987; Jeanette Favrot Peterson, *The Paradise Garden Murals of Malinalco: Utopia and Empire in Sixteenth-Century Mexico* (Austin: University of Texas Press, 1993); Dana Leibsohn, "Colony and Cartography: Shifting Signs on Indigenous Maps of New Spain," in *Refiguring the Renaissance: Visual Culture in Europe and Latin America 1450–1650*, ed. Claire Farago (New Haven, Conn., and London: Yale University Press, 1995), 265–81; and Barbara E. Mundy, *The Mapping of New Spain: Indigenous Cartography and the Maps of the Relaciones Geográficas* (Chicago: University of Chicago Press, 1996). On colonial South American art, see Valerie Fraser, *The Architecture of Conquest: Building in the Viceroyalty of Peru 1535–1635* (Cambridge, England: Cambridge University Press, 1990); Tom Cummins, "Representation in the Sixteenth Century and the Colonial Image of the Inca," in *Writing*

Without Words: Alternative Literacies in Mesoamerica and the Andes, eds. Elizabeth Hill Boone and Walter D. Mignolo (Durham, N.C.: Duke University Press, 1994), 188–219; and Carolyn Dean, *Inka Bodies and the Body of Christ: Corpus Christi in Colonial Cuzco, Peru* (Durham, N.C.: Duke University Press, 1999). On the Virgin of Guadalupe, see Peterson, "The Virgin of Guadalupe: Symbol of Conquest or Liberation?" *Art Journal* 51, no. 4 (Winter 1992): 39–47. Two exhibitions in the 1990s focused on depictions of St. Joseph and the Holy Family in the New World. The authors of the catalogue essays came to different conclusions than have I about St. Joseph, demonstrating the interpretive potential of his figure. *Patron Saint of the New World*, exh. cat. and *The Holy Family as Prototype of the Civilization of Love: Images from the Viceregal Americas*, exh. cat. (Philadelphia: St. Joseph's University, 1996).

4. James Lockhart, *The Nahuas After the Conquest: A Social and Cultural History of the Indians of Central Mexico, Sixteenth through Eighteenth Centuries* (Stanford, Calif.: Stanford University Press, 1992), Chapter 6, and especially 235–51. For a recent study of an important Mexican saint, see Brendan R. Branley, "Felipe de Jesús: Images and Devotions," M.A. thesis, University of New Mexico, 2000.

5. On the Inquisition's power to censor religious art, see Henry Kamen, *Inquisition and Society in Spain in the Sixteenth and Seventeenth Centuries* (Bloomington: University of Indiana Press, 1985), Chapter 11, "Popular Culture and the Counter Reformation," and especially 201 and 204. Images that did not meet the Holy Office's standards for religious art were removed from churches and buried. Also consult V. Pinto Crespo, "La actitud de la Inquisición ante la iconografía religiosa," *Hispania Sacra* 31 (1978): 285–322. Francisco Pacheco, the teacher of Velázquez and author of one of the key art treatises of the Spanish Golden Age, worked as an art censor for the Inquisition, a post he discusses on 561 of *El arte de la pintura*, written in the first third of the seventeenth century and published in 1648. The Holy Office's guidelines for the depictions of specific religious imagery are spelled out in Pacheco's "Adiciones a algunas imágines," the fourth and final section of his treatise, *El arte de la pintura*, ed. Bonaventura Bassegoda i Hugas (Madrid: Cátedra, 1990).

6. See Néstor García Canclini, *Hybrid Cultures: Strategies for Entering and Leaving Modernity* (Minneapolis: University of Minnesota Press, 1995); James Clifford, *The Predicament of Culture: Twentieth-Century Ethnography, Literature, and Art* (Cambridge, Mass.: Harvard University Press, 1988); and Stuart Hall, "When Was the 'Post-Colonial'? Thinking at the Limit," in *The Post-Colonial Question: Common Skies, Divided Horizons*, eds. Iain Chambers and Lidia Curtis (London: Routledge, 1996), 242–60.

7. Admittedly, this approach is sure to generate controversy, but it is one that can be very revealing, especially for religious imagery. Microhistories are not always necessary, nor desirable. See the informative discussion of microhistory in Steve J. Stern, *The Secret History of Gender: Women, Men, and Power in Late Colonial Mexico* (Chapel Hill: University of North Carolina Press, 1995), Chapter 9.

8. My thinking on this has been inspired by Svetlana Alpers's critique of stylistic categories in her ground-breaking study, *The Art of Describing: Dutch Art in the Seventeenth Century* (Chicago: University of Chicago Press, 1983); and "Style is What You Make It: The Visual Arts Once Again," in *The Concept of Style*, ed. Beral Lang (Philadelphia: University of Pennsylvania Press, 1979), 95–117.

9. Scholars of Spanish literature, which is marked by traits similar to those seen in painting (including awkwardness, additive compositions, and insistent naturalism), have employed treatises on rhetoric to analyze literary modes, an approach that promises to alter significantly our understanding of Spanish art. My visual readings have been influenced by a belief in the relevance of rhetoric. See Luisa López Grigera, *La rétorica en la España del Siglo de Oro* (Salamanca, Spain: Universidad de Salamanca, 1994). I wish to thank Javier Durán Barceló for directing my attention to the significance of rhetoric for Spanish painting.

10. See Joan Scott's classic article "Gender: A Useful Category of Analysis," *American Historical Review* 91 (1986): 1053–78, as well as more recent theorizing: Judith P. Butler, *Gender Trouble: Feminism and the Subversion of Identity*, 10th anniversary ed. (New York: Routledge, 1999), Preface, and Elizabeth Grosz, *Volatile Bodies: Toward a Corporeal Feminism* (Bloomington: University of Indiana Press, 1994), Chapters 1 and 8.

11. See Mieke Bal and Norman Bryson, "Semiotics and Art History," *Art Bulletin* 73 (1991): 206–7. For an overview of semiotics and art history, consult Bal's and Bryson's entire article (174–208) as well as Donald Preziosi, *The Art of*

Art History: A Critical Anthology, Oxford History of Art (Oxford: Oxford University Press, 1998), Chapter 5.

12. David Herlihy, "The Family and Religious Ideologies in Medieval Europe," in *Family History at the Crossroads*, eds. Tamara Hareven and Andrejs Plakans (Princeton, N.J.: Princeton University Press, 1987), 3–17. Herlihy and others have convincingly argued that medieval hagiographies and religious images "respond" to the realities of households of the times. The overlap between lives of the saints and lives of real people is one of the major themes of Donald Weinstein and Rudolph M. Bell, *Saints and Society: The Two Worlds of Western Christendom, 1000–1700* (Chicago: University of Chicago Press, 1982), Part 1. In the words of another scholar, "The function of religious paintings in conditioning religious and social attitudes cannot be overestimated." See Margaret Miles, "The Virgin's One Bare Breast: Nudity, Gender, and Religious Meaning in Tuscan Early Renaissance Culture," in *The Expanding Discourse: Feminism and Art History*, ed. Norma Broude and Mary D. Garrard (New York: HarperCollins, 1992), 27–37. Recent postmodern theorizing has arrived at similar conclusions: Edith Wyschogrod, *Saints and Postmodernism: Revisioning Moral Philosophy* (Chicago: University of Chicago Press, 1990), especially 25–30. According to Wyschogrod, although all hagiographies are constructions (even those that purport to record the life of a documentable person), they must contain enough elements of facticity to make them believable to period readers.

13. The following studies on masculinity have influenced my thinking: Steven Ozment, *When Fathers Ruled: Family Life in Reformation Europe* (Cambridge, Mass.: Harvard University Press, 1983); Stern, *Secret History of Gender*; Patricia Simons, "Alert and Erect: Masculinity in Some Italian Renaissance Portraits of Fathers and Sons," in *Gender Rhetorics: Postures of Dominance and Submission in History*, ed. Richard C. Trexler (Binghamton: Center for Medieval and Renaissance Studies, State University of New York, 1994), 163–86; Richard C. Trexler, *Sex and Conquest: Gendered Violence, Political Order, and the European Conquest of the Americas* (Ithaca, N.Y.: Cornell University Press, 1995); Abigail Solomon-Godeau, *Male Trouble: A Crisis in Representation* (London: Thames and Hudson, 1997); R. W. Connell, *Masculinities* (Berkeley and Los Angeles: University of California Press, 1995); and Ralph LaRossa, *The Modernization of Fatherhood: A Social and Political History* (Chicago: University of Chicago Press, 1997).

14. For the initial development in the eighteenth century of the idea that paintings are primarily aesthetic objects, see Thomas E. Crow, *Painters and Public Life in Eighteenth-Century Paris* (New Haven, Conn., and London: Yale University Press, 1985), 1–3. According to the Catholic church, religious images are never simply aesthetic, but always act as objects of religious devotion. As early as 787, at the Council of Nicea, the Church decreed that art should be not only aesthetic but also didactic and an aid to stimulate worship. This position was reiterated at the Council of Trent, in its twenty-fifth session (1563). For further information, see Juan Ferrando Roig, *Iconografía de los santos* (Barcelona, Spain: Omega, 1950), 744. The Council of Trent's guidelines for the depiction of religious imagery were codified by Francisco Pacheco in his treatise *El arte de la pintura* (1648).

15. Consult the following important early studies on iconography by Erwin Panofsky, "Iconography and Iconology," *Burlington Magazine* 64 (1934): 117–27; "'Et in Arcadia Ego'," *Philosophy and History: Essays Presented to Ernst Cassirer* (Oxford: Oxford University Press, 1936), 223–54; and *Studies in Iconology: Humanistic Themes in the Art of the Renaissance* (Oxford: Oxford University Press, 1939). Classic examples of the iconographic approach include, among many others, Leo Steinberg, *The Sexuality of Christ in Renaissance Art and Modern Oblivion* (New York: Pantheon, 1983); and John F. Moffit, "Mary as 'Prophetic Seamstress' in Siglo de Oro Sevillian Painting," *Wallraf-Richartz-Jahrbuch* 4 (1993): 141–61. Two important recent studies of secular art in Golden Age Spain employ contemporary texts to shed light on painting: Steven Orso, *'Los Borrachos' and Painting at the Court of Philip IV* (Cambridge, England: Cambridge University Press, 1994); and Barry Wind, *'A Foul and Pestilent Congregation': Ribera and Images of 'Freaks' in Baroque Art* (Aldershot, England: Ashgate, 1997).

16. Louis Réau, *Iconographie de l'art Chrétien*, vol. 3 (Paris: Presses Universitaires de France, 1958), 304–13; and F. L. Filas, S.J., *The Man Nearest to Christ: Nature and Historical Development of the Devotion to Joseph* (Milwaukee, Wis.: Bruce, 1944), 18.

CHAPTER ONE
Creating the Cult of St. Joseph

Fray Antonio Joseph de Pastrana, *Empeños del poder, y amor de Dios, en la admirable, y prodigiosa vida del sanctissimo patriarcha Ioseph, esposo de la madre de Dios* (Madrid: Viuda de Francisco Nieto, 1696), 334: "Qve Despves de Christo Señor Nvestro, Y su Sanctissima Madre, el mayor Sancto, y que mas resplandesce en gracia, y gloria, es mi señor San Joseph." Other Spanish and Mexican Josephine authors expressed similar sentiments: Francisco de Zarate, *El Cordial Devoto de San Joseph* (Mexico City: Francisco Rodriguez Lupercio, 1674), 2: "ninguna devocion despues de la de Maria, no es mas obligatoria, mas honrosa y mas provechosa, que la de este santissimo Patriarca: . . ." Gabriel de Santa Maria, *Tratado de las siete missas de Señor San Joseph, en reverencia de svs siete Dolores, y siete Gozos* (Cádiz, Spain: Juan Lorenço Machado, 1670), 13: "Suposicion tercera que despues de Christo, y Maria Santissima, el mayor Santo que mas resplandece en gracia, y gloria es el señor San Ioseph." On 25, "Cap. II. Prosigue la misma materia, como Señor S. Ioseph se auentaja a los demàs santos en santidad, y en gloria." Joseph de Paredes, *El Santo de Suposicion. Sermon de el Patriarcha Señor San Joseph, Que en su dia 19. de Marzo de 1749. en la Santa Iglesia Cathedral de Merida Provincia de Yucatan* (Mexico City: Nuevo Rezado, de Doña Maria de Ribera, 1749), 1: "Quien pensara, que siendo el objecto glorioso de la presente solemnidad un Santo el mas honrado de Dios en la tierra, y su mas favorecido en el Cielo;" and 16: "desde luego suponemos, que el mas privilegiado no solo de los que han nacido hasta ahora, mas tambien, de los que despues nacerán, es el Señor San JOSEPH: . . ." Ignacio Tomay, *El Sagrado Corazon del Santissimo Patriarcha Sr. San Joseph* (Mexico City: Viuda de D. Joseph Bernardo de Hogal, 1751), 18: "no se halla, ni se ha hallado santo tan engrandecido de Dios con tantos singularissimos dones, favores, y privilegios, como este Celestial Patriarcha."

1. Fray Antonio Joseph de Pastrana, *Empeños del poder, y amor de Dios, en la admirable, y prodigiosa vida del sanctissimo patriarcha Ioseph, esposo de la madre de Dios* (Madrid: Viuda de Francisco Nieto, 1696), 408; and Joseph de Barcia y Zambrana, *Despertador Christiano Santoral, de varios sermones de Santos, de Anniversarios de Animas, y Honras, en orden à excitar en los fieles la devocion de los Santos, y la imitacion de sus virtudes. Que dedica al Gloriosissimo Patriarcha Sr. S. Joseph, Padre, en la opinion, de Jesu-Christo S. N. Esposo verdadero de Maria Santissima, y Patrono Vniversal de los Christianos* (Madrid: Blàs de Villa-Nueva, 1725), 90, "Sermon Decimo, y Tercero del Santissimo Patriarca Señor San Joseph, en la Iglesia del Sacro Monte de Granada, Año de 1677." St. Stephen is traditionally regarded as the New Testament's first saint.

2. My thinking on this point has been influenced by Edith Wyschogrod, *Saints and Postmodernism: Revisioning Moral Philosophy* (Chicago: University of Chicago Press, 1990), Chapter 1, "Why Saints?"

3. For a recent survey of pre-Tridentine Josephine theology, see Carolyn C. Wilson, *St. Joseph in Italian Renaissance Society and Art: New Directions and Interpretations* (Philadelphia: Saint Joseph's University Press, 2001), 3–9. See also F. L. Filas, S.J., *The Man Nearest to Christ: Nature and Historical Development of the Devotion to Joseph* (Milwaukee: Bruce, 1944), 21; Henri Rondet, S. J., *Saint Joseph*, trans. Donald Attwater (New York: P. J. Kennedy and Sons, 1956), 10, 65–66, 76, 105; Enrique del Sagrado Corazón and Fray Pedro de la Inmaculada, O.C.D., "La Doctrina de San Jerónimo sobre San José, esposo de María," *Estudios josefinos* 3 (1949): 51–54; and Marcel Lalonde, C.S.C., "La signification mystique du mariage de Joseph et de Marie," *Cahiers de Josephologie* 19 (1971): 548. In the 4th and 5th centuries, the subject of the marriage between Joseph and Mary was a timely one, as Mary's virginity was under attack by the heretics Helvidius, Bonosus, and Jovinian. On Jesus' "brethren," see Rondet, *Saint Joseph*, 11. In the 16th century, the major early modern Spanish hagiographer Alonso de Villegas, in his life of St. Joseph, soundly rejected the idea that Jesus had brothers: Alonso de Villegas, *Flos Sanctorum Quarta y Ultima Parte, y Discursos, ò Sermones, sobre los Euangelios de todas las Dominicas del año, ferias de Quaresma, y de santos principales: en que se contienen exposiciones literales, dotrinas morales, documentos espirituales, auisos y exemplos prouechosos, para todos estados* (Madrid: Pedro Machado, 1589), 411–13, "Discurso. CXIIII. de san Ioseph, esposo de la Virgen."

4. Rondet, *Saint Joseph*, 14; Tom Richardson Pitts, "The Origin and Meaning of Some Saint Joseph Figures in Early Christian Art," Ph.D. dissertation,

University of Georgia, 1988, 2; Filas, *Man Nearest to Christ*, 98–99; and Marina Warner, *Alone of All Her Sex: The Myth and the Cult of the Virgin Mary* (New York: Vintage, 1983), 189. Devotion to the saint in this early period seems to have developed in the Eastern church, however, where he was worshipped with the Old Testament patriarchs as early as the 9th to 11th centuries. The first liturgical calendars to include a feast of St. Joseph were in Palestine, where Joseph's day was celebrated the Sunday after Christmas in conjunction with the Old Testament patriarch King David. The Greek church celebrated Joseph's feast throughout the Middle Ages on July 20.

5. Rondet, *Saint Joseph*, 8–9, 13–14 and Filas, *Man Nearest to Christ*, 9–11. Arranged in chronological order, they include the following: the *Protoevangelium of James* (c. A.D. 150), the *Gospel of St. Thomas*, the *History of Joseph the Carpenter* (Egyptian, 4th–6th century), the *Arabic Gospel of the Infancy of the Savior* (7th–8th century), the *Gospel of the Pseudo-Matthew*, the *Gospel of the Nativity of Mary* (Carolingian), and the *Gospel of the Infancy*. See James Orr, ed., *New Testament Apocryphal Writings* (London: J. M. Dent and Sons; Philadelphia: J. B. Lippincott, 1923); and Jacobus de Voragine, *The Golden Legend: Readings on the Saints*, trans. William Granger Ryan, 2 vols. (Princeton, N.J.: Princeton University Press, 1993).

6. See the *Protoevangelium of James* and *History of Joseph the Carpenter*, in *New Testament Apocryphal Writings*, and discussed in Rondet, *Saint Joseph*, 19; Filas, *Man Nearest to Christ*, 9–11, 18, 20–21; and Warner, *Alone of All Her Sex*, 23, 26, 27, 30. For additional information on the Council of Trent's concern with the historical "authenticity" of saints, see Louis Réau, *Iconographie de l'art Chrétien*, vol. 3 (Paris: Presses Universitaires de France, 1958), 304–13.

7. Rondet, *Saint Joseph*, 18, 20, 63–66; and Giuliano Gasca-Queirazza, S.J., "San Giuseppe nelle 'Meditationes Vitae Christi' dell Pseudo-Bonaventura. Loro diffusione nei secoli XV–XVI. Confronto con altri testi in ambito italiano," *Estudios josefinos* 31 (1977): 435–45.

8. This has been noticed by numerous scholars. See, for example, James Snyder, *Northern Renaissance Art: Painting, Sculpture, the Graphic Arts from 1350 to 1575* (Englewood Cliffs, N.J.: Prentice-Hall, 1985), 120.

9. Warner, *Alone of All Her Sex*, 188. Two paintings by Hieronymus Bosch typify the representation of Joseph as a ridiculous figure. In his *Epiphany* (Philadelphia Museum of Art) Joseph is set off from the main scene scratching his head in bewilderment. In Bosch's *Epiphany Triptych* the saint can be seen washing diapers in the left panel of the *Adoration of the Magi*.

10. Filas, *Man Nearest to Christ*, 34. Medieval examples influenced by St. Bridget are numerous, and include Rogier van der Weyden's *Nativity Altarpiece of Pieter Bladelin* (1452–55, Gemäldegalerie, Staatliche Museen, Berlin); Rogier van der Weyden's *Miraflores Altarpiece* (c. 1440–44, Gemäldegalerie, Staatliche Museen, West Berlin; another version divided between Metropolitan Museum of Art, New York, and Museo de Bellas Artes, Granada, Spain); Master Francke's *Nativity*, from the *Englandfahrer Altarpiece* (1424, Kunsthalle, Hamburg); and Robert Campin's *Nativity* (c. 1425, Musée des Beaux-Arts, Dijon, France). Snyder, *Northern Renaissance Art*, 58, 85, 123, 134, 133, and 127. For further information, see ibid., respectively figs. 129, 134, 127, 122, plate 14, 118, and 123. Also refer to Miguel Ángel García Guinea, "San José en la pintura germana gótico-renacentista," *Estudios josefinos* 3 (1949): 81–108.

11. Rondet, *Saint Joseph*, 22–23 and 70–74. The history of Joseph's cult in Italy in the Renaissance is discussed in detail in Wilson, *St. Joseph in Italian Renaissance Society and Art*, 12–20.

12. Ibid., 23–24, 67–69; Filas, *Man Nearest to Christ*, 24; and Warner, *Alone of All Her Sex*, 188–89. Gerson's writings on St. Joseph are numerous: Jean Gerson, *Oeuvres Complètes, IV: L'oeuvre poétique* (Paris: Desclée, 1962), nos. 107, 109, 110, 120, 125, 135, 137, 138 (the *Josephina*, 31–100), 148, 156, 163, 202; Gerson, *VII: L'oeuvre française* (Paris: Desclée, 1966), nos. 300 and 301; and Gerson, *VIII: L'oeuvre spirituelle et pastorale* (Paris: Desclée, 1971), nos. 404 (the office for St. Joseph's feast day), 405, 405a, 405b, and 405c.

13. *New Catholic Dictionary* (New York: McGraw-Hill, 1967–79), s.v. "Joseph."

14. David Herlihy, "The Family and Religious Ideologies in Medieval Europe," in *Family History at the Crossroads*, ed. Tamara Hareven and Andrejs Plakans (Princeton, N.J.: Princeton University Press, 1987), 14; and David Herlihy, "Tuscan Names, 1200–1530," *Renaissance Quarterly* 41 no. 4 (1988): 574. His sample consisted of 30,000

names of Florentine officeholders from the mid-14th century to 1530.

15. Teófanes Egido, "La cofradía de San José y los niños expósitos de Valladolid (1540–1757)," *Estudios josefinos* 53 (1973): 77–100.

16. John McAndrew, *The Open-Air Churches of Sixteenth-Century Mexico: Atrios, Posas, Open Chapels, and Other Studies* (Cambridge, Mass.: Harvard University Press, 1965), 396. Today, in parts of the United States—for example, in states with large Spanish-speaking populations, such as California and Texas—"José" is the most frequently chosen name for newborn baby boys. *USA Today*, 1 Jan. 2000, 1.

17. Snyder has linked the creation of the *Mérode Altarpiece* to new devotion to the saint in the Netherlands (Snyder, *Northern Renaissance Art*, 120). Cynthia Hahn, "'Joseph Will Perfect, Mary Enlighten and Jesus Save Thee': The Holy Family as Marriage Model in the Mérode Triptych," *Art Bulletin* 68 (1986): 54–66.

18. Snyder, *Northern Renaissance Art*, 120 and Charles Ilsley Minott, "The Theme of the Mérode Altarpiece," *Art Bulletin* 51 (1969): 267–71, and especially 268.

19. Isidoro de Isolanis, *Suma de los dones de San José*, trans. José Pallés (Barcelona: Pablo Riera, 1887), a translation of the first Latin edition.

20. Rondet, *Saint Joseph*, 25–26.

21. Wilson, *St. Joseph in Italian Renaissance Society and Art*.

22. Raphael's Marriage scene, which features the unusual detail of Joseph placing the ring on Mary's finger, may betray the influence of Josephine devotion centered in Perugia. Raphael, as is well known, studied there with Perugino. Perugia was the location of one of the few known relics of St. Joseph, the ring from the Betrothal. For this relic, see Miguel Ángel García Guinea, "La representación de San José a través de la pintura italiana," *Estudios josefinos* 1 (1947): 76–77.

23. See the recent study of St. Joseph in Italian art by Wilson.

24. Antonio de Mansilla, *Padrino de este Reyno de las Yndias, de este Invicto Rey de las Españas, y de esta Primera Yglesia de las yglesias. S. Ioseph Patriarcha. Sermon, que en la fiesta de su Patrocinio, que en nombre de su Magestad, hizo su Vi Rey, y Capitan General, en la Parrochia de los Yndios, sita en el Patio del Convento grande de N. S. P. S. Francisco de esta Ciudad de Mexico; con la asistencia de todos los Tribunales desta Corte. Predicô el dia veinte y nueve de Abril de el Año de mil setecientos, y catorce* (Mexico City: Heredèros de la Viuda de Francisco Rodriguez Lupercio, 1724), fols. 12–15; and McAndrew, *The Open-Air Churches*, 380. Cortés's St. Joseph chapel—not to be confused with the native parish of San José—was founded in 1525 in the chancel of San Francisco as his family's burial chapel. It was destroyed in the 1590s.

25. According to McAndrew, *The Open-Air Churches*, 368, the Indians paid for the erection of the Church of San José out of their great religious zeal. Other sources, however, report that Cortés paid for the building (cf. previous note). On Pedro de Gante, see McAndrew, *The Open-Air Churches*; Justino Cortés Castellanos, *El catecismo en pictogramas de Fray Pedro de Gante* (Madrid: Fundación Universitaria Española, 1987), Chapter 10; and Biblioteca Nacional, Mexico, Archivo Franciscano, MS 1037, Escritores religiosos de los siglos XVI y XVII. V. Nueva España, fols. 58–62, "Establecimiento de los Padres Franciscanos Observantes de la Ciudad de Mexico," (a discussion of the First Twelve Franciscans sent by Charles V); fol. 60 (the building of the capilla de San José at Cortés's expense); and fol. 59 (the site of San José and the Franciscan monastery: "Fuè este sitio en otro tiempo casa de divercion del emperador Moctesuma donde tenia variedad de fieras Terrestros, y volatiles a cargo detrescientos hombres.")

26. McAndrew, *The Open-Air Churches*, Chapter 10, 374ff.; and Jaime Lara, *City, Temple, Stage: Eschatological Architecture and Liturgcal Theatrics in New Spain* (Notre Dame: University of Notre Dame Press, 2004).

27. McAndrew, *The Open-Air Churches*, 388–93, 409.

28. Ibid., 400ff.

29. Ibid., 389; and *Códice de Yanhuitlán*, a facsimile of the original manuscript dating c. 1545–50 with a study by Wigberto Jiménez Moreno and Salvador Mateos Higuera (Mexico City: Museo Nacional, 1940). Some friars sent to the New World may have been active in the conversion in Spain. One of the First Twelve Franciscans was from Córdoba, another from Seville, and two others from Andalucía, all former Islamic areas.

30. On mission architecture and liturgical drama, see Lara, *City, Temple, Stage*. On the influence of Serlio on Mexican mission architecture, see McAndrew, *The Open-Air Churches*, 392–93, 400.

31. Cayetano de Cabrera y Quintero, *Escudo de Armas de Mexico: Celestial Proteccion de esta Nobilissima Ciudad, de la Nueva-España, y de casi todo el*

Nuevo Mundo, Maria Santissima, en su Portentosa Imagen del Mexicano Guadalupe, Milagrosamente Apparecida en el Palacio Arzobispal el Año de 1531 (Mexico City: Viuda de Joseph Bernardo de Hogal, 1746), 259: "La antiquissima, y por mejor decir, primera de San Joseph de Naturales en Mexico, y en que tambien se administraron Españoles, no es oy todo lo que fue en sus principios."

32. McAndrew, *The Open-Air Churches*, 394.

33. Archivo General de la Nación, Mexico City, Clero Secular, Tomo 191, 1701 á 1784, expediente 6, fols. 229ff.; and fols. 252–54.

34. McAndrew, *The Open-Air Churches*, 398–99.

35. Mansilla, *Padrino de este Reyno de las Yndias*, unpaginated prologue: "vna Capilla, que fué su primera Yglesia, y primera, por que en la America e la mas antigua, y como se tituló SAN IOSEPH; la Parrochia, e Yglesia de SAN IOSEPH, por sea la primera de las Yndias." On 14: "porque haziendo la Primera Yglesia de los Yndias, en esta Parrochia, en qué estamos, la tituló, y nombró SAN JOSEPH. Luego entró SAN JOSEPH en esta America."

36. *Concilio Mexicano I* (1555), Chapter 18, as reported in *Concilio III Provincial Mexicano, celebrado en México el año 1585, confirmado en Roma por el Papa Sixto V, y mandado observar por el gobierno español en diversas reales órdenes*, 2d ed. in Latin and Spanish (Barcelona: Manuel Miró y D. Marsá, 1870), 151, n. 2; Hermengildo Ramírez, M. J., "San José en la evangelización de América Latina," *Estudios josefinos* 45 (1991): 613–15; José Carlos Carrillo Ojeda, M.J., "San José en la Nueva España del siglo XVII," *Presencia de San José en el siglo XVII. Actas del Cuarto Simposión Internacional (Kalisz, 22–29 septiembre 1985)* in *Estudios josefinos* 41 (1987): 631–32, 639–40; and McAndrew, *The Open-Air Churches*, 394.

37. Biblioteca Nacional, Mexico, Archivo Franciscano, MS 1037, Escritores religiosos de los siglos XVI y XVII. V. Nueva España, fols. 56–57, Noticias de las Provincias de R. R. P. P. Franciscanos de la America Septentrional, y sus estados por el año de 1735: "Provincia de S. José de Yucatan. Se erigio el año de 1559."

A vast number of Mexican locales are named after St. Joseph. A sampling follows. In seventeenth-century Michoacán, the following could be found: three haciendas named after the saint, two chapels, six farms and orchards, and a hospital. Also note the following pueblos in

Michoacán: San José Pascuaro, San José Tzinimbo, San José Asuchitlan, San José de Alaia, San José Patamban, and San José de San Pedro Tzacan. Information on Michoacán drawn from File 0325, San José en el Obispado de Michoacán, St. Joseph Archive in the Parish of the Holy Family (directed by Father José Carlos Carrillo Ojeda, M.J.), Mexico City, two typewritten manuscripts, one based on Ramón López Lara, *El Obispado de Michoacán en el siglo XVII: Informe inédito de beneficios, pueblos y lenguas* (Morelia, Mexico: Fímax, 1973). Fifty-nine Mexican cities and towns take St. Joseph as their patron, according to a 1988 anthropological survey, Imelda de León, ed., *Calendario de fiestas populares* (Mexico City: Dirección General de Culturas Populares, 1988). I have encountered eleven additional places named after St. Joseph; see also n. 37.

38. McAndrew, *The Open-Air Churches*, 396, and 443–65. Documentary information on many missions can be found in the Archivo Franciscano, Biblioteca Nacional, Mexico City catalogued by Ignacio del Río, *Guía del Archivo Franciscano de la Biblioteca Nacional de México*, vol. 1 (Mexico City: UNAM, Instituto de Investigaciones Bibliográficas, 1975): Cajas 21, 22, 25 (Nuestra Señora de Guadalupe y San José, in Texas); 285 and 290 (San José de Comondú); 2228 (San José de Copala, Sonora); 1012 (San José de Temeichici, Chihuahua); 2259 (San José de Tumacácori, in Arizona); 2288–484 (San José de los Pimas); 812, 847, 861, 871, 872, and so forth (San José del Parral, Chihuahua). Additional information on Josephine missions drawn from documentation in the Archivo General de la Nación, Mexico City. For San José Xilipan (near Meztitlan), see Clero, Villa de Cadercita, año de 1777, fol. 211. An 18th-century inventory of the mission's belongings can be found on fols. 225ff. It included five altars: "El primero de Señor San Joseph. cuia ymagen de talla es de mediana colocada en vn retablo de madera dorado." On fol. 226: "el Tercer Alttar, que estta en el Cruzero de la Sieniesstra, tiene vn retablo pinttado en la pared, y en el la Ymagen de Señor San Josef." Later, fol. 226: "en el cuerpo de la Yglesia, junto a el choro . . . vn lienzo de seis varas de alto, y en el pintado el Triunpho dela fee, y el Patrocino de Señor San Joseph." For "los naturales de la hermita de San Joseph sugeto de Tlaxcala," consult AGN, Indios, vol. 10, exp. 54. fol. 25.

39. *Concilio III Provincial Mexicano*, 151: "§II.—Señor san José, patrono de esta provincia. Siendo en verdad extraordinaria la devocion con que se honra, obsequia y reverencia en esta provincia al castísimo Patriarca señor san José, esposo de María santísima, por cuyos méritos é intercesion puede creerse piadosamente que la Nueva-España ha sido favorecida de Dios con particulares beneficios, lo proclamó el Concilio provincial celebrado en el año del Señor 1555, como Patrono general de este arzobispado y provincia, y mandó que se guardase el dia en que se solemniza su festividad. Por tanto, este Concilio, renovando y confirmando aquella proclamacion, decreta que se celebre con octava."

40. Pedro Mvñoz de Castro, *Sermon del Glorioso Patriarcha San Joseph Predicado En su dia 19 de Marzo de este año de 1696 En la Feria segunda despues de la Dominica segunda de Quaresma, en la Iglesia del Hospital de Nuestra Señora de la Concepcion de esta ciudad de Mexico* (Mexico City: Juan Joseph Guillena Carrascoso, 1696), unpaginated prologue: "que es vniversal Patron San Joseph de Nueva España, y por consiguiente de sus habitadores todos en general, con quien tiene cordialissima devocion todo este Reyno." On fol. 11: "O Patriarcha divino, Joseph illustre, Padre estimativo de Jesu Christo, Esposo de su Madre, Patron, y Titular de todo aqueste tan devoto Reyno de Nueva España, que os invoca." José Ignacio Vallejo, *Vida del Señor San José, Dignisimo Esposo de la Virgen Maria y Padre Putativo de Jesus*, 3d ed., by Juan Rodriguez de San Miguel (rev. version of Vallejo's 2d ed. of 1779; Mexico City: J. M. Lara, 1845), unpaginated prologue: "Sensible serìa que en la Republica Mexicana, en donde desde que se planteò la verdadera religion se ha profesado tan constante y general devocion al Señor San José."

41. Interestingly, the concerns raised in teaching Jewish *conversos* and Mexican Indians about St. Joseph were surprisingly similar. Compare the catechism in the form of a dialogue reproduced and analyzed in Enrique Llamas-Martínez, "Testimonio josefino de un catecismo anti-judío: Mss. en el British Museum (s. XVII)," *Estudios josefinos* 24 (1970): 215–26, with the Náhuatl sermon discovered by Carrillo, "San José en la Nueva España," 629–30.

42. Fray Juan de la Anunciacíon, O.S.A., *Sermonario en lengua mexicana, donde se contiene (por el orden del Missal nuevo Roman), dos Sermones en todas las Dominicas y Festividades principales de todo el año; y otro en las Fiestas de los Santos, con sus vidas, y comunes. Con un Cathecismo en Lengua Mexicana y Española con el Calendario* (Mexico City: n.p., 1577); and Bernardino de Sahagún, *Psalmodia Cristiana y sermonario de los Santos del Año, en lengua mexicana. Ordenada en cantares o Psalmos, para que canten los indios en los areitos que hace en las iglesias* (Mexico City, 1583), both discussed in Carrillo, "San José en la Nueva España," 529–30; and Fray Martin de Leon, *Primera Parte del Sermonario del tiempo de todo el año, duplicado, en lengua Mexicana* (Mexico City: Viuda de Diego Lopez Daualos, 1614).

43. *La Devocion al Señor San José en la Nueva España* (Mexico City: n.p., 1778), unpaginated: "Desde que se conquisto este nuevo Mundo, juntamente con la verdadera Religión plantaron en él sus primitivos Padres la devoción al Señor San Joseph."

44. Mansilla, *Padrino de este Reyno de la Indias*, fol. 12: "O Mexico, oye como estavas! Ni sentias, ni entendias, ni mirabas, porque tu inumana barbaridad, y gentilidad ciega te tenia en tal estado, que tenias embargadas operaciones, y sentidos. Te cogió San JOSEPH a su cargo: . . . y luego, luego, sentiste con su Patrocinio tu consuelo. Y porque veas que en esto no te engaño; oye en la precission de tu convercion, lo que le deves ä el Patriarcha tu Padrino. Este Reyno tuvo, Señor, dos converciones. La vna, devida á el sin igual valor, industria, y afabilidad de D. Fernando Cortez: La otra, devida, â quien? A el zelo de aquellos primeros Parrochos? A el espiritu de aquellos primitivos Religiosos? De esto no hablo: solo diglo, que si Fernando Cortez con sus Armas, é industria, convirtiò à los Indios, de Basallos de su Emperador Catholico; San Joseph Patriarcha los convirtiô de modo, que mediante su Patrocinio, se bautisaron, dejando por nuestro Dios verdadero, toda la varia multitud de sus Dioses falsos."

45. This idea is further discussed in my article, "Las imágenes milagrosas de San José en España y Sudamérica, las teorías del arte y el poder de la imagen en el siglo XVII," *Estudios josefinos* 48 (1994): 27–46.

46. Sor Juana Inés de la Cruz, *Obras Completas*, ed. Francisco Monterde (Mexico City: Porrúa, 1989), 277: "¡que pulo ser Neglo Señor San José!" The entire series of villancicos can be found on 270–79, *San José, 1690: Villancicos con que se*

solemnizaron, en la S. I. Catedral de la Puebla de los Ángeles, los Maitines del Gloriosísimo Patriarca Señor San José, Año de 1690, nos. 291–303. Sor Juana penned a series of poems in the saint's honor, including a sacred romance, a rondelet, a sacred sonnet, and a series of twelve villancicos to be sung on St. Joseph's feast day in Puebla Cathedral in 1690. To the latter she added a dedication to the saint that she signed "your unworthy slave." *Obras Completas*, nos. 54, 70–76; 137, 128; 209, 165–66; and 291–303, 270–79. No other series of Sor Juana's villancicos bears a similar dedication or closing.

47. Juan Ignacio Castorena y Ursua, *Lo mas de la Sanctificacion del Señor San Joseph. Sanctificado antes de nacer â los siete meses de concebido para nacer sanctificado, y ser Padre Estimativo de Christo, y Esposo Castissimo de la Reyna de los Angeles* (Mexico City: Joseph Bernardo de Hogal, 1727), unpaginated preface: "porque la Conquista de las Indias se debió â su jurado Patrocinio, como lo publica el celo del Santo Concilio Mexicano."

48. Reported in McAndrew, *The Open-Air Churches*, 393; Gerónimo de Mendieta, *Historia eclesiástica indiana*, 2d facsimile ed., vol. 3 (Mexico City: Porrúa, 1971), 88.

49. Vallejo, *Vida del Señor San José*, 254–55: "La iglesia catedral lo celebra con la mayor magnifencia y solemnidad en el dia 19 de marzo dedicado á la memoria de este gran Santo, y despues hace fiesta á su patrocinio, y particularmente á sus desposorios, en accion de gracias por la victoria alcanzada en el dia 26 de noviembre de los indios conjurados contra el rey."

50. *La Devocion al Señor San José en la Nueva España*, unpaginated: "Se han dedicado á su Nombre en esta America muchos magnificos, y curiosos Templos; muchos Altares en que se luce su mayor culto; y en todas es aclamada su proteccion." This anonymous author was probably the priest Antonio Paredes of Puebla, who wrote a book of the same title, as described in Vallejo, *Vida del Señor San José*, 247.

51. McAndrew, *The Open-Air Churches*, 386, 574–75. In McAndrew's estimation, the main altarpiece was evidently very large, consisting of two superimposed triptychs with a predella below, and it was probably executed in a Flemish style. He has posited that the retablo in Zinacantepec may be a distant reflection of Marcos's original.

52. Other images created after 1570 are discussed in later chapters. On New Mexican hide paintings, see E. Boyd, *Popular Arts of Spanish New Mexico* (Santa Fe: Museum of New Mexico, 1974); Kelly Donahue-Wallace, "Print Sources of New Mexican Colonial Hide Paintings," *Anales del Instituto de Investigaciones Estéticas* 68 (1996): 46–64; and Charlene Villaseñor Black, "Arts," in *American Eras: Early American Civilizations and Exploration until 1600*, ed. Gretchen D. Starr-LeBeau (Detroit: Gale, 1998), 55–76. I know of three Mexican feather works ("paintings") that depict St. Joseph and the Christ Child (Berlin, Staatliche Museen zu Berlin Preussicher Kulturbesitz, 18th–19th century; Madrid, Museo de América, 17th century? [pl. 1]; and collection of Michael Haskell).

53. See Jeanette Favrot Peterson, *The Paradise Garden Murals of Malinalco: Utopia and Empire in Sixteenth-Century Mexico* (Austin: University of Texas, 1993).

54. The information on Tlaloc is drawn from the most important studies of his figure: Cecelia F. Klein, "Who Was Tlaloc?" *Journal of Latin American Lore* 6 (1980): 155–204; Arthur J. O. Anderson, "A Look into Tlalocan," in *Smoke and Mist: Mesoamerican Studies in Memory of Thelma D. Sullivan*, ed. J. Kathryn Josserand and Karen Dakin (Oxford, England: Oxfordshire, 1988), 151–59; and Esther Pasztory, "The Aztec Tlaloc: God of Antiquity," in *Smoke and Mist: Mesoamerican Studies in Memory of Thelma D. Sullivan*, ed. Kathryn J. Josserand and Karen Dakin (Oxford, England: Oxfordshire, 1988), 290–327. For the appellation "god of the rains" ("dios delas pluuias") see *Cantares mexicanos* (MS 1628, Fondo Reservado, Biblioteca Nacional, Mexico), fols. 85ff., "Kalendario Mexicano, Latino y Castellano," and specifically fol. 88r. Similar information can be found in Fray Martin de Leon, *Camino del Cielo en Lengva Mexicana, con todos los requisitos necessarios para conseguir este fin, con todo lo que vn Christiano deue creer, saber, y obrar, desde el punto que tiene vso de razon, hasta que muere* (Mexico City: Diego Lopez Daualos, 1611), 97.

55. Leon, *Camino del Cielo*, 97: "El 3. Mes empieça, a catorce de Março y llamarle toçoztontli, y en el hazen fiesta atlaloc Dios de las aguas, que dizen auita en el Parayso Terrenal que llaman tlalòcan, ofrecen estos dias las primicias de las flores y rosas de aquel Mes y año, en vn alto, cu, llamado Iupico, y ninguno podia oler flor antes que se ofreciessen las primicias, y los que tenian de officio hazer los suchiles entre año que sellaman

xochimanque, hazen vna gran fiesta à vna diosa llamada, Cihuatlycue, y por otro hombre, coat-lantona, con muchos supersticiones y embustes." The passage closely follows *Cantares mexicanos*, fol. 88: "Tercero Mes delos Mexicanos llamado: *Toçoztontli*, en el qual hazia fiesta al dios llamado Tlaloc, que es el dios delas pluuias. . . . En esta fiesta offrecian las primicias de las flores que acquel año primero nacian enel cu llamado *jupico* y antes que las offreciesen nadie osaba oler flor alguna."

Later, the manuscript describes how Tlaloc cured illnesses during his festival: "Algunos enfermos hazian voto de hallarse presentes aesta procession por sanar de sus enfermedades, y disenque sanaban algunos de ellos." Toçoztontli reportedly lasted from March 14 until April 3, according to Bernardino de Sahagún's trilingual Náhuatl, Latin, and Spanish calendar from the 1580s. Significantly, the only Catholic feast days included in this month were the Annunciation to Mary and St. Joseph's March 19 feast day. *Cantares mexicanos*, fols. 85ff., Kalendario Mexicano, Latino y Castellano, and fol. 88.

56. Anderson, "A Look into Tlalocan," 152–53.

57. Taken from Anderson, "A Look into Tlalocan," 152; the original can be found in Fray Bernardino de Sahagún, *General History of the Things of New Spain: Florentine Codex*, ed. and trans. Arthur J. O. Anderson and Charles E. Dibble (Santa Fe, N. Mex.: School of American Research; and Salt Lake City, Utah: University of Utah, 1950–82), 6:115.

58. For St. Joseph and earthquakes, see Juan Joseph Mariano Montufar, *El Argumento, y Firmeza de la Tierra, el Abrigo de Maria Señora Nuestra, El Sossiego, y Quietud de Dios, Sermon Panegyrico al Glorioso Patriarcha Sr. S. Joseph, por el Patronato de Temblores, que predicò en la Santa Iglesia Cathedral Metropolitana, el dia 16. de Octubre de 1734* (Mexico City: Imprenta Real, 1735).

59. Nicolas Carrasco Moscoso, *Sermon de el Patrocinio, Qve contra los Rayos y Tempestades goza dichosa la Ciudad de la Puebla en el Esclarescido Patriarcha San Joseph* (Puebla, Mexico: Diego Fernandez de Leon, 1688), fol. 1: "y quien no admiró por mysterioso siempre el voto, que esta siempre Noble, Cesarea, Augusta, Imperial Ciudad de los Angeles consagró al esclarezido Patriarcha San Joseph, por los años de 1580. eligiendole, ó sorteandole entre otros Santos por su Protector, y

Patron contra los rayos, y tempestades, de que se hallaba combatida, atemorizada, y casi arruynada esta Ciudad." Also see Pedro López de Villaseñor, *Cartilla Vieja de la Nobilisima Ciudad de Puebla (1781)*, ed. José I. Mantecón (Mexico City: Universitaria, 1961), 228, 230–31.

60. File 0326, Puebla, Ciudad de, varias fichas josefinas, Centro Mexicano de Estudios Josefinos, Mexico City. Typewritten transcription of documents: "1637 Novenario Perpetuo a San José en Catedral de Puebla: Octubre 13.—En vista de los rayos y tempestades que han azotado la región y habiéndose salvado de uno de ellos los Capitulares de la Catedral y cientos de personas que estaban presentes cuando cayó un rayo en la torre . . . dijeron que perpetuamente todos los años se haga en esta dicha catedral un novenario al glorioso Patriarca san Joseph Patrón de esta dicha ciudad y abogado de los rayos . . . entrando dentro de dicho novenario el día veinte y cuatro de septiembre empezando siempre en sábado y acabándose a Domingo, en el cual ha de haber sermón y se ha de hacer con la solemnidad, adorno y gravedad que ser pudiere . . . y el último y postrero día haciéndose la procesión por de fuera de la Iglesia llevando el Santo en ella." Taken from Libro No. 8 del Gobierno del Cabildo, 13 de Octubre de 1637 y Libro de Gobierno de la parroquia de San José, que se abre el año de 1631 (Dichos datos son del Sr. Cura Daniel López). The story of the sculptor carving the image of St. Joseph also reported in File 0325, credited to Eloisea Castillo Varela, *La leyenda de los Angeles de Puebla* (Mexico City, 1952), 29–30. (I have been unable, however, to locate a copy of this text).

61. File 0326, Puebla. Typewritten transcriptions from documents: "1600 San José Patrono de Puebla contra los rayos. En 1600, el Ilmo. Sr. Romano erigió muchas parroquias, entre ellas la de San José en Puebla. Como era muy atormentada esta ciudad por las tempestades y rayos, procedió a la elección de Patrono contra tales calamidades y salió electo el Castísimo Patriarca Sr. S. José a quien, desde esta época (y con mayor solemnidad desde el primer tercio del siglo xvii), se le hace cada año, en Septiembre, un solemne novenario." The following source is credited: "Episcopalegio, 159, Puebla, Puebla."

62. López de Villaseñor, *Cartilla Vieja de la Nobilisima Ciudad*, 228, "Patronato del Santisimo Patriarca

Señor San José contra los rayos," and 230–31, "Memoria Pía de Misas y Fiestas." According to López, the invocation of St. Joseph's protection during storms was by 1556 already an old tradition. He relies upon the Actas de Cabildo de Puebla, libro 7, foxa 102 vuelta, 15 de junio de 1556; and libro 14, foxa 187, 13 de agosto de 1611. Carrasco Moscoso, *Sermon de el Patrocinio*, fols. 1–2: "y quien no admiró por mysterioso siempre el voto, que esta siempre Noble, Cesarea, Augusta, Imperial Ciudad de los Angeles consagró al esclarezido Patriarcha San Joseph, por los años de 1580. eligiendole, ó sorteandole entre otros Santos por su Protector, y Patron contra los rayos, y tempestades, de que se hallaba combatida, atemorizada, y casi arruynada esta Ciudad. Con cuya tutela, y proteçcion piadosa, experimento la serenidad que deseaba, hasta que por los años de 1611. [ó porque se olvidó de la obligacion, o porque se faltaba en las circunstancias á la promessa] levantó la mano de su patrocinio, dejando que las nubes con sus rayos, y espantosos truenos, despertassen su ingratitud, y descuydo, experimentando su ruyna en muchos de sus moradores. Por lo qual encendida otra vez la devocion, revalidó a los 13. de Agosto de dicho año de 1611. El voto que tenia hecho, con tanto fervor, que hasta oy no á desmayado su desvelo en celebrar a Joseph esta annual Fiesta, que en reconozimiento de tal beneficio le consagra con la pompa, y magestad que miramos, costeando sus crezidos gastos, de sus dezimas, o proprios, para decirle a Joseph."

63. File 0326, Puebla. See n. 59.

64. Carrasco Moscoso, *Sermon de el Patrocinio*, unpaginated prologue, "Patron Jurado contra las tempestades, y rayos, celebra annualmente esta muy Noble, y muy Leal, Cesarea Ciudad de los Angeles."

65. Ibid., 3: "En los horrores de vna tempestuosa noche, en los espantos de vna confussion sombria, nublados con el asombro los corazones, timidos con el horror los animos, se hallaba esta Ciudad quando le assaltò para su bien la suerte. Combatida, se veia de rayos, quando en medio de tan tenebrosa noche amanezio la luz en el patrocinio de San Joseph, por que para consuelo desta Ciudad aparecio como estrella de la mañana, para anunciar las alegrias del deseado dia: . . . Quando el Pueblo, la Ciudad de la Puebla se hallaba aflixida con las calamidades de

Tempestades, y rayos que la combatian: con la sosobra de espantosos truenos, que la atemorizaban vuelto en noche el dia, por las obscuras sombras, conque la enlutaban las negrejuras de sus nublados: . . . Aparezio la estrella de la mañana Joseph para nuestro consuelo."

66. Vallejo, *Vida del Señor San José*, 254: "La imágen del Señor San José, que se venera en este santuario, se lleva cada año por octubre á la iglesia metropolitana, donde está por espacio de siete dias, y le cantan las siete misas de Santa Teresa, como á Patron contra las tempestade, que antes eran de las mas formidables, y despues la vuelve aquel venerable cabildo en procesion."

67. McAndrew, *The Open-Air Churches*, 396, and Vallejo, *Vida del Señor San José*, 260: "El dia 14 de octubre de 1732 se juró solemnísimamente por los cabildos eclesiastico y secular, al Señor San José, patrono especial de esta ciudad, contra los continuos fuertes temblores que sufria."

68. Mariano Montufar, *El Avgmento, y Firmeza de la Tierra*, 296. According to Pasztory, Tlaloc was generally associated with the earth.

69. Numerous mines were named after St. Joseph in the colonial era, including las minas de San José de Copala, las minas de los reales de San José de Ibonia, San José del Parral, and so on.

70. Pasztory, "The Aztec Tlaloc," 289.

71. Ibid., 298.

72. Ibid., 296–97. At least one additional Aztec legend reported a similar story, according to Pasztory.

73. An early and important study of the hybridity of Mexican Catholic icons is Jacques Lafaye, *The Virgin and Quetzalcóatl: The Formation of Mexican National Consciousness, 1531–1813*, trans. Benjamin Keen (Chicago: University of Chicago Press, 1976). The bibliography on the Virgin of Guadalupe is immense. See Jeanette Favrot Peterson, "The Virgin of Guadalupe: Symbol of Conquest or Liberation?" *Art Journal* 51 (1992): 39–47 and Stafford Poole, *The Virgin of Guadalupe* (Tucson: University of Arizona Press, 1995). I discuss the conflation of St. Anne with Toci in "St. Anne Imagery and Maternal Archetypes in Spain and Mexico," in *Colonial Saints: Discovering the Holy in the Americas, 1500–1800*, ed. Allan Greer and Jodi Bilinkoff (New York: Routledge, 2002), 3–25. On the hybridity of Crucifixion imagery, see Carol H. Callaway, "Pre-Columbian and Colonial Mexican Images of

the Cross: Christ's Sacrifice and the Fertile Earth," *Journal of Latin American Lore* 16 (1990): 199–231.

74. Louise M. Burkhart, *Holy Wednesday: A Nahua Drama from Early Colonial Mexico* (Philadelphia: University of Pennsylvania Press, 1996).

75. This according to a 1988 survey of popular religious celebrations undertaken by a team of Mexican anthropologists: León, *Calendario de fiestas populares*. The only saints whose feast days are more widely celebrated are Santiago and St. John the Baptist. Although today the Mexican Virgin of Guadalupe is recognized as the patroness of Mexico's native population, recent research has demonstrated that until the twentieth century, it was primarily the European creole class who embraced her cult. The lack of indigenous devotion to the *Guadalupana* may be partly explained by the energetic promotion of St. Joseph as patron of Mexico and of the conversion. On creole devotion, see Peterson, "Symbol of Conquest or Liberation?"

76. Numerous sources mention St. Teresa's devotion to St. Joseph: Rondet, *Saint Joseph*, 75–77; Filas, *Man Nearest to Christ*, 157; Jeannine Baticle, *Zurbarán*, exh. cat. (New York, The Metropolitan Museum of Art, 1987–88), cat. no. 20; and Michel Ferrand, O.C.D., "L'iconographie de Saint Joseph dans les premiers carmels français du XVIIe siècle," *Estudios josefinos* 41 (1987): 743–60. Also consult Santa Teresa de Jesús, *Libro de la Vida*, ed. Otger Steggink (Madrid: Castalia, 1986), 136–40, 390, 418, 445–48, and 484; Filas, *Man Nearest to Christ*, 157; and Jodi Bilinkoff, *The Avila of St. Teresa: Religious Reform in a Sixteenth-Century City* (Ithaca: Cornell University Press, 1989).

77. Rondet, *Saint Joseph*, 28; and Teresa, *Libro de la Vida*, chapter 30, 390.

78. Rondet, *Saint Joseph*, 28; Aimé Trottier, C.S.C., *Essai de bibliographie sur Saint Joseph*, 3d ed. (Montreal: Centre de Recherche et de Documentation Oratoire Saint-Joseph, 1962); Baticle, *Zurbarán*, cat. no. 20; and José Antonio del Niño Jesús, O.C.D., "Fray Gerónimo Gracián de la Madre de Dios y su 'Summario de las excelencias del glorioso S. Joseph, esposo de la Virgen María' o 'Josefina' (1597)," *Estudios josefinos* 31 (1977): 295–322.

79. Rondet, *Saint Joseph*, 33. For the 17th-century documents that sanction Joseph's position as the patron of Spain, consult José Antonio del Niño Jesús, O.C.D., "Tres documentos josefinos del

Archivo de Simancas," *Estudios josefinos* 2 (1948): 111–24 and 217–28. Emmanuel Díaz, S.J. (1574–1659) translated Joseph's life and his litanies into Chinese as *Chen jo chée tao wen* (litanies) and *Chen jo chée king che* (his life). See cat. nos. 1669 and 1670 in Aimé Trottier, *Essai de bibliographie sur Saint Joseph*, 3d ed. (Montreal: Centre de Recherche et de Documentation Oratoire Saint-Joseph, 1962). For devotional works in Tagalog, the Malaysian language of the Philippines, consult the holdings of Mexico's Biblioteca Nacional.

80. José Fombuena, *Las fallas de Valencia* (León, Spain: Everest, 1971).

81. Baticle, *Zurbarán*, cat. no. 20; Rondet, *Saint Joseph*, 33.

82. Anonymous, *Meditaciones sobre el Patriarca San José, para el Mes de Marzo* (Mexico City: Juan Mariana y Sanz, 1868), 19.

83. McAndrew, *The Open-Air Churches*, 396.

84. Castorena y Vrsua, *Sanctificacion del Señor San Joseph*. The sermon was preached on the second Sunday of October as one of the seven masses before St. Teresa's feast day in the Convent of Corpus Christi. According to the unpaginated prologue, the sermon commemorates "la nueva Fiesta . . . su venerada santificacion antes de su dicho Nacimiento." The Discalced Carmelites introduced it; it had been celebrated twice before in the previous three years. According to Maria de Ágreda in her *Mystica Ciudad de Dios*, Joseph was sanctified in the womb seven months after conception. A new image of St. Joseph and new retablo commemorated the feast, paid for by the viceroy, the Marqués de Valero.

85. McAndrew, *The Open-Air Churches*, 395. According to McAndrew, Jiménez did not, however, promote a public cult to Joseph. On El Greco's commission, see Halldor Soehner, *Una obra maestra del Greco, la Capilla de San José en Toledo* (Madrid: Hauser y Manet, 1961).

86. The painting, last thought to be in the Bravo Collection in Seville, is described in Elizabeth Du Gué Trapier, *Valdés Leal: Spanish Baroque Painter* (New York: Hispanic Society of America, 1960), 30.

87. For the Prado painting, see Peter C. Sutton's discussion in *The Age of Rubens*, exh. cat. (Boston, Museum of Fine Arts, 1993–94), cat. no. 27, 291–93. Similar Holy Families by Rubens include the *Holy Family with St. John the Baptist* (London, Thos. Agnew and Sons; reproduced in *The Age of*

Rubens, 291, fig. 2); the *Holy Family with St. Francis* (Windsor Castle, Royal Collection, H. M. the Queen; reproduced in *The Age of Rubens*, 291, fig. 3); the *Holy Family* (New York, The Metropolitan Museum of Art); and the *Holy Family under the Apple Tree*, the St. Ildefonso Triptych (Vienna, Künsthistorisches Museum). Also refer to Miguel Ángel García Guinea, "Algunas representaciones barrocas de San José: Rubens y Tiepolo," *Estudios josefinos* 3 (1949): 237–60.

88. Howard Hibbard, *Caravaggio* (New York: Harper and Row, 1983), 54–55. On the general topic of St. Joseph in Italian art, see Miguel Ángel García Guinea, "La representación de San José a través de la pintura italiana."

89. For reproductions, see D. Stephen Pepper, *Guido Reni: A Complete Catalogue of His Works with an Introductory Text* (Oxford, England: Phaidon, 1984), plate 14, cat. no. 185, fig. 215.; David M. Stone, *Guercino: Catalogo completo dei dipinti* (Florence: Cantini, 1991), cat. no. 138 (*St. Joseph and the Christ Child*, 1633, Bologna, Lauro Collection); cat. no. 152 (*St. Joseph and the Christ Child*, 1637–38, Dublin, National Gallery of Ireland); and cat. 242 (*St. Joseph*, 1648–49, Bologna, Italy, Pinacoteca Nazionale); and Luigi Salerno, *I Dipinti del Guercino* (Rome: Ugo Bozzi, 1988), cat. no. 146, cat. no. 171, and cat. no. 259.

90. Georges Bottereau, S.J., "Saint Joseph et les Jésuites français de la seconde moitié du XVIIe siècle," *Estudios josefinos* 41 (1987): 565–72, and especially 565; and Michel Ferrand, "L'iconographie de Saint Joseph."

91. John Rupert Martin, *Baroque* (New York: Harper and Row, 1977), 127. Also refer to Christopher Wright, *The French Painters of the Seventeenth Century* (Boston: Little, Brown, 1985), 46–47.

92. See Bernard Dorival, *Philippe de Champaigne 1602–1674: La vie, l'œuvre, et le catalogue raisonné de l'œuvre*, vol. 2 (Paris: Léonce Laget, 1976), cat. 29. For an older Joseph, see Dorival, cat. no. 28 (another version of the *Dream of St. Joseph*, Paris, Musée du Louvre), cat. no. 46 (the *Presentation in the Temple*, Brussels, Musées Royaux des Beaux-Arts de Belgique), and cat. nos. 35, 38, and 39 (various versions of the *Adoration of the Shepherds*).

93. For the perception of crisis, see José Antonio Maravall's *Culture of the Baroque: Analysis of a Historical Structure*, trans. Terry Cochran (Minneapolis: University of Minnesota Press, 1986), 20–26; Antonio Domínguez Ortiz, *La sociedad española en el siglo XVII* (Madrid: Consejo Superior de Investigaciones Científicas, Instituto Balmes de Sociología, 1963), 72; and Mary Elizabeth Perry, *Gender and Disorder in Early Modern Seville* (Princeton, N.J.: Princeton University Press, 1990).

CHAPTER TWO
Love and Marriage

1. "Porque segun son los sobresaltos, molestias y afanes que le sobrevienen a este estado, lo mesmo parece que es casarle a vn hombre, que cruzificarle, lo mismo serà darle vna Crua, que vna muger"; 89 in Diego Niseno, *Asvntos predicables para todos los Domingos, del primero de Adviento, al ultimo de la Pascua de Resurrecion* (Zaragoza, Spain: Iuan de Lanaja y Quartanet, 1633). Also see the entire sermon, 85–97, "Sermon para el Domingo Segundo despves de la Epifania," and especially 88, "Asvnto II: Que en todos los estados y professiones ay sus afanes y trabajos, mas en el del Matrimonio ay mas trabajos y afanes que en todos los demas estados juntos. Verdaderamente, que como esta vida es tentacion y gverra, que no ay estado, ni profession donde no aya muchas çoçobras y disgustos. Mas yo hallo por mi cuenta, que no ay estado ni profession donde aya mas cargas y trabajos que en el del matrimonio." On 89: "Al hombre que le dan en matrimonio vna muger, luego le embiste de tropel vn numeroso y horrible exercito de penas y cuydados; si no tiene hijos, el desseo de tenerlos; si los tiene, el cuydado de criarlos; si es la muger vana y hermosa, el auer de ser continuo alcayde de la fortaleza de su honor; si es fea y desagradecida, la molestia del tener siempre delante de los ojos vna enojosa vista; si es auisada y discreta, sufrir sus bachillerias: el procurar el sustento de la casa, el estar siempre en frontera de enemigos, o vezinos, que todo se es vno; los pleytos, las pendencias que cada dia se ofrecen, ocasionadas de varios sucessos: juntamente, pues, las primeras palabras del Santo con las vltimas. . . . Que no ay dia que no se pase sin algun trabajo, sin alguna cantera, no ay hora que no esté expuesta a algun nublado de pena, o a algun torbellino de pesadumbre. Que con vna muger, esso, y mucho mas suele venir."

2. Christiane Klapisch-Zuber was the first person to demonstrate how Betrothal paintings gave visual form to Catholic marriage ritual, focusing on paintings produced between 1300 and 1500 in Italy. See her *Women, Family, and Ritual in Renaissance*

Italy, trans. Lydia Cochrane (Chicago and London: University of Chicago Press, 1985), chapter 9.

3. On the Ribalta commissions, see Fernando Benito Doménech, *The Paintings of Ribalta 1565/1628* (New York: The Spanish Institute, 1988), 56–57 (with the suggestion that the Betrothal may actually be by a member of his workshop). For Andrés de Vargas, consult Diego Angulo Íñiguez and Alfonso E. Pérez Sánchez, *Historia de la pintura española: Escuela madrileña del segundo tercio del siglo XVII* (Madrid: Instituto Diego Velázquez, 1983), cat. 4. For further information on other commissions, see Elizabeth Du Gué Trapier, *Valdés Leal: Spanish Baroque Painter* (New York: Hispanic Society of America, 1960), 41–42; Juan José Martín González, *El escultor Gregorio Fernández* (Madrid: Ministerio de Cultura, 1980), pl. 92; Angulo and Pérez Sánchez, *Escuela madrileña del segundo tercio*, cat. 318, 144 (for Carducho); and the Fototeca, Instituto Diego Velázquez, Consejo Superior de Investigaciones Científicas, Madrid (for information on Lucca Giordano). Numerous other paintings of the themes discussed in this chapter can be found in churches today.

4. The following verses either refer specifically to Joseph or to the parents of Jesus: Matthew 1:16–24, 2:13–19; Luke 1:27, 2:4, 16, 33, 43, 3:23; and John 1:45, 6:42. The Gospels' discussion of Joseph as the spouse of Mary is found in the Annunciation and Nativity sequence in Matthew 1:16–24 and Luke 1:26–27. Matthew and Luke identify the saint as the husband of the Virgin, or report that she is betrothed to him, Hebrew law assuming from betrothal that they will become husband and wife. For information on Hebrew marriage laws, see Gabriel Palomero Díaz, "El santo evangelio proporciona datos demostrativos suficientes de que San José y María contrajeron verdadero matrimonio," *Estudios josefinos* 8 (1954): 7–25; and Pablo Luis Suárez, C.M.F., "Matrimonio de María y José a la luz del Antiguo Testamento," *Estudios josefinos* 20 (1965): 187–202.

5. On these assumptions, see Fray Antonio Joseph de Pastrana, *Empeños del poder, y amor de Dios, en la admirable, y prodigiosa vida del sanctissimo patriarcha Ioseph, esposo de la madre de Dios* (Madrid: Viuda de Francisco Nieto, 1696), 386; and Joseph de Barcia y Zambrana, *Despertador Christiano Santoral, de Varios Sermones de Santos, de Anniversarios de Animas, y Honras, en orden à excitar en los fieles la devocion de los Santos, y la imitacion de sus virtudes* (Cádiz, Spain: Christoual de Requena, 1694), 105.

6. See P. Felipe G. Llamera, O.P., "El matrimonio de María y José," *Estudios josefinos* 19 (1965): 53; José María Canal, C.M.F., "Investigación sobre el matrimonio virginal de José y María en la teología de los siglos XIV, XV y XVI," *Estudios josefinos* 8 (1954): 39–43; and Marina Warner, *Alone of All Her Sex: The Myth and the Cult of the Virgin Mary* (New York: Simon and Schuster, 1976), 189. For sermons on the Betrothal preached on St. Joseph's March 19 feast day, see, among other examples, "Sermon Primero en la Festiuidad del glorioso san Ioseph. *Cùm esset desponsata mater Iesus Maria Ioseph* Matth. 1," in Pedro de Valderrama, *Primero, segvnda, y tercera parte de los exercicios espiritvales, para todas las festividades de los santos* (Madrid: Alonso Martin, 1608), 294–301. In the same volume, "Sermon Segvndo en la Festiuidad del glorioso san Ioseph. *Cùm esset desponsata Mater Iesu Maria Ioseph.* Matth. 1," 302–5.

7. Pastrana, *Empeños del poder*, 147. For the Virgin's observance of the Betrothal, see Ivan Martinez de Llamo, *Marial de todas las fiestas de Nuestra Señora, desde sv concepcion pvrissima, hasta la festividad mas moderna de svs desposorios con el patriarca San Ioseph. Con otros tres sermones de la descension de la imagen de el glorioso patriarca Santo Domingo, traìda por manos de Maria Santissima à la Villa de Soriano* (Madrid: Antonio de Zafra, 1682), 203 (part of a sermon on 203–18, "Sermon de los Desposorios de Nvestra Señora con San Ioseph").

8. Fray Juan Interián de Ayala, *El pintor Christiano, y erudito, ó Tratado de los errores que suelen cometerse freqüentemente en pintar, y esculpir las Imágenes Sagradas*, trans. Luis de Durán y de Bastéro (Madrid: Joachîn Ibarra, 1782), Book 4, Chapter 3, 16, "De las Pinturas, é Imágenes de la Presentacion de la Virgen, y de su Desposorio." I have relied upon the modern version of Pacheco's text, written in the first third of the seventeenth century and published in 1648: Francisco Pacheco, *El arte de la pintura*, ed. Bonaventura Bassegoda i Hugas (Madrid: Cátedra, 1990). Pacheco's text inspired that of Interián, which is replete with references to his Spanish predecessor and to the Counter-Reformation artistic reformer Johann Molanus. See Johann Molanus (Jean Vermeulen), *De Historia SS. Imaginvm et Pictvrarvm, Provero Earvm Vsv contra abusvs*, Libri IIII (Louvain, Belgium: Laurence Durand, 1619). For St. Joseph, see 331–37. Molanus's text is now also available in modern facsimile edition and French translation: *De Historia SS. Imaginum et*

Picturarum pro vero earum uso contra abusas/ Traité des saintes images, 2 vols., intro., trans., and ed. François Bœspflug, Olivier Christian, and Benoît Tassel (Paris: Cerf, 1996). The Inquisition's guidelines for the depictions of specific religious imagery are spelled out in Pacheco's "Adiciones a algunas imágenes," the fourth and final section of his treatise, *El arte de la pintura.* On the Inquisition's power to censor religious art, see Henry Kamen, *Inquisition and Society in Spain in the Sixteenth and Seventeenth Centuries* (Bloomington: University of Indiana Press, 1985), Chapter 11, "Popular Culture and the Counter-Reformation," and especially 201 and 204. Images that did not meet the Holy Office's standards for religious art were removed from churches and buried. Also consult V. Pinto Crespo, "La actitud de la Inquisición ante la iconografía religiosa," *Hispania Sacra* 31 (1978): 285–322.

9. For the comedia by Guillén de Castro y Bellvís (1569–1631), consult Nicolas González Ruiz, ed., *Teatro teológico español II: Comedias,* 2d ed. (Madrid: Editorial Católica, 1953), 361–417, vol. 18 in the series Biblioteca de Autores Cristianos. Also see the following article: P. Pedro Tomás de la Sagrada Familia, C.D., "'El mejor esposo S. José': Comedia bíblica de Guillén de Castro," *Estudios josefinos* 4 (1950): 89–109. Of all the themes from the life of St. Joseph, the Betrothal seems to have inspired the most writings. In the sixteenth and seventeenth centuries scores of new devotional texts, poems, songs, sermons, and sacred plays were written to celebrate it. The Betrothal routinely appeared in the numerous lives of St. Joseph published at the time, as well as in texts on the Virgin, Saints Anne and Joachim, Mary's mother and father. See the inclusion of the Betrothal (as well as other parts of Joseph's life) in the following: Sebastian de Nieua Caluo, *La meior Mvger, Madre, y Virgen. Svs Excelencias, Vida, y grandezas, repartidas por sus fiestas todas* (Madrid: Iuan Gonçalez, 1625), fols. 66v–122v; Martinez de Llamo, *Marial de todas las fiestas;* and Valentina Pinelo, *Libro de las alabanças y excelencias de la gloriosa Santa Anna* (Seville, Spain: Clemente Hidalgo, 1601), fols. 371–82.

Given the popularity of Castro's comedia, it is not surprising that stage sets influenced the settings seen in Betrothal paintings. The influence of scenography is apparent in those paintings where the architecture of the temple forms receding planes, and in those with tiled perspec-

tival floors. Both elements are drawn from the repertoire of scenographic devices used on the stage. A painting by Francisco Gutiérrez clearly draws its inspiration from seventeenth-century Spanish stage scenery, as can be seen when it is compared to extant engravings of stage sets, as does a canvas by Juan de Valdés Leal (fig. 7). On the Spanish stage in the Golden Age, see N. D. Shergold, *A History of the Spanish Stage from Medieval Times until the End of the Seventeenth Century* (Oxford, England: Clarendon, 1967). For a summary of Golden Age theatrical techniques, see his glossary, 360–63. Also see Acisclo Antonio Palomino de Castro y Velasco, *Museo pictórico y escala óptica,* 3 vols. (Madrid: 1715–24; modern edition, Madrid: M. Aguilar, 1947), "Capitulo VI. En que se trata la delineación de los teatros, altares, y monumentos de perspectiva," 622–27; Alfonso E. Pérez Sánchez, "José Caudí, un olvidado artista, decorador de Calderón," *Goya* 161–62 (1981): 266–73; and Ángel Valbuena Prat, "La escenografía de una comedia de Calderón," *Archivo español de arte y arqueología* 1 (1925): 1–25. Architectural settings and spatial recession were indicated on the stage by series of gradational side wings, called *bastidores.* Drop cloths with fictive tile floors were commonly employed to create the illusion of spatial recession. Both of these elements were adapted in several of the paintings. See the stage sets reproduced in Pérez Sánchez, "José Caudí."

10. Guillén in González Ruiz, *Teatro Teológico,* 367: "Para saber lo que en mi nombre apruebo, / de la tribu de Judá, con causa ufano, / manda venir hasta el menor mancebo, / y aquél entonces tan divino humano / que vea hacerse en fresco ramillete / la seca vara en su dichosa mano, / el ser electo esposo le compete / de la sin par María."

11. Guillén in González Ruiz, *Teatro Teológico,* 370: "¿Qué veo? ¡Ay de mí! Parece / que el fresco vapor que arroja / mi seca vara humedece. / ¡Ya brota reciente hoja, / ya blancas flores florece!/ (*Florece la vara.*) / ¡En tan humilde supuesto, / decreto tan soberano! / ¡Tal bien a mis ojos puesto! / ¡Tal palma en la indigna mano / de José! Señor, ¿qué es esto? / (*Pónese una paloma sobre la / vara.*) / Vos, paloma sacrosancta, / ¿traéisme la verde oliva? / ¿Tanto por vos se levanta / a vuestra región altiva / mi paz cierta y mi fe santa?"

12. Interián, *El pintor Christiano,* 147: "Porque el pintarle teniendo en sus manos una vara llena de

flores, es cosa que suelen, y pueden hacerla muy bien, por denotarse con esto, no sola la purísima continencia de este varon santisimo; sino tambien su perpetua virginidad, la que sin ninguna duda atribuyó al castísimo Esposo de María, el insigne defensor de esta virtud S. Gerónimo. Aunque, si esto se refiere á aquello de que hicieron mencion algunos Historiadores, que comunmente se tienen por bastante plausibles, de los quales tocamos algo arriba; no porfiaré sobre esto, ni procuraré arrastrarlos, como dicen, por los cabellos, á mi opinion."

13. Pacheco, *El arte de la pintura* (1990), 591: "Vinieron todos los mancebos del linaje de David con sus varas y entre ellos San Josef, cuya vara floreció brotando unas hermosas flores de almendro, sobre las cuales se puso el Espíritu Santo en figura de una blanquísima paloma." For the significance of almond flowers, see Juan de Robles, *La vida y excelencias y miraglos de Santa Anna y de la gloriosa nuestra señora Santa Maria fasta la edad de quatorze años: Muy deuota y contenplatiua nueuamente copilada* (Seville, Spain: Jacobo Cromberger, 1511), unpaginated, "Capitulo. Viij. de la hystoria del sancto desposorio de nuestra señora con sant Joseph y como despues de asi desposada se boluio del templo para casa de su madre santa anna donde concebio al hijo de dios y de como y porque su santo esposo la quiso dexar y lo que el angel sobre ello le reuelo." See the following phrase: "E por esto asi mismo fue prefigurada por el almendra que echa su flor primero que ningun otro arbol por dar a entender que ella auia de hallar y mostrar la excelencia de la flor de la virginidad y del merito della antes que ninguna otra persona humana." Although published in 1511, this text enjoyed popularity into the early seventeenth century; it was republished in Valencia, in Navarro (1576), in Burgos (1577) and in Seville (1604). Also consult Interián, *El pintor Christiano*, 147.

14. Joseph de Barcia y Zambrana, *Despertador Christiano Santoral, de varios sermones de Santos, de Anniversarios de Animas, y Honras, en orden à excitar en los fieles la devocion de los Santos, y la imitacion de sus virtudes. Que dedica al Gloriosissimo Patriarcha Sr. S. Joseph, Padre, en la opinion, de Jesu-Christo S. N. Esposo verdadero de Maria Santissima, y Patrono Vniversal de los Christianos* (Madrid: Blàs de Villa-Nueva, 1725), 80, "Sermon Nono, y Segundo del Gloriosissimo Patriarcha Señor San Joseph, en la Iglesia del Sacro Monte de Granada, Año de 1672." On 82: "fue Ioseph singularmente privilegiado en ser electo para Esposo de la Santissima Virgen Maria Madre de Dios: Cum esset desponsata Ioseph. Concurrieron (dize San Eustachio) con Ioseph otros onze mancebos de la Tribu Real de Judà, con sus varas en las manos, segun disposicion del Oraculo Divino, y solo bolò vna paloma hermosa à la cabeza de Joseph, y sola su vara floreciò, que fue la señal de elegirle Dios por Esposo de la Santissima Virgen. La Iglesia dize oy, que fue electo entre todos los hombres."

15. Beatrice Gottlieb, *The Family in the Western World from the Black Death to the Industrial Age* (Oxford, England: Oxford University Press, 1993), 81. A medieval English miracle play on the marriage of Joseph and the Virgin, described by Warner (27), included bawdy jokes about Joseph's advanced age.

16. Stanley Brandes studied attitudes toward sex, masculinity, and fatherhood in 1975–76 in southern Spain in his book *Metaphors of Masculinity: Sex and Status in Andalusian Folklore* (Philadelphia: University of Pennsylvania Press, 1980), which helps cast light on the historical construction of masculinity in Andalusia. Also see Gottlieb, *The Family in the Western World*, 101, for attitudes toward men's sexual prowess.

17. Interián, *El pintor Christiano*, 25.

18. Fray Diego Niseno, *Segvnda Parte, del Politico del Cielo. Hallado en las misteriosas acciones del sagrado Patriarca Iacob* (Madrid: Maria de Quiñones, a espensas de la Hermandad de los Mercaderes de Libros desta Corte, 1638), fol. 34r: "Va el Apostol san Pablo hablando de las obligaciones que las mugeres tienen, para que puedan ser agradables à los divinos ojos, i entre otras cosas dice, que deben criar mucha cantidad de cabello que les sirva de velo i cortina natural con que se esconda aquel bello i hermoso escandalo donde suelen tropeçar i caer las mas recogidas i rectadas onestidades: *Mulier si comam nutriat gloria est illi: quoniam capilli provelamine dati suntei.*" See the margin reference to 1 Corinthians 11:15.

19. Niseno, *Segvnda Parte, del Politico del Cielo*, folio 34r: "Esplicando el erudito Dotor Iuan Benceo este lugar, dice: *Capilli dati sunt: hoc est à natura habentur, in signum subjectionis.* Los cabellos se dieron à la muger para marca i señal de sugecion, son como la S. i el clavo que Dios colocò en lo eminente de la cabeça, para que se conociesse lo inescusable de su servidumbre, i assi cuanto mas

cabello criare, mas informacion harà de la sumision que debe prestar al onbre, pues cada cabello es un testigo de su suabe i sabrosa esclavitud." Long hair can of course have the opposite connotation of sexual allure.

20. Interián dedicated an entire chapter to the topic: *El pintor Christiano*, Book 5, Chapter 10, "De las Imágenes, y Pinturas del Santísimo Patriarca San Joseph, dignísimo Esposo de la Virgen nuestra Señora," 139. Interián, 140: "Confieso gustoso, que debe pintársele en trage comun, y mas acomodado al estilo de la gente vulgar, que al de los magnates; pues que siendo esta la voluntad de Dios, no pasó los límites de una fortuna vulgar."

21. Interián, *El pintor Christiano*, 140: "pero no por esto se puede aprobar, el que le pinten disforme, con semblante féo, y la cabellera tan poco cuidada, que tira casi al desaliño: particularmente por ser la modestia, que se ocupa en cuidar, y moderar el aséo en el cuerpo, y en el vestido, una virtud, y no la postrera entre ellas."

22. Interián, *El pintor Christiano*, 139–40: "como si fuera un hombrecillo rudo, y casi de ninguna estimacion, y que (como suelen decir) no sabia aun qual era su mano derecha."

23. Interián, *El pintor Christiano*, 140: "Pero, como sea verdad, que *In vitium ducit culpæ fuga, si caret arte,* tampoco puedo aprobar la imprudencia de otros, que por el contrario pintan al santísimo Patriarca, y castísimo Esposo de María, mas hermoso, y aseado de lo justo, los quales le representan con un semblante muy risueño, compuesta la barba, tendido su pelo medio rizado por sus hombros, y finalmente adornado de modo que mas parece que el vestido le sirve de adorno, que para cubrirse. Todo hombre sensato debe estár muy lejos de semejantes niñerías, y pintar al purísimo Esposo de la Virgen, no al modo de un mozo muy bien peynado, y amante de afeytes, sino á la manera de un varon grave sin ninguna afectacion, y como á hombre recomendable á todas luces por su modestia, y gravedad."

24. Interián, *El pintor Christiano*, 140.

25. Interián, *El pintor Christiano*, 140–41: "Dixe de propósito, como á varon, y no como á mozo, ni tampoco (lo que hicieron algunos, y sobre que hemos tocado algo arriba, tratando de las Pinturas del Nacimiento de Christo) como á viejo lleno de años, y decrépito. Este ha sido el principal escollo en que han tropezado, no solo los Pintores, sí tambien hombres doctísimos; pensando, que quando S. Joseph se desposó con la

Santísima Virgen, no solamente era hombre ya de alguna edad, sino que era viejo." On 142, he reiterates his position: "luego es error, y absurdo el decir, y hacen muy mal en pintar haberse desposado con María el Esposo de la castísima Virgen S. Joseph, quando ya muy viejo."

26. Pacheco, *El arte de la pintura* (1990), 590: "Dixe que su esposo era de poco más de treinta años, porque la buena razón no lleva que San Josef fuese viejo, y por esto, la glosa ordinaria y Nicolao de Lira le aplican la profecía de Isaías: *habitavit Juvenis cum Virgine*; que la desigualdad trae graves inconvenientes y, si la edad no era para tener hijos, mal se pudiera salvar la buena fama de la Virgen, y un hombre de ochenta años no había de tener fuerzas para caminos y peregrinaciones y sustentar su familia con el trabajo de sus manos. También convienen los doctores en que después de sus desposorios hizo voto absoluto de castidad (que antes la Virgen y él lo habían hecho aunque perpetuo condicional) y no venía hacerlo de tanta edad y en aquel pueblo era novedad estar a tal hora por casar: y por esto San Lucas le llama varón: *ad Virginem desposatam Viro*, que es la mejor de las edades entre la juventud y virilidad."

27. Jerónimo Gracián de la Madre de Dios, *Josefina. Excelencias de San José Esposo de la Virgen María* (1597; reprint, Madrid: Apostolado de la Prensa, 1944), 33: "Y si en las pinturas se pinta anciano, es porque era varón sabio y prudente y de maduro consejo; y para obviar la ligereza de los pensamientos de personas torpes y flacas, que les pareciera que viviendo juntas dos personas de tanta hermosura y poca edad, no podrían conversar con tan inefable pureza; no acordándose que José era castísimo, y la castidad vale más para la pureza que la mucha edad." Also consult *Nueva relacion de los desposorios de San Joseph, y la Virgen* (N.p., seventeenth century), unpaginated: "vn bellessimo Mancebo."

28. Interián, *El pintor Christiano*, 142–43; and Andres de Soto, *Libro de la vida y excelencias de el glorioso S. Ioseph, Esposo de la Virgen N. Señora* (1593; reprint, Brussels: Iuan Mommaerte, 1600), 70–73: "Gerson hablando en este particular de Ioseph dice asi, no es raçon creer que Ioseph era viejo ançiano y devilitado quando se desposo con la Virgen de tan tierna edad y años, ni para el decoro de su virginidad es necesario decirlo por que mas pudo obrar el spiritu sancto en el, ligando, ó quitando la vida al fomite de la concupis-

cençia, que no podia la edad sola a los muchos años, pues sabemos que suele auer viejos de setenta años, y mas, deshonestos y nada castos, viejos eran, no moços los que contra la casta Susanna inuentaron tan lasçiuo y Peligroso testimonio y pues la castidad es don de Dios, no son la guarda los años, y en confirmaçion de esta opinion sea la primera raçon el parecer cosa conueniente que vbiese en este desposorio la proporcion en la edad que comunmente para viuir mas a su gusto y mas bien a venidos suele auer entre marido y muger, la segunda, que quando los Sanctos y los Doctores scolasticos dicen que hizo Ioseph voto de virginidad de comun consentimiento de los dos, suponen como cosa cierta que Ioseph no era viejo, ni para otro casamiento insuffiçiente, & in habilitado por los años, enspecial que todos diçen que auia sido hasta ese puncto toda su vida casto y virgen. y como segun la costumbre de los Hebreos, quasi todos se casaban, no es cosa verisimil, que Ioseph esperara a casarse, quando ya fuera viejo."

29. Gracián, *Josefina*, 32–33: "*San José no era viejo.*—Y aunque San Epifanio dice que era de ochenta años cuando se desposó, los más de los otros autores refieren que fué de cuarenta hasta cincuenta años, en edad que pudiera ser solamente padre de la Virgen. Prueban esto porque fué escogido para sustentarla con el trabajo de sus manos, acompañarla en sus caminos y peregrinaciones, defenderla del juicio temerario y que nadie entendiera que tenía hijo sin marido. Con estas cosas no cumpliera José siendo de mucha edad. Y así declaran los doctores de su poca edad y hermosura aquellas palabras de Isaías (62, 5): *Se holgará el esposo con la esposa y morará el mancebo con la virgen*; que se entienden de José y María."

30. Pacheco, *El arte de la pintura* (1990), 590; Interián, *El pintor Christiano*, 140, 143–44: "pienso que se debe pintar á dicho varon santísimo de edad perfecta, y varonil, esto es, segun me parece, de edad de cerca de quarenta años." At this age, "las fuerzas del cuerpo" and "las virtudes del alma" reach perfection (144). Joseph should be neither too old, nor too young (147). Also on 147, see the following: "Y así, no es este el motivo por el qual advierto, que el castísimo Esposo de la Virgen, debe pintarse de edad robusta, y varonil, sino porque (como insinuamos antes) la edad mas robusta, y perfecta, parece mucho mas apta, y conforme para representar la excelsa dignidad de S. Joseph, que aquí queremos significar." The

opinions of Pacheco and Interián on this topic follow theologians of the time. For example, Soto maintained that "lo mas probable y la sentençia mas comun oy dia es que era moço de mediana edad hermoso, bien dispuesto y gracioso." Gracián also favored an age in the thirties, but was willing to concede that the saint could have been as old as forty or fifty. Joseph was not eighty, as some theologians had maintained. These debates over Joseph's age at the time of the Betrothal are highlighted when comparing seventeenth-century texts with sixteenth-century ones. See Robles's 1511 life of St. Anne, Chapter 8. This pre–Council of Trent version of the story asserted that because of his old age Joseph was very reluctant to marry the Virgin, and when called to the temple along with all the other Jewish men, he hid his staff: "Y cerca de la hedad que auia sant Joseph quando se desposo con nuestra señora ay dos opiniones que parescen diuersas o contrarias y bien entendidas no lo son. . . . sant joseph podia aver al tienpo que se desposo cinquenta años o cerca dellos." After the author presents various arguments relative to Joseph's age at the time of the Betrothal, he concludes that Joseph probably was not the ancient old man envisioned by St. Jerome, nor the youth advocated by Jean Gerson: Joseph was about fifty at the time.

31. Pacheco, *El arte de la pintura* (1990), 591: "La Virgen y San Josef se han de pintar muy hermosos, en la edad referida, vestidos decentemente con sus túnicas y mantos como se acostumbran pintar, dándose las manos derechas con grande honestidad y, en medio el sacerdote bendiciéndolos, con el traje que pintamos a Zacarías cuando recibe a la Virgen en el Templo." Interián, *El pintor Christiano*, 25: Artists must represent the Virgin in front of the priest, "en la edad de su niñez, adornada con mucha modestia." St. Joseph should be "de edad varonil; y teniendo ademas un ramo muy florido, dándose mutuamente sus castísimas manos." The painting must express "la santidad de vida, pureza, y virginidad tambien del Santísimo Esposo."

32. Luther also advocated marriage for priests. See the following: *Catholic Encyclopedia* (Vatican City: Thomas Nelson, 1952), 8:412–13; J. P. Dolan, "Luther, Martin," in *New Catholic Encyclopedia*, ed. Robert C. Broderick (New York: McGraw-Hill, 1967–79), 8:1085–91; and Steven Ozment, *When Fathers Ruled: Family Life in Reformation Europe*

(Cambridge, Mass.: Harvard University Press, 1983), 87.

33. *Tratado del santo sacramento de matrimonio* (Lyons, France: Dionisio Gerault, 1677), unpaginated. Also see Sergio Ortega Noriega, "Los teólogos y la teología novohispana sobre el matrimonio, la familia y los comportamientos sexuales. Del Concilio de Trento al fin de la Colonia," 16 in Seminario de Historia de las Mentalidades, *Del dicho al hecho . . . Transgresiones y pautas culturales en la Nueva España* (Mexico City: Instituto Nacional de Antropología e Historia, 1989), 11–28.

34. Valderrama, *Los exercicios espirituales*, 294. The complete sermon is on 294–301, "Sermon Primero en la Festiuidad del glorioso san Ioseph."

35. Soto, *Libro de la vida*, 127. In chapter 12, he continues in the same vein (entitled, "De el exemplo que en este Sancto matrimonio se da a los casados, acerca de el amor que se an de tener.") On 127–28, he writes, "Da se les tambien a los casados en este casamiento sancto, dechado y exemplo de el amor, que se deben tener, y de la hermandad que entre ambos a de haber, y de la conformidad en las voluntades con que an de viuir." Also see 132: "la Virgen amaba a su Ioseph como a si misma, y le tenia sobre sus ojos, y sobre su cabeça: Ioseph la queria a ella como a su vida, y trataba con blandas y amorosas palabras."

36. Ibid., 108–9.

37. Ibid., 113.

38. Guillén in González Ruiz, *Teatro teológico*, 374. First Joseph addresses his wife: "Virgen bella, esposa pura, / a quien consagro en el pecho / mi corazón satisfecho, / que mil dichas me asegura." She then responds (375): "Dueño mío, esposo amado, / . . . Y yo pues tan tuya soy, / que, indigna de ser esposa, / en tu mano milagrosa / siempre contemplando estoy / florida la seca vara, / donde digno asiento toma / la soberana paloma, / que tu valor me declara, / debo a todo preferirte, / estimarte, engrandecerte, / como a padre obedecerte / y como a dueño servirte."

39. On the change in Mary, see Pastrana, *Empeños del poder*, 163; in this passage Joseph notices "nuevos efectos en su alma, con las palabras, y conversacion de su amada Esposa." Pastrana describes the embrace between Mary and Elizabeth on 165: "Sancta Isabel que yà conocia la buena dicha del castissimo Esposo Joseph (aunque entonces la ignoraba èl) le acariciò, regalò, y tratò con grande reverencia, y estimacion."

40. Pacheco, *El arte de la pintura* (1990), 596–99, "Pintura de la Visitación de Nuestra Señora a Santa Isabel."

41. Pacheco, *El arte de la pintura* (1990), 596.

42. Also see the anonymous paired poems on these two subjects in *Nueva relacion de los desposorios*.

43. Pacheco, *El arte de la pintura* (1990), 602: "Un pedazo de casa pobre y junto a élla un banco de carpintero cercado de astillas y San José sentado sobre un zoquete de madera, con su túnica y manto y recortado sobre el brazo derecho de él, vencido de la congoja y el sueño; junto a sí está una talega con ropa atada con una cuerda y arrimadas a la casa algunas herramientas de su oficio, las más forzosas; una sierra, azuela, cepillo, barrena y formón, todo atado con un cordel; y su báculo arrimado para caminar; detrás está un ángel muy hermoso, tocándole en la cabeza con la mano derecha y con la siniestra señalando la casa, mirándolo después de haberle desengañado y dicho: *Joseph filii David, noli timere, accipere Mariam coniugen tuam*, que habiéndole declarado el misterio y dejándolo consolado se volvió. Lo restante del lienzo es un país y un alegre cielo."

44. Tom Richardson Pitts, "The Origin and Meaning of Some Saint Joseph Figures in Early Christian Art," Ph.D. dissertation, University of Georgia, 1988, 18–22.

45. Antonio Navarro, *Abcedario Virginal y Excelencias del Santissimo nombre de Maria: Donde se le dan a la Virgen dozientos y veintiocho nombres segun la sagrada Escritura, y propiedades naturales de Piedras preciosas, Aues, Animales, Fuentes, Arboles y otros secretos de Naturaleza* (Madrid: Iuan de la Cuesta, 1604), folio 108r: "la Virgen es Puerta Celestial, porque nos abrio el Cielo, y escala del Cielo, pues por ella descendio Dios a humanarse."

46. I refer to Pacheco's *Dream of St. Joseph* (fig. 13), in Enrique Valdivieso and Juan Miguel Serrera, *Historia de la pintura española: Escuela sevillana del primer tercio del siglo XVII* (Madrid: Instituto Diego Velázquez, 1985), 71, cat. III, pl. 63.

47. Pastrana, *Empeños del poder*, Tratado Quinto.

48. Ibid., 172: "Pero quando se hallò en este aprieto testificandole la vista la novedad que no podia negarle, quedò su alma dividida con el sobresalto, y aunque satisfecho, que en su Esposa havia aquel accidente, no diò al discurso mas de lo que no pudo negar à los ojos, porque como era varon Sancto, y recto, aunque conociò el efecto, suspendiò el juicio de la causa; porque si se per-

suadiera à que su Esposa tenia culpa, sin duda el Sancto muriera de dolor naturalmente."

49. Ibid., 171.

50. Ibid., 173–74: "Altissimo Dios, y Señor Eterno, no son ocultos à vuestra Divina presencia mis deseos, y gemidos. Combatido me hallo de las violentas olas que mis sentidos han llegado à herir mi corazon. Yo le entreguè seguro à la Esposa que recebi de vuestra mano. De su grande sanctidad he confiado, y los testigos de la novedad, que en ella veo, me ponen en question de dolor, y temor de frustrarse mis esperanças. Nadie que hasta oy la ha conocido, pudo poner duda en su recato, y excelentes virtudes; pero tan poco puedo negar, que està preñada. Juzgar que ha sido infiel, y que os ha ofendido, serà temeridad à la vista de tan peregrina pureza, y sanctidad. Negar lo que la vista me asegura es impossible, mas no lo serà morir à fuerça desta pena, si aqui no ay encerrado algun misterio que yo no alcanço. La razon la disculpa, el sentido la condena. Ella me oculta la causa del preñado, yo lo veo, que he de hazer? Conferimos al principio los votos de castidad, que entrambos prometimos para vuestra gloria, y si fuera possible que huviera violado vuestra fè, y la mia, y defendiera vuestra honra, y por vuestro amor depusiera la mia. Pero como tal pureza, y sanctidad en todo lo demàs se puede conservar, si huviera cometido tan grave crimen? Y como siendo Sancta, y tan prudente, me zela este suceso? Suspendo el juicio, y me detengo ignorando la causa de lo que veo. Derramo en vuestra presencia mi afligido espiritu: ò Dios de Abraham, de Isaac, y Jacob! Recebid mis lagrimas en acepto sacrificio, y si mis culpas merecieron vuestra indignacion, obligaos Señor de vuestra propria clemencia, y benignidad, y no despreciéis tan vivas penas. No juzgo que Maria os ha ofendido, pero tampoco siendo yo su Esposo puedo prevenir misterio alguno de que no puedo ser digno. Governad mi entendimiento, y corazon con vuestra luz Divina, para que yo conozca, y execute lo mas acepto à vuestro benplacito."

51. Martinez de Llamo, *Marial de todas las fiestas*, 7.

52. Matthew 1:18–21 and Luke 1:28–30. The story is recounted by Pastrana, *Empeños del poder*, 181–84.

53. Valderrama, *Los exercicios espirituales*, 300; Pastrana, *Empeños del poder*, 181; Melchior Rodriguez de Torres, *Iornadas de Iosef y su familia Maria y Iesus* (Burgos, Spain: Pedro de Huydobro, 1628), fol. 23v: "Y sino dime, no fue martyrio de amor

forzexar Iosef con las sospechas de su Esposa hecha el alma ceniza de celos?" Also see fol. 28v for Joseph's status as a confessor saint.

54. See Pedro de Ribadeneira, *Flos Sanctorvm, o Libro de las vidas de los Santos* (Barcelona: Sebastián Cornella, 1643), 263–65; Pastrana, *Empeños del poder*, 384; Matheo de Zubiaur, *Peso, y fiel contraste de la vida, y de la mverte. avisos, y desengaños, exemplares, morales, y politicos. Con vn tratado, intitvlado, observaciones de palacio y corte. Y vn breve apuntamiento de la llegada de la Reyna N. S. a esta corte* (Madrid: Andres Garcia, 1650), fols. 80–81; Barcia, *Despertador Christiano* (1694), 116; Ioseph Martinez de Grimaldo, *Ramillete de las flores, qve del iardin del ingenio, regado con el rocio de la devocion brotaron algvnos de los elegantes y devotos congregantes del Santissimo Sacramento. Para cantar svs glorias en las festividades, que este año de 1650. ha celebrado su Esclauitud en el Convento de Santa Maria Madalena de esta Corte* (N.p., c. 1650), fol. 247; Manuel de Leon Marchante, *Obras poeticas posthumas, que a diversos assumptos escrivio el maestro Don Manuel de Leon Marchante, Comisario del Santo Oficio de la Inquisicion, Cappelan de su Magestad, y del Noble Colegio de Cavalleros Manriques de la Vniversidad de Alcalá, Racionero de la Santa Iglesia Magistral de San Justo, y Pastor de dicha Ciudad. Divididas en tres classes, sagradas, humanas, y comicas* (Madrid: Gabriel del Barrio, 1722), fols. 44–45 (villancicos); Martinez de Llamo, *Marial de todas las fiestas*, 203–18; and Valderrama, *Los exercicios espirituales*, 297.

55. See Julio Caro Baroja, "Honour and Shame: A Historical Account of Several Conflicts," trans. Mrs. R. Johnson, in J. G. Peristiany, ed., *Honour and Shame: The Values of Mediterranean Society* (Chicago: University of Chicago Press, 1966), 82–84, 86, 118; María de Lourdes Villafuerte García, "Casar y compadrar cada uno con su igual: casos de oposición al matrimonio en la ciudad de México, 1628–34," in Seminario de Historia de las Mentalidades, *Del dicho al hecho . . .*, 63; and Lyman L. Johnson and Sonya Lipsett-Rivera, eds., *The Faces of Honor in Colonial Latin America: Sex, Shame, and Violence* (Albuquerque: University of New Mexico Press, 1998).

56. See Julian Pitt-Rivers, "Honour and Social Status," in Peristiany, *Honour and Shame*, 24, 36, 38, 44, and 68. For more specific information on masculine honor in the period in question, consult Patricia Seed, *To Love, Honor, and Obey in Colonial Mexico: Conflicts over Marriage Choice,*

1574–1821 (Stanford, Calif.: Stanford University Press, 1988) and Richard E. Boyer, *Lives of the Bigamists: Marriage, Family, and Community in Colonial Mexico* (Albuquerque: University of New Mexico Press, 1995).

57. Pitt-Rivers, "Honour and Social Status," 42, 45–46.

58. Pastrana, *Empeños del poder*, 412; also see 332: "Privilegios que Dios concediò à los devotos de mi señor San Joseph. . . . El primero, Es para alcançar auxilios poderosos, la virtud de la castidad, y vencer los peligros de la sensualidad carnal." See also 445–47, "Exemplo XXIV. Cuydado particular que tubo mi señor S. Joseph de la guarda de vna muger casada, porque no ofendiesse à su marido." And 453–54, "Exemplo XXIX. Favorece mi señor San Joseph varias vezes à vna muger afligida su devota que confiada le invoca." On 540: "Exemplo CVIII. A vna muger casada, muy devota de mi señor San Joseph, la libra milagrosamente de vn peligro de la vida, honra." On 466: "Exemplo XXXXII. La devocion de mi señor San Joseph es medio muy eficaz para mejorar la vida." See 483 for a man "encenagado en el vicio de la sensualidad, ciego del amor de vna muger que lo tubo perdido," in "Exemplo LIV. La devocion de los siete mayores dolores, y gozos de mi señor San Joseph, es medio eficaz para mudar de vida." Also see 537, "Exemplo CV. Es eficaz remedio para refrenar vicios la poderosa intercession de mi señor San Joseph." On 497, "Exemplo LXVII. Vn hombre de mala, y extragada vida, la mejora por la intercession de Maria, y Joseph." On 455: "Exemplo XXXI. Por los ruegos, y lagrimas de su muger muy devota de mi señor San Joseph, se vè vn hombre libre de los hechizos con que le tenia ciego, y fuera de si vna mala, y peruersa hembra." The final quote can be found on 407: "Los casados tomen por patron à mi señor San Joseph, si quieren tener paz, y conformidad en el matrimonio, especialmente quando se ven afligidos de zelos, acudan por remedio à este Esposo de la Virgen."

59. Ibid., 447: "Exemplo XV. A vn devoto de mi señor San Joseph, à quien mataron alevosamente conservò Dios la vida en la lengua milagrosamente hasta que se confessò."

60. Ibid., 539: "Exemplo 107. Libra mi señor San Joseph, milagrosamente, a vna muger que la queria matar su marido, haziendosela invissible."

61. According to Émile Mâle, the phrase in Latin "Ite ad Joseph" was inscribed on chapels dedicated to St. Joseph. See his *L'art religieux du XVIIe siècle*, new ed. of 1954 2d ed. (Paris: Armand Colin, 1984), 283.

62. The Chapel of St. Joseph in the Cathedral of Seville housed a painting of *Christ and the Adulterer* (Bolognese School). See Enrique Valdivieso González, "La pintura en la Catedral de Sevilla. Siglos XVII al XX," in Fernando Chueca Goitia et al., *La Catedral de Sevilla* (Seville, Spain: Guadalquivir, 1984), 455.

63. Gottlieb, *The Family in the Western World*, 104.

64. Reported in Electa Arenal and Stacey Schlau, *Untold Sisters: Hispanic Nuns in Their Own Works* (Albuquerque: University of New Mexico Press, 1989), 208 (in Spanish), 217–18 (English translation). Taken from *Vida de la Venerable Madre Isabel de Jesús, recoleta Augustina en el convento de San Juan Bautista de la villa de Arenas. Dictada por ella misma y añadido lo que faltó de su dichosa muerte* (Madrid: Viuda de Francisco Nieto, 1675). According to Arenal and Schlau, the text was dictated in 1645–58. See Chapter 3, "The Poor Pray More: A Peasant Nun (Isabel de Jesús)," 191–227; on her marriage, 192.

65. Pastrana, *Empeños del poder*, "Exemplo XXXXI. Vna muger que deseaba casarse lo consiguiò por la intercession de San Joseph," 465. Also see 484, "Exemplo LXV. Favores que de mi señor San Joseph ha recibido vna devota suya." Pastrana, 477: "Exemplo XXXXIX. Fabores que ha hecho mi señor San Joseph à vna devota suya, y reprehension que diò à vna Religiosa de satenta." In a similar case, an image of Joseph in a church assured a worried woman that she was indeed with child by making the fetus move in her womb. Another statue of Joseph later assuaged her pains during the pregnancy. This woman named her child after the saint. Recounted in Pastrana, 515–16: "Exemplo LXXXII. Consuela mi señor San Ioseph à vna devota en aflicciones que padezia." Joseph also helped a woman eleven months pregnant deliver her child, according to Pastrana, 527–28: "Exemplo LXXXXIV. Conocimiento que tuvo vna devota de mi señor San Joseph, de lo mucho que le agrada confesar, y comulgar su dia, y señal cierta que tubo, estando preñada, de que habia oìda su peticion." Pastrana, 332: "Privilegios que Dios concediò à los devotos de mi señor San Joseph." "El primero, Es para alcançar auxilios poderosos, la virtud de

la castidad, y vencer los peligros de la sensualidad carnal. [. . .] El septimo privilegio para alcançar sucession de hijos en las familias."

66. During the so-called "Golden Age," Spain suffered not only catastrophic wars, epidemics, and other disasters, but also significant population losses. Spain's loss of power, prestige, land, and people in the seventeenth century caused it to slip from its position as the most powerful monarchy in the world. Although Spain was not the only country to suffer population decline—a wider European phenomenon in the seventeenth century—it was one of the slowest to recover from its effects. The "decline of Spain" is one of the major issues to occupy historians in the field. Recent historians have re-evaluated the traditional view that contrasts decadent, declining Habsburg Spain with France's newly emerging power and prestige. See, for example, J. H. Elliott, "The Question of Decline," Part 4 of his *Spain and Its World 1500–1700* (New Haven: Yale University Press, 1989), 213–86. Also consult the introduction in Helen Nader, *Liberty in Absolutist Spain: The Habsburg Sale of Towns, 1516–1700* (Baltimore: Johns Hopkins University Press, 1990). According to Nader, the original essay on the topic dates to 1938: Earl J. Hamilton, "The Decline of Spain," *Economic History Review* 8 (1938): 168–79.

My view of Spain's decline follows that of Elliott, who, while pointing out the symptoms of Spain's loss of power in the seventeenth century, cautions against broad characterizations of Spanish society as "decadent." Texts and documents of the period indicate that seventeenth-century Spaniards thought of their society as one in crisis. For information on the general European decline, I have relied on R. Schofield, D. Reher, and A. Bideau, eds., *The Decline of Mortality in Europe* (Oxford: Clarendon Press/Oxford University Press, 1991).

67. See Antonio Domínguez Ortiz, *La sociedad española en el siglo XVII* (Madrid: Instituto Balmes de Sociología, 1963), 60–63, 72; J. H. Elliott, *The Count-Duke of Olivares: The Statesman in an Age of Decline* (New Haven, Conn., and London: Yale University Press, [1986] 1988), 410; and Mary Elizabeth Perry, *Gender and Disorder in Early Modern Seville* (Princeton, N.J.: Princeton University Press, 1990), 12; for general attitudes on marriage in the period, also see her Chapter 3,

"Perfect Wives and Profane Lovers." One may also consult the original documents in the Archivo Municipal de Sevilla, Sección 11, Conde de Águila, many of them discussed by Perry, *Gender and Disorder*, 70–74.

68. See Michel Foucault, *The History of Sexuality. Volume I: An Introduction*, trans. Robert Hurley (New York: Random House, 1980) (originally published in French in 1976).

69. Asunción Lavrin, "Introduction: The Scenario, the Actors, and the Issues," in Asunción Lavrin, ed., *Sexuality and Marriage in Colonial Latin America* (Lincoln: University of Nebraska Press, 1992), 4: "the main preoccupation of canon lawyers and theologians of the sixteenth century was the acceptance of Christian marriage by the indigenous society." Also see Stafford Poole, Part I, "Iberian Catholicism Comes to the Americas," in Charles H. Lippy, Robert Choquette, and Stafford Poole, *Christianity Comes to the Americas, 1492–1776* (New York: Paragon House, 1992), 40–48. See the definitive discussion of the theology of matrimony in New Spain by Ortega, "Los teólogos."

70. See Book 4 in *Concilio III Provincial Mexicano, celebrado en México el año 1585, confirmado en Roma por el papa Sixto V, y mandado observar por el gobierno español en diversas reales órdenes*, 2d ed., ed. Mariano Galván Rivera (Barcelona: Manuel Miró y D. Marsá, 1870). Also consult Ortega, "Los teólogos," 11–28, and Villafuerte, "Casar y compadrar," 60–64.

71. *Concilio III Provincial Mexicano*, Book 4, Title I, Article 8, 352. The prohibitions against divorce can be found in Articles 14 and 15, 355. The Council's findings on polygamy are in Book 2, Title I, Article 14, 141.

72. Lavrin, *Sexuality and Marriage*, 7. The official Council of Trent catechism was approved in 1566 by Pope Pius V.

73. The first published Náhuatl sermon dedicated to Joseph appeared in 1577. It was rediscovered, transcribed, and translated into Spanish by Carrillo, "San José en la Nueva España del siglo XVII," 629–30. A second sermon was published in 1614: Fray Martin de Leon, *Primera Parte del Sermonario del tiempo de todo el año, duplicado, en lengua Mexicana* (Mexico City: Viuda de Diego Lopez Daualos, 1614). A print associating St. Joseph with native conversion forms the frontispiece to Luis de Neve y Molina, *Reglas de orthographia, diccionario, y arte del idioma othomi,*

breve instruccion para los principiantes (Mexico City: Bibliotheca Mexicana, 1767.)

74. My thinking on this point has been influenced by James Clifford, *The Predicament of Culture: Twentieth-Century Ethnography, Literature, and Art* (Cambridge, Mass.: Harvard University Press, 1988).

75. Consult Richard F. Townsend, *The Aztecs* (London: Thames and Hudson, 1992), Chapter 9, "The Family and Education," and especially 156–57, 164–65; Richard R. Wilk, "Maya Household Organization: Evidence and Analogies," 135–51 (and especially 135–36, and 141), in Wilk and Wendy Ashmore, eds., *Household and Community in the Mesoamerican Past* (Albuquerque: University of New Mexico Press, 1985); and Alfredo Mirandé, *Hombres y Machos: Masculinity and Latino Culture* (Boulder, Colo.: Westview Press/HarperCollins, 1997), Chapter 2, "Genesis of Mexican Masculinity," 29–61, and especially his discussion of Fray Bernardino de Sahagún's *Florentine Codex* on 50–53. Important information on native marriage can also be found in the *The Codex Mendoza*, ed. Frances F. Berdan and Patricia Rieff Anawalt (Berkeley and Los Angeles: University of California Press, 1992), vol. 2 (facsimile).

76. My thinking on reported cannibalism in the New World has been influenced by Peter Mason's *Deconstructing America: Representations of the Other* (New York: Routledge, 1990) and W. Arens, *The Man-Eating Myth. Anthropology and Anthropophagy* (New York: Oxford University Press, 1979).

77. See the following studies that discuss marriage in Spain's Golden Age and colonial Latin America: Anne J. Cruz and Mary Elizabeth Perry, eds., *Culture and Control in Counter-Reformation Spain* (Minneapolis: University of Minnesota Press, 1992); Perry, *Gender and Disorder*; Boyer, *Lives of the Bigamists*; Ramón A. Gutiérrez, *When Jesus Came, the Corn Mothers Went Away: Marriage, Sexuality, and Power in New Mexico, 1500–1846* (Stanford, Calif.: Stanford University Press, 1991); Seed, *To Love, Honor, and Obey*; and the following essays in Lavrin's *Sexuality and Marriage*: Lavrin, "Sexuality in Colonial Mexico: A Church Dilemma," 47–95; Ruth Behar, "Sexual Witchcraft, Colonialism, and Women's Powers: Views from the Mexican Inquisition," 178–208; and Richard Boyer, "Women, *La Mala Vida*, and the Politics of Marriage," 252–86.

CHAPTER THREE
Happy Families

1. See the following for the patronage of the works cited in this paragraph: Harold E. Wethey, *El Greco and His School* (Princeton, N.J.: Princeton University Press, 1962), fig. 104; María Elena Gómez-Moreno, *Alonso Cano: Estudio y catálogo de la exposición celebrada en Granada en junio de 1954*, exh. cat. (Granada: Museo de Bellas Artes, 1954), no. 38, 62. Other versions of Cano's painting can be found in the Sagrario, Granada (a copy without the Virgin Mary); and in a collection in Barcelona (also without the Virgin Mary; reportedly from a convent in Granada). A third version, with the Holy Family intact, but with Mary's head bowed, was reproduced in Museo Español de Arte Contemporáneo, *San José en el arte español*, exh. cat. (Madrid: Ministerio de Educación y Ciencia, 1972), cat. nos. 82, 17, and 128, from the Antonio Gómez del Castillo Collection in Seville. For Valentín Díaz, see Federico Wattenberg, *Museo Nacional de Escultura de Valladolid*, 2d ed. (Madrid: N.p., 1964), 279. On Carreño, see Rosemary Marzolf, "The Life and Work of Juan Carreño de Miranda (1614–1685)," Ph.D. dissertation, University of Michigan, 1961, 34–35, 113, fig. 4. On Roelas, see Enrique Valdivieso González and Juan Miguel Serrera, *Historia de la pintura española: Pintura sevillana del primer tercio del siglo XVII* (Madrid: Instituto Diego Velázquez, 1985), pl. 100, no. 71, 155–56. On Coello, Edward Sullivan, *Baroque Painting in Madrid: The Contribution of Claudio Coello with a Catalogue Raisonné of His Works* (Colombia: University of Missouri Press, 1986), 111. On Martínez Montañés, see Beatrice Proske, *Juan Martínez Montañés: Sevillian Sculptor* (New York: Hispanic Society of America, 1967), 74–75, pl. 95; and José Hernández Díaz, *Juan Martínez Montañés (1563–1649)* (Seville: Guadalquivir, 1987), 69, 79, 92, 134. Proske doubts the attribution, as does Hernández Díaz, who describes the work as being in the style of the sculptor. On Ribalta, see Fernando Benito Doménech, *The Paintings of Ribalta 1565–1628* (New York: The Spanish Institute, 1988), pl. 22. The Holy Family painting appears above the *Institution of the Eucharist*, at the very top of the *altar mayor* commissioned by the Colegio. For Herrera Barnuevo, see Alfonso E. Pérez Sánchez, *Pintura barroca española 1600–1750* (Madrid: Cátedra,

1992), 304 and 306. The information on Cajés is gleaned from information in the photograph archive (fototeca) of the Instituto Diego Velázquez, Consejo Superior de Investigaciones Científicas, Madrid. I am unaware of the painting's current location. It was, however, offered for sale in Madrid in the Edmund Peel gallery on 29 October 1991.

2. Pereyns also claimed that it was a greater sin to have a love affair with a married woman than with an unmarried one and that one did not have to reveal all one's sins in confession. After being sentenced in 1568, Pereyns was denounced to the Inquisition on three additional occasions. See Manuel Toussaint, *Colonial Art in Mexico*, trans. and ed. Elizabeth Wilder Weismann (Austin: University of Texas Press, 1967), 134; and Toussaint, "Proceso y denuncias contra Simón Pereyns en la Inquisición de México," *Anales del Instituto de Investigaciones Estéticas* (1938), Supplement. Unfortunately, the painting was destroyed in an electrical fire in the Cathedral in 1967.

3. On Villalpando, consult Francisco de la Maza, *El pintor Cristóbal de Villalpando* (Mexico City: Instituto Nacional de Antropología e Historia, 1964), 204, where he posits that the painting was one of four in the monastery that originally formed part of the Life of the Virgin series, the rest of which is housed in the Church of Gualupito, Zacatecas. On Herrera, see Gabrielle Palmer and Donna Pierce, *Cambios: The Spirit of Transformation in Spanish Colonial Art* (Santa Barbara, Calif.: Santa Barbara Museum of Art/University of New Mexico Press, 1992), 88.

4. On depictions of the Holy Kinship in the late medieval period, see Pamela Sheingorn, "Appropriating the Holy Kinship: Gender and Family History," in Kathleen Ashley and Pamela Sheingorn, eds., *Interpreting Cultural Symbols: Saint Anne in Late Medieval Society* (Athens: University of Georgia Press, 1990), 169–98.

5. Joseph's minor place in sixteenth-century European religious art has been remarked upon previously by Howard Hibbard, *Poussin: The Holy Family on the Steps* (New York: Viking, 1974), 60, and by other authors.

6. Other similar images include a canvas from about 1580–85 (New York, Hispanic Society of America) and one from about 1595–1600 (National Gallery, Washington, D.C.). See the catalogue of El Greco's works by Harold Wethey,

El Greco and His School. The *toledano* artist Juan de Sánchez Cotán employed a similar strategy in an early painting of the theme dating from about 1590 (private collection, Granada).

7. Two Castillian versions, by Juan Sánchez Cotán (Carmelitas, Madrid, before 1627) and Vicente Carducho (Museo Nacional del Prado, Madrid, 1631), give prominence to St. Anne at the expense of Joseph, who appears on the sidelines. Two Sevillian works by Antonio Mohedano (Museo de Bellas Artes, Seville, c. 1605) and a follower of Murillo equalize Anne and Joseph by placing them in the foreground adoring the Christ Child (MacCrohon Collection, Madrid). Other permutations of the extended family occur so infrequently as to make them unique. In canvases by El Greco and his follower Luis Tristán, the Holy Family appears with St. Anne (fig. 19; and Lupiáñez Collection, Seville). In other paintings, El Greco includes St. John the Baptist in addition to St. Anne (National Gallery, Washington, D.C., c. 1595–1600; and Museo Nacional del Prado, Madrid, c. 1595–1600). In two Sevillian examples by Juan de las Roelas and Zurbarán, the Holy Family appears with the Virgin's parents and the Baptist (Catedral, Las Palmas, Canary Islands, 1607; and Collection of the Marqués de Perinat, Madrid, c. 1625–30). In a single painting by Vicente Carducho, these figures are joined by St. Elizabeth (private collection, London).

8. Compare the following sixteenth- and seventeenth-century hagiographies of St. Anne: Juan de Robles, *La vida y excelencias y miraglos de Santa Anna y de la gloriosa nuestra señora Santa Maria fasta la edad de quatorze años: Muy deuota y contenplatiua nueuamente copilada* (Seville, Spain: Jacobo Cromberger, 1511), "Capitulo.ix. en que se torna a proseguir y acabar la historia de sancta Anna y sant Joachim y algo de sant Joseph;" Fray Francisco de Lizana, *Vida, prerrogativas, y excelencias de la inclita matrona señora Santa Ana* (Madrid: Ioseph Fernandez de Buendia, 1677); Valentina Pinelo, *Libro de las alabanças y excelencias de la gloriosa Santa Anna* (Seville, Spain: Clemente Hidalgo, 1601); Pedro de Ribadeneira, *Flos Sanctorvm, o Libro de las vidas de los Santos*, vol. 1 (Madrid: Luis Sanchez, 1616), 493–94, "XXVI. de Iulio. La vida de santa Ana, madre de la madre de Dios"; and Johannes Molanus, *De Historia SS. Imaginvm et Pictvrarvm, Provero Earvm*

Vsv contra abusus, vol. 3 (Louvain, Belgium: Lawrence Durand, 1619).

9. Francisco Pacheco, *El arte de la pintura*, ed. Bonaventura Bassegoda i Hugas (Madrid: Cátedra, 1990), 580: "Pintura no usada de Santa Ana: En un tiempo, estuvo muy válida la pintura de la gloriosa Santa Ana asentada, con la santísima Virgen y su Hijo, en brazos y acompañada de tres maridos, de tres hijas y de muchos nietos, como en algunas estampas antiguas se halla; lo cual hoy no aprueban los más doctos y lo deben escusar, justamente, los pintores cuerdos; porque, como dixo, con razón, Tertuliano: 'El tiempo aumenta la sabiduría y descubre las verdades en la Iglesia.' Así, vemos hoy favorecido el único matrimonio de Santa Ana y San Joachín como verdad cierta y segura."

10. Marqués de Lozoya, "¿Un precedente de la Sagrada Familia del Pajarito?" *Archivo español de arte* 40 (1967): 83; Alfonso E. Pérez Sánchez, *Pintura italiana del siglo XVII en España* (Madrid: Universidad de Madrid y Fundación Valdecilla, 1965), 229; Pacheco, *El arte de la pintura* (1990), n. 106, 627; and Museo del Prado, *Bartolomé Esteban Murillo, 1617–1682*, exh. cat. (Madrid: Museo del Prado, 1982), cat. no. 8, 158. As early as 1577, engravings of Barocci's painting were circulating throughout Spain; the composition inspired frequent copies. Murillo also could have easily seen a copy of this painting in nearby Écija (Tamarit Martel Collection) or Valencia (Private collection).

11. The prevalence of depictions of male saints having visions of the Christ Child is a new phenomenon in the seventeenth century. Previously, female saints were more typically granted these experiences. See David Herlihy, "The Family and Religious Ideologies in Medieval Europe," in Tamara Hareven and Andrejs Plakans, eds., *Family History at the Crossroads* (Princeton, N.J.: Princeton University Press, 1987), 13.

12. Ribadeneira, *Flos Sanctorvm* (1616), 262: "Y si los casamientos, para ser acerrados y pacificos, deuen hazerse entre personas iguales, y conformes en el linage, estado, condicion y costumbres; de creer es, que nuestra Señor, que juntò con vn lazo tan estrecho de amor, como a Esposo y Esposa, a Ioseph y a Maria, los hizo en la santidad muy semejantes, no con igualdad, sino de la manera que Ioseph podia imitar a la que, aunque era su esposa, y por esta parte subdita, era su Señora y Reyna del cielo, y dechado de los Ser-

afines en santidad." Juan Martínez de Llamo, *Marial de todas las fiestas de Nuestra Señora, desde sv concepcion pvrissima, hasta la festividad mas moderna de svs desposorios con el patriarca San Ioseph. Con otros tres sermones de la descension de la imagen de el glorioso patriarca Santo Domingo, traìda por manos de Maria Santissima à la Villa de Soriano* (Madrid: Antonio de Zafra, 1682), 205: "pero en los que haze la divina gracia, aquellos à quien el Cielo con especialidad vne, procura de los dos en todo lo possible, y congruente la semejança. Tanto es esto verdad, que aun entre animales sin razon, no queria Dios que dos desiguales se juntassen en vn yugo."

13. Ribadeneira, *Flos Sanctorvm* (1616), 262: "Y si Dios formo a Eua de la costilla de Adan, para que le ayudasse, y fuesse su semejante, porque no creemos, que auiendo dado a Ioseph, para que ayudasse, y siruiesse a Maria, le haria muy semejante, y parecido a ella, y le formaria como de su espiritu, y celestiales dones, para que siendo como vn viuo retrato de sus virtudes, mas facilmente se conseruasse, y acrecentasse el amor de ambos entre si?" Martínez de Llamo, *Marial de todas las fiestas*, 206: "La semejança en la santidad, virtudes entre Maria y Ioseph, hemos menester discurrir, abraçando de vno, y otro la santidad."

14. Balthasar de San Joseph, *Panegirico del religioso reformado compuesto por el P. Fr. Balthasar de San Joseph religioso carmelita descalzo que dedica al glorioso patriarca S. Joseph Padre en la opinion de Jesu Christo S. N. esposo verdadero de Maria S.S. y patron vniversal del reformado carmelo*, MS, Biblioteca Nacional, Madrid, unpaginated: "caveza de la casa." For a similar phrase ("la mujer, cuya cabeza es el marido"), see Jerónimo Gracián de la Madre de Dios, *Josefina: Excelencias de San José esposo de la Virgen María* (1597; reprint, Madrid: Apostolado de la Prensa, 1944), 37: "Luego que Dios ordenó el matrimonio, puso *por ley que por la mujer se deje el padre y la madre y que sean dos corazones en una carne* (*Gen.*, 2, 24). Esta ley igualmente obliga al marido y a la mujer, y antes con más fuerza a la mujer, cuya cabeza es el marido." Pedro del Espiritu Santo, *Sermones de Jesus, Maria, y Joseph, a que se añaden otros de N. S. M. Doctora Mystica Santa Teresa de Jesus: y de Nuestro Mystico Padre, y Doctor S. Juan de la Cruz, que en todos son quarenta* (Madrid: Blàs de Villanueva, 1717), 243–53, "Joseph Poderoso contra el demonio," and specifically 246, a passage on the house of the Holy

Family: "si claro està, que San Joseph era el presidente, Patron, y dueño de esta casa." On 246–47: "en Casa de Maria y en la Santa Familia que preside Joseph." Diego de Malo Andveza, *Oraciones panegiricos en las festividades varias de santos* (Madrid: Domingo Garcia Morràs, 1663), 30: "porque si es varon de la Virgen, luego es su cabeça, luego es Padre de Christo legitimo. Luego si Iosef lo es, al parecer, respeto de la Esposa, y del Hijo: de la Esposa, porque es su cabeça: del Hijo, porque es su Padre." Diego de San Francisco, *Exercicios de señor San Joseph, varon justo, patriarcha grande, esposo purissimo de la Madre de Dios, y altissimo padre estimativo de el Hijo de Dios* (Mexico City: Imprenta Real del Superior Govierno, y del Nuevo Rezado, de Doña Maria de Rivera, 1747), 9, "Oracion con que se da fin â los Exercicio": "Dios te Salve, Santissimo Patriarcha Sr. S. JOSEPH, amorosissimo esposo de MARIA, tu amabilisima Esposa, deposito de sus afectos, â quien venerò como á Esposo, y sirviò como â superior, y cabeza, gozandose de esta dulce, y amorosa servidumbre. . . . el mismo Dios humanado, por graciosa dignacion, quisiera ser tu subdito: bendito tu eres, pues siendo humildissimo, entre todos los hombres, solo te ensalzas con el renombre glorioso de Estimativo Padre de JESUS, Señor de su casa, y Principe de su possession." Francisco de Zarate, *El cordial devoto de San Joseph* (Mexico City: Francisco Rodriguez Lupercio, 1674), 6: "De mas desto por el Matrimonio fue constituido Ioseph Cabeza de Maria, y Maria propria de Ioseph." Francisco Garcia, S.J., *Novena del glorioso patriarca señor San José, padre putativo de Jesus, y esposo dignisimo de Maria* (originally published in the seventeenth century; reprint, Aguascalientes, Mexico: Imprenta Económica, 1876), 3 (a passage on the Holy Trinity, where "te" refers to "Trinidad Santísima"): "Gracias te doy, con todos los afectos de mi corazon, por la inesplicable dignidad á que sublimaste á Señor San José haciéndole cabeza de la casa de la Madre de Dios, y dándole en la tierra, en cierta manera, el lugar del Eterno Padre, primera persona de tu Trinidad augusta, por haberle escogido para Padre putativo de Jesus." On 8 can be found another prayer to Joseph: "mayordomo de la casa de Dios, cabeza de mas noble familia del mundo, tercera persona de la Trinidad de la tierra, refugio de agonizantes." On 14 another prayer reads: "cabeza de la familia de Dios en la tierra."

15. Ribadeneira, *Flos Sanctorvm* (1616), 261: "Escogiole el Señor para Esposo y verdadero marido (fuera del vso conjugal) y por consiguiente (en esto) para cabeça y superior de nuestra Señora la Virgen Maria, y juntamente para padre putatiuo de su vnigenito y benditissimo hijo."

16. Juan de Villa Sánchez, *Sermones varios* (Mexico City: Rivera, 1738), 34: "Y el mismo Dios atento à los fueros, al derecho, al dominio de Joseph, no manda à la Santissima Virgen, si no manda à Joseph, que le mande: ni dispone de JESUS, sino que le ordena à Joseph, que disponga. . . . Assi obedecia la Madre de Dios à Joseph, como à Señor. . . . porque Joseph era Cabeza de la Santissima Virgen, como Christo Cabeza de su Iglesia."

17. Gracián, *Josefina*, 29: "Según las reglas y leyes de matrimonio, María era de José; porque hemos probado ser verdadero matrimonio entre los dos, y según el Apóstol (1 *Cor.*, 7, 4): *La mujer no es señora de su cuerpo, que ya es del marido.* Y así, supuesto que Dios la casó, los pechos y entrañas de María eran de José para que le engendraran y criaran sus hijos. Y pués este Rey, que es de infinita justicia y rectitud, se la toma a José para engendrar y criar su Unigénito Hijo, el Verbo divino, y depositar en ella todo su tesoro, razón es que se le pague y se le remunere, porque no quede este carpintero agraviado."

18. Antonio de Molina, *Exercicios Espirituales de las excelencias, provecho, y necessidad de la Oracion Mental, reducidos à Doctrina, y Meditaciones, sacados de los Santos Padres, y Doctores de la Iglesia* (1612; reprint, Barcelona: Rafael Figverò, 1700), 1–23, "Sermon Primero de San Joseph, Dignissimo Esposo de la Madre de Dios." On 13–14: "Assi Joseph tenia derecho para fecundar aquel Campo Virginal: supendiò el concurso por orden del Cielo; la fecundò el Espiritu Santo. Norabuena, dize Joseph, ponga el Espiritu Santo el influxo, que mio ha de ser el concepto, porque le cedo mi derecho. . . . Aun mas, que como advierte Gerson, Christo era muy parecido à Joseph en la especie corporal; luego serà Hijo de Joseph: pero no, que faltò el concurso: pero si: aqui pido atento à mi discreto Auditorio." On 20–21: "El campo virgineo, que diò por fruto el pan del Cielo, à quièn reconocia por dueño? A què dominio estaba Maria sugeta, quando nacieron de sus entrañas sin el surco de arado las Divinas espigas para formar el pan de las Angelicas Inteligencias? A Joseph, està claro; pues el titulo de Esposo plenamente le diò esse dominio."

19. On women's legal status in Spain, see Richard E. Boyer, *Lives of the Bigamists: Marriage, Family, and Community in Colonial Mexico* (Albuquerque: University of New Mexico Press, 1995), 63 and 113. Fray Antonio Joseph de Pastrana, *Empeños del poder, y amor de Dios, en la admirable, y prodigiosa vida del sanctissimo patriarcha Ioseph, esposo de la madre de Dios* (Madrid: Viuda de Francisco Nieto, 1696), 406: "Està le obligada porque fue guarda de su Virginidad, porque la sustentò con el sudor de su rostro, porque la acompañò en sus caminos, porque la consolò, y aliviò en sus trabajos, porque la sirviò con fidelidad, porque la amò ternissamemente con amor puro, sancto, y casto, porque la ayudò à criar su Sanctissimo Hijo." Also see Andres de Soto, *Libro de la vida y excelencias de el glorioso S. Ioseph, Esposo de la Virgen N. Señora* (1593; reprint, Brussels: Juan de Mommaerte, 1600), 96: "El diuino Bernardo dice que fue la causa de este sancto matrimonio para que su esposo diese testimonio de su pureça y virginidad, por que era costumbre de los Hebreos guardar sus esposas desde el dia que se desposaban."

20. Gracián, *Josefina*, 44–45: "Bien entendián, dice San Gregorio Niseno (1), los sacerdotes del templo que *el marido es cabeza de la mujer* y que ella le había de servir y respetar; y conociendo la excelencia de María, no quisieron sujetarla a hombre mortal. Dios ordenó este desposorio, Dios fué el casamentero de estas bodas, y el mismo Señor, como dice su Apóstol (*Efes.*, 5, 23), mandó que el marido fuese cabeza, mandase y governase, y las mujeres, como dice San Pedro (1 *Petr.*, 3, 1), fuesen *súbditas*, obedientes e inferiores a sus maridos; y que en todo les obedezcan, respeten, reverencien y hagan su voluntad, como Sara obedeció a Abraham, Raquel a Jacob y las demás. Y pues ordenó que José fuese marido de María, de su divina voluntad procedía que ella le obedeciese, y que él la gobernase y mandase como padre a hija, que en tal posesión la tenía, como tutor a su pupila y menor, que así le llama San Andrés Jerosolimitano (2), como esposo a su esposa y verdadero marido a su mujer. Y así a José enviaba Dios su ángel con los mensajes de ir a Egipto y volver a Egipto, como al que era cabeza (*Mt.*, 2, 13, 20), para que José ejecutase sus mandamientos y governase la casa donde moraban María y Jesús."

21. Gracián, *Josefina*, 27: "el patrón y Señor de su casa y familia, que eran María y Jesús." Joseph de Paredes, *El Santo de Suposicion. Sermon de el Patriarcha Señor San Joseph, Que en su dia 19. de Marzo de 1749. En la Santa Iglesia Cathedral de Merida Provincia de Yucatan Dixo el P. M. Joseph de Paredes* (Mexico City: Imprenta del Nuevo Rezado, de Doña Maria de Ribera, 1749), 17: "O grandeza incomparable de Santo, con quien es menester andar con precauciones, para no apropiarle Divinidad! Quien atento considerare, que JESUS es Dios, y al mismo tiempo viere, que à este Dios le manda JOSEPH como à su Hijo y que este Hijo le respecta, y obedece en todo como à Padre hasta doblarle muchas vezes la rodilla." On 22: "JOSEPH manda á MARIA como á su Esposa: MARIA á JESUS como a su hijo natural: este manda en el Cielo, y en la tierra: luego JOSEPH es, el que en ambos imperios manda." Villa, *Sermones varios*, 23–44, "Sermon II. Del Gloriosissimo Patriarcha Señor San Joseph, predicado en el Convento de Señoras Religiosas Carmelitas Descalzas, de la Ciudad de la Puebla, en el dia de su Festividad, año de 1726," 34: "Y el mismo Dios atento à los fueros, al derecho, al dominio de Joseph, no manda à la Santissima Virgen, si no manda à Joseph, que le mande: ni dispone de JESUS, sino que le ordena à Joseph, que disponga. . . . Assi obedecia la Madre de Dios à Joseph, como à Señor. . . . porque Joseph era Cabeza de la Santissima Virgen, como Christo Cabeza de su Iglesia."

22. Gracián, *Josefina*, 27: "Y que *todo el mundo obedezca a José y sea el principal en la casa de Dios* no es mucho, pues él mismo y María, su Madre, le obedecieron, y él fué el patrón y Señor de su casa y familia, que eran María y Jesús." Francisco de Iesvs Maria, O.C.D., *Excelencias de la Caridad, y de otras mvchas virtudes, y de la Devocion con la Virgen Santissima Nuestra Señora, y con su Dvlcisimo Esposo San Ioseph. Con Motivos, y medios para las mismas virtudes, y Devociones* (Salamanca, Spain: Lvcas Perez, 1680), 429: "La segunda excelencia de la devocion con San Ioseph, nace de lo mucho, que puede, y vale con la Virgen Sacratissima, à quien èl sirviò tanto, y de quien fue tan singularmente amado en esta vida, y lo es aora en el Cielo. Fuèle esta gran Señora sujeta acà en la tierra, miròle como à su superior, obedeciòle tanto, que no se apartò vn punto de su voluntad. Què le negarà, pues aora que èl le pida por sus devotos? Harà sin duda quanto la suplique." Gracián, *Josefina*, 6: "Y si de cualquier santo podemos esperar favor e intercesión para con Cristo y su Madre, y es

bueno ser nuestro abogado y devoto, ¿cuándo más conviene lo seamos, confiemos, y busquemos la intercesión del glorioso San José, que siendo siervo de Cristo Jesús, tuvo oficio de su padre, y le mandó como si fuera señor; y siendo privado y vasallo del Rey y Reina del Cielo, a la Reina mandó como esposo, y el Rey del Cielo le fué súbdito y obedeció como a padre? Esta particularidad no la ha tenido ningún santo; y pues en la bienaventuranza, como dijo la Virgen a Santa Brígida, Ella y su Hijo no se olvidan de la humildad con que obedecieron a José cuando estaban en la tierra, no hay duda sino que tendrá alguna más particularidad en el Cielo para alcanzar lo que por su medio pidiéremos."

23. Beatrice Gottlieb, *The Family in the Western World from the Black Death to the Industrial Age* (Oxford: Oxford University Press, 1993), 91, 234. As the household's head, Joseph was the source of discipline in the family. Gracián, *Josefina*, 60: "*Padre por elección. . . .* que aunque José no engendró a Jesús ni fué su padre natural, Jesús le eligió por padre. Y después de hecha esta elección, le obedece, respeta y reverencia como hijo, y él ejercita el mando, superioridad y govierno como padre de Jesús."

24. This according to a revelation reported by the sixteenth-century Josephine author Isidoro Isolanus. Francisco de Iesvs Maria, *Excelencias de la Caridad*, 470–71: "Motivo II. Por los mucho que amaron Iesvs, y Maria à S. Ioseph, como à cuidadosissima guarda, y prenda preciosissima suya. Amòle el Hijo de Dios con tiernissimo amor, como declarò su Magestad en vna revelacion, que refiere Isidoro Isolano, lib. I. cap. 4. por estas palabras: Yo conversava con èl en todas las cosas, como si fuera su Hijo; en todo le era obediente, como los hijos à sus padres; y amava yo à Ioseph, como à la niñera de mis ojos."

25. Martin de León, *Primera Parte del Sermonario del tiempo de todo el año, duplicado, en lengua Mexicana* (Mexico City: Viuda de Diego Lopez Daualos, 1614), "Sermon de la Epiphania/Dominica Infra Octava Epiphaniae. Sermo I" (on Mary and Joseph losing the Christ Child in the temple), fol. 85 verso, lines 1–11: "La primera vez que él, por su devocion, San José va a la casa de Dios, aunque estaba algo lejos de Jerusalén, fue a cumplir el mandato de Dios, para la segunda vez fue voluntad del querido Hijo de Dios ir al templo para allí mostrarse, ser muy obediente, que obedecía a San José, como si fuera su padre." The

original Náhuatl reads: "Inic centlamantli ca in yehuatl initlateomatilihtzin San Ioseph, mohuica inichantzinco Dios, maco elihui in achihueca Ierusalen, ca quimoneltililiz initlanahuatiltzin Dios, inic ontlamantli itechpatzinco in itlaço Piltzin Dios, in huel ocpiltzintli teopan mohuica ytlanequiliztzicatzinco, ic oncan neci, ca cenca motetlacamachiltiani, inic quimotlacamachiltiaya in San Ioseph, in yuhquimma itatzin."

Also see folio 85 verso, lines 34 and 35, and folio 86 recto, lines 1–13: "Esto que se nos ordena por Dios, que es mandamiento de la Santa Iglesia, ver y escuchar bien una misa en las fiestas y los domingos, y allí tener devoción, hacer oración en el templo, aun cuando viváis algo lejos del templo, que así lo hizo San José, que estaba en Nazareth, y de allí fue a Jerusalén en Pascua, la primera vez alli se nos enseñó que lo hizo solo San José; para la segunda vez nos enseña Dios cómo los jovenes, las doncellas, los chiquillos han de ser obedientes, han de obedecer a sus padres, cuando deben inducirlos a alguna obra buena, así como obedeció Nuestro Señor Jesucristo a San José, que no era su padre, sino solamente su cuidador, su administrador, su ayo, su tutor." The original Náhuatl reads: "Inin ca ipampatzinco in Dios techmonahuatilia, ca itehtzinco ca in Santa Yglesia initlanahuatiltzin, huel centetl Missa mottaz mocaquiz in ilhuitl ipan, yhuan Domingotica, auh oncan tlateomachoz, tlatlatlauhtiloz in teopan, maçonelihui in achihueca teopan anquitztcate, ca yuh oquimochihuilitzino in San Ioseph, Nazareth ipan moetzticatca, auh ompa mohuicac in Ierusalen inipan Pascua, in in ic centlamantli oncan itech timachtilo inoquimochihuilitzino in San Ioseph; ynic ontlamantli oncan techmomachtilia in Dios, ininitechcopa telpopochtin inichpopochtli, in pipiltontin, in quenin tetlacamatizque, in quin quin tlacamatizque inintahua, iniicuac itla tlein cuallachihualli qncuitlahuiltia, in yuh oquimotlacamachiltitzino Totecuyo Iesu Xpo Sa Ioseph in amo itatzin, ca itepixcatzi, ycalpixcatzi, yteizcalticatzin, itlacahuapahualtzin." I located this sermon in file 0805 of the Centro Mexicano de Estudios Josefinos in Mexico City, under the direction of Father José Carlos Carrillo Ojeda, M.J. A signature and the date of 26 February 1986 are found at the end of the Spanish translation, presumably the name of the translator (Father Carrillo?), which unfortunately, I was unable to decipher.

26. Ribadeneira, *Flos Sanctorvm* (1616), 265: "Por que adonde pudo baxar mas la humildad de Dios, que a sujetarse a vn pobre carpintero? Y adonde puede subir la dignidad y soberania de vn hombre, mas que a mandar y ser obedecido de Dios? En esto se encierra todo lo que se puede dezir de los priuilegios, virtudes y excelencias de S. Ioseph, que sin duda fueron tales, que las deuian ser las de vn varon santissimo, que era esposo de la madre de Dios, y padre putatiuo de tal hijo, como diximos."

27. Balthasar de San Joseph, *Panegirico del religioso reformado*, unpaginated. The same information is repeated by other authors, such as Martínez de Llamo, *Marial de todas las fiestas*, 10: "O IOSEPH Divino, elijate el Cielo para que estés al Lado de IESVS, Principe Niño." Martínez de Llamo, 15: "Mucho se escusô IOSEPH para ponerse al Lado de IESVS, Principe Niño, y governarle: Pero repetidas fueron las instancias de el Cielo, para que lo aceptasse. Sin duda solo IOSEPH era merecedor de tal Lado, y a proposito para esso, no lo dudo, y lo tengo por cosa muy acertada: Pues si miramos las acciones de IOSEPH, atenderêmos, que su Lado fue para beneficiar â otros. Pusose IOSEPH al Lado de IESVS, Principe Niño, mas para el bien de los otros, que para intereses suyos."

28. See, for example, Martínez de Llamo, *Marial de todas las fiestas*, 206.

29. Balthasar de San Joseph, *Panegirico del religioso reformado*, unpaginated: "Ninguno puede ser devoto de Maria, sin serlo tambien de San Joseph: pues el Esposo lleno de virtud, es corona lustrosa de la muger. Si es Maria como todo poderosa y Joseph tiene imperio sobre esta señora (digo en quanto Esposo: pero no en quanto perfecto) quien tubiere de su mano à este Santo glorioso, tiene en su favor à la Reyna del Cielo, y juntamente el poder del mui alto." Pastrana, *Empeños del poder*, 406: "La honra del Padre es honra del Hijo, y de la Esposa, y assi la honra de Joseph, es honra de Jesvs y de Maria."

30. Gracián, *Josefina*, 40–41: "¿qué mujer casada hubo en el mundo que más buenas obras haya recibido de marido que María de José? Por causa de José no la apedrearon, si la acusara de adulterio, y con ella a su Niño en el vientre, con que ella perdiera la vida y sus parientes la honra. Por José no le mataron su Hijo en sus brazos, como a otras madres de los Inocentes; José la sustentó, consoló, acompañó y sirvió con tanta voluntad y gracia como se puede pensar. De suerte que, después de Dios, de ninguna criatura, ni del propio padre que la engendrió y madre que la parió, recibió María los beneficios que recibió de José. Y como amaba sin comparación mucho más que a sí a su Hijo Jesús, cualquiera beneficio que hacían al Hijo, agradecía la Madre en más alto grado que si le recibiera en su propia persona. Según esto, ¿cuánto agradeciera María a José verle con cuidado de que Herodes no se le matase? ¿Qué pensaría cuando le viese sudando y trabajando por los caminos, llevándole en brazos y acepillando para darle de comer y vestir? Bienaventurados los ojos que vieron lo que vió José y los oídos que oyeron lo que él oyó."

31. Ribadeneira, *Flos Sanctorvm* (1616), 262: "El tenia por Esposa la mas santa muger que ha auido, ni jamas aurà en el mundo; de la qual canta la Iglesia: *Nec similem visa est; neque habere sequentem*, que ni tuuo, ni tendra otra semejante. Y esta es vna inestimable gracia de Dios, de la qual dize la Escritura, que los padres dan a los hijos la casa y la hazienda, mas que la muger prudente es don propio de la mano de Dios." Gracián, *Josefina*, 37: "Y pues ningún marido del mundo ha sido ni será tan amado de su mujer como José de María, ninguno ha gozado tanto del fruto de sus oraciones. Suele ser grande el amor de las buenas mujeres para sus maridos; y como ninguna fué tan santa y perfecta como María, ninguna se le igualó en la grandeza y perfección de este amor. Luego que Dios ordenó el matrimonio, puso por ley que *por la mujer se deje el padre y la madre y que sean dos corazones en una carne* (Gen., 2, 24). Esta ley igualmente obliga al marido y a la mujer, y antes con más fuerza a la mujer, cuya cabeza es el marido. Y todo lo que en las demás mujeres casadas se divierte en amor natural o amor de carne, que va a parar en gustos del apetito, se recogía en María dentro del corazón en amor santo y espiritual y unido con Dios; y cuanto es mayor y mejor el alma que el cuerpo, el espíritu que la carne, tanto es mayor y mejor el amor de María a José que el de las demás casadas del mundo a sus maridos." Pastrana, *Empeños del poder*, 403–4: "El singularissimo amor, que la Virgen le tubo, y la incomparable honra que le hizo, tambien engrandeze mucho à este glorioso Sancto, porque como sea perfeccion de vna muger casada."

32. Pastrana, *Empeños del poder*, 404: "Amar, y servir à su marido, y la Virgen fue en todas las cosas

perfectissima, hizo el vinculo conjugal tan vno estos dos corazones, que despues de Christo Nuestro Señor, à ninguna otra persona amò tanto la Virgen como à San Joseph."

33. Gracián, *Josefina*, 42–43: "Hablando la sacratísima Virgen con Santa Brígida, le dijo estas palabras: 'Aunque desde la eternidad fuí predestinada para el más alto y encumbrado trono de la bienaventuranza, y para la mayor gloria y honra que ninguna criatura alcanzó, con todo eso fuí humilde y no me desprecié de servir y guisar de comer para José y para mi Hijo; porque también mi Hijo servía a José.'" On 43: "Dichoso tal carpintero José, que mereció ser servido en la tierra de la Reina a quien todos los ángeles sirven en el Cielo; dichosa comida guisada por tales manos como las de María, que en buen provecho entraría a José y se convertiría en sangre aparejada para criar complexión sobre que asentase bien cualquier virtud y santidad. ¿Qué rey, emperador ni monarca ha habido en el mundo que haya sido servido de tales dos personas, María y Jesús, como lo fué José?" Despite discussion of the Virgin's cooking in Josephine texts, I have not located any images of the scene.

34. *Nueva relacion de los desposorios de San Joseph, y la Virgen* (N.p., seventeenth century), unpaginated: "Servia la Virgen pura / à su Esposo amado Dueño / con tanto amor, y humildad, / que no puedo encarecerlo." Also see the following texts: Gracián, *Josefina*, 15 (a passage discussing St. Joseph's five excellences): "La primera, por haber sido elegido por mano de Dios para esposo de su Madre; la segunda, haber sido dotado del Padre Eterno como marido de tal Esposa; la tercera, ser particularmente remunerado de Dios, por haberse servido de María, su Esposa, para engendrar, parir y criar a su hijo Jesús; la cuarta, haber merecido que le sirviese tan alta Señora; la quinta y última, haberle encomendado muchas veces a Dios la Virgen María en sus benditísimas oraciones." Also consult later passages in Gracián, 43–44: "En el Cielo el trono de la Virgen está colocado sobre todos los tronos de los apóstoles y serafines, y ninguna otra criatura merece asentarse en él; y así como en el cielo, siendo grande es humilde, en la tierra, siendo humilde es grande. . . . ¿cuál será un santo que en su trono y en su casa se aposenta María y Jesús, y no sólo esto, per que le sirvieron y respetaron? Cuando en el Cielo pase María por los asientos de los serafines, patriarcas, profetas, apóstoles o

los santos más aventajados de la gloria, a nuestro modo de entender, levantaránse ellos de su asiento, reverenciarán y postraránse a los pies de María, llamándola su Señora, su Reina y Emperatriz; y cuando llegare al asiento y trono donde estuviere José, pues dice que es tan humilde en el Cielo como en la tierra lo era, no dejará de dar muestras de su humildad reconociendo haberle servido y obedecido mientras estuvo en el mundo; y a quien todos los demás llaman Reina y Emperatriz puede llamar José Esposa y mujer. Y cuando toda la corte celestial vea que su Reina hace particular honra a San José, no serán ellos perezosos en reverenciarle."

Also consult Pastrana, *Empeños del poder*, 375: "Cap. X. Lo Mucho qve Mi Señor San Joseph Fve servido, y estimado de su Sanctissima Esposa, y la reverencia que los Cortesanos del Cielo le hazen, como à Esposo de su Reyna, y Señora." Later on the same page, see the discussion of Joseph's "tenth star," defined as: "es lo mucho que fue servido, y estimado de su Sanctissima Esposa." Pastrana stressed that although Mary was destined to be the mother of God, she humbly served and cooked for Joseph and her Child: "Dichoso Joseph qve mereciò en la tierra ser servido de la Reyna, à quien sirven todos los Angeles en el Cielo."

35. Martínez de Llamo, *Marial de todas las fiestas*, 206: "En nada se diferencia la substancia de la muger del varon, sino en la diversidad de estados, varon el vno, y muger la otra. Sirvale esta de ayudar al hombre."

36. Ibid: "Ayudele à llevar el peso del matrimonio: sirvale en los oficios, y exercicios domesticos: sirvase el vno al otro de auxilio, y socorro."

37. Soto, *Libro de la vida*, 74: "La occupaçion y exercicios de estos bienauenturados esposos, serian por su pobreça, del sancto Ioseph, su officio de carpintero, y de la Virgen gloriosissima, hilary texer para assi ayudar al marido a la sustentacion de la vida." Pre-Columbian cultures similarly valorized weaving, as discussed in Thelma D. Sullivan, "Tlazolteotl-Ixcuina: The Great Spinner and Weaver," in Elizabeth Hill Boone, ed., *The Art and Iconography of Late Postclassic Central Mexico* (Washington, D.C.: Dumbarton Oaks, 1982), 7–35. Louise M. Burkhart has suggested that weaving may have been a metaphor for women's sexuality in pre-Columbian Mexico. The Mexican reception of images of Mary weaving, then, deserves more investigation. See Burkhart, "Mex-

ica Women on the Home Front: Housework and
Religion in Aztec Mexico," in Susan Schroeder,
Stephanie Wood, and Robert Hackett, eds.,
Indian Women of Early Mexico (Norman: Univer-
sity of Oklahoma Press, 1997), 48.

38. *Nueva relacion de los desposorios*, unpaginated; and
Pastrana, *Empeños del poder*, 404. The painting
censor Pacheco specified that Mary wove a
"seamless tunic" for her Son, Christ, the activity
shown in Murillo's painting. *El arte de la pintura*,
625–26: "Aquí, como el Niño iba creciendo, entre
sus ocupaciones de manos, es de creer que, texió
la Virgen la túnica inconsútil para su Hijo. . . . la
cual le puso en su infancia desde que dexó los
pañales." This has been discussed by John F.
Moffit, "Mary as 'Prophetic Seamstress' in Siglo
de Oro Sevillian Painting," *Wallraf-Richartz
Jahrbuch* 54 (1993): 141–61.

39. Fray Luis de León, *La perfecta casada* (Madrid:
Espasa-Calpe, 1975), 47–55.

40. Pastrana, *Empeños del poder*, 404: "Que ventura
fue la de San Joseph en tantos años como
vivieron juntos, comiendo à vna mesa, y de vn
mesmo pan, y morando en vna mesma casa, y
que tantas vezes vistiò ropa, no solo dada de la
Virgen, mas tambien cosida, y aderezada
con sus proprias manos, y con tan amoroso
cuydado?"

41. Ibid.: "Exemplo XXIX. . . . Todo Nuestro bien
engendra el trabajo, y nuestro daño el ocio, la
fiera mas fiera, el bruto mas valiente se amansa,
teme el Leon al Leonero, el Elephante al Cornaca
su maestro, el Rinozeronte al cazador, el Vni-
cornio à la prision, y cepo, el Toro se dexa encer-
rar, el Cavallo se rinde al freno, el Buey à la
coyunda, el Pez al ançuelo, el Lebrel à la cadena.
Esto lo consigue el afan, y trabajo del hombre, à
quien lo criado le sirve, y ofrece vassallaje à sus
plantas. Sola la muger, que es de mal natural, y
depravadas costumbres, es animal indomito, en
quien es ocioso todo el cuidado que à sugetarla
se encamina, porque no ay imperio à que se
rinda, ni consejo à que se sugete, ni freno que la
humille, ni yugo que la amanse, ni temor que la
espante, ni castigo que la enmiende. Si hazen
empeño à vn desacierto, han de rendir la vida
hasta conseguirlo. El aviso le es de injuria; de la
amenaza forma querella, desprecia el cariño, del
desden se agravia, y desespera, el disimulo la
ensoberbece, y el castigo la buelve bibora; con el
ruego no se enmienda, ni con el rigor se mejora.
Son las tales como la anguila en manos del

pescador, que si la aprieta se desliza, y si la afloja
resvla."

42. Pedro de Sandoval, *Sermon Panegirico del Glorioso
Patriarcha S. Ioseph, Desposado con Maria Santis-
sima, que discurrió, y dixo el dia de su festividad en el
Convento de N. P. S. Francisco de la Ciudad de la
Puebla* (Mexico City: Doña Maria de Benavides
Viuda de Juan de Ribera, 1700), fols. 2–3: "Solo la
sabiduria infinita, que puso las cosas todas en
igual numero, conoce la desigualdad, y quanto
tenga de mayor excelencia el Varon, que su infe-
rior la muger, y quanta sea de esta la obligacion, y
el dote, que ha de ofrecer liberal.

Fue Adan el primero Esposo, y entre todos
el mas enriquezido, porque de Eva nuestra
primera Madre recibiò el el dote mas dilatado,
diò sela el infinito poder, por Esposa suya, y
como conoce bien la esfera baxa de la Muger, si
se compara con la superioridad Varonil, se la
ofreciò Dios bien dotada midiendo igualdad con
Adan por ser tan enriquezida." On fol. 3: "Aora
entiendo quantas mal registradas acciones han
fabricado mugeres, intentando passar à jurisidic-
cion agena, y brios Varoniles, por desmentir poco
cuerdas, como mucho presumidas sus fuerças
femeniles."

43. Fray Ioseph de Iesvs Maria, *Historia de la Virgen
Maria Nvestra Señora. Con la declaracion de algunas
de sus Excellencias* (Antwerp, Belgium: Francisco
Canisio, 1652), 682: "San Ioseph està en el cielo
en cuerpo y alma glorioso: para que, como ay en
el vna Trinidad de personas en la naturaleza
diuina; assi tambien aya otra Trinidad de per-
sonas en la naturaleza humana, que son Christo,
la Virgen, y San Ioseph." Another Spanish devo-
tional writer, however, offered a slightly different
intepretation that equated Joseph—not Mary—
with the Holy Spirit. See Gracián, *Josefina*, 13:
"¡Bendito, loado y glorificado sea Dios, Padre,
Hijo y Espíritu Santo, una esencia y trinidad de
personas; y glorifíquenle todos los moradores del
Cielo, que nos dió en la tierra a tales tres per-
sonas, Jesús, María y José! María se parece al
Padre en que es Madre de Jesús, que le concibió
en sus entrañas como el Padre Eterno le engen-
dró *antes que criase el lucero de la mañana* (Ps. 109,
3). Jesús es el mismo Verbo Divino que nace de la
Madre en cuanto hombre y en cuanto Dios del
Eterno Padre. José se parece al Espíritu Santo en
ser esposo de su misma Esposa María, y el que
conforta, anima, acompaña, recrea y consuela a
María y a Jesús."

44. Manuel de Piño, *Segvnda Parte de Villancicos, y Romances, a La Natividad del Niño Iesus, nuestra Señora, y varios Santos* (Lisbon: Pedro Craesbeeck, 1618), fol. 69v: "A San Ioseph / Villancico. / Sobre Iesus Maria, y Ioseph // Lo mejor que mi alma vé / aunque suba al mismo Cielo, / es mirar en nuestro suelo / Iesus, Maria, y Ioseph // En la celestial Ciudad / Dios vno, y Trino se encierra, / pero tambien nuestra tierra / goza de otra Trinidad. // La Trinidad que se vè / fuera la del mismo Cielo, / es mirar en nuestro suelo / Iesus, Maria, y Ioseph//."

45. Enrique del Sagrado Corazón, O.C.D., "Estudios de historia josefina: Temas sobre San José en la Inquisición española: Juicio Inquisitorial contra una obra de devoción a San José," *Estudios josefinos* 10 (1956): 201–4. For example, censors expurgated the phrase "honor to the Trinity of the Earth, Jesus, Mary, and Joseph" from a book by Francisco Romero, his *Devocionario sagrado de los privilegios, gracias y glorias del Padre estimativo de Jesús y Esposo de María, el Santísimo Patriarca, Señor San José, compatrono de Cádiz.*

46. Martin de León, *Primera Parte del Sermonario del tiempo de todo el año, duplicado, en lengua Mexicana* (Mexico City: la Viuda de Diego Lopez Daualas, 1614), "Sermon de la Epiphania/Dominica Infra Octava Epiphaniae. Sermo I," folio 86r, lines 1–13: "así como obedeció Nuestro Señor Jesucristo a San José, que no era su padre, sino solamente su cuidador, su administrador, su ayo, su tutor." The original reads: "in yuh oquimotlacamachiltitzino Totecuyo Iesu Xpo Sa Ioseph in amo itatzin, ca itepixcatzi, ycalpixcatzi, yteizcalticatzin, itlacauapahualtzin." See n. 25 on the Spanish translation of this text.

47. Pastrana, *Empeños del poder*, 439: "Exemplo XV. Aparecense Jesvs, Maria, y Ioseph à vn Religioso devoto suyo el dia de Pascua de Navidad, y regalanle con su hermosa vista." Pastrana reports that a religious had a vision of "esta Sanctissima Trinidad de la tierra."

48. Caroline Walker Bynum, *Holy Feast and Holy Fast: The Religious Significance of Food to Medieval Women* (Berkeley and Los Angeles: University of California Press, 1987), Parts 2 and 3. In an earlier book, she explored gender reversal in devotion to Christ: *Jesus as Mother: Studies in the Spirituality of the High Middle Ages* (Berkeley and Los Angeles: University of California Press, 1982).

49. Soto, *Libro de la vida*, 69–70, 74: "Lo quinto, por que tambien fue (como luego diremos) el matrimonio, para guardar la honrra de la virgen a çerca de los judios, y en cubrir el secreto al demonio, la qual causa çesaba, si Ioseph viejo y muy cano vieran que era su marido: por que como se pudiera de el creer, o presumir ser padre de el diuino infante, ni de otro alguno? assi consiguientemente diçe Gerson que le parecia a Christo nuestro Señor en el rostro, y en la de mas disposicion de el cuerpo. Lo qual quiso Dios que assi fuese por que sino hubiera entre Christo y Ioseph semejança, y vieran que no se parecian, como suelen parecer se el padre y el hijo, no fuera tenido de los judios (como fue) por padre suyo, y assi tubieran por adultera a la Virgen su madre. era (pues) moço, hermoso, honestissimo, vergonçoso sabio, discreto." Molina, *Exercicios Espiritvales*, 13: "como advierte Gerson, christo era muy parecido à Ioseph en la especie corporal."

50. Depictions of the Holy Trinity are plentiful in colonial Mexican art. See the examples reproduced in *Pintura Novohispana. Museo Nacional del Virreinato, Tepotzotlán*, 3 vols. (Tepotzotlán, Mexico: Asociación de Amigos del Museo Nacional del Virreinato; and Américo Arte, 1992, 1994, and 1996): Francisco Martínez, *Assumption of the Virgin* (which includes the Trinity), eighteenth century; Manuel Arellano, *Holy Trinity*, eighteenth century; and anonymous, *Holy Trinity*, eighteenth century. Compare the following images of St. Joseph: Francisco Martínez, *St. Joseph*, eighteenth century; André López, *St. Joseph and the Christ Child*, 1797; and José de Páez, *St. Joseph and the Christ Child*, eighteenth century.

51. Enrique del Sagrado Corazón, "Estudios de historia josefina . . . Juicio Inquisitorial," 201–4. The article discusses the expurgation of the phrase "Padre de Jesús" from a Spanish devotional text.

52. Figures of the Christ Child often demonstrate a rhetorical repetitiveness that removes them from the realm of the "real."

53. Gracián, *Josefina*, 60: "tomaba al Niño en sus brazos y le traía cantando cantarcicos, acallábale si lloraba, brincábale para que se durmiese en la cuna, gorjeábale, regalábale y dábale dijes como a niño, y no salía vez fuera de casa, que los pajaritos o manzanitas o cosas semejantes que hallase, de que suelen gustar los niños, no trajese para su Niño Jesús, volviéndose de edad de niño el que trataba con Dios infinito hecho Niño."

54. These little birds were popular pets in the period. See Iuan Bautista Xamarro, *Conocimiento de las Diez Aves menores de jaula, su canto, enfer-*

medad, cura y cria (Madrid: Imprenta Real, 1604), 19–25, "Del Girgvero. De la Propriedad y naturaleza del Girgvero," with a print of the goldfinch. Herbert Friedmann, *The Symbolic Goldfinch: Its History and Significance in European Devotional Art* (Washington, D.C.: Pantheon, 1946), 9, 24 for the christological reading; for a list of Spanish paintings that employ the goldfinch, see his appendix, 138–39. Also consult Moffit, "Mary as 'Prophetic Seamstress,'" 143–44.

55. Francisco de Iesvs Maria, *Excelencias de la Caridad*, 470–71: "Motivo II. Por lo mucho que amaron Iesvs, y Maria à S. Ioseph, como à cuidadosissima guarda, y prenda preciosissima suya. Amòle el Hijo de Dios con tiernissimo amor, como declarò su Magestad en vna revelacion, que refiere Isidoro Isolano, lib. I. cap. 4. por estas palabras: Yo conversava con èl en todas las cosas, como si fuera su Hijo; en todo le era obediente, como los hijos à sus padres; y amava yo à Ioseph, como à la niñera de mis ojos." Pastrana, *Empeños del poder*, 372: "Pues que consolacion recibiria mi señor San Joseph, que veinte y siete años viviò con Christo, y su Madre, comiendo con ambos en vna mesa, y estando en vna casa mesma, y gozando de sus dulcissimos coloquios, no vna vez sola, sino todas las que el Sancto queria?" Pastrana, 375: "Cap. X. Lo Mucho qve Mi Señor San Joseph Fve servido, y estimado de su Sanctissima Esposa, y la reverencia que los Cortesanos del Cielo le hazen, como à Esposo de su Reyna, y Señora. . . . es lo mucho que fue servido, y estimado de su Sanctissima Esposa . . . Dichoso Joseph qve mereciò en la tierra ser servido de la Reyna, à quien sirven todos los Angeles en el Cielo." Gracián, *Josefina*, 41–42: "*La comunicación causa amor.*—El trato continuo y familiaridad y la conversación hacen crecer el amor; que muchas veces se quieren más tiernamente los que se crían juntos que los que nacieron de un vientre, según aquel refrán: 'No con quien naces, sino con quien paces.' Pues ¿quién podrá pensar el amor que resultaría en María y José de la conversación de tantos años como moraron juntos? Que, según refiere un autor (2), José se desposó siendo de cuarenta años y murió de sesenta y nueve, y casi treinta años gozó de la dulce compañía de María y Jesús." Pastrana, 404: "Que ventura fue la de San Joseph en tantos años como vivieron juntos, comiendo à vna mesa, y de vn mesmo pan, y morando en vna mesma casa, y que tantas vezes

vistiò ropa, no solo dada de la Virgen, mas tambien cosida, y aderezada con sus proprias manos, y con tan amoroso cuydado?" See also Pastrana, 401, quoting from the *Flos Sanctorum* of Alonso de Villegas (Madrid: Pedro Machado, 1589).

56. Lawrence Stone, "The Rise of the Nuclear Family in Early Modern England: The Patriarchal Stage," in Charles E. Rosenberg, ed., *The Family in History* (Philadelphia: University of Pennsylvania Press, 1975), 13–57. Also see Gottlieb, *The Family in the Western World*, 12; Michael Mitterauer and Reinhard Sieder, *The European Family: Patriarchy to Partnership from the Middle Ages to the Present*, trans. Karla Oosterveen and Manfred Hörzinger (Oxford: Basil Blackwell, 1982), 7–8; Jack Goody, *The Development of the Family and Marriage in Europe* (Cambridge, England: Cambridge University Press, 1983); and Francisco Chacón Jiménez, ed., *Historia social de la familia en España. Aproximación a los problemas de familia, tierra y sociedad en Castilla (ss. XV–XIX)* (Alicante, Spain: Instituto de Cultura "Juan Gil-Albert," 1990), 137–64, "Introducción a la historia de la familia en España. El ejemplo de Murcia y Orihuela (Siglos XVII–XIX)." See especially 146, 156, and 157. In the same volume, see "Notas para el estudio de la familia en la región de Murcia durante el antiguo régimen," 101–37, and especially 122.

57. Mitterauer and Sieder, *The European Family*, 7–8.

58. Pamela Sheingorn, "Appropriating the Holy Kinship: Gender and Family History," in Kathleen Ashley and Pamela Sheingorn, eds., *Interpreting Cultural Symbols: Saint Anne in Late Medieval Society* (Athens: University of Georgia Press, 1990), 169–98.

59. John Boswell, *Same Sex Unions in Premodern Europe* (New York: Villard, 1994).

60. Patricia Seed, *To Love, Honor, and Obey in Colonial Mexico: Conflicts over Marriage Choice, 1574–1821* (Stanford, Calif.: Stanford University Press, 1988), 35: "Such attitudes were in keeping with the broader Protestant emphasis on the authority of parents, especially fathers, in the family, and its glorification of the patriarchal family." Lawrence Stone, "The Rise of the Nuclear Family," 30–31; and Steven Ozment, *When Fathers Ruled: Family Life in Reformation Europe* (Cambridge, Mass.: Harvard University Press, 1983).

61. Sheingorn, 169–89; and Stone, "The Rise of the Nuclear Family," 13–57, 25.

62. Stone, "The Rise of the Nuclear Family," 25 and 29.

63. Mary Elizabeth Perry, *Gender and Disorder in Early Modern Seville* (Princeton, N.J.: Princeton University Press, 1990), 12; for general atittudes on marriage in the period, also see her Chapter 3, "Perfect Wives and Profane Lovers." On Spanish military conscription, see Ruth MacKay, *The Limits of Royal Authority: Resistance and Obedience in Seventeenth-Century Castile* (Cambridge: Cambridge University Press, 1999).

64. J. H. Elliott, *The Count-Duke of Olivares: The Statesman in an Age of Decline* (New Haven, Conn.: Yale University Press, 1986 and 1988), 410.

65. Charlene Black, "Las imágenes milagrosas de San José en España y Sudamérica, las teorías del arte y el poder de la imagen en el siglo XVII," *Estudios josefinos* 48 (1994): 34.

66. Perry, *Gender and Disorder*, 9, 12, and Chapter 1.

67. Quoted in ibid., 14.

68. This is the thesis of ibid.

69. Quoted in Antonio Domínguez Ortiz, *La sociedad española en el siglo XVII* (Madrid: Instituto Balmes de Sociología, 1963), 71–72: "algunas cosas notables del año pasado de 48. y deste de 49 . . . Enfureciose el contagio manera que ya no había padres para hijos, y se salían los hombres huyendo como fieras por los campos. . . . Los niños huérfanos . . . discurrían por las calles balando como corderitos hasta que se hizo hospital donde ampararlos."

70. This is one of the themes of Michel Foucault, *Madness and Civilization: A History of Insanity in the Age of Reason*, trans. Richard Howard (New York: Random House, 1988). The perception that the family was in crisis can be detected in other European countries. For Protestant examples, see Ozment, *When Fathers Ruled*, 1.

71. Linda Martz, *Poverty and Welfare in Habsburg Spain: The Example of Toledo* (Cambridge, England: Cambridge University Press, 1983), 244. Also see Teófanes Egido, "Ambiente josefino en el tiempo de Santa Teresa," *Estudios josefinos* 36 (1982): 18. Madrid's infamous orphanage, the Inclusa, was originally dedicated to St. Joseph. See Joan Sherwood's study of the institution, *Poverty in Eighteenth-Century Spain: The Women and Children of the Inclusa* (Toronto: University of Toronto Press, 1988).

72. On Gutiérrez de Haro's plan, see Elliott, *The Count-Duke of Olivares*, 413. For the appellation "St. Joseph's children," see Teófanes Egido, "La cofradía de San José y los niños expósitos de Valladolid (1540–1757)," *Estudios josefinos* 53 (1977): 78.

73. The images are reproduced in Juan Luis Morales, *El niño en la cultura española*, vol. 2 (Madrid: T.P.A., 1960), 229, fig. 170. Also consult his history of Spanish orphanages in *El niño en la cultura española*, vol. 1, 435ff. Morales dates the painting to the sixteenth century. The same image in miniature of multiple babies sleeping together in a bed decorates the Casa Cuna's *libro de protocolos* (reproduced as the frontispiece to volume 1). Originally, the orphanage was founded under St. Joseph's name, but later the entire Holy Family was elevated as its patrons.

74. Archivo Franciscano, Biblioteca Nacional de México, MS 336, Papeles Varios; #1: Indulgencia plenaria concedida por la Santidad de Pío IV a quienes visitasen la Capilla de San Joseph de México e hiciesen limosna a los pobres. Año 1560." Part of the text reads: "Indulgentia plenaria concendida por la Sanctità del Papa Pio Quarto à todos los fieles Christianos que visitaren la Capilla de sant Iosepe en el Monasterio de sant Francisco de la Cibdad del Mexico, e ayudaren con sus limosnas a sustentar los pobres y huerfanos del Hospital del dicho Monasterio."

75. MS 1403, *fojas* 219–52, Biblioteca Nacional de México, Alonso Nuñez de Haro y Peralta, document dated 1794 at end, "Constituciones que para el mejor Govierno, y Direccion de la Real Casa del Señor San José de Niños Espósitos de esta Ciudad de Mexico. Formo el Illmo Sr Dr Dn Alonso Nuñez de Haro y Peralta, del Consejo de S. M. Arzobispo de esta Santa Yglesia Metropolitana, Aprovò el Rey Nro Sõr (Dios le guarde) y mando obserbar en todo, y por todo con las declaraciones que contienen."

76. José Ignacio Vallejo, *Vida del Señor San José, Dignisimo Esposo de la Virgen Maria y Padre Putativo de Jesus* (revised edition based on third edition of 1779; reprint, Mexico City: J. M. Lara, 1845), 248: "Estos cultos del Señor San José no se ven solamente en las iglesias, se frecuentan y florecen casi en todas las familias, que en sus devociones domésticas invocan al santísimo Patriarca como á su insigne protector."

77. *La devoción al señor San José en la Nueva España* (Mexico City: N.p., 1778), unpaginated: "De las Iglesias se ha comunicado á los interiores de las Casas, donde las Madres con sus Familias invocan afectuosamente la proteccion del Santissimo Patriarcha en su Dia."

78. See Burkhart, "Mexica Women on the Home Front," 29.

79. Information on native family structures and gender roles drawn from Schroeder, Wood, and Haskett, eds., *Indian Women of Early Mexico*; in particular Burkhart, "Mexica Women on the Home Front," 25–54; Susan Kellogg, "From Parallel and Equivalent to Separate but Unequal: Tenochca Mexica Women, 1500–1700," 123–43; and Lisa Mary Sousa, "Women and Crime in Colonial Oaxaca: Evidence of Complementary Gender Roles in Mixtec and Zapotec Societies," 199–214; as well as Susan Kellogg, *Law and the Transformation of Aztec Culture, 1500–1700* (Norman: University of Oklahoma Press, 1995).

80. Burkhart, "Mexica Women on the Home Front," 52.

81. Nicolas de Jesvs Maria, *La Mano de los Cinco Señores Jesvs, Maria, y Joseph, Joachin, y Anna* (Mexico City: Herederos de la Viuda de Miguel de Rivera, 1726). The sermon was preached on 11 November 1725, according to the author.

82. Juan Anselmo del Moral y Castillo de Altra, *Sermon, que con Motivo de la Dedicacion, y estrenas de la Iglesia del Convento de Carmelitas Descalzos de la Ciudad de Tehuaca: En el dia, que el mismo Religiosísimo Convento Celebra la fiesta de los Cinco Señores, sus patronos, y Titulares de la dicha Iglesia, Predicó en ella, (el 19 de enero de 1783)* (Puebla, Mexico: Pedro de la Rosa, 1792), from the unpaginated *dedicatoria*: "la Sagrada Familia de Jesus, Maria, Joseph, Joquin, y Ana; Poderosos Señores; Soberanos Señores." Also see 7.

83. See, for example, Santiago Sebastián, Mariano Monterrosa, and José Antonio Terán, *Iconografía del arte del siglo XVI en México* (Zacatecas, Mexico: Universidad Autónoma de Zacatecas, 1995), 11: "Como vamos a ver, en el México virreinal repercutieron las tradiciones medievales durante el siglo XVI."

84. Kelly Donahue-Wallace, "Prints and Printmakers in Viceregal Mexico City, 1600–1800," Ph.D. dissertation, University of New Mexico, 2000; and Brendan R. Branley, "Felipe de Jesús: Images and Devotions," M.A. thesis, University of New Mexico, 2000.

85. My thinking on this point has been inspired by Michel Foucault's discussion of the panopticon in *Discipline and Punish: The Birth of the Prison* (New York: Pantheon, 1977).

86. In Mexico City, the Spanish colonizers eventually attained success in their campaign to Hispanize native family structures. According to Kellogg, by 1600, complementary gender roles and the extended kinship network, both of which increased women's standing in pre-Hispanic Mexico, had been replaced by the patriarchal, authoritative family of Spain in Mexico City. Native women's status continued to decline dramatically throughout the colonial period.

87. Joseph de Espinosa Sotomayor, *Sermon Panegyrico en Glorias de la Señora Santa Ana, Fiesta, que en el Convento de San Juan Baptista de Metepec, celebrò el dia 26. de Julio de este año de 1716* (Mexico City: Herederos de la Viuda de Miguel de Ribera Calderon, 1716); Joseph Francisco Valdes, *Vida de la Gloriosísima Madre de la Madre de Dios, y Abuela de Jesuchristo Séñora Santa Ana* (Mexico City: Herederos de Don Felipe de Zúñiga y Ontiveros, 1794); Robles, *La vida y excelencias y miraglos de Santa Anna*; Lizana, *Vida, prerrogativas, y excelencias*; Pinelo, *Libro de las alabanças y excelencias de la gloriosa Santa Anna*; Ribadeneira, *Flos Sanctorvm* (1616), 493–94; and Molanus, *De Historia SS. Imaginvm et Pictvrarvm*.

88. On St. Anne's importance in late medieval and sixteenth-century Spain, see William A. Christian, Jr., *Local Religion in Sixteenth-Century Spain* (Princeton, N.J.: Princeton University Press, 1981), 68. St. Anne's cult in Spain and Mexico is discussed in greater detail in my article, "St. Anne Imagery and Maternal Archetypes in Spain and Mexico," in Allan Greer and Jodi Bilinkoff, eds., *Colonial Saints: Discovering the Holy in the Americas, 1500–1800* (New York: Routledge, 2002), 3–25.

89. Pacheco, *El arte de la pintura* (1990), 582–84 ("querida y admirada por los fieles").

90. I draw on Julia Kristeva's theories of maternality, as elaborated in *Tales of Love*, trans. Leon S. Roudiez (New York: Columbia University Press, 1987), and in particular her "Stabat Mater," 234–63.

91. Herlihy, "The Family and Religious Ideologies in Medieval Europe," 13–14.

92. See, for example, Perry, *Gender and Disorder*.

93. On St. Anne's universality, see Christian, *Local Religion*: for Spanish chapels dedicated to St. Anne, 72; shrines dedicated to St. Anne, 123; Anne's popularity in sixteenth-century Spain, 123; observance of her feast day, 238; Anne's intercession against disease, 43 and 94, and plague, 55; Anne's status in Spanish culture, 37–38; devotion and vows to Anne, 52–53, 67–68, 240; a miraculous image of St. Anne, 76; and Anne's patronage of sterile women, 245. Also

consult Christian's Appendix A, Text of Madrid Vow to Saint Anne and Saint Roch, 1597; and Appendix B, District and Regional Shrines, 1575–1580, New Castile. An intriguing discussion of St. Anne's association with woodworking can be found in Francesca Sautman, "Saint Anne in Folk Tradition: Late Medieval France," 69–94, in Kathleen Ashley and Pamela Sheingorn, eds., *Interpreting Cultural Symbols: Saint Anne in Late Medieval Society* (Athens: University of Georgia Press, 1990).

94. Fray Bernardino de Sahagún, *Historia general de las cosas de Nueva España*, vol. 3, ed. Angel María Garibay (Mexico City: Porrúa, 1981), 352–53. Fray Martin's report was probably based on Sahagún's text. Fray Martin de Leon, *Camino del Cielo en Lengva mexicana, con todos los requisitos necessarios para conseguir este fin, con todo lo que vn Christiano deue creer, saber, y obrar, desde el punto que tiene vso de razon, hasta que muerte* (Mexico City: Diego Lopez Daualos, 1611), 96: "Vna de las mayores disimulaciones es la de las fiestas que hazen en sus barrios, y pueblezuelos en las quales lo que parece exteriormente es honrrar al Santo ò Santa, cuya fiesta se celebra, y muchos dellos honrran al Idolo que honrrauan sus antiguos en su gentilidad, con algunas cerimonias disimuladas puestas en el calendario, matando aues à este modo sobre dicho.

La 2. es de las ymagines que traen en las andas à las processiones que como son de bulto y es tan huecas, dentro dellas suelen poner cosas indecentes como yo halle vna vez.

La 3. es tomada de los mismos nombres, de los Idolos que en los tales pueblos se venerauan que los nombres con que se significa en Latin, ò Romance son los proprios en significacion que significauan los nombres destos Idolos como en la Ciudad de Mexico en el cerro donde esta Nuestra Señora de Guadalupe, adorauan vn Idolo de vna diosa que llamauan Tonantzin, que es neustra [sic] madre y este mismo nombre dan à Nuestra Señora y ellos siempre dizen que van à Tonantzin, ò que hazen fiesta à Tonantzin y muchos dellos lo entienden por lo antiguo y no porlo moderno de agora, que es como dixe de la de Tlaxcalan Yglesia de Santa Ana por vna diosa que llamauan Tocitzin nuestra aguela, y oy en dia dizen que hazen fiesta à toci, ò van al templo de toci."

All information on Toci drawn from the definitive study by Sullivan, "Tlazolteotl-

Ixcuina," in Elizabeth Hill Boone, ed., *The Art and Iconography of Late Postclassic Central Mexico* (Washington, D.C.: Dumbarton Oaks, 1982), 7–35.

95. Émile Mâle, *L'art religieux du XVIIe siècle* (1954; reprint, Paris: Armand Colin, 1984), 263–64, signalled the dramatic increase in depictions of the Holy Family in seventeenth-century European art.

96. Boyer, *Lives of the Bigamists*, 63, 109–10.

97. Quoted in ibid., 129, 163.

98. Ibid., 132–33: "Probably more than is usually thought, violence was part of the day-to-day content of married life. Thus it would be a mistake to think of it as abnormal or aberrant." See 133–34: Fray Jaime de Corella, *Prática de el confessionario*. On domestic violence, also consult Steve J. Stern, *The Secret History of Gender: Women, Men, and Power in Late Colonial Mexico* (Chapel Hill: University of North Carolina Press, 1995). Of course, we should not assume the total subordination of women within patriarchal systems. Historically, women have been creative in their resistance to male oppression. See Linda A. Pollock, "Rethinking Patriarchy and the Family in Seventeenth-Century England," *Journal of Family History* 23 (1998): 3–27, and especially 5. Some women did find recourse in the Spanish court system when their marriages failed, or when their husbands inflicted *la mala vida* (the bad life), defined as "abuse, overwork, lack of support, beatings," on them. See Boyer, 128–29.

99. Pastrana, *Empeños del poder*, 477: "Exemplo XXXXIX."

100. Ibid., 407: "Los casados tomen por patron à mi señor San Joseph, si quieren tener paz, y conformidad en el matrimonio, especialmente quando se ven afligidos de zelos, acudan por remedio à este Esposo de la Virgen." Ibid.: "Los Padres encomienden sus hijos à San Ioseph mi señor, procurando desde la niñez imprimirles su devocion, para que aseguren toda la vida su proteccion, porque à quien podran mejor encomendar sus hijos, que à aquel à quien el Padre Eterno encomendò su Hijo Vnigenito?"

CHAPTER FOUR
Mothering Fathers

1. Jerónimo Gracián de la Madre de Dios, *Josefina. Excelencias de San José Esposo de la Virgen María* (1597; reprint, Madrid: Apostolado de la Prensa,

1944), 62: "Y tengo por muy cierto que si se pusiese todo el amor que los padres canales han tenido a sus hijos en una balanza y en otra sólo el amor de José a Jesús, se hallaría ser mayor el amor de José."

2. Ibid.: "Dejo aparte las demás buenas obras de criarle, sustentarle, regalarle y amarle con más entrañable amor que ningún padre a su hijo."

3. Ibid., 56: "el oficio suyo de padre, que fué criarle, sustentarle, traerle en brazos y defenderle."

4. Halldor Soehner, *Una obra maestra del Greco, la Capilla de San José en Toledo* (Madrid: Hauser y Manet, 1961), 25–26.

5. Mary Crawford Volk, *Vicencio Carducho and Seventeenth-Century Castilian Painting* (New York: Garland Outstanding Dissertations in the Fine Arts, 1977), 51–52, and 257, n. 51, and cat. no. 96; and Diego Angulo Íñiguez and Alfonso E. Pérez Sánchez, *Historia de la pintura española: Escuela madrileña del primer tercio del siglo XVII* (Madrid: Instituto Diego Velázquez, 1969), cat. no. 437.

6. The Getafe painting is still in situ, part of the epistle altarpiece dedicated to *Nuestra Señora de la Paz* located in the right transept. The Annunciation is featured as the main scene; the retablo also includes a painting of St. Michael (opposite Joseph). See María Elena Gómez-Moreno, *Exposición de obras de Alonso Cano: Estudio y catálogo*, exh. cat. (Granada: Museo de Bellas Artes, 1954), cat. nos. 7 and 48; and Harold E. Wethey, *Alonso Cano: Painter, Sculptor, Architect* (Princeton, N.J.: Princeton University Press, 1955), 51, fig. 64, 54. For the San Ginés version, originally painted for a retablo in the St. Joseph Chapel of the Church of San Ginés in Madrid, and now in a private collection, see Gómez-Moreno, *Exposición de obras de Alonso Cano*, cat. no. 14; Wethey, fig. 71, 51 and 169; and Hospital de los Venerables Sacerdotes, *La pintura sevillana de los siglos de oro*, exh. cat. (Seville: Ministerio de Cultura, 1991), cat. 25. Another version exists in the Hispanic Society in New York.

7. Archival information on the commission was published by Balbina Martínez Caviró, "El convento toledano de las benitas, don Francisco de Pisa y El Greco," *Archivo español de arte* 61 (1988): 115–30.

8. For information on Roelas and this painting, see Enrique Valdivieso and Juan Miguel Serrera, *Historia de la pintura española: Escuela sevillana del primer tercio del siglo XVII* (Madrid: Instituto

Diego Velázquz, 1985), cat. no. 74, pl. 130. For information on Castillo, see 332, cat. no. 66, pl. 243.

9. Canvases by Murillo's own hand include paintings in the Pushkin Museum in Moscow (c. 1670), in Saint Louis, Missouri (pl. 6), and in the Ringling Museum in Sarasota (fig. 67). See Angulo, *Murillo*. The sketchy canvas in the Newhouse Collection (New York) has been described as a probable study for the Sarasota painting. Versions of the theme executed by Murillo's workshop or his followers include paintings in Seville (Collection of the Duque de Montpensier), Jérez (Pérez Asencio Collection), Woodburn, England (Inskipp-Hawkins), Madrid (Collection of the Marqués de Chozas), and Chantilly, France, Musée Condé.

10. On the dispersal and destruction of Mexican colonial art, see Francisco de la Maza, *El pintor Cristóbal de Villalpando* (Mexico City: Instituto Nacional de Antropología e Historia, 1964), 239–40.

11. Soehner, *Una obra maestra del Greco*, 24–25.

12. Joseph de Barcia y Zambrana, *Despertador Christiano Santoral, de Varios Sermones de Santos, de Anniversarios de Animas, y Honras, en orden à excitar en los fieles la devocion de los Santos, y la imitacion de sus virtudes* (Cádiz, Spain: Christoual de Requena, 1694), 121, "Sermon Decimo Tercio, y Sexto del Patrocinio de Señor San Joseph, en el Convento de Madres Carmelitas Descalças de Toledo, Domingo Tercero despues de Resureccion, año de 1686." Barcia, 125: "No sè si abreis reparado en la imagen de nuestro Santo. Como le pintan? Ya se vè: vn varon venerable, que lleva de la mano al Niño Jesus. De què mano? De la izquierda; que assi le llevaba en vida, dize Isolano: *Virgo pueri dexteram tenebat, Ioseph autem sinistram.*"

13. Barcia, *Despertador Christiano* (1694), 125: "ò para que se vea haze oficio de Padre, llevando à Jesus infante de la mano." Several art historians have noted that these images are emblems of Joseph's paternal relationship with Jesus. See Soehner, *Una obra maestra del Greco*, 24–25; Jonathan Brown, *El Greco of Toledo* (Toledo, Ohio: Toledo Museum of Art, 1982), cat. no. 29, and Alfonso E. Pérez Sánchez, "On the Reconstruction of El Greco's Dispersed Altarpieces," 149–76, and especially 167; and Jonathan Brown, "El Greco and Toledo," 75–147, both in the same catalogue. Also see Jeannine Baticle, *Zurbarán*, exh. cat.









que fue formado para Throno del Vnigenito de Dios Christo Iesvs."

29. Barcia, *Despertador christiano* (1696), 117. The entire passage, drawn from a similar text in Gracián's *Josefina*, reads: "Quien le viera (dize San Bernardo) poner al Niño Dios sobre sus rodillas y hazerle mil caricias, como si fuesse su Padre?"

30. Balthasar de San Joseph, *Panegirico del religioso reformado*: "Fue Joseph la lustrosa Carroza, viva, y real, que à todas partes llevò la eterna palabra de la humanada Deidad."

31. Gracián, *Josefina*, 68–69: "Y no sólo José dormiría en el pecho de Jesús, pero innumerables veces Jesús se adormecería sobre el pecho de José, puesta su divina boca enfrente de aquel corazón, robándole, abrasándole, desmenuzándole y haciendo en él heridas de amor. Y José le guardaría el sueño, contemplando los misterios en Cristo encerrados, afervorándose más en amor; y con la grandeza de tan alta oración llegaría al sueño que en la Sagrada Escritura se llama *tardemach*, que es el éxtasis o rapto de quien después diremos." Balthasar de San Joseph *Panegirico*, unpaginated: "Humillese Atlante, aunque aia tenido sobre sus ombros el olimpo: que vencido queda de Joseph, que llevò sobre los suios, al Señor, de tierra, y Cielo."

32. Hospital de los Venerables Sacerdotes, *La pintura sevillana*, cat. no. 27, 84. The author writes: "el Niño, sentado en el regazo de su padre, muestra una corona de espinas alusiva a su futura pasión y muerte; este gesto ensombrece el rostro de San José y lo tiñe de una intensa melancolía." Herrera executed several versions of the scene. For the Madrid painting, see Hospital de los Venerables Sacerdotes, cat. no. 27, 84. The canvas is signed and dated 1648. For the Budapest painting, see Palazzo della Permanente, *L'Europa della pittura nel XVII secolo: 80 capolavori dai musei ungheresi*, exh. cat. (Milan: Palazzo della Permanente, 1993), cat. no. 65. The Budapest painting bears the date 1645. For the Barcelona version, see Museo Español de Arte Contemporáneo, *San José en el arte español*, exh. cat. (Madrid: Ministerio de Educación y Ciencia, 1972), cat. no. 113, pl. 19.

33. Exceptions to this do occur, but in general Joseph's gaze tends to remain within the picture.

34. A concise discussion of Mary as throne is provided by Carol J. Purtle, *The Marian Paintings of Jan van Eyck* (Princeton, N.J.: Princeton University Press, 1982), Chapter 5 ("The Enthroned Madonna as a Devotional Image"), 98–126.

35. Leo Steinberg, *The Sexuality of Christ in Renaissance Art and in Modern Oblivion* (New York: Pantheon, 1983), 3: "Thus no Christian artist, medieval or Renaissance, would have taken this long-fixed convention for anything but a sign of erotic communion, either carnal or spiritual." On 4: "In decoding such ostensible genre motifs as the chin-chuck, our charge is to remain undeceived by their verisimilitude." Steinberg traces the genealogy of the motif on 3–5, and 112–16.

36. According to Steinberg, *The Sexuality of Christ*, the chin-chuck in depictions of the Madonna and Child loses its erotic meaning around the mid-seventeenth century.

37. Trens, *María*, 604. I explore *Virgen de la leche* imagery in Spanish art in "The Moralized Breast in Early Modern Spain," in Anne L. McClanan and Karen Rosoff Encarnación, eds., *The Material Culture of Sex, Procreation, and Marriage in Premodern Europe* (New York: Palgrave, 2002), 191–219.

38. Trens, *María*, 607. The author describes the gesture as "una fórmula pudorosa de la representación de la Virgen de la Leche."

39. Gracián, *Josefina*, 68–69: "Y no sólo José dormiría en el pecho de Jesús, pero innumerables veces Jesús se adormecería sobre el pecho de José, puesta su divina boca enfrente de aquel corazón, robándole, abrasándole, desmenuzándole y haciendo en él heridas de amor."

40. This was a very common appellation in the period. See, for example, Gracián, *Josefina*, 47–72. For the phrase in its original Latin, "Nutritie Jesu-Christi amantissime," see the early seventeenth-century *Litania Sancti Josephi* discussed in Enrique del Sagrado Corazón, O.C.D., "Estudios de historia josefina: Temas sobre San José en la Inquisición Española," *Estudios josefinos* 7 (1953): 102–11.

41. Gracián, *Josefina*, 60: "*Amo de leche.*—El marido de la que cría el niño a sus pechos, que se suele llamar amo de leche, oficio y amor tiene de padre, y el niño le llama padre a boca llena. Este oficio, dice San Bernardo, que hizo extremadamente San José; porque como amo de leche tomaba al Niño en sus brazos y le traía cantando cantarcicos, acallábale si lloraba, brincábale para que se durmiese en la cuna, gorjeábale, regalábale y dábale dijes como a niño, y no salía vez fuera de casa, que los pajaritos o manzanitas o cosas semejantes que hallase, de que suelen gustar los niños, no trajese para su Niño Jesús, volviéndose

de edad de niño el que trataba con Dios infinito hecho Niño." Sebastián de Covarrubias, in his 1611 dictionary *Tesoro de la lengua castellana o española*, ed. Martín de Riquer (Barcelona, Spain: Horta, 1943), s.v. "Amo." Covarrubias writes that "amo" "[p]uede sinificar el marido del ama que cría al niño, *latine nutritius*, o el señor que mantiene al criado, *vide ama*."

42. Joseph de Barcia y Zambrana, *Despertador Christiano Santoral, de varios sermones de Santos, de Anniversarios de Animas, y Honras, en orden à excitar en los fieles la devocion de los Santos, y la imitacion de sus virtudes. Que dedica al Gloriosissimo Patriarcha Sr. S. Joseph, Padre, en la opinion, de Jesu-Christo S. N. Esposo verdadero de Maria Santissima, y Patrono Vniversal de los Christianos* (Madrid: Blàs de Villa-Nueva, 1725), 72–80, "Sermon octavo, y primero del Gloriosissimo Patriarca San Joseph, en la Parroquia de Señora Santa Ana de Granada, Año de 1671." See especially 76.

43. Consult the following primary sources and articles: Juan Luis Vives, *Instrucción de la mujer cristiana*, trans. Juan Justiniano, ed., prologue, and notes, Salvador Fernández (Madrid: Signo, 1936), 138–40; Charlene Villaseñor Black, "The Moralized Breast," 191–219; Steinberg, *The Sexuality of Christ*, 14, 127–30; Margaret Miles, "The Virgin's One Bare Breast: Nudity, Gender, and Religious Meaning in Tuscan Early Renaissance Culture," in *The Expanding Discourse: Feminism and Art History*, ed. Norma Broude and Mary D. Garrard (New York: HarperCollins, 1992), 27–37 (originally published in *The Female Body in Western Culture: Contemporary Perspectives*, ed. Susan R. Suleiman (Cambridge, Mass.: Harvard University Press, 1986), 193–208; and Clarissa W. Atkinson, *The Oldest Vocation: Christian Motherhood in the Middle Ages* (Ithaca, N.Y.: Cornell University Press, 1991), 156–58, 194–202.

44. Vives, *Instrucción*, 139–40.

45. Cecelia F. Klein, "None of the Above: Gender Ambiguity in Nahua Ideology," in Cecelia F. Klein, ed., *Gender in Pre-Hispanic America: A Symposium at Dumbarton Oaks, 12 and 13 October 1996* (Washington, D.C.: Dumbarton Oaks, 2001), 183–239.

46. See the definitive study of the topic by Suzanne L. Stratton, *The Immaculate Conception in Spanish Art* (Cambridge, England: Cambridge University Press, 1994). On Spanish attempts to have the Immaculate Conception declared dogma, see Chapter 3, 70–75, 78–87.

47. Gracián, *Josefina*, 64.

48. Francisco de Iesvs Maria, O.C.D., *Excelencias de la Caridad, y de otras mvchas virtudes, y de la Devocion con la Virgen Santissima Nuestra Señora, y con su Dvlcisimo Esposo San Ioseph. Con Motivos, y medios para las mismas virtudes, y Devociones.* (Salamanca, Spain: Lvcas Perez, 1680), 477: "Pues qual encenderian, y abrasarian el pecho, y corazon del vienaventurado S. Ioseph, no solo las palabras, sino tambien los amorosos cariños, la vista, presencia, y exemplos del Hijo de Dios, por espacio de treinta años? Dichosos los ojos, que tantas vezes le vieron, felizes los oidos, que tantas le oyeron, los brazos, que tantas le abrazaron, las manos: que tantas le tocaron, y los ombros, y pechos, que tantas le traxeron."

49. Gracián, *Josefina*, 65: "y muchas veces tocó y lavó los pies y los besó; y no sólo pies, sino manos, pechos, cabeza y boca del dulcísimo Jesús, sin que jamás le dijese *Noli me tangere*; y fué besado innumerables veces con inefable amor y ternura del Niño eterno."

50. Francisco de Iesvs Maria, *Excelencias de la Caridad*, 477: "Dichosos los ojos, que tantas vezes le vieron, felizes los oidos, que tantas le oyeron, los brazos, que tantas le abrazaron, las manos: que tantas le tocaron, y los ombros, y pechos, que tantas le traxeron."

51. Pastrana, *Empeños del poder*, 372: "Porque entre los Sanctos ninguno hubo, despues de la Sanctissima Virgen, que gozasse en la tierra de los privilegios que gozo mi señor San Joseph como el que fue testigo, y Secretario del cumplimiento de las Prophecias, que hablaban del Verbo Encarnado, al qual tomò innumerable vezes en sus brazos, tratòle con sus manos, y en ellas le adorò con la Fè, y gozò de el mil prendas de amor, y singulares sabores."

52. Gracián, *Josefina*, 70: "Tengo por muy cierto que después del abrazo infinito entre el Padre Eterno y el Hijo, del cual procede el infinito amor, que es el Espíritu Santo, entre todos los otros principios de amor, ninguno hubo más eficaz que los abrazos amorosos que Jesús daría a su Madre, la Virgen, y a su Padre, José."

53. Francisco de Iesvs Maria, *Excelencias de la Caridad*, 429: "La primera excelencia de la devocion con este Glorioso Patriarca, es, ser devocion con quien tiene tan gran valimiento, cabida, y poder con el Hijo de Dios, que parece quiere su Majestad, que se entienda, que assi

como le escogiò acà en la tierra, para Padre puta-tivo, y Ayo suyo, se hizo su subdito, y se sujetò à su voluntad; assi aora en el cielo, no le niega cosa, que le pide, haze todo quanto le ruega, y le suplica."

54. Zubiaur, *Peso, y fiel contraste de la vida*, fol. 84r: "Ofrecimiento.—O glorioso Patriarca San Ioseph, estas peticiones que à deuocion vuestra he rezado, denotamente os ofrezco, ronandoos humilde, que intercedais por mi, indigno deuoto vuestro, ante la presencia de la Magestad Sober-ana de Christo, Redemptor de todo el linage humano, a quien tantas vezes tuuisteis en vue-stros dichosos braços, mientras viuiò Niño en este mundo, para que perseuerando por vuestra intercession en su gracia, goze de su eterna bien-aventurança en compañia vuestra. Amen."

55. See Charlene Black, "Las imágenes milagrosas," 7–46.

56. On Spanish medieval masculinities, see Louise Mirrer, "Representing 'Other' Men: Muslims, Jews, and Masculine Ideals in Medieval Castilian Epic and Ballad," in *Medieval Masculinities: Regard-ing Men in the Middle Ages*, ed. Clare A. Lees (Minneapolis: University of Minnesota Press, 1994), 169–86.

57. Saint Cajetan (d. 1547) had a vision of St. Joseph with the Christ Child in his arms. He is often depicted holding the Child himself in Spanish art. See Marina Warner, *Alone of All Her Sex: The Myth and the Cult of the Virgin Mary* (New York: Vintage, 1983), 189.

58. Judith Butler, *Gender Trouble: Feminism and the Subversion of Identity*, 10th anniversary ed. (New York: Routledge, 1999), Preface. In my opinion, Spain seems to be home to the most complex gender discourses in all of Europe.

59. Emilie Bergmann, "The Exclusion of the Femi-nine in the Cultural Discourse of the Golden Age: Juan Luis Vives and Fray Luis de León," in Alain Saint-Saëns, ed. *Religion, Body and Gender in Early Modern Spain* (San Francisco: Mellen Research University Press, 1991), 123–36. On 124, she writes that "mothers virtually disappear as cultural protagonists in literary representation," and on 125, "mothers disappear almost com-pletely from literary representations of the fam-ily."

60. Bergmann, "The Exclusion of the Feminine," 131. Also consult Vives, *Instrucción*. Mothers in Protestant countries were similarly discouraged from being tender with their children and the importance of fathers in child rearing was stressed. See Steven Ozment, *When Fathers Ruled: Family Life in Reformation Europe* (Cam-bridge, Mass.: Harvard University Press, 1983), 132–47.

61. Vives, *Instrucción*, 143: "Allende desto deben las madres guardarse mucho de regalar sus hijos según en otras partes desta obra está tocado. No me acuerdo haber visto hombre que supiese a hombre ni que fuese como los hombres han de ser, que haya seído criado regalado. Y es la causa que los cuerpos y aun los ánimos, siendo amol-lentados y enternecidos en delicadezas y regalos, dejan de cobrar las fuerzas naturales que ternían criados en asperezas y honestos ejercicios. De manera que las pobres madres pensando hacer bien a sus hijos los degüellan, y creyéndose de darles salud (144) y vida, les menguan vida y salud. Yo no me meto agora aquí en decir que la madre deje de amar a sus hijos, antes te digo que los ames según es razón de amarlos, es a saber, muy mucho . . . Mas dígote que los ames de man-era que ellos no te lo sientan. Item por cierto que no hay cosa hoy so la capa del cielo tan necesaria hara bien criar los hijos cuanto disimular los padres el amor que les tienen. Madres: si no sabéis, sabed esto de mí, que quanto malo hom-bre y belaco hay en el mundo es por culpa de vosotras y las gracias dello a vos se deben, porque veáis en cuanto cargo os es el mundo y la obligación que os tienen vuestros hijos. Vosotras, embebescidas con el amor desgobernado que les tenéis, los traéis engañados, holgando y riéndoos de sus liviandades y desconciertos, dándoos a entender en todo vuestro seso que no es nada criarse los mochachos desvergonzados y que es muy gran agudeza no tender reposo ni sosiego de persona."

62. Fray Ioseph de Iesvs Maria, *Historia de la Virgen Maria Nvestra Señora. Con la declaracion de algunas de sus Excellencias* (Antwerp, Belgium: Francisco Canisio, 1652), 73: "Aristotle, lib. 8, Ethic. c. II.— *"Porque por raçon de ser los padres causa del ser, de los hijos, y por el beneficio de su criança y enseñança, les pertenece el imperio y señorio sobre ellos. . . . siempre el padre es superior al hijo.'* Later he adds: "Por otra razon del mismo Aristoteles, se prueba tambien esto: conuiene à saber, que el imperio y potestad que el padre tiene en el hijo, vsurpa vna seme-jança de Reyno, y por esta potestad se puede decir, que los padres Reynan en los hijos. Segun lo qual, si el hijo alcança dignidad de Rey, sera el

padre Rey de otro Rey, y Rey por derecho superior; particularmente si el Reyno del hijo viene por sucession, y no por eleccion." For additional sermons on fatherhood, see Joseph de Barcia y Zambrana, *Despertador Christiano Quadragessimal de sermones doctrinales, para todos los dias de la Quaresma, con remissiones copiosas al Despertador Christiano, de Sermones enteros para los mismos dias*, 3d ed., 2 vols. (Madrid: Viuda de Juan Garcia Infanzon, 1724), 1:236–49: "Sermon Vigesimo Primo del Miercoles Segvndo, de las Señales, y quarto de esta Feria. En San Millan de Madrid, año de 1670." In the same volume, 250–61, "Sermon Vigesimo Segundo del jveves segvndo, de la Chananea. Al Señor Nuncio, en el Colegio Imperial de la Compañia de Jesvs de Madrid, año de 1689." In the same volume, 300–315, "Sermon Vigesimo Septimo. Del viernes segundo, de la Piscina, y quinto de esta Feria. En Santiago de Madrid Año de 1670." In vol. 2, see 310, "IV. Qvexanse las Familias de la falta de la educacion, exemplo, y castigo de los padres." In the same volume, 382–92, "Sermon Trigesimo Quarto del Martes Segundo, de la Cathedra. En el Convento de Religiosas de Santa Paula de Granada, año de 1671." In vol. 2, see especially 384, "I. Perfeccion del Superior, y Maestro para mandar, y del subdito, y discipulo para obedecer."

63. Barcia y Zambrana, *Despertador Christiano* (1724), 1:236–49, "Sermon Vigesimo Primo del Miercoles Segvndo, de las Señales, y quarto de esta Feria. En San Millan de Madrid, año de 1670." See 1:244, "Parte IV. Hijos, y Padres Gentiles confundir à muchos de los Christianos." On 1:245: "Digan los padres Catholicos, como han cumplido su obligacion con sus hijos? Debenlos criar, doctrinar, corregir, darles buen exemplo, y encaminar à la eterna salvacion; pero quantos antes padres son los que cumplen lo que deben?" Later he adds: "Deben los hijos à sus padres, amor, veneracion, obediencia, sufrimiento de sus condiciones, agradecimiento à sus beneficios, socorro en sus necessidades; de lo qual, aun quando faltàra el precepto, bastàra para el exemplo, y aun la confusion de los ingratos hijos."

64. Ibid., 1:250–61, "Sermon Vigesimo Segundo del jveves segvndo, de la Chananea. Al Señor Nuncio, en el Colegio Imperial de la Compañia de Jesvs de Madrid, año de 1689." On 252: "Individuemos, pues, estas tres cosas de que tanto pende: educacion, vigilancia, exemplo."

65. Joseph de Barcia y Zambrana, *Despertador Christiano Quadragessimal de sermones doctrinales, para todos los dias de la Quaresma, con remissiones copiosas al Despertador Christiano, de Sermones enteros para los mismos dias*, 3d ed., vol. 3 (Madrid: Blàs de Villa-Nueva, 1724), 12–20, "Sermon LXXXII. Del Miercoles Sexto de las Encenias, y segundo de esta Feria, à la Reyna Madre Nuestra Señora, en el Real Monasterio de San Geronimo de Madrid. Año de 1689." See 3:19: "IV. El Lvgar de la Renovacion de el Christiano, ha de ser la Corte, su casa, y su corazon." "En donde ha de ser la renovacion? Vbi? O, Christianos! En la casa, y familia de cada vno: porque cada vno en su casa debe reformar, y renovar." This new emphasis on education in the Church has been interpreted as a by-product of the Counter-Reformation. See Jean Delumeau, *Catholicism between Luther and Voltaire. A New View of the Counter Reformation*, trans. Jeremy Moiser (Philadelphia: Westminster, 1977), 57. On education and fatherhood in Protestant countries, see Ozment, *When Fathers Ruled*, 132–47.

66. Barcia, *Despertador Christiano* (1724), 2:254, on what to teach children: "Pero en què le ha de instruir? Cuydado, padres Christianos. Le ha de enseñar à leer, à escrivir, à contar, à danzar, à negociar, à cazar, y à exercer otras habilidades? Esso fuè solo formar vn corazon natural . . . lo que ha de enseñar el padre (dize S. Gregorio) es la gloria eterna, el fin vltimo para que Dios le criò. . . . Muestre al hijo la gloria à que ha de aspirar: digale los vicios, y pecados, de que debe huir, que esse es (dize el Santo) el combate que se pinta à Jerusalen . . . Y enseñele las virtudes Christianas para defendese, y resistir . . . Esto es (Fieles) instruccion, y educacion: y lo que no es esto no lo es." On 259: "Estas son, padres Christianos, las tres principales obligaciones que teneis para con vuestros hijos, educacion, vigilancia, y exemplo, de cuya execucion pende regularmente la salvacion de vuestros hijos, y la vuestra: como de su falta puede pender la suya, y vuestra eterna condenacion, quando se os pida cuenta estrecha en el severissimo juizio. O valgame Dios, y què conflicto tan horroroso serà el de los malos padres que faltaron à estas obligaciones, quando se vean en aquella vltima hora!" See also another sermon on 382–92, "Sermon Trigesimo Quarto del Martes Segundo, de la Cathedra. En el Convento de Religiosas de Santa Paula de Granada, año de 1671." On 384: "I. Perfeccion del

Superior, y Maestro para mandar, y del subdito, y discipulo para obedecer. . . . Fue maxima muy celebre en la antiguedad, que pende todo el bien de la Republica, de tener escrita con perfeccion tres vezes la letra P: porque pende su bien de que ay en ella Prelado perfecto, Padre perfecto, y perfecto Preceptor. Del Prelado perfecto nace el govierno acerrado: de el perfecto padre de familia nace la educacion conveniente: del preceptor, y maestro perfecto nace la sana doctrina; y yà se vè que Republica en que ay sana doctrina, educacion conveniente, y acertado govierno, llega sin dudar à tener su mayor felicidad."

67. Perry, *Gender and Disorder*.

68. David Herlihy and others have convincingly argued that medieval hagiographies and religious images "respond" to the realities of households of the times. He writes (14): "The history of medieval religion is thus intimately connected with the history of the family." Discussing familial images of saints' lives, he maintains (13): "These familial images would have been totally ineffective, had they not reflected authentic domestic experiences and emotions." See Herlihy, "The Family and Religious Ideologies in Medieval Europe," in *Family History at the Crossroads*, ed. Tamara Hareven and Andrejs Plakans (Princeton, N.J.: Princeton University Press, 1987), 11–14. The overlap between lives of the saints and lives of real people is one of the major themes of Donald Weinstein and Rudolph M. Bell, *Saints and Society: The Two Worlds of Western Christendom, 1000–1700* (Chicago: University of Chicago Press, 1982). See Part 1. Also consult Warner, *Alone of All Her Sex*, 190, where she writes: "The rise of Joseph's cult as the head of the Holy Family [sic] illustrates how Christian devotion can reflect and affirm the prevailing social mode."

CHAPTER FIVE
Men at Work

"Las noches, y días parten por mitad, siempre assistiendo al trabajo con cuydado y a la Oración con afecto." Poem, author unknown, seventeenth century, Madrid, Biblioteca Nacional.

1. Francisco Pacheco, *El arte de la pintura*, ed. Bonaventura Bassegoda i Hugas (Madrid: Cátedra, 1990), 625–26: "Siete años permaneció la Virgen y su Hijo y esposo desterrados en Egipto . . . Esta vivienda y habitación en Egipto aquellos

siete años podrá pintar cada uno, con algunas pías consideraciones, a su modo. Yo la dispuse así, siendo mancebo: En una casa pobre, por cuya puerta se ve la calle, San Josef acepillando una tabla sobre su banco de carpintería; su sombrero colgado en la pared, sierra y compás pendientes de un cordel; por el suelo, entre las astillas y virutas, otras herramientas como el azuela, cartabón y martillo; el Niño Jesús, de un año o dos, con su túnica, sentado entierra junto a su Madre, mirando una cruz de dos palitos atados con un hilo. La Santísima Virgen, sentada y vestida con su túnica y manto, haciendo labor en su almohadilla y una canastica par de sí, con sus paños blancos, tijeras y hilo."

2. Antonio Joseph de Pastrana, *Empeños del poder, y amor de Dios, en la admirable, y prodigiosa vida del sanctissimo patriarcha Joseph, esposo de la madre de Dios* (Madrid: Viuda de Don Francisco Nieto, 1696), 72–74. Francisco de Zarate, *El cordial devoto de San Joseph* (Mexico City: Francisco Rodriguez Lupercio, 1674), 12: "El aver sustentado à Iesus con el trabaxo de sus manos, es singularissima gloria de Ioseph." Similar sentiments can be found in countless other texts. See, for example, Francisco Riojano, "Sermon Decimotercio qve a las Festivas Memorias del Glorioso S. Ioseph Esposo de Maria, y Padre de Christo, dixo en el Religiosissimo y Real Conuento de las Descalças de Madrid, año de 1644," 326: "Tambien fue generoso para sustentar su familia, que si es empeño de vn Esposo, el sustentar la casa, mostro ser Esposo Ioseph en la atencion con que la sustentô, que para eso le hizieron Padre." In *Escvela de Discvrsos Formada de Sermones Varios, excritos por diferentes Autores, Maestros Grandes de la Predicacion*, [various authors] (Alcalá de Henares, Spain: Maria Fernandez, Viuda), 1645, 305–32.

3. Ignacio de Paredes, *Promptuario manual mexicano* (Mexico City: Bibliotheca Mexicana, 1759), 291–300: "Platica Trigesimaseptima: Del Septimo Sacramento del Matrimonio." The sermon is in Náhuatl, but glossed in Spanish. See 298: "es verguenza, que los maridos dependan para su sustento de sus mugeres."

4. Sebastian de Nieua Caluo, *La meior Mvger, Madre, y Virgen. Svs Excelencias, Vida, y grandezas, repartidas por sus fiestas todas* (Madrid: Iuan Gonçalez, 1625), unpaginated prologue: "El Maestro Ioseph de Valdiuielso, al Licenciado Sebastian de Nieua Caluo, en su Poema de la mejor

muger. / SILVA. / Tu la mejor muger, la mejor Virgen, / tu la mejor muger, la mejor Madre, /la mejor Madre Virgen, Virgen alma, / si el cuerpo vn cielo, el alma muchos Soles, / hermosa a todas luzes, toda hermosa, / antes de ver la luz, de luzes rica, / a quien para su Madre, Hija, y Esposa / con preuenidos dones dignifica: / Fenix, diuinidad en tres personas."

5. Fray Luis de León, *La perfecta casada*, ed. Mercedes Etreros (Madrid: Altea, Taurus, Alfaguara, 1987), 47–55; Pedro de Guzmán, *Los bienes de el honesto trabajo, y daños de la ociosidad en ocho discursos* (Madrid: Emprenta Real, 1614), 23–26; and Gaspar Gutierrez de los Rios, *Noticia General para la Estimacion de las Artes, y de la Manera en qve Se conocen las liberales de las que son Mecanicas y seruiles, con vna exortacion a la honra de la virtud y del trabajo contra los ociosos, y otras particulares para las personas de todos estados* (Madrid: Pedro Madrigal, 1600), 325–31.

6. Pastrana, *Empeños del poder*, 371: "Muchas vezes el Hijo de Dios administraba à mi señor San Joseph familiarmente, ayudandole en las cosas manuales de su oficio, como dandole el escoplo, la azuela, y otras erramientas de su oficio, ayudandole à aserrar la madera, y haziendo con el otras cosas decentes à la persona de Christo."

7. Andrés de Soto, *Libro de la vida y excelencias de el glorioso S. Ioseph, Esposo de la Virgen N. Señora*, 2d ed. (1593; reprint, Brussels: Iuan de Mommaerte, 1600), 74: "el benditissimo Iesus se exercitaba en trabajos corporales, para mostrar la obediencia que a sus padres tenia."

8. Guzmán, *Los bienes de el honesto trabajo*, 23–26; Gutierrez de los Rios, *Noticia General*, 325–31.

9. Soto, *Libro de la vida*, 46–47: "la occiosidad, es origen y fuente de todos los males." Also: "por sus prophetas reparte a los que comen los trabajos de sus manos, y les dice, que seran bienauenturados, y que les ira siempre muy bien y les sucederan sus cosas con mucha prosperidad."

10. Soto, *Libro de la vida*, 46: "Y si dixese alguno si era Ioseph de sangre real, como era official?" "Sermon del Patriarca San Iosef, predicose en San Ivan del Mercado Domingo 13. post Pentecoste, en tres de Setiembre, 1645 ajustando el Euangelio de la Dominica con el de la fiesta de san Iosef, y sus alabanças," 430–55, in *Escvela de Discvrsos Formada de Sermones Varios*, and especially 447: "San Iosef . . . Pobre ya de espiritu, y falto de bienes temporales en abundancia, vn pobre carpintero, que auia de trabajar para passar la

vida (pero rico de grandes virtudes, y meritos) aunque le competia el Reyno de Israel, por ser hijo legitimo y decendiente del Rey Dauid."

11. Pastrana, *Empeños del poder*, 74: "Exercitò mi señor San Joseph el oficio de Carpintero, mas por virtud, que por necesidad, y por ocupar el tiempo honestamente."

12. Pastrana, *Empeños del poder*, 73: "Y como no ha sido cosa desusada entre las personas Reales, qual era mi señor San Joseph, exercitarse en diferentes oficios, y artes, para entretener la vida loablemente, y librarse de la ponçoña de la ociosidad, tan contraria à la virtud, y Santidad, que es la verdadera nobleza." On 73: "lo mesmo podemos considerar en mi señor San Joseph: y que como en aquellos no fuera caso de menos valer, si se hallaran (despojados de sus Reynos, y estados) en pobreza, sustentarse con el arte, ù oficio, que huviessen aprendido, sino antes materia de alabança; assi tambien lo fue mi señor San Joseph, sustentarse honestamente en el estado en que se hallaba, tan ageno de la grandeza de sus abuelos, con el oficio que havia escogido, reduciendo el trabajo corporal al merito de la paciencia."

13. Marcelin Defourneaux, *Daily Life in Spain in the Golden Age*, trans. Newton Branch (London: George Allen and Unwin, 1970), 41–43.

14. Pastrana, *Empeños del poder*, 73, quoted in n. 12. Pastrana, 72: "Aunque el patrimonio de mi señor San Joseph, fue muy crecido, y sus padres fueron muy ricos, y nobles, exercitò el oficio de Carpintero, porque era costumbre que todos los descendientes de Reyes, aprendiessen algun oficio, por librarlos de la ociosidad, y de qualquier infortunio del tiempo, como vemos lo hazen oy los Reyes con sus hijos." Soto, *Libro de la vida*, 48–49: "era vso y costumbre antiguamente, saber los nobles y principales officios."

15. Marco Antonio Alòs y Orraca, *Arbol Evangelico enxerto de Treinta Ramas de Sermones Varios de Festividades, Divididas en tres decimas, y classes* (Valencia: Claudio Macé, 1646), 262–76, "Sermon de San Iosef, predicado en el Convento de la Pvridad de Valencia, Domingo infraoctaua de la Ascension, a 28. de Mayo, 1645. Fiesta, que hazen los Torneros." See the opening lines, 262: "Consagran el dia de oy los deuotos, y pios Artifices de torneria, los Torneros, fiesta al Esposo purissimo de la purissima Virgen nuestra Señora, al Patriarca san Iosef, padre de Christo, aunque no natural." On 263: "Y fiesta tan grande

a tan singular Santo la celebran los Torneros, como a su patron, y tutelar, por ser santo de su arte de carpinteria, artifice de maderos; que Torneros, y Carpinteros, todos son de vna arte de carpinteria, tan ingenua parece, que Reyes no se dedignaron de exercitar la por sus manos, como del primer Rey de los Griegos Vlises, lo refiere Homero, *lib. 3. Odisseæ*. . . . Mucha honra se le sigue a esta arte de torneria, y carpinteria, que Rey tan gran de la aya vsado; pero mucho mayor, que san Iosef, hijo de la Real casa de Dauid Rey, *Iosef fili Dauid* . . . Pues este santo nobilissimo, y el mayor despues de Maria, fue Carpintero, que es gloriosa honra para todos los de esta arte; mayor, que por auerla vsado Vlises."

16. Pastrana, *Empeños del poder*, 72: "Aunque el patrimonio de mi señor San Joseph, fue muy crecido, y sus padres fueron muy ricos, y nobles, exercitò el oficio de Carpintero, porque era costumbre que todos los descendientes de Reyes, aprendiessen algun oficio, por librarlos de la ociosidad, y de qualquier infortunio del tiempo, como vemos lo hazen oy los Reyes con sus hijos."

17. See Defourneaux, *Daily Life in Spain*; Julio Caro Baroja, "Honour and Shame: A Historical Account of Several Conflicts," trans. Mrs. R. Johnson, in *Honour and Shame: The Values of Mediterranean Society*, ed. J. G. Peristiany, (Chicago: University of Chicago Press, 1966), 82–86, 118; and Julian Pitt-Rivers, "Honour and Social Status," in *Honour and Shame*, ed. Peristiany, 24, 36–38, 44, and 68.

18. Quoted in Defourneaux, *Daily Life in Spain*, 43.

19. Ibid., 44.

20. Ibid., 40–44.

21. Pastrana, *Empeños del poder*, 196–97: "Y aunque travajaba de sus manos, y tambien la Divina Esposa, jamàs pedian precio por la obra, ni dezian esto vale, ni me habeis de dar, por que hazian las obras, no por interes, sino por obediencia, y charidad."

22. Jerónimo Gracián de la Madre de Dios, *Josefina: Excelencias de San José Esposo de la Virgin María* (1597; reprint, Madrid, Apostolado de la Prensa, 1944), 125: "Pues aunque la casa de San José era pobre y pequeña, en ella moraba el Rey de los Cielos y la Reina de los ángeles, y así era de José el reino de los Cielos."

23. Ibid. See the following prayer: Matheo de Zubiaur, *Peso, y fiel contraste de la vida, y de la mverte. avisos, y desengaños, exemplares, morales, y politicos. Con vn tratado, intitvlado, observaciones de palacio y corte. Y vn breve apuntamiento de la llegada de la Reyna N. S. a esta corte* (Madrid: Andres Garcia, 1650), fol. 82: "Alabança al Santo, Iesus Maria Ioseph. / Ioseph, que muerto el poder / De tantas humanas fieras, / Peso, y contraste / Con el Niño, y con su Madre / Te bolviste à Galilea. / Y llegando à Naçaret / Con la humildad mas perfecta, / Pusiste casa, aunque pobre, / Rica de diuinas prendas."

24. Pastrana, *Empeños del poder*, 196: "Sucedia no pocas veces, que la divina señora, y su Esposo San Joseph, se hallaban pobres, y destituidos del socorro necessario para la vida, porque con los pobres eran liberalissimos de lo que tenian." Gracián, *Josefina*, 126–27: "Lo que nos sobraba de hacienda, fuera de los necesario para una pobre comida, repartíamos a los pobres."

25. Pedro de Ribadeneira, *Flos Sanctorvm, o Libro de las vidas de los Santos* (Barcelona, Spain: Sebastian Cornella, 1643), 263: "quiso el Señor que fuesse vn pobre carpintero, para que entendiessemos que la pobreza no es vileza, ni tan mala como el mundo engañado piensa; y que assi como escogio la madre pobre, y la patria pobre, assi tambien quiso que el padre putatiuo fuesse pobre . . . que su diuinidad era la que auia conuertido y transformado el mundo, y traydole a su conocimiento y amor."

26. Ribadeneira, *Flos Sanctorvm* (1643), 263: "Y no menos para manifestarnos la bondad de san Ioseph, que con ser persona tan calificada, no se auergonçò de ser pobre ni buscò medios, ni tratos escrupulosos, para enriquezerse; queriendo mas la pobreza innocente y segura, que la abundancia culpable y peligrosa."

27. Gracián, *Josefina*, 126–27: "Y hablando de la pobreza con que vivían, dice [la Virgen] estas palabras: Lo que nos sobraba de hacienda, fuera de los necesario para una pobre comida, repartíamos a los pobres." Also: "En este grado fué pobre de espíritu José, que con su sudor sustentó tan buenos dos pobres como María y Jesús. Y si pobreza de espíritu quiere decir humildad y obediencia y no tener otro ningún deseo sino servir a Dios—porque llamándose *espíritu* el deseo, el que menos deseos tiene es más pobre de espíritu—bien claro dice la Virgen, maestra de humildad, en el lugar que cité y en otros muchos, la humildad, obediencia y sinceridad de deseos de su esposo San José." Zarate, *El cordial devoto*, 30–31: "Considera los efectos del humildissimo Corazon de este Santo, que son el proprio aba-

timiento, y desprecio, y el vivir desconocido, y sin nombre sobre la tierra; pues siendo de nobilissima Estirpe, y de Sangre Real, se abrazó con la pobreza y quiso emplearse en el baxo ministerio de Carpintero, aun despues que se desposó con la Santissima Virgen, distribuyendo à los pobres los bienes, que tenian, fuera de lo que les era necessario para su sustento, como la manifestò la Santissima Virgen à Santa Brigida y con las obras de sus manos, y sudor de su rostro alimentar por toda la vida su Santa Familia."

28. Fray Juan Interián de Ayala, *El Pintor Christiano, y erudito, ó Tratado de los errores que suelen cometerse freqüentemente en pintar, y esculpir las Imágenes Sagradas*, trans. Luis de Durán y de Bastero, 2 vols. (1730, Latin ed.; reprint, Madrid: Joachîn Ybarra, 1782), 292. The original edition in Latin dates from 1730.

29. Francisco de Iesvs Maria, O.C.D., *Excelencias de la Caridad, y de otras mvchas virtudes, y de la Devocion con la Virgen Santissima Nuestra Señora, y con su Dvlcisimo Esposo San Ioseph. Con Motivos, y medios para las mismas virtudes, y Devociones* (Salamanca, Spain: Lvcas Perez, 1680), 478:"Acordaos dulces dueños mios, es de creer les dize, de lo que trabajè en vuestro servicio, de los caminos que anduve, para guardaros; mirad las cicatrizes de mis llagas, y los callos de mis manos, causados del continuo trabajo, con que ganara el pan para sustentaros. Poned los ojos en este rostro, que estuvo tostado del Sol, curtido de los aires, y surcado de los tiempos, que afanè, trabajè, y caminè en vuestro servicio, y no me neguèis lo que os suplico, pues no me neguè yo à ningun trabajo, por serviros."

30. Francisco de Iesvs Maria, *Excelencias de la Caridad*, 478:"Es muy para considerar, que assi como la Reyna de los Angeles, quando aboga por los pecadores en el Tribunal de Christo, descubre sus purissimos pechos, y alega averle dado leche, y traido en sus entrañas, para inclinarle a que le conceda lo que le suplica. Assi tambien el Glorioso San Ioseph, quando aboga por nosotros, para alcançar lo que pide, muestra las manos, con que trabajò, para acudir à Christo, y à su Madre, y el sudor que derramò para sustentarles, y los pies llagados de los caminos, que anduvo para guardarles, y defenderles."

31. Pastrana, *Empeños del poder*, 73:"Carpintero debia de ser . . . porque este oficio, como dize el Venerable Beda, y otros Authores, fue representacion de su dignidad, porque representaba en èl cierta

semejança con Dios, Artifice vniversal de todas las cosas criadas."

32. Gracián, *Josefina*, 83:"De Job se colige que la Majestad de Dios Eterno, usando oficio de *fabro* o carpintero, labró y fabricó esta gran máquina y excelente fábrica del mundo y extendió a nivel el Cielo y la tierra."

33. Alòs y Orraca, *Arbol Evangelico*, 263:"Mas digamos el vltimo encarecimiento en esta materia; que es, que el mismo Dios fue oficial de torneria en la creacion del cielo, tierra, elementos, &c. essas esferas tan lindas, perfetas, columnas de los elementos, el globo redondo de la tierra, lo fabricò al torno de su sabiduria, y omnipotencia." On 264:"Luego el Padre, Hijo, y Espiritu santo, que son vn Criador omnipotente, son torneros, y obraron sus perfetas obras a torno, que lo que sale labrado al torno, sale tan liso, y tan perfeto, que aun los plateros para perficionar sus pies, y subimientos de Calizes, de candeleros, &c. los encomiendan a los Torneos, para que al torno les den la vltima mano. Aora basta esto para engrandecer esta arte, y a los oficiales della."

34. See the discussion of the polemic in Soto, *Libro de la vida*, 49–50.

35. Gracián, *Josefina*, 79:"Agrádame la opinión de San Ambrosio en este caso, que dice que San José supo muy bien y con mucho primor el arte del herrero, y también la del carpintero y cualquier otro arte mecánico, porque era ingenioso e industrioso sobremanera." Pedro Munoz de Castro, *Sermon del Glorioso Patriarcha San Joseph Predicado En su dia 19 de Marzo de este año de 1696 en la Feria segunda despues de la Dominica segunda de Quaresma, en la Iglesia del Hospital de Nuestra Señora de la Concepcion de esta ciudad de Mexico* (Mexico City: Juan Joseph Guillena Carrascoso, 1696), unpaginated. The author asserts that St. Joseph was "artesano, carpintero, Herrero—tengo por cierto que supo San Joseph todas las ciencias, y artes."

36. See the sermon published and translated in José Carlos Carrillo Ojeda, M.J.,"San José en la Nueva España del siglo XVII," *Estudios josefinos* 41 (1987): 629–60, Fray Juan de la Anunciación, O.S.A, *Sermonario en lengua mexicana, donde se contiene (por el orden del Missal nuevo Romano), dos Sermones en todas los Dominicas y Festividades principales de todo el año; y otro en las Fiestas de los Santos, con sus vidas, y comunes. Con un Cathecismo en Lengua Mexicana y Española, con el Calendario* (Mexico City: N.p., 1577).

37. Treatises on carpentry took pains to describe these tools meticulously. See Diego de López de Arenas, *Breve compendio de la Carpintería de lo blanco y tratado de Alarifes; con la Conclvsion de la Regla de Nicolas Tartaglia, y otras cosas tocantes a la Ieometría, y pvntas del compas. Dedicado al glorioso patriarcha San Ioseph* (Seville, Spain: Luis Estupiñan, 1633); *Los Veinte y vn Libros de los Yngenios, y Maquinas de Iuanelo, los quales le Mando escribir y Demostrar el Chatolico Rei D. Felipe Segundo Rey de las Hespañas y nuebo Mundo*), Treatise Four, "El Quarto trata de los Nibeles y sus Formas Para estas Fabricas," (BNM, MS 3372, 17th-century manuscript copy of lost 16th-century original); and Marqués de la Victoria, *Diccionario de Construccion Naval* (Madrid: Museo Naval, manuscript from the first half of the 18th century.). On the latter, see W. L. Goodman, *The History of Woodworking Tools* (London: G. Bell and Sons, 1964), 127, 139.

38. P. Gregorio de Jesús Crucificado, O.C.D. "San José Corredentor (Estudio directo)," *Estudios josefinos* 11 (1957): 215–27; P. José María Canal, C.M.F. "San José Corredentor: Estudio positivo. Desde los orígenes hasta el siglo XIII," *Estudios josefinos* 11 (1957): 197–21; and P. Fernando Soria, O.P., "Conocimiento y consentimiento de San José a los misterios de la Encarnación y Redención," *Estudios josefinos* 11 (1957): 172–96.

39. Pastrana, *Empeños del poder*, 74: "Tambien es representacion del Hijo de Dios, que en vn madero obrò la redempcion del genero humano."

40. Gracián, *Josefina*, 50: "San Juan Chrisostomo dice: que vna de las razones porque Christo Señor Nuestro, eligiò à mi señor San Joseph, por su Padre Putativo, y Esposo de su Sanctissima Madre, fue porque era Carpintero; porque en la madera estaba representada la Cruz, en que havia de morir, y vivia ansioso con este deseo." On 78: "Capítulo 5. Del misterio que se colige en haber sido San José carpintero y que el mismo oficio ejercitó Jesús, y lo que debemos a este santo, por haber Cristo comunicado con él la fábrica de la Iglesia Católica. Pónense algunas alabanzas del arte de carpintería." On 83: "descubramos el altísimo misterio que está encerrado en haber ejercitado José y Jesús el oficio de la carpintería."

41. Pastrana, *Empeños del poder*, 73: "Carpintero debia ser, el que havia de ser Coadjutor en la fabrica de la Iglesia de Dios. Carpintero havia de ser el que debia acepillar, y pulir à los arboles de Dios, que son los hombres, con sus palabras, exemplo, y su patrocinio. Carpintero debia ser el que havia de llebar en sus brazos, cuydar, y educar al leño de la vida Jesu-Christo."

42. My interpretation has been inspired by Cynthia Hahn, the first person to explain the association of St. Joseph, tree limbs, and human salvation, an idea she traces to St. Ambrose and which was current in the Middle Ages: "Joseph as Ambrose's 'Artisan of the Soul' in the *Holy Family in Egypt* by Albrecht Dürer," *Zeitschrift für Kunstgeschichte* 4 (1984): 515–22.

43. For the Virgin and Child as symbolic of the altar, see Antonio Navarro, *Abcedario Virginal y Excelencias del Santissimo nombre de Maria: Donde se le dan a la Virgen dozientos y veintiocho nombres segun la sagrada Escritura, y propiedades naturales de Piedras preciosas, Aues, Animales, Fuentes, Arboles y otros secretos de Naturaleza* (Madrid: Iuan de la Cuesta, 1604), fol. 130r–fol. 131v.

44. Hahn, "Joseph as Ambrose's 'Artisan of the Soul,'" 518.

45. See Herbert Friedmann, *The Symbolic Goldfinch: Its History and Significance in European Devotional Art* (Washington, D.C.: Pantheon, 1946).

46. Gracián, *Josefina*, 84: "Y para servir, acompañar y sustentar a Madre e Hijo, crió Dios *un carpintero* y le desposó con la Virgen, para que estando juntos aserrando, acepillando y ejercitando los oficios de carpintería, José y Jesús comunicasen, hablasen y tratasen de la nueva fábrica de la Iglesia en presencia de la misma Virgen." On 78: "Del misterio que se colige en haber sido San José carpintero y que el mismo oficio ejercitó Jesús, y lo que debemos a este santo, por haber Cristo comunicado con él la fábrica de la iglesia católica. Pónense algunas alabanzas del arte de carpintería." On 84–85: St. Joseph "ayudó a las trazas, modelos y diseños de nuestra redención."

47. Fray Ioseph de Iesvs Maria, *Historia de la Virgen Maria Nvestra Señora. Con la declaracion de algunas de sus Excellencias* (Antwerp, Belgium: Francisco Canisio, 1652), "Capitulo XXXIII. De la muerte del glorioso San Ioseph," 675–78; and Gracián, *Josefina*, 34.

48. Gracián, *Josefina*, 50: "Gustaba mucho en su niñez, de hazer, y ver Cruzes, y le pedia al Sancto le hiziesse muchas. Contemplabasse puesto en ella, recreabasse con su vista, y con esta representacion aliviaba lo dilatado del tiempo. Causabale à mi señor San Joseph grande dolor la representacion continuada de la pasion y muerte

de su Sanctissimo Hijo, desfallecia, con la pena, y sino fuera confortado, y auidado de Dios, le quitar la vida muchas vezes el dolor."

49. Ibid., 75: "De suerte que, aunque no se halló en compañía de la Virgen debajo de la cruz cuando Cristo fué crucificado, recibió las dádivas que le dieran allí si estuiera presente."

50. Lorenzo Fernández de Arébalo, *Universal Patronato del gloriosissimo Patriarcha Sr. S. Joseph por un nuevo Convento* (N.p., 1749). The title page is missing. The following information is drawn from the second page: "los dos Sermones, que predicò en la Ciudad de la Puebla el Señor Lorenzo Fernández de Arébalo . . . en el Conuento de la Purissima Concepcion de dicha Ciudad." The quote in the text is drawn from the first sermon, "el Patrocinio de Señor San Joseph para vn nueuo Conuento, y singular Paternidad con Christo," unpaginated: "Dize el erudito Luata, que el agua que manò del sagrado costado de Jesus, no fue otra cosa, que los sudores de Señor San Joseph despositados alli: *A qua lateris Christi sudores Joseph fundebaat*, el sudor del Santo Patriarcha aun despues de muerto en el costado de Christo deposito, como es facil de entender? De esta manera: quando à vno le cuesta muchos afanes lo que come, suele decir se que se alimenta del sudor de su trabajo; pues como Señor San Joseph estaba todo el dia en el continuo afán de su trabajo derramando sus sudores, para que de estos se mantuuiera su querido hijo Christo, cumpliendo con esto con la obligacion de amoroso Padre, el alimento de Jesus eran aquellos sudores, y como estos se hallaban en la sangre, y linfa que tenia como verdadero hombre, al tiempo de la muerte de Christo ocurrieron estas à su corazon, como á patrocinarlo, y alli se hallaban los sudores de Joseph, con que abriendo el Soldado en aquella."

51. Alòs y Orraca, *Arbol Evangelico*, 263: "Pues este santo nobilissimo, y el mayor despues de Maria, fue Carpintero, que es gloriosa honra para todos los de esta arte."

52. Badajoz: Archivo Histórico Nacional, Madrid (AHNM), Consejos, Legajo 1722, "Badajoz." The document reads in part: "Relacion Jurada, y firmada, que Yo Joseph Antonio Capilla Vezino De estta Cuidad, Maestro De Carpintero Doy, como Mayordomo Dela Cofradia Del Glorioso Patriarcha Señor San Joseph sita ensu Hermita intramuros De esta Cuidad que su ereccion fue enel año De mill quinientos sesenta y seis." At the

end, sworn, signed, and dated "Joseph Antonio Capilla / Badajoz 14 Jan. 1771."

For Valladolid, see Teófanes Egido, "La cofradía de San José y los niños expósitos de Valladolid (1540–1757)," *Estudios josefinos* 53 (1973): 77–100; and Esteban García Chico, "La cofradía de San José de los maestros entalladores," *Estudios josefinos* 7 (1953): 235–57.

Ciempozuelos: AHNM, Sección de Clero, Libros, S. XVII–XVIII, signatura Libro 8229, *Libro de la Cofradía del Senor San Joseph de 40 Horas desde el año de 1663 asta oi de 1760. Cienpozuelos, Iglesia de Sta. Maria Magdalena.* Barco de Ávila: AHNM, Clero, Secular, Regular, Libros, Signatura 821–23, *Libro de la Cofradía de San José de los gremios de carpinteros y hortelanos, establecida en la parroquia de la Asuncion.* Seville: Archivo del Palacio Arzobispal de Sevilla (APAS), Sección: Justicia, Serie: Ordinarios/Hermandades, Legajo 87, Año 1593–1792.

Seville: APAS, Justicia, Ordinarios/Hermandades, Legajo 12, Año 1586–1968, "Regla y Constituciones de la Congregacion y Esclavitvd de la Siempre Virgen Maria Nuestra Señora del Coral, y Deuocion del Santissmo Rossario y del Gloriosso Patriarcha Señor San Ioseph y del Señor San Ildefonso, Sita en su Iglessia Parroquial desta Ciudad de Seuilla. Año 1693." Madrid: AHNM, Consejos, Legajo 1687, Corte, 1791, "Expediente formado à instancia de la Hermandad de San Josef sita en la Parroquial de Santa Maria de la Almudena de esta Corte sobre Aprobacion de las ordenanzas formadas para su regimen y gobierno." The title page bears a print of St. Joseph.

APAS, Justicia, Ordinarios/Hermandades: Legajo 21, Año 1677–1859, Sevilla/Hermandad y Ermita de San José; Legajo 200, Sevilla/San Andrés; and Legajo 74, Año 1640–1753, Sevilla/Hermandad de San José.

53. Badajoz: AHNM, Consejos, Legajo 1722, quoted in n. 52.

For Valladolid, see Egido, "La cofradía de San José," and García Chico, "La cofradía de San José."

54. Seville: Archivo Municipal de Sevilla (AMS), Sección 11, Conde de Águila, tomo 16 en folio, "Comunidades Religiosas Tomo 2.°," document no. 29, "Estado comparativo de conventos, parroquias, hospitales, ermitas y oratorios entre Madrid y Sevilla." Also see Juan Ignacio Carmona García, *El sistema de hospitalidad pública en*

la Sevilla del Antiguo Régimen (Seville, Spain: Diputación Provincial de Sevilla, 1979), 56, 74, 136–37. Utrera: AMS, Sección II, Conde de Águila, tomo II en folio, "Cofradías y Hermandades/Comedias," document no. 1.

55. The documents from the commission, which identify the artist as Antonio López, were published by García Chico in "La Cofradía de San José."

56. Ciempozuelos: AHNM, Sección de Clero, Libros, S. XVII–XVIII, signatura Libro 8229, *Libro de la Cofradía del Senor San Joseph de 40 Horas desde el año de 1663 asta oi de 1760. Cienpozuelos, Iglesia de Sta. Maria Magdalena.* Barco de Ávila: AHNM, Clero, Secular, Regular, Libros, Signatura 821–23, *Libro de la Cofradía de San José de los gremios de carpinteros y hortelanos, establecida en la parroquia de la Asuncion.* Seville: Archivo del Palacio Arzobispal de Sevilla (APAS), Sección: Justicia, Serie: Ordinarios/Hermandades, Legajo 87, Año 1593–1792.

57. Seville: APAS, Justicia, Ordinarios/Hermandades, Legajo 12, Año 1586–1968, "Regla y Constituciones." Madrid: AHNM, Consejos, Legajo 1687, Corte, 1791, "Expediente formado à instancia de la Hermandad de San Josef sita en la Parroquial de Santa Maria de la Almudena de esta Corte sobre Aprobacion de las ordenanzas formadas para su regimen y gobierno."

58. APAS, Justicia, Ordinarios/Hermandades: Legajo 21, Año 1677–1859, Sevilla/Hermandad y Ermita de San José; Legajo 200, Sevilla/San Andrés; and Legajo 74, Año 1640–1753, Sevilla/Hermandad de San José.

59. Cayetano de Cabrera y Quintero, *Escudo de Armas de Mexico: Celestial Proteccion de esta Nobilissima Ciudad, de la Nueva-España, y de casi todo el Nuevo Mundo, Maria Santissima, en su Portentosa Imagen del Mexicano Guadalupe, Milagrosamente Apparecida en el Palacio Arzobispal el Año de 1531* (Mexico City: Viuda de D. Joseph Bernardo de Hogal, 1746), 396–97.

60. *Jubileos y gracias concedidas a la esclavitud del glorioso patriarca señor San José, fundada en la parroquia de la Asuncion de Aguascalientes en el año de 1855* (Aguascalientes, Mexico: J. T. Pedroza, 1871), 3: "Los Sumos pontífices Urbano VIII é Inocencio XI, en los años de 1634 y 1677 confirmaron la esclavitud del glorioso Patriarca Sr. S. José, que se fundó en la ciudad de Puebla el año de 1631 con las gracias y jubileos que contiene este Sumario." See 4 for additional information on

this new confraternity dedicated to St. Joseph. *Devoto mes josefino en que se describe la vida del Castisimo Patriarca, repartida en XXXI consideraciones exornadas con ejemplos de los favores que ha dispensado á los habitantes de la nacion mexicana. Dispuesto por un indigno esclavo del Santo* (Mexico City: Imprenta Religiosa de M. Torner, 1873), 16–17. José Vergara Vergara, "La parroquia de La Asunción de Pachuca y Juan Correa," in *El arte en tiempos de Juan Correa*, ed. María del Consuelo Maquívar (Mexico City: Museo Nacional del Virreinato and Instituto Nacional de Antropología e Historia, 1994), 120. *Summario de las Indulgencias, y Gracias Perpetuas, Concedidas por Nrô. Smo. Padre Clemente Papa XII. de feliz memoria, â los Cofrades, y Cofradas de la Pia, y devota Esclavitud del Glorioso Patriarcha Señor San Joseph* (Mexico City: Viuda de D. Joseph Bernardo de Hogal, 1742): "Assimesmo de la especial Gracia de su Santidad, por otro Breve Apostolico, expedido en Roma en Santa Maria la Mayor, debajo del Anillo del Pescador, el dia catorce de Febrero, del año de mil setecientos treinta, y cinco, el año quinto de su Pontificado, con que ha privilegiado el Altar â favor de las Almas de los Fieles Difuntos, cofrades de dicha Cofradia, diciendo en èl Missa qualquier Sacerdote Secular, ô Regular, todos los Miercoles del año, el dia de la Commemoracion de los Difuntos, y por toda su Octava: Y este vale por quince años, que empiezan â contarse desde este presente de 1736. hasta el futuro de 1751."

61. J. Carlos Carrillo Ojeda, M.J., "Un orgullo de la Catedral de Saltillo, la ciudad josefina del estado de Coahuila (México)," 8–11, *El Propagador de la devoción al señor san José* 126 (1997): 10. Also see J. Fuentes Aguirre, *La Catedral del Santiago de Saltillo* (Saltillo, Mexico: Amigos del Patrimonio Cultural de Saltillo, 1991).

62. AHNM, Consejos, Legajos 7090–91, Cofradías, "La Villa de Albuquerque," "El [gremio] de los Carpinteros y Albañiles con la [advocación] de Señor San Joseph;" Talavera la Real, 1770, "El Gremio de San Joseph, que se compone de los carpinteros, Herreros, y Herradores." Seville: APAS, Justicia, Ordinarios/Hermandades, Legajo 200, Sevilla/San Andrés, "Hermandad de los Acerradores." AHNM, Clero, Secular, Regular, Libros, Signatura 821–23, *Libro de la Cofradía de San José.* AHNM, Consejos, Legajos 7090–91, Cofradías, Nogales, "La Cofradia del Patriarca Señor San Joseph de Procuradores y Medicos."

Seville: APAS, Justicia, Ordinarios/Herman-dades, Legajo 82, "Hermandad y Colegio de Señor San Joseph de maestros Boticarios," founded in 1625, according to Manuel Fombuena Escudero (personal correspondence).

63. See Pastrana's *Tratado Quarto, Empeños del poder,* 419–590, and especially 433–34 and 559–62.

64. Defourneaux, *Daily Life in Spain,* 36ff.

65. On the commission, consult David M. Kowal, *Ribalta y los Ribaltescos: La evolución del estilo bar-roco en Valencia,* trans. Manuel Lloris (Valencia: Diputación Provincial de Valencia, 1985).

66. John McAndrew, *The Open-Air Churches of Six-teenth-Century Mexico: Atrios, Posas, Open Chapels, and Other Studies* (Cambridge, Mass.: Harvard University Press, 1965), 389.

67. This is one of the theses of Michel Foucault, *Madness and Civilization: A History of Insanity in the Age of Reason,* trans. Richard Howard (New York: Vintage, 1973; Random House, 1988). For an interpretation of Spanish society in these Foucauldian terms, see Mary Elizabeth Perry, *Crime and Society in Early Modern Seville* (Hanover, N.H.: University Press of New Eng-land, 1980).

68. Perry, *Crime and Society,* Chapter 8.

69. All three of these authors and their texts are dis-cussed in Linda Martz, *Poverty and Welfare in Habsburg Spain: The Example of Toledo* (Cam-bridge, England: Cambridge University Press, 1983). For Vives's treatise, *De subventione paupe-rum* (1526), see 7–11; on Giginta's *Tratado de reme-dios de los pobres* (1579), see 67; and on Pérez de Herrera's *Amparo de pobres* (1598), see 86.

70. Martz, *Poverty and Welfare,* 2, 8–10.

71. Guzmán, *Los bienes de el honesto trabajo,* 36–37, 77, and 131: "La ociosidad es causa del vicio de la lux-uria, y destruydora de Imperios." On 81: "la ociosidad ha destruydo los mejores Imperios del mundo, el de los Persas, el de los Griegos, como lo pinta Horacio en el segundo libro de sus epis-tolas, el de los Romanos."

72. Ibid., 81.

73. Ibid., 1: "Qvan ageno sea del hombre el vicio de la Ociosidad, y quan propio y conatural el honesto trabajo . . . Es propio del hombre el trabajar." On 71: "Es la ociosidad madre de vicios." On 69: "Quantas familias, y casas se han arruynado, y destruydo por la ociosidad de sus dueños!"

74. On St. Isidore the Farmer, and Lope de Vega's comedia, see Louis Réau, *Iconographie de l'art chré-tien* (Paris: Presses Universitaire de France), vol.

3, 688–89, s.v. "Isidore le Laboreur de Madrid (15 mai)."

75. Alonso de Villegas, *Flos Sanctorum* (Madrid: Pedro Machado, 1589), 891.

76. See, for example, the introduction to R. W. Con-nell, *Masculinities* (Berkeley: University of Cali-fornia Press, 1995).

CHAPTER SIX
The Good Death

1. See the accounts of Joseph's death in José de Val-divielso, *Vida, excelencias y muerte del gloriosísimo patriarca san Josef, esposo de nuestra señora,* in *Poe-mas épicos,* ed. Cayetano Rosell, Biblioteca de autores españoles, 29, no. 2 (1603; reprint, Madrid: Hernando, 1925), 235; Fray Ioseph de Iesvs Maria, *Historia de la Virgen Maria Nvestra Señora. Con la declaracion de algunas de sus Excellen-cias* (Antwerp, Belgium: Francisco Canisio, 1652), Chapter 33, 676, and Chapter 34, 679; Antonio Joseph de Pastrana, *Empeños del poder, y amor de Dios, en la admirable, y prodigiosa vida del sanctis-simo patriarcha Joseph, esposo de la madre de Dios* (Madrid: Viuda de Don Francisco Nieto, 1696), Chapters 47–49, 323ff.; Alonso de Villegas, *Flos Sanctorum. Vida, y Hechos de Jesu-Christo, Dios, y Señor Nuestro, y de Todos los Santos, de que Reza la Iglesia Catholica* (Barcelona, Spain: Viuda Piferrer, 1787); Pedro de Ribadeneira, *Flos Sanctorvm, o Libro de las vidas de los Santos* (Barcelona, Spain: Sebastian Cornella, 1643); and Francisco Garcia, S.J., *Devoción a San Ioseph, esposo de la virgen Maria nuestra señora* (Madrid: Iuan Garcia Infançon, 1684).

2. Fray Ioseph de Iesvs Maria, *Historia de la Virgen Maria,* 676: "Siendo pues la muerte de San Ioseph antes de la passion de Christo, sin duda se hallarian en aquella hora à su cabecera (como dice San Bernardino) aquellas dos lubreras del cielo de Christo, y de la Virgen su madre: y es de creer, que este Señor que para tan gran dignidad escogio à San Ioseph, y le santificò en el vientre de su madre (como dice Iuan Gerson) le pre-seruò de pecado mortal (como afirma San Agustin) y le conseruò Virgen (como dice San Ieronimo) le diria tambien la hora de su muerte, y le consolaria en ella."

3. Pastrana, *Empeños del poder,* 319: "Por este camino real llevò al Esposo de su Madre Sanctissima Joseph, à quien amaba su Magestad sobre todos los hijos de los hombres; y para acrecentar los

merecimientos, y corona, antes que se le acabasse el termino de merecerla, le diò en los vltimos años de su vida algunas enfermedades de calenturas, y dolores vehementes de cabeza, y coyunturas del cuerpo, muy sensibles, y que le afligieron, y extenuaron mucho." Also see 323: "Corrian ya algunos años, que las enfermedades, y dolencias del mas que dichoso Joseph, le exercitaban, purificando cada dia mas su generoso espiritu en el crisol de la paciencia, y del amor divino, y creciendo tambien los años con los accidentes, se iban debilitando sus flacas fuerzas, desfalleciendo el cuerpo, y acercandose al termino inexcusable de la vida, en que se paga el commun estipendio de la muerte, que debemos todos los hijos de Adam." Joseph Atanasio Diaz y Tirado, *Sermon Panegirico, Que en La Plausible Y Festiva Imperial Coronacion del Santisimo Patriarca Señor San Joseph, Celebrada el dia veinte y seis de septiembre del año de mil setecientos ochenta y ocho en la Ciudad de la Puebla de los Angeles* (Puebla, Mexico: Oficina del Real Seminario Palafoxîano, 1789), 8: "Enfermó este Santísimo PATRIARCA de muerte, y eran vehementes los dolores de cabeza, que como otros tantos agudos punzones la traspasaban y labraban la mas dolorosa CORONA. Duró esta pena, con otras graves dolencias, el tiempo de ocho años, hasta que dando fin á su vida, puso, al parecer, termino á sus trabajos." Ignacio Tomay, *El Sagrado Corazon del Santissimo Patriarcha Sr. San Joseph, Venerado por todos los dias de la Semana, Con la Consideracion de sus excelencias, y diversidad de afectuosos Coloquios* (Mexico City: Viuda de D. Joseph Bernardo de Hogal, 1751), 83: "Assi mismo fueron espinas, que ciñieron, è hirieron su Corazon, las enfermedades de fiebres, y dolores behementes de cabeza, y de las coyunturas, que por casi ocho años antes de su muerte toleró este Dichosissimo Santo, como nos lo assegura la V. M. Agreda."

4. Fray Juan Interián de Ayala, *El Pintor Christiano y erudito, ó Tratado de los errores que suelen cometerse freqüentemente en pintar, y esculpir las Imágenes Sagradas,* trans. Luis de Durán y de Bastéro (Latin ed. 1730; reprint, Madrid: Joachîn Ibarra, 1732), 145: "Por lo que, teniendo entonces S. Joseph, conforme á lo que probablemente hemos establecido, unos setenta años, ó algo mas, es muy puesto en razon, que en esta ocasion se le pinte viejo, pues ademas de la edad, tenia quebrantadas las fuerzas por los muchos trabajos, que habia padecido."

5. Valdivielso, *Vida, excelencias y muerte,* 235: "Jamás sus graves ojos se enturbiaron / Ni sus fuerzas jamás desfallecieron, / Sus mejillas jamás se marchitaron / Ni sus dientes jamás se le pudrieron; / Jamás enfermedades le acosaron / Ni dolores jamás se le atrevieron: / Con salud siempre alegre trabajaba, / Y á su Esposa y su Amado sustentaba."

6. Pastrana, *Empeños del poder,* 324: "Bolviò San Joseph de este rapto lleno su rostro de admirable resplandor, y hermosura, y hablando con su Esposa Sanctissima le pidiò su bendicion, y ella à su benditissimo Hijo que se la diesse, y su divina Magestad lo hizo. Luego la gran Reyna, Maestra de humildad puesta de rodillas, pediria à San Joseph tambien la bendixesse, como Esposo, y cabeza, y no sin divino impulso el varon de Dios por consolar à la prudentissima Esposa, le daria su bendicion à la despedida, y ella le pediria que de su parte saludasse à los Sanctos Padres del Limbo; y para que el humildissimo Joseph cerrasse el testamento de su vida con el sello de esta virtud, pidiò perdon à su divina Esposa, de lo que en su servicio, y estimacion habia faltado como hombre flaco, y terreno, y que en aquella hora no le faltasse su assistencia, y con la intercession de sus ruegos."

7. Ibid.: "Antes que muriesse sucediò que inflamado todo en el divino amor con estos beneficios, tubo vn extasis altissimo, y en este grandioso rapto viò, y conociò lo que por la Fè habia creido, assi de la Divinidad incomprehensible, como del Misterio de la Encarnacion, y redempcion humana, y de la Iglesia militante, con todos los Sacramentos que à ella pertenescen."

8. See Valdivielso, *Vida, excelencias y muerte,* 235. For other versions, see the following: Ribadeneira, *Flos sanctorvm* (1643), 266; and Fray Ioseph de Iesvs Maria, *Historia de la Virgen Maria,* 675–76.

9. Pastrana, *Empeños del poder,* 329. He based his calculation on the belief that Joseph was thirty-three when he married the fourteen-year-old Virgin, and that they had lived together for twenty-seven years.

10. Interián, *El pintor Christiano,* 145.

11. Guillén de Castro y Bellvís, *El Mejor Esposo San José,* in *Teatro Teológico Español,* ed. Nicolas González Ruiz (Madrid: Católica, 1963), 2:416: "Corren una cortina; aparece JOSÉ en una cama, a un lado JESÚS, y al otro, MARÍA." Other sources that describe Mary and Christ at the bedside include Valdivielso, *Vida, excelencias y muerte,* 236;

Fray Ioseph de Iesvs Maria, *Historia de la Virgen Maria*, 676 and 679; Interián, *El pintor Christiano*, 145; and Valentina Pinelo, *Libro de las alabanças y excelencias de la gloriosa Santa Anna* (Seville, Spain: Clemente Hidalgo, 1601), fol. 410.

12. Fray Ioseph de Iesvs Maria, *Historia de la Virgen Maria*, 677: "Que tiernas serian las vltimas palabras, con que se despidiria de Christo y de su madre, para no verse mas en carne mortal? Dadme vuestros braços hijo amado (dira al Redemptor del mundo) y aunque es oficio de Padre dar la bendicion en este tiempo, la vuestra pido, paraque amparado della, no me dañen las furias del infierno."

13. Pastrana, *Empeños del poder*, 324: "En estos nuebe dias los Sanctos Angeles le darian musica Celestial al dichoso enfermo con canticos de loores del Altissimo, y bendiciones del mesmo Sancto."

14. Valdivielso, *Vida, excelencias y muerte*, 238.

15. Daniel 10:13–21 and 12:7–9. In 12:1 he is described as the "guardian" of the Israelites.

16. Pastrana, *Empeños del poder*, 4: "su Santissima Esposa, que le assistiò, y sirviò de rodillas en toda su enfermedad."

17. Pastrana, *Empeños del poder*, 4: "Pues què dirè de la feliz, y dichosa muerte que tuvo, hallandose à su felicissimo transito su Santissima Esposa, que le assistiò, y sirviò de rodillas en toda su enfermedad, y tambien su Santissimo Hijo, en cuyos brazos muriò, y entregò el Alma, que la llevaron el Seno de Abraham millares de Angeles, que tambien assistieron à su enfermedad, y à su muerte; y el mesmo Dios le cerrò los ojos, y la voca, y mandò à los Angeles que le vngiessen, le previno sepultura, y acompañò el entierro."

18. Fray Ioseph de Iesvs Maria, *Historia de la Virgen Maria*, 678: "Lo que los Autores dicen que la Virgen y su hijo reciuieron los pesames de la muerte de San Ioseph, y que le lloraron, y trataron de su enterramiento, que se pusieron las insignias de luto y tristeza, que en aquel tiempo se vsauan por los difuntos, y que hicieron todos los demas oficios funerales, que la piedad y costumbre auia introducido en aquel pueblo, es muy verisimil. Porque la Virgen por razon de Esposa, y Christo nuestro Señor por razon de hijo, (en cuya opinion le tenia el mundo) no podian dexar de cumplir estas obligaciones sin nota de sus vezinos, y nunca en sus obras dieron ocasion à esto, sino singular exemplo." Also on the burial, see Pastrana, *Empeños del poder*, 326: "La gran Señora de los Cielos viendo à su Esposo difunto, preparò su cuerpo para la sepultura, y le vistiò conforme à la costumbre de los demàs, sin que llegassen à el otras manos que las suyas, y de los Sanctos Angeles, que en forma humana la ayudaron." And further: "fue llegado el sagrado cuerpo del glorioso San Joseph, à la commun sepultura." On 327: "Fue enterrado el cuerpo de mi señor San Joseph en el Valle de Josaphat, y dize el Venerable Beda, que en su tiempo se veìa su sepulcro junto al de la Sagrada Virgen su Esposa." Also see Ribadeneira, *Flos sanctorvm* (1643), 266: "El cuerpo de san Ioseph fue sepultado en el valle de Iosafad, como dize Beda, y cerca del sepulcro donde despues fue tambien depositado el cuerpo de la sacratissima Virgen en el mismo valle, entre el monte Sion, y el monte Oliuete."

19. Valdivielso, *Vida, excelencias y muerte*, 239–44; Pastrana, *Empeños del poder*, 335; and Fray Ioseph de Iesvs Maria, *Historia de la Virgen Maria*, 677. Christ blessed Joseph's body so that it would not decay.

20. Pastrana, *Empeños del poder*, 417–18.

21. Centro Mexicano de Estudios Josefinos, Mexico City (CMEJ), Box 0326: Puebla, Ciudad de, varias fichas josefinas. See the following, drawn from typewritten transcriptions of documents: "1658, Jubileo Plenario el Dia del Transito de San José— . . . Jubileo plenísimo en esta Santa Iglesia en el día de la festividad del glorioso Patriarca San Joseph, patrón de este Reyno y de esta ciudad que se celebra mañana veinte de julio día de su Tránsito." From Libro del Gobierno del Cabildo 19 de julio de 1658. *Devoto mes josefino en que se describe la vida del Castisimo Patriarca, repartida en XXXI consideraciones exornadas con ejemplos de los favores que ha dispensado á los habitantes de la nacion mexicana. Dispuesto por un indigno esclavo del Santo* (Mexico City: Imprenta Religiosa de M. Torner, 1873), 74. The Oratorians had just recently taken over La Profesa, formerly a Jesuit church.

22. These various arguments can be found in the following text, originally published in the eighteenth century, and in an appendix added by the nineteenth-century editor: José Ignacio Vallejo, *Vida del Señor San José, Dignisimo Esposo de la Virgen Maria y Padre Putativo de Jesus*, ed. Juan Rodriguez de San Miguel (3d rev. ed. from Vallejo's 2d ed. of 1779; reprint, Mexico City: J. M. Lara, 1845), 237–42; Appendix, 256–59.

23. Pastrana, *Empeños del poder*, 417–18: "Capitulo XIX. Del Modo Que Tienen De Celebrar a Mi señor San Joseph en algunos conventos, è iglesias." "Nueve dias antes de su fiesta principal que es à 19. de Março adornan muy bien el Choro baxo, y ponen en el como enfermo en la cama à mi señor San Joseph, assistido de Christo Señor Nuestro, y de su Sanctissima Esposa, rodeado de Angeles, y las Religiosas assisten aquellos nueve dias al Sancto de dia y noche, siguiendose todas desde la Prelada hasta las criadas, de dos en dos, à mas si quieren. Llevanle aquellos dias olores, flores, y cosas comestibles que embian despues à enfermos de la Ciudad, en nombre del Sancto, lo qual reciben con mucho consuelo, y alivio. Para el dia, adornan bien su Iglesia, y puesto en sus andas aderezadas con aseo, y curiosidad lo celebran con grande solemnidad." Presumably the image was an *imágen de vestir* (image to be dressed). These polychromed wood sculptures usually have articulated limbs that can be moved and are made to be dressed in clothes.

24. Vallejo, *Vida del Señor San José*, 249: "La novena del Santo se hace en los nueve dias que preceden á su primera fiesta, así en los templos como en las casas particulares, despues del rosario que por la noche acostumbra rezar junta y puesta de rodillas toda la familia. La misma veneracion quese tiene en las ciudades, se frecuenta en las poblaciones pequeñas, y aun en las haciendas del campo. Por la mayor parte me esplico con palabras generales, porque en toda nuestra América mexicana se ven brillar con igualdad los cultos y veneracion del Señor San José."

25. Vallejo, *Vida del Señor San José*, 265: "Concluiré refiriendo una devota práctica que de muchos años atrás se observaba en la villa de Atlixco del departamento de Puebla (y que supongo no habrá cesado en aquella religiosa poblacion). Habia, pues, una asociacion de doce personas de las principales, que á mas de concurrir el dia 19 á la misa, acompañaban con luces en mano á una respetable imágen del Santo, que en la noche era trasladada con música á la casa del devoto á quien correspondía tenerla todo el mes, hasta que el siguiente dia 19 era en igual forma conducida á la de otro, esmerándose cada uno á su vez en tenerla devotamente alumbrada en las noches, y todos en la decente festividad del 19 de marzo."

26. *Devoto mes josefino*, 73–74: "Habiendo esperimentado esta Congregacion por espacio de doce años la funesta calamidad de que ningun año pasase sin llorar difunto á alguno de los pocos sujetos que la componian, acordó que nuestros venerables Fundadores reconocieron por Patrono al gloriosísimo Patriarca señor san José."

27. Ibid., 74: "y habiendo pasado el espacio de siete años sin que alguno de los Congregantes haya muerto, ha podido persuadirse la piedad á que Dios por intercesion del santísimo Patriarca nos ha concedido este beneficio, confirmándonos la esperanza de lograr el que principalmente deseamos y pedimos, de conseguir un dichoso tránsito á la vida eterna."

28. For the Brotherhood of the Good Death ("la Hermandad de la Buenamuerte") under the patronage of St. Joseph, see Ioseph Martinez de Grimaldo, *Ramillete de las flores, qve del iardin del ingenio, regado con el rocio de la devocion brotaron algvnos de los elegantes y devotos congregantes del Santissimo Sacramento. Para cantar svs glorias en las festividades, que este año de 1650. ha celebrado su Esclauitud en el Conuento de Santa Maria Madalena de esta Corte* (N.p., c. 1650), fol. 246v. Also see the Archivo Histórico Nacional, Madrid (AHNM), Consejos, legajo 7090, Cofradias y hermandades de la corte, cofradia de San José y la Buenamuerte de la Vitoria.

29. J. Carlos Carrillo Ojeda, M.J., "Un orgullo de la Catedral de Saltillo, la ciudad josefina del estado de Coahuila (México)," *El Propagador de la devoción al señor san José* 126 (1997): 8–11.

30. *Summario de las Indulgencias, y Gracias Perpetuas, Concedidas por Nrô. Smo. Padre Clemente Papa XII. de feliz memoria, â los Cofrades, y Cofradas de la Pia, y devota Esclavitud del Glorioso Patriarcha Señor San Joseph, Fundada canonicamente en la Iglesia del Monasterio de Religiosas de S. Joseph de Gracia, de esta Ciudad de Mexico, por su Bula expedida en Roma, en Santa Maria la Mayor, debajo del Anillo del Pescador, el dia catorce de Febrero, del año de mil setecientos treinta y cinco, el año quinto de su Pontificado* (Mexico City: Viuda de D. Joseph Bernardo de Hogal, 1742), unpaginated: "Quando acompañaren para la sepultura Ecclesiastica los cuerpos de los difuntos, assi de los Cofrades, como de los otros Fieles Christianos." Also: "Tambien quando rezaren cinco veces el sobredicho Padre nuestro, y Ave Maria por las Almas de los Fieles difuntos Cofrades, y Cofradas de dicha Cofradia." Also consult the section "Obligacion de Esclavos": "Han de dar por su assiento dos reales, y cada mes medio real para costear las

Misas del dia diez, y nueve; y cada año dos reales para la Fiesta del Patrocinio, y Suffragio de los Difuntos; y los de la Mesa han de dar quatro real."

31. For in-depth investigation into new Counter-Reformation attitudes toward death and dying, see the definitive study of death in early modern Spain by Fernando Martínez Gil, *Muerte y sociedad en la España de los Austrias* (Mexico City: Siglo XXI, 1997).

32. Matheo de Zubiaur, *Peso, y fiel contraste de la vida, y de la mverte. avisos, y desengaños, exemplares, morales, y politicos. Con vn tratado, intitvlado, observaciones de palacio y corte. Y vn breve apuntamiento de la llegada de la Reyna N. S. a esta corte* (Madrid: Andres Garcia, 1650), fol. 83v: "PETICION SEPTIMA. / Alabança al Santo, Iesus Maria Ioseph. / Ioseph feliz, que en los ombros / De Iesus, y de maria, / Tuuieron cama, y alibio / Tus mortales agonias. / Varon justo, Casto Esposo, / Glorioso ya de justicia, / Humilde, y deuoto pido / Que dia, y noche me assistas."

33. On the last sacraments see Robert C. Broderick, ed., *The Catholic Encyclopedia* (New York: Thomas Nelson Publishers, 1986), 340; *New Catholic Encyclopedia* (New York: McGraw-Hill, 1967–79), s.v. "Sacraments, Iconography of;" and Thomas N. Tentler, *Sin and Confession on the Eve of the Reformation* (Princeton, N.J.: Princeton University Press, 1977), 6.

34. Pastrana, *Empeños del poder*, 494: "Exemplo LXIV. A tan cordial devocion de esta devota señora con mi señor San Joseph, correspondiò vna buena, feliz, y dichosa muerte, pues habiendose dispuesto muy bien con los Sanctos Sacramentos de la Iglesia, con muchos actos de contricion, y de amor de Dios, y para su consuelo pidiò que le pusiessen al lado derecho vn Sancto Crucifijo, y al otro lado vn bulto de mi señor San Joseph (que para aquel articulo tienen los de su Casa, que se ha ido heredando de padres à hijos) diò su alma à su criador este año de 1690." For general information on miracles associated with St. Joseph and in particular, miraculous images, see Charlene Black, "Las imágenes milagrosas de San José en España y Sudamérica, las teorías del arte y el poder de la imagen en el siglo XVII," *Estudios josefinos* 48 (1994): 27–46.

35. The Last Rites, along with Matrimony, Holy Orders, and Confirmation, were the object of renewed attentions, since the Protestants only recognized the validity of Baptism and Communion. See Broderick, *The Catholic Encyclopedia*, 340.

36. Revelation 12:7. Also see James Hall, *Dictionary of Subjects and Symbols in Art*, rev. ed. (New York: Harper and Row, 1979), s.v. "Michael, archangel."

37. See "Sermon Decimo Tercio, y Sexto del Patrocinio de Señor San Joseph, en el Convento de Madres Carmelitas Descalças de Toledo, Domingo Tercero despues de Resurreccion, año de 1686," in Joseph de Barcia y Zambrana, *Despertador Christiano Santoral, de Varios Sermones de Santos, de Anniversarios de Animas, y Honras, en orden à excitar en los fieles la devocion de los Santos, y la imitacion de sus virtudes* (Cádiz: Christoual de Requena, 1694), 120: "Si gloriosissimo Sancto mio: Admirámos, y celebrámos tus singulares excelencias, y augmentos, de varon perfecto, de mancebo prodigioso, y portentoso niño: pero de tus augmentos reparte á tus devotos: Como Varon, la imitacion de tus admirables virtudes: Como mancebo, la copia de tu Virginal pureza: Como niño, la semejanza de tu rendimiento á la voluntad de Dios: Para que viviendo de hazer essa voluntad, merezcamos en la peligrosa batalla de la hora de la muerte el favor de tu poderoso Patrocinio para vencer."

38. Ibid., 127: "Patrocinio de S. Joseph en la muerte, librando del peligro a sus devotos." Later: "De esta suerte patrocina en vida Ioseph; veamos su patrocinio en la muerte. Ay en la muerte que temer las fatigas de aquella hora; los peligros en que se vè la alma: lo formidable del juizio de Dios, de que pende la salvacion, ò condenacion eterna; pero saldrà bien de todas essas fatigas, sustos, y peligros el Christiano que tuviere por su Patrono, y Abogado à S. Ioseph."

39. Ibid.

40. Ibid., 129: "Almas Christianas, que temblais, y con razon, de los peligros de la muerte: quereis seguridad en aquel forçoso passo peligroso? *Ite ad Ioseph*, id à Ioseph, que os allanarà con su intercession el passo, para llegar con felicidad à la eterna patria."

41. Pastrana, *Empeños del poder*, 407–8: "Encomendemonos à mi señor San Ioseph toda la vida, y particularmente en la hora de la muerte, y para entregar el alma en manos de Iesvs, tomemos por patrones à Ioseph, y à Maria, porque donde està Maria, y Joseph, no puede faltar Iesvs."

42. Barcia y Zambrana, *Despertador Christiano* (1694), 128: "IV. Patrocinio de San Joseph

despues de la muerte, alcançando à sus devotos la salvacion. . . . Vltimamente, Catolicos: hasta despues de la muerte llega el poder eficaz del Patrocinio de Ioseph: porque (como dixo Bernardino de Busto) de las dos llaves del Cielo, que tiene Jesus Christo N. S. diò vna à su Madre purissima Maria, y otra diò à S. Joseph, como à su padre legal."

43. Pastrana, *Empeños del poder*, 408: "auxiliadores de la hora de la muerte."

44. Tomay, *El Sagrado Corazon*, 119 (a prayer for a Good Death): "el passo á la eternidad me ha de ser sumamente espantoso, el Demonio, mi comun enemigo, me ha de combatir formidable-mente con todo el poder de su Infierno, à fin de que yo pierda à Dios eternamente."

45. Fray Pedro del Espiritu Santo, *Sermones de Jesus, Maria, y Joseph, a que se añaden otros de N. S. M. Doctora Mystica Santa Teresa de Jesus: y de Nuestro Mystico Padre, y Doctor S. Juan de la Cruz, que en todos son quarenta* (Madrid: Blàs de Villanueva, 1717), 243–53: "Joseph Poderoso contra el demo-nio. Sermon XXVIII del Glorioso Patriarcha San Joseph, predicado en el Convento de Carmelitas Descalças de la Ciudad de Alcalà de Henares, Domingo tercero de Quaresma, que llaman del Demonio mudo, patente el Santis-simo Sacramento." On 244: "dixe que San Joseph es enemigo capital de el Demonio; y el Demonio del Santo." On 243–44, the author claims that the subject of this sermon is completely new and never has been preached before.

46. Fray Gabriel de Santa Maria, *Missas y Patrocinio de Señor S. Joseph Dvque, y Ecvdo de su Sagrada Familia. El mas poderoso abogado del cielo despves de Christo y sv Ss. Madre* (Cádiz: Juan Lorenço Machado, 1670), 135: "O qué glorioso muerte se puede prometer el que de veras fuere deuoto de Joseph Santissimo! Porque sin temeridad alguna, antes con much confiança puede esperar seme-jantes fauores, y consuelos de su mano, y que acompañado de su sagrada Familia Jesus, y Maria, le assista en medio de las congojas de la muerte, convirtiendolas en diuinas flores, y la muerte en vn ameno, y celestial Paraìso. Esto sin duda harà el dulcissimo Joseph por virtud de la vara que floreció en su mano, ahuyentando con ella a los demonios, templando los dolores, y fati-gas de la muerte, y convirtiendolas en vna muerte florida, y dichosa."

47. Pastrana, *Empeños del poder*, 434–35.

48. Ibid., 452.

49. Ibid., 520: "Exemplo LXXXVI. Aparecese mi señor San Joseph à vn devoto suyo, estando para morir, y dandole nuevas ciertas de su salvacion, le dixo el dia, y hora en que moriria."

50. See the following examples in ibid., 436: "Exem-plo XI. Aparecese mi señor San Joseph a vna Devota suya, en su vltima enfermedad, y dexala regalada, y favorecida con su vista;" 452: "Exemplo XXVIII. Otra aparicion de mi señor San Joseph à vna alma devota suya en la hora de su muerte;" 463–64: "Exemplo XXXIX. Apare-cense, Jesvs, Maria, y Joseph, à vn Mercader Valenciano su devoto a la hora de su muerte, y de otros que le imitaron en su devocion;" 507: "Exemplo LXXVI. Aparecese mi señor San Ioseph à vn devoto suyo en la hora de su muerte, en compañia de su Sanctissima Esposa, y de nue-stro Seraphico Padre San Francisco;" 521: "Exem-plo LXXXVIII. Aparecese Nuestra Señora, y mi señor San Joseph à vn Religioso Capuchino su devoto à la hora de su muerte;" and 531: "Exem-plo LXXXXVIII. Aparecese Nuestra Señora con su Sanctissimo Esposo, en compañia de nue-stro Seraphico Padre San Francisco, con Sancta Vrsola, y las onçe mil Virgenes à vn Religioso Capuchino à la hora de su muerte." Also see Diego de San Francisco, *Exercicios de señor San Joseph, varon justo, patriarcha grande, esposo purissi-mo de la Madre de Dios, y altissimo padre estimativo de el Hijo de Dios* (Mexico City: Imprenta Real del Superior Govierno, y del Nuevo Rezado, de Doña Maria de Rivera, 1747), 24–25.

51. Pastrana, *Empeños del poder*, 492: "Exemplo LXIII. A vn devoto de mi señor San Joseph que todos los dias daba de comer tres pobres, en rev-erencia de Jesus, Maria, y Ioseph, le augmentan mucho el caudal, y los bienes temporales, y assistiendo en su muerte à vista de todos lo lle-van al cielo."

52. Ibid., 463, 532. On 451: "Exemplo XXVII. Apare-cese mi señor San Joseph à vn devoto suyo Reli-gioso Capuchino Chorista à la hora de su muerte, y en compañia de muchos Cortesanos Celestiales los lleva al cielo." On 517: "Exemplo LXXXIV. Devocion cordial del Venerable Padre Luis de Cañaveral, de la Compañia de Iesus, con mi señor San Ioseph." On 518: "Todas las estam-pas que tenia en su apossento eran del Sancto." When he died, Joseph appeared to him and said: "Vengo por ti, devoto, y querido mio, para lle-varte al Cielo, donde tendràs premio eterno, por

el amor, y devocion que me has tenido." He enjoyed a "felicissima muerte."

53. Ibid., 438: "Exemplo XIII. La devocion de los siete dolores, y gozos de mi señor San Joseph, es eficaz medio para morir con los Sanctos Sacramentos." On 522: "Exemplo LXXXIX. Favorece mi señor San Joseph en la hora de su muerte à vn Religioso que se viò en grande peligro de ser condenado."

54. Ibid., 512: "Exemplo LXXX. Por intercession de mi señor S. Ioseph resuscita vn Indio que habia muerto en pecado mortal, y bien confessado, y dispuesto, buelve à morir, dexando señales ciertas de su salvacion."

55. Ibid., 454: "Exemplo XXX. Favorece mi señor San Joseph à vn devoto suyo en el articulo de la muerte que se viò en peligro de ser condenado, y la dichosa y feliz muerte que tubo." This man, a rich noble in Venice, had an image of Joseph in his house: "Tenia en su casa con grande veneracion vna Imagen suya, haziale cada dia oracion, encomendandose à èl, y poniendo en sus manos sus buenos aciertos." He became gravely ill, so much so that he forgot about salvation, and was in danger of dying without the sacraments (455): "viò entrar à San Joseph su devoto, en la misma figura de la imagen que en salud saludaba en su casa."

56. Ibid., 429, 431, 437, 462, 465, 491, 523, and 524.

57. Ibid., 432: "Exemplo VIII. Libra mi señor San Joseph milagrosamente à vn Negro que se cayò en vn pozo profundo, por la intercession del Venerable siervo de Dios Fr. Juan Masias."

58. Ibid., 438: "Exemplo XVI. Por la intercession de mi señor San Joseph fue libre de la muerte vn niño que se ahogaba en el rio de Lima." The Jesuit father Francisco del Castillo saw a child drowning in the river (439), and kneeled to pray before an image of St. Joseph (440): "Arrodillose el Siervo de Dios à vna Imagen de mi señor San Joseph, que estaba como Patron de la eschuela de Niños, que ay alli, en vn Altar, y habiendo hecho vna breve oracion al Sancto Patriarcha, se lebantò alegre, y dixo: la gracias à Dios que passò bien, y està con vida por la intercession del glorioso Patriarcha San Joseph. Assi fue que sin saber el modo, escapò el niño."

59. Ibid., 430: "Exemplo IV. Favorece Mi Señor San Joseph a Vna Devota suya, en vn peligro de perder la vida."

60. Ibid., 488: "Exemplo LX. Acude mi señor San Ioseph à los piadosos ruegos de vna devota suya

afligida, y sanaba instantaneamente vn viznieto que estaba para morir." This occurred in 1666 in Lima. The grandmother of the eleven-year-old boy, who was dying of typhus, came to see him: "y mandò à su nieta Doña Maria Luisa Calvo de Herrera, madre del enfermo, que le pusiesse sobre la cama vn lienço que tenia muy devoto de mi señor San Joseph, y con grande fè le pidiò la vida, y salud de su viznieto."

61. Ibid., 524: "Exemplo LXXXXI. Sana mi señor san Joseph, de la enfermedad de tabardillo à vn Religioso del Orden de Predicadores, que hizo voto de celebrar su fiesta."

62. Ibid., 529: "Exemplo LXXXXVII. Librase vn Indio de la muerte, milagrosamente, con vna estampa de mi señor San Joseph."

63. Ibid., 490: "Exemplo LXI. Resucitan Iesus, Maria, y Ioseph vna niña, y cayendose despues en vn rio, la assisten, y libran milagrosamente." The little girl was sick and died ("estubo enferma de dolor de costado"). She lay dead for three hours, during which time her mother prayed and embraced an image: "Quando lo supo su madre fue grande el sentimiento que tubo, y passada la fuerça del primer dolor, se abrazò con vna lamina de Jesvs, Maria, y Joseph, y puesta de rodillas, con grande sentimiento, le pidiò à San Joseph, con grande fè, resucitansse su hija, que no dudaba que con su intercession lo podia hazer, y que pues estaba à su cargo, y era padre de su casa, que no permitiesse en su dia vna desgracia tan grande, siendo tan devota suya toda ella, que le prometia de hazer su fiesta todos los años." The child was miraculously brought back to life: "Fue oido su oracion, porque luego le llegò nueba de que la niña habia resucitado. El gozo que tubo fue à la medida del dolor, y muy alegre dixo: No lo dudo de mi señor San Joseph, y el Niño Bendito."

64. Antonio Domínguez Ortíz, *La sociedad española en el siglo XVII* (Madrid: Instituto Balmes de Sociología, 1963), 67: "Despues de la Peste Negra del siglo XIV, ningún siglo conoció contagios tan devastadores como el XVII." I have also consulted the following on the plagues: Vicente Pérez Moreda, *Las crisis de mortalidad en la España interior siglos XVI–XIX* (Madrid: Siglo XXI, 1980) and Vicente Pérez Moreda and David-Sven Reher, eds., *Demografía histórica en España* (Madrid: Orán, 1988).

65. Ibid., 68–71, 74, 75, 78, 81. On the devastation of the seventeenth century, Domínguez (17) writes

that by 1660 Castile "era ya una pura ruina." For documents related to the plague, see the Archivo Municipal de Sevilla (AMS), Section 11, Conde de Águila, tomo IX in folio, no. 13, "Extracto de algunos Autos Capitulares sacados de los Libros de ellos que empezaron en el año de 1478." On the plagues, see "año de 1601 30.abril./. Que se hagan en la Antigua 9 fiestas de Nra. Señora por la Peste; y que la Ciudad comulgue en ellas el dia que quisiere, avisando antes." Also see tomo IX en folio, no. 14, "S.N. Laureano: Solemnidad en su dia por la Peste en Junio de 1601." See the description of the series of epidemics, beginning in the year 1579: "Año de 1579. Estte año comenzó el Moquillo (fue Enfermedad Epidemica)"; "Año de 1580. En estte año de 1580, fue el año de Moquillo, que settendio por España, y estubo mala, y murio mucha gente;" "Año de 1599. Notta con la Pestte de estos años, y las Landres referidas auiendose aumenttado la devozion a San Roque." Also see tomo IX in folio, no. 49, "Efemérides de la riada de 1642: ms." The latter details the succession of floods and resulting disasters, such as the rise in food prices, that struck Seville in the seventeenth century. In response, the city council ("cabildo") ordered charity to be given to the hospitals. The document also notes that these disasters particularly affected the poor, beggars, and women. In the same volume, see document no. 53, "Memoria de las cosas notables de la Santa Iglesia y ciudad de Sevilla, por el canónigo D. Juan de Loaisa: De las cosas notables que an susedido en esta Santa Iglecia, y Cuidad de Sevilla y de otras cosas antiguas sacadas por el Señor Canonigo don Juan de Loaiza del Libro del Capataz desde el folio 119 en adelantte en el año de 1691. Añadense algunas notas por Don Diego Alessandro de Galves."

66. Ibid., 67, 106, and 113. Other additional factors led to Spain's depopulation in the seventeenth century, including numerous wars, high taxes, the 1609 expulsion of the *moriscos*, and emigration to the New World. On the expulsion of the moriscos, see 81–84; on the numbers of Spaniards in the Netherlands, Italy, Africa, and the New World, see 86.

67. See Martínez Gil, *Muerte y sociedad*; Manuel Sánchez Camargo, *La muerte y la pintura española* (Madrid: Nacional, 1944); and Werner Weisbach, *Spanish Baroque Art* (Cambridge, England: Cambridge University Press, 1941).

68. Santiago Sebastián, *Contrarreforma y barroco: Lecturas iconográficas e iconológicas*, 2d ed. (Madrid: Alianza, 1989), 93–125: "El triunfo de la muerte." See 94, 95, 122. Also see Sánchez Camargo, *La muerte y la pintura española*; and Jonathan Brown, "Hieroglyphs of Death and Salvation: The Decoration of the Church of the Hermandad de la Caridad, Seville," in *Images and Ideas in Seventeenth-Century Spanish Painting* (Princeton, N.J.: Princeton University Press, 1978), 128–45.

69. See the thorough study of Hugo G. Nutini, *Todos Santos in Rural Tlaxcala: A Syncretic, Expressive, and Symbolic Analysis of the Cult of the Dead* (Princeton, N.J.: Princeton University Press, 1988).

70. Valdivielso, *Vida, excelencias y muerte*, 238.

71. The painting's provenance is not known, and very little has been written about it in the literature. See Jonathan Brown, *Francisco de Zurbarán* (New York: Harry N. Abrams, 1991), 23, 29–31; Museo Español de Arte Contemporáneo, *San José en el arte español*, exh. cat. (Madrid: Ministerio de Educación y Ciencia, 1972), cat. no. 143; and Miguel Ángel García Guinea, "San José en el arte barroco español," *Estudios josefinos* 2 (1948): 210. Nor has a convincing source for its composition been found. It does bear similarities to another work by Zurbarán, however, namely his *Vision of Fray Andrés Salmerón* of 1639. See Jonathan Brown's "Patronage and Piety: Religious Imagery in the Art of Francisco de Zurbarán," in Jeannine Baticle, *Zurbarán*, exh. cat. (New York: Metropolitan Museum of Art, 1987), 1–24, and especially 6–12.

72. Museo Nacional del Virreinato, Tepotzotlán, *Pintura Novohispana* (Tepotzotlán, Mexico: Asociación de Amigos del Museo Nacional del Virreinato and Américo Arte, 1996), 3: cat. 567.

73. Mexican sermons, in fact, make this connection explicit. Fray Antonio Mansilla, *Padrino de este Reyno de las Yndias, de este Invicto Rey de las Españas, y de esta Primera Yglesia de las yglesias. S. Ioseph Patriarcha. Sermon, que en la fiesta de su Patrocinio, que en nombre de su Magestad, hizo su Vi Rey, y Capitan General, en la Parrochia de los Yndios, sita en el Patio del Convento grande de N. S. P. S. Francisco de esta Ciudad de Mexico; con la asistencia de todos los Tribunales desta Corte. Predicô el dia veinte y nueve de Abril de el Año de mil setecientos, y catorce* (Mexico City: Heredèros de la Viuda de Francisco Rodriguez Lupercio, 1724), unpaginated prologue: "Dichoso este Reyno, si como el de Egypto tiene a

San JOSEPH, por Padrino! Dichoso este Rey, si como Pharaon, tiene à San Joseph, por Padrino!" The theme reappears on fols. 10–11. For sixteenth-century Italian paintings that link St. Joseph with the idea of rulership, see Carolyn C. Wilson, *St. Joseph in Italian Renaissance Society and Art: New Directions and Interpretations* (Philadelphia: Saint Joseph's University Press, 2001).

74. Fray Ioseph de Iesvs Maria, *Historia de la Virgen Maria*, 679: "Honròle despues de muerto, lo primero, el dia de Parasceue, quando baxò à despojar los infiernos, tratandole, y cariciandole mas que à todos los otros Santos Padres. Honròle lo segundo, el dia de la Resurrecion resucitandole consigo. Porque si leemos, que algunas mugeres reciuieron de la Resurreccion sus muertos, como dexaria de reciuir la Virgen à su Esposo? Y si dice San Matheo, que en la Resurreccion de Christo, resucitaron muchos cuerpos de Santos ya muertos, y saliendo de los sepulcros despues de resucitado el Señor, entraron en la ciudad de Ierusalem, y se aparecieron à muchos, como dexaria de goçar deste priuilegio San Ioseph?" Also see 679, "Capitvlo XXXIV. Como resucito el cuerpo de San Ioseph glorioso, el dia de la Resurreccion del Señor." See also Valdivielso, *Vida, excelencias y muerte*, 242.

75. Fray Ioseph de Iesvs Maria, *Historia de la Virgen Maria*, 679: "Honròle tambien el dia de la Ascension, lleuandole consigo al cielo, adonde està (como dice San Bernardino) en cuerpo y alma, y alli goça de premios incomparables con la sagrada Virgen sobre los coros de los Angeles; y quando ora por nosotros son sus oraciones breuemente oidas." Also in Valdivielso, *Vida, excelencias y muerte*, 243, and Pastrana, *Empeños del poder*, 332.

76. For the debate over the issue, see Fray Ioseph de Iesvs Maria, *Historia de la Virgen Maria*, 680–82.

77. Ibid., 682: "San Ioseph està en el cielo en cuerpo y alma glorioso: paraque, como ay en el vna Trinidad de personas en la naturaleza diuina; assi tambien aya otra Trinidad de personas en la naturaleza humana, que son Christo, la Virgen, y San Ioseph."

78. Ibid., 680: "Para principio de lo qual, referiremos aqui lo que San Bernardino (a quien este Autor graue cita) dice à este proposito por estas palabras: *Piadosamente se a de creer, pero no afirmar como de fe, quel piadossimo hijo de Dios, honrò con semejante priuilegio à su padre putatiuo, que a su santissima madre; y que assi como quando murio la Virgen la lleuò gloriosa al cielo en cuerpo y alma; assi*

tambien el dia que resuscitò, lleuò consigo al Santissimo Ioseph con la gloria de la Resurreccion, paraque assi como aquella santa familia (conuiene à saber, Christo, la Virgen y Ioseph) viuieron juntos en la tierra en vida trauajosa, y en conforme gracia; assi en amorosa gloria reynen en el cielo, en cuerpo y alma. Hasta aqui son palabras deste Santo."

79. Ribadeneira, *Flos sanctorvm* (1643), 266: "Y assi no ay duda sino que este santissimo Patriarca està en el cielo en lugar eminentissimo: y algunos Doctores dizen, que està en cuerpo, y en alma; assi por no saberse donde està su cuerpo (y si estuuiesse en la tierra, no querria el Señor que estuuiesse escondido, y careciesse de aquella honra que tienen otros menores Santos)." See also Pastrana, *Empeños del poder*, 337–38.

80. Vallejo, *Vida del Señor San José*, 268–70. On 270: "En la capilla que está en el pueblo de Tepotzotlán, situado en los contornos de México hácia la parte septentrional, se veneraba tambien una parte muy pequeña del manto del santo Patriarca, el que, segun me ha informado el Sr D. Agustin Castro, es de aquel color pajizo ó que tira á azafranado que tiene la clámide ó vestido del Señor San José que se venera en Roma en la iglesia de Santa Atanasia. Otras reliquias que están en la Santa Casa de Loreto, son algunas piezas comunes al Padre de Jesus y á su santísima Esposa, las cuales se muestran y esponen á la veneracion de los peregrinos."

81. Pastrana, *Empeños del poder*, 338: "Por grande si se venera su capa, que es de color leonada obscura. Està en Roma en la Iglesia de Sancta Anasthasia, y de alli se ha repartido à diversas partes de la Christiandad. Los Padres de la Compañia de Jesvs tienen de ella en Mexico, y en Lima. Y en esta Cuidad de Lima la ay tambien en los Conventos de Sancta Maria Magdalena del Orden de Predicadores, y en las Descalzas de mi señor San Joseph, todas con sus Bullas, y originales autenticos." The relic of Joseph's ring from the Betrothal was located in Perugia. See Miguel Ángel García Guinea, "La representación de San José a través de la pintura italiana," *Estudios josefinos* 1 (1947): 76–77.

82. Valdivielso, *Vida, excelencias y muerte*, 238–43. After his coronation, Joseph was seated in heaven at the side of the Virgin Mary.

83. Pastrana, *Empeños del poder*, 335: "Capitulo LII. De Como mi Señor San Joseph Resvscito con Christo Señor Nuestro, y en su compañia subiò al Cielo en cuerpo y Alma. Del lugar que tiene en el Cielo con tres Coronas de Virgen, Martyr, y

Doctor, y de como el dia del juicio tendrà silla entre los Apostoles para juzgar el genero humano." Fray Pedro del Espiritu Santo, *Sermones de Jesus, Maria, y Joseph*, 230–43: "Joseph mas que bienaventurado. Sermon XXVII del Glorioso Patriarca San Joseph, predicado en el Convento de las Religiosas Carmelitas Descalças, sito à la puerta que llaman de los Aguadores de los muros de la Ciudad de Alcalà, al concurso de el Colegio Mayor, Religiones, y lo demàs restante de la Vniversidad, Martes despues de la Dominica Quinta de Quaresma, patente el Santissimo Sacramento."

84. Pastrana, *Empeños del poder*, 356.

85. Valdivielso, *Vida, excelencias y muerte*, 238.

86. Diaz y Tirado, *Sermon Panegirico*, unpaginated: "es JOSEPH acreedor á la Guirnalda de mejores Flores, por la mas fragrante de su virginidad."

87. Fray Manuel Martinez, *Panegirico, Qve en 24. de Enero se hizo al Patriarca San Ioseph, estando patente el Señor Sacramentado: en rogativa, por los bvenos svcessos del viaje de sv Alteza, y Bien de la Monarquia* (Zaragoza, Spain: N.p., 1677), 8–10: "En fin sois Persona Real; y como tal no necessitais de cosa." Also: "IOSEPH es Hijo de vn Rey, pues era Hijo de David: IOSEPH *fili David*. Era persona Real." Also see Andres de Soto, *Libro de la vida y excelencias de el glorioso S. Ioseph, Esposo de la Virgen N. Señora* (1593; reprint, Brussels: Iuan Mommaerte, 1600), 42–46.

88. Pastrana, *Empeños del poder*, 356, "Capitulo III. De la Excelencia de la Corona de mi Señor San Joseph, y de como goza de Dignidad Real en los premios de la Gloria." Fray Gabriel de Santa Maria, *Missas y Patrocinio*, 22: "Cierta cosa es tambien, que donde està el Rey està la Corte; pues donde estaua el Rey de los Reyes, y Señor de los señores Christo Jesus, y donde estaua la suprema Reyna del mundo Maria Madre suya, y donde estaua Joseph a quien tan deuido le era el titulo de Rey, no solo porque de derecho, y linea recta de venia el Reyno de Israël, de quien era heredero, y natural Señor, por ser de sangre Real, como consta del Evangelio, y le cantaua antiguamente en vn Hymno la Santa Iglesia de Seuilla."

89. Martínez Gil, *Muerte y sociedad*, 17.

90. Mansilla, *Padrino de este Reyno de las Yndias*, unpaginated: "el virey de Dios."

91. Diaz y Tirado, *Sermon Panegirico*, unpaginated prologue: "virey del Universo . . . Asi Joseph, como Principe Soberano y Señor del Universo, recibe de mano del Sumo Sacerdote Christo otras tres alegóricas Coronas, que lo constituyen Rey, no de un limitado Reyno, sino Emperador del Orbe."

92. Diaz y Tirado, *Sermon Panegirico*, 2: "Es acreedor JOSEPH á la Corona que llamaron Civica, porque él libró almas noble Ciudadano Christo en el mayor peligro de su vida de la sangrienta tirania del cruel Herodes. Es JOSEPH acreedor á la Corona Castrense, porque tomando en sus manos aquel Verbo en Carne, que es la espada de dos filos, se entró solo y sin temor á los mismos reales de los infieles, desplomó en Heliópolis sus Idolos. Es JOSEPH acreedor á la Corona Obsidional, porque él fue capaz á desarmar el bloquéo, y deshacer el cerco con que todo nuestro terreno se hallaba sitiado, trayéndonos en sus dias el mas oportuno socorro y mas poderoso auxîlio. Es JOSEPH acreedor á la Corona Triunfal, propia solo de las Augustas sienes, porque el triunfó de mas fuertes contrarios, de mas poderosos enemigos, que los que vencieron los mas gloriosos Emperadores Romanos, quando se coronaron del mas fino oro. Es JOSEPH acreedor á la Guirnalda de mejores Flores, por la mas fragrante de su virginidad: á la Corona de Oliva, por que él anunció la paz: á la de Laurel y todas laureolas, porque ál se aventajó á todos los privilegiados; á la de Rey del mas suntuoso convite, y á la de Esposo el mas feliz, porque él celebró los mas castos Desposorios."

93. Martínez Gil, *Muerte y sociedad*, 18: "O prodigioso JOSEPH! . . . Prodigioso Patriarca, esse Pan vivo del Cielo, que oy està patente en essa lucida Messa, tomasteis â vuestra cuenta; y saliô tan bien la cuenta, que fue para el bien comun de todos. Lado hizisteis â IESVS, Principe Niño, mas para aumentarle su Corona, que por intereses vuestros. Rogad, Santo mio, â Dios, sea servido de poner al Lado de nuestro Rey, vno que restaure la Monarquia; que mire por el bien comun del Reyno, quitando tanto mal, como padece, assi como al Lado de Christo Rey, huvo vn IVAN, cuyo fin fue quitar todos los males del Mundo: *Ecce Agnus Dei, Ecce qui tolit peccata Mundi*. Para evitar tanto mal, como se passa en España. Poned otro al Lado de nuestro Rey muy semejante â San IVAN, que de essa suerte gozarêmos la Paz, nos bañarêmos en gozos, dandole gracias â Dios que deponga tal Privado. Solo en vos, Santo mio, espero el buen sucesso de la Monarquia, la quietud de nuestro Principe, y el consuelo de todo el Reyno."

94. Ibid.: 18: "Pves Basta Vvestra Intercession para conseguirse todo. Santo mio, lo que en vuestra Rogativa se busca, es la Paz, el consuelo de España, el bien comun de el Reyno. Iusto fuisteis: IOSEPH *cum esset iustus*. Temerosos: *Noli timere*. Tan Grande, que os assistiô el Espiritu Divino, y tuvisteis muchas vezes en vuestras divinas manos â Dios. Interceded con su Divina Magestad sea servido dar Paz â la Monarquia, gozo â España, consuelo al Reyno; y por vltimo â nuestro Rey vn Privado, que solo tire â aumentos de su Corona: Que de essa suerte, se desterrarâ la Guerra, se auyentarâ la embidia, y la emulacion; se assegurarâ el consuelo Vniversal. Espero en vos, Santo mio, que lo hareis; y que por vuestra intercession veremos lo que en misterioso rapto viô David. Y que es lo que viô? Viô muchos Grandes, y Principes en la Corte Celestial bañados en gozo, que vnidos saltavan de alegria. . . . Por quê tanto gozo? Yâ lo dize. . . . A tiempo, que en la Corte Celestial estavan los Grandes delante de su Rey, entrô el Benjamin. Y quien es? El Docto Português dize: Que era IVAN. Pues si IVAN era, recogijense todos. Al entrar, (ô Santo mio!) el Principe DON IVAN, con los Grandes, â visitar â Nuestro Rey CARLOS; infundió gozo; conseguidnos Paz; vnion entre los Grandes; bien comun al Reyno; salud â Nuestro Rey; Gracia â todos: Prenda de la Gloria. Amen."

95. Vallejo, *Vida del Señor San José*, 256: "Habiendo solicitado de la Silla apostólica el rey Cárlos segundo por medio de su embajador en Roma, el Marqués del Cárpio, que se declarase al Señor San José universal Patrono de toda la monarquía española, el Sr. Inocencio undécimo accedió y despachó al afecto un Breve confirmatorio de la eleccion real á 19 de abril de 1679, concediendo á los que visitasen alguna iglesia del Santo desde las primeras vísperas hasta puesto el sol el dia de su festividad, 19 indulgencias que espresa la ordinat. 388 en la obra Fasti Novi Orbi, que dice lo siguiente."

96. Centro Mexicano de Estudios Josefinos, Caja 4 (Papal Documents on St. Joseph). Information drawn from a document transcribed by Carlos Carrillo Ojeda, M.J. (11 de marzo de 1988): "SE PRESENTA AL CABILDO ECLESIASTICO DE MORELLA, LA CEDULA REAL EN LA QUE SE DISPONE RECONOCER AL SEÑOR SAN JOSEPH COMO TUTELAR DE TODAS LAS POSESIONES DE ESPAÑA; 2 de Abril de 1680"; Francisco Rosales, vecino de esta Ciudad . . . hizo demonstración de una Cédula Real en que Su Majestad (que Dios guarde), manda a los Virreyes, Presidentes, Audiencias, Governadores y a los Cabildos de las Ciudades de la Provincias del Perú y Nueva España, y encarga a los Arzobispos, Obispos y Cabildos de las Iglesias Metropolitanas y Catedrales de ellas, que cada uno por lo que le toca reciba al Glorioso Patriarca San Joseph por Tutelar. . . . Habiéndose leído esta Cédula que todos los Señores atendieron, dijeron que para la resolución de lo que sobre el caso se debería obrar, darían cuenta al Ilmo. Sr. Obispo de esta Santa Iglesia que anda atendiendo en la Visita de su Obispado." Libro de Acuerdos, No. 11.

97. CMEJ, Caja 0326, Puebla, Ciudad de, varias fichas josefinas (typewritten extracts from documents from the city of Puebla): "1680 Mayo 12 Celebración del Patronato de San José sobre la monarquía de España: En la ciudad de los Angeles, Domingo 12 de este mes de mayo de mil seiscientos y ochenta años, habiéndose repicado las campanas a la hora de las ocho de la mañana, se juntó gran número de personas de todos estados en la Sta. Iglesia catedral. . . . se formó procesión para la celebridad de la fiesta destinada para este día al glorioso Patriarca S. Joseph en virtu de lo mandado por Real cédula . . . para que se tenga que venerar como tutelar de la Monarquía de España." Puebla de los Angeles, Libro de Decretos del Cabildo No. 17, Año de 1680, 299 v.

98. CMEJ, Caja 0424 (documents transcribed by Carlos Carrillo Ojeda, M.J., dated "11 de marzo de 1988"): "RESUELVE EL CABILDO ECLESIASTICO DE MORELIA LO QUE SE HARA PARA CUMPLIR LO DISPUESTO POR LA CEDULA REAL TOCANTE A TOMAR AL SR. SAN JOSE POR TUTELAR DE ESTE REINO. Lunes 2 de mayo de 1680. Así mismo dicho Sr. Dean propuso a todos los señores cómo era necesario dar cumplimiento a la Cédula . . . que llegó a este Reyno por el mes pasado de México . . . en orden al mandato que Su Majestad (que de Dios goce) hace en ella de que se reciba por Patrón Tutelar en todos sus Reinos al Sr. Sn Joseph y que su Sría determinase el día en que se había de recibir por tal Patrón y Tutelar . . . y en esta razón, dichos Señores decretaron, mandaron y determinaron que en el Domingo próximo siguiente a la octava de la festividad del Corpus Christi, se trajese al Sr. S. Joseph de esta Santa Iglesia en procesión como es de costumbre, y que se celebrasen por cuenta de esta Santa Iglesia tres días, el primero de bienes de fábrica

espiritual, y el segundo y tercero de bienes de misas." Drawn from *Libro de Acuerdos*, no. 11, 28–29.

99. A sermon preached in Mexico City in 1727 described Joseph's position of honor on the altarpiece. Juan Ignacio Castorena y Ursua, *Lo mas de la Sanctificacion del Señor San Joseph. Sanctificado antes de nacer à los siete meses de concebido para nacer Sanctificado, y ser Padre Estimativo de Christo, y Esposo Castissimo de la Reyna de los Angeles* (Mexico City: Joseph Bernardo de Hogal, 1727): "Mudamente lo acredita bien la costosa obra, que en la Capilla de los Reyes de aquella Metropolitana mandó erigir para su Real adorno el piadossissimo animo de V. Exc. en su hermoso Altar; vistosa maquina, que blasona de singular por su artefacto, para hazer lugar à doze primorosas estatuas, que descuella cada vna en mas de tres varas de altura; seis de Santos Reyes (par que viniesse bien con el titulo) y otras seis de Reynas Santas; en el centro, vn valiente pincel de la adoracion de los Reyes, y arriba vecino à su coronacion el simulacro de la Assumpcion de Nuestra Señora titular de aquel Templo, que ayrosamente sube al Empyreo à coronarse Reyna de los Angeles: al lado diestro, vna Imagen de s. JOSEPH, y otra de Santa Theresa al siniestro lado; lugares, que dejó libres à la devocion de V. Exc. la obligacion, y el titulo, y que yà avian ocupado sus afectos à estos dos Exclarecidos Sanctos."

100. *Devoto mes josefino*, 25: "Ejemplo. En una de las numerosas y sangrientas revoluciones de que la ambicion ha hecho teatro a nuestro desgraciado país, las fuerzas insurrectas contra el gobierno estuvieron atacando á la ciudad del Saltillo desde el 21 de Noviembre hasta el 5 de Diciembre de 1871." For Santiago's appearances in battles in the Reconquest and Conquest, see Rafael Heliodoro Valle, *Santiago en América* (1946; reprint, Querétaro, Mexico: Gobierno del Estado de Querétaro, 1996).

101. Vallejo, *Vida del Señor San José*, 242.

102. Mansilla, *Padrino de este Reyno de las Yndias*, fol. 5r: "Yo, Señores, diría V. Exc. ignorava si aquella Capilla de San JOSEPH, de los Indios, que està en el patio de el Convento de el Señor San Francisco, avia sido en toda la America, la primera. No savia si por esto, estaba tan indultada, y favorecida con Cedulas de mis Señores, y Amos, el Emperador Carlos V y Phelippe II. Supelo yo, porque lo oì, con verdad; lo leì, con fundamento, y lo asegurè con Autores. Aóra, no serà bueno

que desagraviemos tanto olvido, con hazer juntos vn Decreto? Hagamoslo: y sea de modo, que anformado nuestro Rey: reciba por suya vna Fiesta, que yo en su nombre empezaré. Ea ya, acabemos de resucitar aquellos primeros beneficios, no seamos, no, ingratos a aquellos antiguos favores."

103. Ibid., fol. 5: "A todos no han de ver juntos los Indios, para que agradescan la memoria que hazemos, de vna Iglesia, que fue la conquistadora de sus Almas, y la livertadora de sus Gentilismos. Estos, y mas, que dirìa V. Exc. ó con razon, que lo es; ò con agradecimiento, que es devido." On fol. 11: "Este, como aquel otro Joseph, sin dejar de patrocinar à todo el mundo se entregó todo à ser Padrino, con amor singular, de este Reyno."

104. Ibid., fol. 11r: "Ya no ay en este Reyno lugar de desocupado à el gozo, por que desde que San JOSEPH se ofreciò a ser su Padrino, quedaron los Indios, y todas las *Indias*, felices por todas partes; por los montes sin Idolos; por los campos, sin esterilidad; por las Ciudades, sin Barbaros; por los lugares, sin Dioses; y por todos caminos, sin supersticiones."

105. *Summario de las Indulgencias*, unpaginated: "3. Assimesmo su Beatitud concede la sobredicha Indulgencia plenaria a los mesmos cofrades, y cofradas, que aora, y por el tiempo sean de dicha cofradia, tambien arrepentidos verdaderamente, y confessados, y de la Sagrada Comunion apacentados, los quales cada un año visitaren la Iglesia, Capilla, û Oratorio de la sobredicha Cofradia, el dia del Patrocinio del glorioso Patriarcha Sr. San Joseph, proprio de la Fiesta Titular de la dicha Cofradia, desde las primeras Visperas hasta la entrada del Sol de dicho dia, y alli derramaren piadosos ruegos à Dios por la concordia de los Principes Christianos, extirpacion de las heregias, y exaltacion de nuestra Santa madre Iglesia."

106. *Devoto mes josefino*, 71–72: "Ejemplo. Ya de muchos años atrás habrán venido notando los concurrentes á la antigua casa Profesa de esta ciudad, un cuadro colosal, que la piedad y gratitud de los reverendos padres oratorianos mandó formar, como un monumento que diese perpetuo testimonio del poder bienhechor, que á su favor experimentaron, del castísimo Patriarca. El Santo está de pié en el centro estendidos por ambos lados sobre los padre felipenses, arrodillados en actitud suplicante y agradecida, los brazos

y manto, cuyos estremos más lejanos sostienen dos ángeles. A la altura de éstos, pero más al centro, y de medio cuerpo se ven, á la diestra de San José, la Vírgen María, que con la mano derecha ayuda á sostener el manto josefino y en su brazo izquierdo tiene al Niño Jesus, que con un libro cerrado en la mano izquierda y la derecha levantada como en accion para hablar, dirige estas palabras á su Padre estimativo." On 73–78: "Por fin remata el pié de la pintura una leyenda, cuyo tenor literal es el siguiente: 'Habiendo esperimentado esta Congregacion por espacio de doce años la funesta calamidad de que ningun año pasase sin llorar difunto á alguno de los pocos sujetos que la componian, acordó que nuestros venerables Fundadores reconocieron por Patrono al gloriosísimo Patriarca señor san José estableciendo la víspera del dia de su Patrocinio para la eleccion trienal, y solemnizando anualmente su dia 19 de Marzo; y esta dulce y justa memoria alentó su confianza á solicitar por este poderoso medio el remedio de tan lastimoso infortunio, (determinando el dia 20 de Julio en que se hace memoria de el glorioso Tránsito de señor san José, (1) se cantase alternativamente por alguno de los padres misa solemne, que se ha establecido en el dia 20 de todos los meses, celebrándose el mismo Tránsito en la domínica inmediata á su dia con la mayor solemnidad): y habiendo pasado el espacio de siete años sin que alguno de los Congregantes haya muerto, ha podido persuadirse la piedad á que Dios por intercesion del santísimo Patriarca nos ha concedido este beneficio, confirmándonos la esperanza de lograr el que principalmente deseamos y pedimos, de conseguir un dichoso tránsito á la vida eterna: y por tanto, á honra y gloria de tan magnífico Patrono (nuevamente proclamado por los padres del decencio en la Congregacion de eleccion el dia 9 de Mayo de el presente año) para monumento perpetuo de nuestra gratitud, y mayor estímulo de los fieles á su devocion, se le dedicó este lienzo el dia 12 de Setiembre de (1767) mil setecientos sesenta y siete, repitiendo el dístico de la Santa Iglesia: Fac, nos innocuam, Joseph, producere vitam, / Sitque tuo semper tuta Patrocinio. / *De José el favorable patrocinio / Nos dé vivir sin daño y sin peligro.* // Mira la solicitud del amable Patriarca en conservar la vida de los que le invocan y son útiles á la Iglesia, y procura en tu línea ser lo mismo para asegurar tanto proteccccion."

107. Diaz y Tirado, *Sermon panegirico*, unpaginated prologue: "Al llegar tu Sagrada Imagen al Atrio, toldaron la region con las crecidas parvas de Palomas, que dieron al vuelo, coronadas de oropel, revestidas con banderillas de colores, y adornados los pecho con los escudos respectivos de sus Barrios. Fueron tantas las flores que arrojaron, que en mas de un minuto no se vió tu Imagen, dexando el pavimento casi igual en el piso al escalon de la puerta."

108. Ibid., unpaginated dedication: "Los mayordomos de tu Esclavitud, y varios de tus devotos esclavos, deseosos de perpetuar por los siglos la Solemnidad de tu *Coronacion* Imperial, han promovido dar á la luz pública el Panegírico que hice en el primero de los tres dias que dedicaron á esta celebridad." "1: Quando se regresó de la Santa Iglesia Catedral, donde anualmente se le hace un solemne Novenario se agolpara toda la Puebla en sola esta Calle Real, y en tumulto, aunque confuso, como era igualmente gozoso, sin las precauciones de buen órden, no hubo que notar al menor desorden. El grande no despreció al pequeño, ni el pequeño tuvo que envidiar al grande; pero lo mas plausible de aquel feliz dia, digno de señalarse, no con una piedra blanca, sino con las quatrocientas diez y siete preciosas de tu Imperial Corona (I: Es el número de los diamantes, esmeraldas, y demás piedras preciosas que tiene la Corona.) fue la reconciliacion general de todos los Barrios, que trayendo como pecado original desde sus primeros Padres una odiosa detestable emulacion, que ni la sagacidad de los Pastores, ni todo el rigor de la Justicia habia logrado extinguir; vi yo en aquel venturoso dia, con el mayor júbilo, y con la mayor ternura, abrazarse estrechamente á los inveterados enemigos, y coronarse unos á otros los mas antiguos contrarios." "Apareciste CORONADO, SANTISIMO PATRIARCA, para ser Arco Iris de Paz, y formar á esta Ciudad su mas feliz corona, enlazando y uniendo christianamente á los que eran espiritus de amistad, formaron una Corona sobre las bovedas y cornizas de la Parroquia, quedando los mas casi en el ayre."

109. *Summario de las Indulgencias*, unpaginated: "5. Demàs de esto, â todos los Cofrades, y Cofradas de dicha Cofradia, perdona su Santidad en la acostumbrada forma de la Iglesia, sesenta dias de las penitencias impuestas â ellos por otra razon de qualquiera modo debidas, por qualquiera de las siguientes obras de piedad, tantas quantas

veces se hicieron; conviene â saber. . . . Quando compusieren entre enemigos paz, ô hicieren, ô procuraren que se compongan."

110. The "decline of Spain" is one of the major issues to occupy historians in the field. Consult Helen Nader's Introduction in *Liberty in Absolutist Spain: The Habsburg Sale of Towns, 1516–1700* (Baltimore: Johns Hopkins University Press, 1990). The original essay on the topic dates to 1938: Earl J. Hamilton, "The Decline of Spain," *Economic History Review* 8 (1938): 168–79. Recent historians have re-evaluated the traditional view, which contrasts decadent, declining Habsburg Spain with France's newly emerging power and prestige. See, for example, J. H. Elliott, "The Question of Decline," Part 4 of his *Spain and Its World 1500–1700* (New Haven, Conn., and London: Yale University Press, 1989), 213–86. Also see my discussion in chapter 2, n. 65.

111. For a sculpture commissioned by a confraternity dedicated to caring for orphans, see Teófanes Egido, "La cofradía de San José y los niños expósitos de Valladolid (1540–1757)," *Estudios josefinos* 53 (1973): 77 –100. For chapels dedicated to Joseph in the sixteenth century, see Luis Rodríguez Martínez and Teófanes Egido, "La devoción popular a San José en el Antiguo Régimen," *Estudios josefinos* 38 (1984): 235. For the importance of confraternities and carpenters' guilds as patrons, see Miguel Ángel García Guinea, "San José en el arte barroco español," 191–92. For Josephine confraternities in Toledo, consult Linda Martz, *Poverty and Welfare in Habsburg Spain: The Example of Toledo* (Cambridge, England: Cambridge University Press, 1983), 167.

112. Egido, "Ambiente josefino en el tiempo de Santa Teresa," *Estudios josefinos* 36 (1982): 18–19.

113. *Summario de las Indulgencias.*

114. Cayetano de Cabrera y Quintero, *Escudo de Armas de Mexico: Celestial Proteccion de esta Nobilissima Ciudad, de la Nueva-España, y de casi todo el Nuevo Mundo, Maria Santissima, en su Portentosa Imagen del Mexicano Guadalupe, Milagrosamente Apparecida en el Palacio Arzobispal el Año de 1531* (Mexico City: Viuda de D. Joseph Bernardo de Hogal, 1746), 396–97. Javier Romero Quiroz, *El convento hospital de Nuestra Señora de Guadalupe y del Señor San José: Recolección de Nuestro Padre San Juan de Dios. El teatro de los hospitalarios* (Mexico City: Gobierno de Estado de México, 1976), 17 (on Toluca). Gilberto F. Aguilar, *Hospitales de antaño: Fundaciones de algunos hospitales de la República* (Mexico City: N.p., 1944), 137–40, 161–62.

115. Biblioteca de México, Mexico City (BMMC), Archivo Franciscano, MS 336, Papeles Varios; #1: "Indulgencia plenaria concedida por la Santidad de Pío IV a quienes visitasen la Capilla de San Joseph de México e hiciesen limosna a los pobres. Año 1560." It reads, in part: "Indulgentia plenaria concendida por la Sanctità del Papa Pio Quarto à todos los fieles Christianos que visitaren la Capilla de sant Iosepe en el Monasterio de sant Francisco de la Cibdad del Mexico, e ayudaren con sus limosnas a sustentar los pobres y huerfanos del Hospital del dicho Monasterio."

116. This is the thesis of William A. Christian, Jr.'s *Local Religion in Sixteenth-Century Spain* (Princeton, N.J.: Princeton University Press, 1981).

117. See Sara T. Nalle, "A Saint for All Seasons: The Cult of San Julián," in *Culture and Control in Counter-Reformation Spain*, ed. Anne J. Cruz and Mary Elizabeth Perry, Hispanic Issues, vol. 7 (Minneapolis: University of Minnesota Press, 1992), 25–50. Christian has documented the patron saints of numerous Spanish villages in *Local Religion*. For an overview, consult his Appendix B.

118. On this topic consult Nader, *Liberty in Absolutist Spain*, and Elliott, *Spain and Its World*.

119. On the Inquisition and the *conversos* in Spain, consult Henry Kamen, *Inquisition and Society in Spain in the Sixteenth and Seventeenth Centuries* (Bloomington: Indiana University Press, 1985), and especially 5, 19, 48–49, and 51. Also see the following essays in Cruz and Perry, *Culture and Control*: Jean Pierre Dedieu, "'Christianization' in New Castile: Catechism, Communion, Mass, and Confirmation in the Toledo Archbishopric, 1540–1650," 1–24; and Jaime Contreras, "Aldermen and Judaizers: Cryptojudaism, Counter-Reformation, and Local Power," 93–123.

120. For the plan, see Kamen, *Inquisition and Society in Spain*, 21.

121. Hermengildo Ramírez, M.J., "San José en la evangelización de América Latina," *Estudios josefinos* 45 (1991): 613–14.

122. Ibid., 615.

123. Black, "Las imágenes milagrosas," 36–37.

124. Colegio de San Ildefonso, *Arte y mística del barroco*, exh. cat. (Mexico City: Colegio de San Ildefonso, 1994), cat. no. 28, *Dolores de San José*, anonymous, Museo del Carmen, México, 17th–18th century.

125. Emmanuel Díaz, S.J. (1574–1659) translated Joseph's life and his litanies into Chinese as *Chen jo chée tao wen* (litanies) and *Chen jo chée king che* (his life). See cat. nos. 1669 and 1670 in Aimé Trottier, C.S.C., *Essai de bibliographie sur Saint Joseph*, 3d ed. (Montreal: Centre de Recherche et de Documentation Oratoire Saint-Joseph, 1962).

126. Pastrana, *Empeños del poder*, 529: "Pero mi Señor San Joseph tiene concedida de Dios vniversal gracia para remediar, y consolar à todos los que à èl se encomiendan en todas sus necessidades, enfermedades, negocios, y desconsuelos." This comprehensive view of Joseph's powers also was held by St. Teresa de Ávila. See her *Libro de la Vida*, ed. Otger Steggink (Madrid: Castalia, 1986), 136–37: "a otros santos parece les dio el Señor gracia para socorrer en una necesidad, a este glorioso Santo tengo espiriencia que socorre en todas."

CHAPTER SEVEN
Epilogue

1. For the documents related to this event, see José Antonio, O.C.D., "Tres documentos josefinos del Archivo de Simancas," *Estudios josefinos* 2 (1948): 217–18.

2. The various debates over elevating the Virgin of Guadalupe as co-patroness are detailed in Cayetano de Cabrera y Quintero, *Escudo de Armas de Mexico: Celestial Proteccion de esta Nobilissima Ciudad, de la Nueva-España, y de casi todo el Nuevo Mundo, Maria Santissima, en su Portentosa Imagen del Mexicano Guadalupe, Milagrosamente Apparecida en el Palacio Arzobispal el Ano de 1531* (Mexico City: Viuda de Joseph Bernardo de Hogal, 1746).

3. On Pope Pius IX, consult Roland Gauthier, "La proclamation de saint Joseph comme patron de l'Église," *Cahiers de Josephologie* 43 (1995): 189–95. On Leo XIII, see José de Jesús María, "En torno a una encíclica josefina centenaria," *Esudios josefinos* 43 (1989): 175–97.

4. His letter was reproduced and translated into Spanish in "Juan XXIII: San José, Patrono del Concilio Vaticano II," *Estudios josefinos* 15 (1961): 189–95. For the insertion of St. Joseph's name into the mass, consult "Decreto de la Sagrada Congregación de Ritos sobre la inserción del nombre de San José en el Canon de la Misa (1962)," *Esudios josefinos* 17–18 (1963–64): 128–208.

BIBLIOGRAPHY

ARCHIVES AND LIBRARIES

Archivo de la Catedral, Seville (ACS)

Archivo General de la Nación, Mexico City (AGNMC)

Archivo Histórico Nacional, Madrid (AHNM)

Archivo Municipal de Sevilla, Seville (AMS)

Archivo del Palacio Arzobispal de Sevilla, Seville (APAS)

Biblioteca del Centro de Estudios Josefinos, Convento de San Benito, Valladolid (BCEJ)

Biblioteca Francisco de Zabálburu y Basabe, Madrid (BFZB)

Biblioteca de México, Mexico City (BMMC)

Biblioteca Nacional, Madrid (BNM)

Biblioteca Nacional de México, Mexico City (BNMM)

Biblioteca de la Universidad de Sevilla, Seville (BUS)

Centro Mexicano de Estudios Josefinos, Mexico City (CMEJ)

Consejo Superior de Investigaciones Científicas, Centro de Estudios Históricos, Departamento de Historia del Arte, Madrid (CSIC)

Universidad Nacional Autónoma de México, Instituto de Investigaciones Estéticas, Mexico City (IIE)

PRIMARY SOURCES

Agullo Cobo, Mercedes. *Noticias sobre pintores madrileños de los siglos XVI y XVII*. Madrid: Universidad de Granada, 1978.

Al Patriarca S. Ioseph. N.p., n.d.

Alberti, Leon Battista. *Della Famiglia. The Family in Renaissance Florence: A Translation*. Trans. Renee Neu Watkins. Columbia: University of South Carolina Press, 1969.

———. *The Albertis of Florence: Leon Battista Alberti's Della Famiglia*. Trans. Guido A. Guarino. Lewisburg, Pa.: Bucknell University Press, 1971.

Alciati. *Emblemas*. Ed. Santiago Sebastián. Madrid: Akal, 1985.

Alòs y Orraca, Marco Antonio. *Arbol Evangelico enxerto de Treinta Ramas de Sermones Varios de Festividades, Divididas en tres decimas, y classes*. Valencia, Spain: Claudio Macé, 1646.

Anselmo del Moral y Castillo de Altra, Juan. *Sermon, que con Motivo de la Dedicacion, y estrenas de la Iglesia del Convento de Carmelitas Descalzos de la Ciudad de Tehuaca: En el dia, que el mismo Religiosìsimo Convento Celebra la fiesta de los Cinco Señores, sus patronos, y Titulares de la dicha Iglesia, Predicó en ella, (el 19 de enero de 1783)*. Puebla, Mexico: Pedro de la Rosa, 1792.

Baeza, Diego de, S.J. *Commentariorvm Moralivm in Evangelicam Historiam. Pars Prima, Complectens Tomo I. De D. Iosephi, B. Mariae, & Christi Domini magnalijs: de Eucharistia, de Spiritu sancto, & de B. Trinitate. Tomo II. De vocationibus, & Conuersionibus à IESU Domino peràctis; insuper de omnibus illius miraculis & nobilioribus prophetijs adimpletis*. N.p., 1644.

———. *Commentaria moralia in evangelicum historiam. Tomus primus de divo Josephi*. N.p., n.d.

Barcia y Zambrana, Joseph de. *Despertador Christiano Santoral, de Varios Sermones de Santos, de Anniversarios de Animas, y Honras, en orden à excitar en los fieles la devocion de los Santos, y la imitacion de sus virtudes*. Cádiz, Spain: Christoual de Requena, 1694.

———. *Despertador christiano santoral de varios sermones de santos . . . que dedica al glorioso patriarca señor san Joseph.* Madrid: N.p., 1696.

———. *Despertador Christiano Quadragessimal de sermones doctrinales, para todos los dias de la Quaresma, con remissiones copiosas al Despertador Christiano, de Sermones enteros para los Mismos dias. Tomo Primero, qve dedicò al Excelentissimo Señor D. Fray Juan Thomas de Roberti, Arçobispo de Valencia, del Consejo de su Magestad, Virrey, y Capitàn General que ha sido de dicha Ciudad, y Reyno; aora Inquisidor General &c.* 3d ed. 2 vols. Madrid: Viuda de Juan García Infanzon, 1724.

———. *Despertador Christiano Quadragessimal de sermones doctrinales, para todos los dias de la Quaresma, con remissiones copiosas al Despertador Christiano, de Sermones enteros para los Mismos dias. Tomo Primero, qve dedicò al Excelentissimo Señor D. Fray Juan Thomas de Roberti, Arçobispo de Valencia, del Consejo de su Magestad, Virrey, y Capitàn General que ha sido de dicha Ciudad, y Reyno; aora Inquisidor General &c.* 3d ed. vol. 3. Madrid: Blàs de Villa-nueva, 1724.

———. *Despertador Christiano Santoral, de varios sermones de Santos, de Anniversarios de Animas, y Honras, en orden à excitar en los fieles la devocion de los Santos, y la imitacion de sus virtudes. Que dedica al Gloriosissimo Patriarcha Sr. S. Joseph, Padre, en la opinion, de Jesu-Christo S. N. Esposo verdadero de Maria Santissima, y Patrono Vniversal de los Christianos.* Madrid: Blàs de Villa-Nueva, 1725.

Bueno y Nueva, Andrea. *Vita sanctissimi patriarchae Joseph.* Valladolid, Spain: Rodriguez, 1690.

Cabrera y Quintero, Cayetano de. *Escudo de Armas de Mexico: Celestial Proteccion de esta Nobilissima Ciudad, de la Nueva-España, y de casi todo el Nuevo Mundo, Maria Santissima, en su Portentosa Imagen del Mexicano Guadalupe, Milagrosamente Apparecida en el Palacio Arzobispal el Año de 1531.* Mexico City: Viuda de Joseph Bernardo de Hogal, 1746.

Carducho, Vicente. *Diálogos de la Pintura,* 2d ed. Ed. G. Cruzada Villamil. Madrid: Manuel Galiano, 1865.

———. *Diálogos de la pintura: Su defensa, origen, esencia, definición, modos y diferencias.* Ed. Francisco Calvo Serraller. Madrid: Turner, 1979.

Carrasco Moscoso, Nicolas. *Sermon de el Patrocinio, Qve contra los Rayos y Tempestades goza dichosa la Ciudad de la Puebla en el Esclarescido Patriarcha San Joseph.* Puebla, Mexico: Diego Fernandez de Leon, 1688.

Castorena y Ursua, Juan Ignacio. *Lo mas de la Sanctificacion del Señor San Joseph. Sanctificado antes de nacer â los siete meses de concebido para nacer sanctificado, y ser Padre Estimativo de Christo, y Esposo Castissimo de la Reyna de los Angeles.* Mexico City: Joseph Bernardo de Hogal, 1727.

Castro y Bellvís, Guillén de. *El Mejor Esposo San José.* In *Teatro Teológico Español,* ed. Nicolas González Ruiz. 2 vols. Madrid: Católica, 1963.

Ceán Bermúdez, Juan Agustín. *Diccionario histórico de los más ilustres profesores de las bellas artes en España.* 6 vols. Madrid: Viuda de Ibarra, 1800.

Cerda, José de la, O.S.B. *De Maria et Verbo incarnato ubi et de sancto Josepho ac de utroque Joanne.* Almería, Spain: n.p., 1640.

The Codex Mendoza. Ed. Frances F. Berdan and Patricia Rieff Anawalt. Berkeley and Los Angeles: University of California Press, 1992.

Códice de Yanhuitlán. Facsimile edition of original of c. 1545–50. Study by Wigberto Jiménez Moreno and Salvador Mateos Higuera. Mexico City: Museo Nacional, 1940.

Concilio III Provincial Mexicano, celebrado en México el año 1585, confirmado en Roma por el papa Sixto V, y mandado observar por el gobierno español en diversas reales órdenes. 2d ed. Ed. Mariano Galván Rivera. Barcelona, Spain: Manuel Miró y D. Marsá, 1870.

Covarrubias, Sebastián de. *Tesoro de la lengua castellana o española.* 1611 with additions of 1674. Ed. Martín de Riquer. Barcelona, Spain: Horta, 1943.

Delgado Buenrostro, Antonio. *Panegiricos sagrados que predico a diuersos assuntos en las Indias de la Nueva España el Licenciado Antonio Delgado y Buenrostro.* Seville, Spain: Lopez de Haro, 1679.

La devoción al señor San José en la Nueva España. Mexico City: N.p., 1778.

Devoto mes josefino en que se describe la vida del Castisimo Patriarca, repartida en XXXI consideraciones exornadas con ejemplos de los favores que ha dispensado á los habitantes de la nacion mexicana. Dispuesto por un indigno esclavo del Santo. Mexico City: Imprenta Religiosa de M. Torner, 1873.

Diaz y Tirado, Joseph Atanasio. *Sermon Panegirico, Que en La Plausible Y Festiva Imperial Coronacion del Santisimo Patriarca Señor San Joseph, Celebrada el dia veinte y seis de septiembre del año de mil setecientos ochenta y ocho en la Ciudad de la Puebla de los Angeles.* Puebla, Mexico: Oficina del Real Seminario Palafoxîano, 1789.

Diego de San Francisco. *Exercicios de señor San Joseph, varon justo, patriarcha grande, esposo purissimo de la Madre de Dios, y altissimo padre estimativo de el Hijo de Dios.* Mexico City: Imprenta Real del Superior Govierno, y del Nuevo Rezado, de Doña Maria de Rivera, 1747.

Dolz del Castellar, Estevan. *Tres diamantes de la mas real corona del meior esposo virgen S. Ioseph.* Valencia, Spain: Vivda de Benito Macè, 1681.

Escvela de Discvrsos Formada de Sermones Varios, excritos por diferentes Autores, Maestros Grandes de la Predicacion. [Various authors]. Alcalá de Henares, Spain: Maria Fernandez Viuda, 1645.

Espinosa Sotomayor, Joseph de. *Sermon Panegyrico en Glorias de la Señora Santa Ana, Fiesta, que en el Convento de San Juan Baptista de Metepec, celebrò el dia 26. de Julio de este año de 1716.* Mexico City: Herederos de la Viuda de Miguel de Ribera Calderón, 1716.

Fernández de Arébalo, Lorenzo. *Universal Patronato del gloriosissimo Patriarcha Sr. S. Joseph por un nuevo Convento.* N.p., 1749.

Francisco de Iesvs Maria, O.C.D. *Excelencias de la Caridad, y de otras mvchas virtudes, y de la Devocion con la Virgen Santissima Nuestra Señora, y con su Dvlcisimo Esposo San Ioseph. Con Motivos, y medios para las mismas virtudes, y Devociones.* Salamanca, Spain: Lvcas Perez, 1680.

Gabriel de Santa Maria. *Tratado de las siete missas de Señor San Joseph, en reverencia de svs siete Dolores, y siete Gozos.* Cádiz, Spain: Juan Lorenço Machado, 1670.

——. *Missas y Patrocinio de Señor S. Joseph Dvque, y Ecvdo de su Sagrada Familia. El mas poderoso abogado del cielo despves de Christo y sv Ss. Madre.* Cádiz, Spain: Juan Lorenço Machado, 1670.

Garcia, Francisco, S.J. *Sermones varios.* Madrid: Iuan Garcia Infançon, 1682.

——. *Devoción a San Ioseph, esposo de la virgen Maria nuestra señora.* Madrid: Iuan Garcia Infançon, 1684.

——. *Novena del glorioso patriarca señor San José, padre putativo de Jesus, y esposo dignisimo de Maria.* 17th century. Reprint, Aguascalientes, Mexico: Imprenta Económica, 1876.

Gerson, Jean. *Oeuvres complètes de Jean Gerson.* Vols. 4, 7, and 8. Ed. Palemon Glorieux. Paris and New York: Desclee, [1962, 1966] 1971.

González de León. *Noticia artística . . . de todos los edificios públicos de esta muy Noble . . . ciudad de Sevilla.* Seville, Spain: N.p., 1844.

González Ruiz, Nicolas, ed. *Teatro teológico español II: Comedias.* 2d ed. Madrid: Católica, 1953.

Gracián de la Madre de Dios, Jerónimo. *Josefina. Excelencias de San José Esposo de la Virgen María.* 1597. Reprint, Madrid: Apostolado de la Prensa, 1944.

Gutierrez de los Rios, Gaspar. *Noticia General para la Estimacion de las Artes, y de la Manera en qve Se conocen las liberales de las que son Mecanicas y seruiles, con vna exortacion a la honra de la virtud y del trabajo contra los ociosos, y otras particulares para las personas de todos estados.* Madrid: Pedro Madrigal, 1600.

Gutiérrez de Salinas, Diego. *Alabanzas, y prerogativas del bienaventvrado San Ioseph, Esposo de Nuestra Señora.* Cuenca, Spain: Iulian Iglesia, 1629.

Guzmán, Pedro de. *Los bienes de el honesto trabajo y daños de la ociosidad en ocho discursos.* Madrid: Emprenta Real, 1614.

Hermogenes. *Hermogenes' "On Types of Style."* Trans. Cecil W. Wooten. Chapel Hill: University of North Carolina Press, 1987.

Interián de Ayala, Juan. *El pintor Christiano, y erudito, ó Tratado de los errores que suelen cometerse freqüentemente en pintar, y esculpir las Imágenes Sagradas.* Trans. Luis de Durán y de Bastero. 2 vols. Latin ed. 1730. Madrid: Joachîn Ibarra, 1782.

Ioseph de Iesvs Maria. *Primera parte de las excelencias de la virtud de la Castidad.* Alcalá, Spain: Biuda de Iuan Gracián 1601.

——. *Historia de la Virgen Maria Nvestra Señora. Con la declaracion de algunas de sus Excellencias.* Antwerp, Belgium: Francisco Canisio, 1652.

Isolanis, Isidoro de. *Suma de los dones de San José.* Trans. José Pallés. Barcelona, Spain: Pablo Riera, 1887.

Jesús de Ágreda, Sor María de. *La mística ciudad de Dios (1670): Sor María de Jesús de Agreda.* Ed. Augustine M. Esposito. Potomac, Md.: Scripta Humanistica, 1990.

José de Jesús María (Quiroga). *Historia de la Vida, y Singvlares Prerrogatiuas del glorioso S. Ioseph, padre putatiuo de Christo Nuestro Señor, y Esposo verdadero de la Virgen Maria su madre.* Madrid: Luys Sanchez, 1613.

Juan de la Anunciación, O.S.A. *Sermonario en lengua mexicana, donde se contiene (por el orden del Missal nuevo Romano), dos Sermones en todas los Dominicas y Festividades principales de todo el año; y otro en las Fiestas de los Santos, con sus vidas, y comunes. Con un Cathecismo en Lengua Mexicana y Española, con el Calendario.* Mexico City: N.p., 1577.

Juana Inés de la Cruz. *Segvndo volvmen de las Obras de Soror Jvana Ines de la Cruz, Monja Profesa en el Monasterio del Señor San Geronimo de la Civdad de Mexico.* Seville, Spain: Tomas Lopez de Haro, 1692.

———. *Obras completas.* Ed. Francisco Monterde. Mexico City: Porrúa, 1989.

Jubileos y gracias concedidas a la esclavitud del glorioso patriarca señor San José, fundada en la parroquia de la Asuncion de Aguascalientes en el año de 1855. Aguascalientes, Mexico: J. T. Pedroza, 1871.

Laredo, Bernardino de. *Tratado de San José.* Madrid: Rialp, 1977. Facsimile of 1st ed., fols. CCV verso to CCXIJ verso of *Subida del monte sion nueuamete renouada: como en la buelta desta hoja se vera. Contiene el conoscimieto nuestro: y el seguimieto de Christo: y el reuereciar a dios e la conteplacion queta.* Seville: Juan Cronburger, 1538.

León, Luis de. *La perfecta casada.* Madrid: Espasa-Calpe, 1975.

———. *La perfecta casada.* Ed. Mercedes Etreros. Madrid: Altea, Taurus, Alfaguara, 1987.

Leon, Martin de. *Camino del Cielo en Lengua mexicana, con todos los requisitos necessarios para conseguir este fin, con todo lo que vn Christiano deue creer, saber, y obrar, desde el punto que tiene vso de razon, hasta que muerte.* Mexico City: Diego Lopez Daualos, 1611.

———. *Primera Parte del Sermonario del tiempo de todo el año, duplicado, en lengua Mexicana.* Mexico City: Viuda de Diego Lopez Daualos, 1614.

Leon Marchante, Manuel de. *Obras poeticas posthumas, que a diversos assumptos escrivio el maestro Don Manuel de Leon Marchante, Comisario del Santo Oficio de la Inquisicion, Cappelan de su Magestad, y del Noble Colegio de Cavalleros Manriques de la Vniversidad de Alcalá, Racionero de la Santa Iglesia Magistral de San Justo, y Pastor de dicha Ciudad. Divididas en tres classes, sagradas, humanas, y comicas.* Madrid: Gabriel del Barrio, 1722.

Libro en qve se hace relacion de la fundacion de el convento de Carmelitas Descalzas de San Ioseph, qve en la villa de Zvmaya hizo la Madre Francisca de Jesvs. N.p., 1614.

Lizana, Fray Francisco de. *Vida, prerrogativas, y excelencias de la inclita matrona señora Santa Ana.* Madrid: Ioseph Fernandez de Buendia, 1677.

López de Arenas, Diego. *Breve compendio de la Carpintería de lo blanco, y tratado de Alarifes, con la Conclvsion de la Regla de Nicolas Tartaglia, y otras cosas tocantes a la Ieometría, y pvntas del compas. Dedicado al glorioso patriarcha San Ioseph.* Seville, Spain: Luis Estupiñan, 1633.

López de Villaseñor, Pedro. *Cartilla Vieja de la Nobilisima Ciudad de Puebla (1781).* Ed. José I. Mantecón. Mexico City: Universitaria, 1961.

Lorenzo de San Nicolas. *Arte y vso de Arquitectura.* Madrid: Placido Barco Lopez, 1736. 4th ed., 1796.

Loyola, St. Ignatius. *The Spiritual Exercises of St. Ignatius Loyola. Spanish and English.* 2d ed. Ed. Joseph Rickaby, S.J. London: Burns, Oates, and Washbourne, 1923.

Luna, Juan de. *Adviento, Natividad, Circunción y Epiphania de nuestro Redentor . . . con las fiestas de . . . San Joseph.* Madrid: Iuan de la Cuesta, 1608.

Malo Andveza, Diego de. *Oraciones panegiricos en las festividades varias de santos.* Madrid: Domingo Garcia Morràs, 1663.

Mansilla, Antonio. *Padrino de este Reyno de las Yndias, de este Invicto Rey de las Españas, y de esta Primera Yglesia de las yglesias. S. Ioseph Patriarcha. Sermon, que en la fiesta de su Patrocinio, que en nombre de su Magestad, hizo su Vi Rey, y Capitan General, en la Parrochia de los Yndios, sita en el Patio del Convento grande de N. S. P. S. Francisco de esta Ciudad de Mexico; con la asistencia de todos los Tribunales desta Corte. Predicô el dia veinte y nueve de Abril de el Año de mil setecientos, y catorce.* Mexico City: Heredèros de la Viuda de Francisco Rodriguez Lupercio, 1724.

Mariano Montufar, Juan Joseph. *El Argumento, y Firmeza de la Tierra, el Abrigo de Maria Señora Nuestra, El Sossiego, y Quietud de Dios, Sermon Panegyrico al Glorioso Patriarcha Sr. S. Joseph, por el Patronato de Temblores, que predicò en la Santa Iglesia Cathedral Metropolitana, el dia 16. de Octubre de 1734.* Mexico City: Imprenta Real, 1735.

Martínez, Jusepe. *Discursos practicables del nobilísimo arte de la pintura.* Ed. Julián Gállego. 1844. Reprint, Barcelona, Spain: Selecciones Bibliófilas, 1950.

Martinez, Manuel. *Panegirico, Qve en 24. de Enero se hizo al Patriarca san Ioseph, estando patente el Señor Sacramentado: en rogativa, por los bvenos svcessos del viaje de sv Alteza, y Bien de la Monarquia.* Zaragoza, Spain: N.p., 1677.

Martinez de Grimaldo, Ioseph. *Ramillete de las flores, qve del iardin del ingenio, regado con el rocio de la devocion brotaron algvnos de los elegantes y devotos congregantes del Santissimo Sacramento. Para cantar svs glorias en las festividades, que este año de 1650. ha celebrado su Esclauitud en el Conuento de Santa Maria Madalena de esta Corte.* N.p., 1650.

Martinez de Llamo, Ivan. *Marial de todas las fiestas de Nuestra Señora, desde sv concepcion pvrissima, hasta*

la festividad mas moderna de svs desposorios con el patriarca San Ioseph. Con otros tres sermones de la descension de la imagen de el glorioso patriarca Santo Domingo, traìda por manos de Maria Santissima à la Villa de Soriano. Madrid: Antonio de Zafra, 1682.

Meditaciones sobre el Patriarca San José, para el Mes de Marzo. Mexico City: Juan Mariano y Sanz, 1868.

Mendieta, Gerónimo de. *Historia eclesiástica indiana.* 2d facsimile ed. Mexico City: Porrúa, 1971.

Molanus, Johannes. *De Historia SS. Imaginvm et Pictvrarvm, Provero Earvm Vsv contra abusus.* Vol. 3. Louvain, Belgium: Laurence Durand, 1619.

———. *De Historia SS. Imaginum et Picturarum pro vero earum uso contra abusus/Traité des saintes images.* 2 vols. Trans., ed. François Bœspflug, Olivier Christian, and Benoît Tassel. Paris: Cerf, 1996.

Molina, Antonio de. *Exercicios Espirituales de las excelencias, provecho, y necessidad de la Oracion Mental, reducidos à Doctrina, y Meditaciones, sacados de los Santos Padres, y Doctores de la Iglesia.* 1612. Reprints, Barcelona, Spain: Rafael Figverò, 1700; Madrid: Juan de Zuñiga, 1730.

Munoz de Castro, Pedro. *Sermon del Glorioso Patriarcha San Joseph Predicado En su dia 19 de Marzo de este año de 1696 en la Feria segunda despues de la Dominica segunda de Quaresma, en la Iglesia del Hospital de Nuestra Señora de la Concepcion de esta ciudad de Mexico.* Mexico City: Juan Joseph Guillena Carrascoso, 1696.

Navarro, Antonio. *Abcedario Virginal y Excelencias del Santissimo nombre de Maria: Donde se le dan a la Virgen dozientos y veintiocho nombres segun la sagrada Escritura, y propiedades naturales de Piedras preciosas, Aues, Animales, Fuentes, Arboles y otros secretos de Naturaleza.* Madrid: Iuan de la Cuesta, 1604.

Neve y Molina, Luis de. *Reglas de orthographia, diccionario, y arte del idioma othomi, breve instruccion para los principiantes.* Mexico City: Bibliotheca Mexicana, 1767.

Nicolás, Antonio. *Bibliotecha Hispana Nova.* 2 vols. 1672. Reprint, Madrid: Juan de Ibarra, 1788.

Nicolas de Jesvs Maria. *La Mano de los Cinco Señores Jesvs, Maria, y Joseph, Joachin, y Anna.* Mexico City: Herederos de la Viuda de Miguel de Rivera, 1726.

Nieua Caluo, Sebastian de. *La meior Mvger, Madre, y Virgen. Svs Excelencias, Vida, y grandezas, repartidas por sus fiestas todas.* Madrid: Iuan Gonçalez, 1625.

Niseno, Fray Diego. *Asvntos predicables para todos los Domingos, del primero de Adviento, al ultimo de la Pascua de Resurrecion.* Zaragoza, Spain: Juan de Lanaja y Quartanet, 1633.

———. *Segvnda Parte, del Politico del Cielo. Hallado en las misteriosas acciones del sagrado Patriarca Iacob.* Madrid: Maria de Quiñones, a espensas de la Hermandad de los Mercaderes de Libros desta Corte, 1638.

Nueva relacion de los desposorios de San Joseph, y la Virgen. N.p., 17th century.

Oración a Iesvs, Maria, Ioseph, Iochin, y Ana. N.p., n.d.

Oratorio de Feliz Transito del Glorioso Esposo de Maria Santissima San Joseph. N.p., 18th century.

Orr, James, ed. *New Testament Apocryphal Writings.* London: J. M. Dent and Sons; Philadelphia: J. B. Lippincott, 1923.

Ortiz de Zuñiga, Diego. *Annales eclesiasticos, y secvlares de la mvy noble, y mvy leal civdad de Sevilla, metropoli de la Andalvzia, que contienen svs mas principales memorias. Desde el año de 1246. En qve emprendio conquistarla del poder de los Moros, el gloriosissimo Rey S. Fernando Tercero de Castilla, y Leon, hasta el de 1671. en que la Catolica Iglesia le concediò el culto, y titulo de Bienauenturado.* Madrid: Iuan Garcia Infançon, 1677.

———. *Annales eclesiasticos, y secvlares de la mvy noble, y mvy leal civdad de Sevilla, metropoli de la Andalvzia, que contienen svs mas principales memorias. Desde el año de 1246. En qve emprendio conquistarla del poder de los Moros, el gloriosissimo Rey S. Fernando Tercero de Castilla, y Leon, hasta el de 1671. en que la Catolica Iglesia le concediò el culto, y titulo de Bienauenturado.* 5 vols. Madrid: N.p., 1795–96.

———. *Annales eclesiasticos, y secvlares de la mvy noble, y mvy leal civdad de Sevilla, metropoli de la Andalvzia, que contienen svs mas principales memorias. Desde el año de 1246. En qve emprendio conquistarla del poder de los Moros, el gloriosissimo Rey S. Fernando Tercero de Castilla, y Leon, hasta el de 1671. en que la Catolica Iglesia le concediò el culto, y titulo de Bienauenturado.* 5 vols. Seville, Spain: Guadalquivir, 1988.

Pacheco, Francisco. *El arte de la pintura, su antigüedad y grandezas.* 2 vols. Ed. F. J. Sánchez Cantón. Seville, 1638. Reprint, Madrid: Instituto de Valencia de Don Juan, 1956.

———. *El arte de la pintura.* Ed. Bonaventura Bassegoda i Hugas. Madrid: Cátedra, 1990.

Palomino de Castro y Velasco, Aciscolo Antonio. *Museo pictórico y escala óptica.* 3 vols. Madrid, 1715–24. Reprint, Madrid: M. Aguilar, 1947.

———. *The Lives of the Eminent Spanish Painters and Sculptors.* Trans. Nina Ayala Mallory. Cambridge, England: Cambridge University Press, 1987.

Paredes, Ignacio de. *Promptuario manual mexicano.* Mexico City: Bibliotheca Mexicana, 1759.

Paredes, Joseph de. *El Santo de Suposicion. Sermon de el Patriarcha Señor San Joseph, Que en su dia 19. de Marzo de 1749. En la Santa Iglesia Cathedral de Merida Provincia de Yucatan Dixo el P. M. Joseph de Paredes.* Mexico City: Imprenta del Nuevo Rezado, de Doña Maria de Ribera, 1749.

Pastrana, Antonio Joseph de. *Empeños del poder, y amor de Dios, en la admirable, y prodigiosa vida del sanctissimo patriarcha Joseph, esposo de la madre de Dios.* Madrid: Viuda de Don Francisco Nieto, 1696.

Pedro del Espiritu Santo. *Sermones de Jesus, Maria, y Joseph, a que se añaden otros de N. S. M. Doctora Mystica Santa Teresa de Jesus: y de Nuestro Mystico Padre, y Doctor S. Juan de la Cruz, que en todos son quarenta.* Vol. 1. Madrid: Blàs de Villanueva, 1717.

Pérez de Herrera, Cristóbal. *Amparo de pobres.* Ed. Michel Cavillac. Madrid: Espasa-Calpe, 1975.

Pérez Villanueva, Joaquín, ed. *Cartas de Felipe IV.* Salamanca, Spain: Caja de Ahorros y Monte de Piedad de Salamanca, 1986.

Pinelo, Valentina. *Libro de las alabanças y excelencias de la gloriosa Santa Anna.* Seville, Spain: Clemente Hidalgo, 1601.

Piño, Manvel de. *Villancicos, y Romances, a la Nauidad del niño Iesu, nuestra Señora, y varios Sanctos.* Lisbon: Pedro Crasbeeck, 1615.

———. *Segvnda Parte de Villancicos, y Romances, a La Natividad del Niño Iesus, nuestra Señora, y varios Santos.* Lisbon: Pedro Craesbeeck, 1618.

Ponz, Antonio. *Viage de España, en que se da noticia de las cosas mas apreciables, y dignas de saberse, que hay en ella.* 18 vols. Madrid: Viuda de Ibarra, 1784–87.

Prieto, Melchior. *Josephina evangelica, literal y mistica, de las excelencias y prerogativas del glorioso patriarca san Joseph.* Madrid: Sanchez, 1613.

Ribadeneira, Pedro de. *Flos Sanctorvm, o Libro de las vidas de los Santos.* Madrid: Luis Sanchez, 1616.

———. *Flos Sanctorvm, o Libro de las vidas de los Santos.* Barcelona, Spain: Sebastian Cornella, 1643.

Riojano, Francisco. "Sermon Decimotercio qve a las Festivas Memorias del Glorioso S. Ioseph Esposo de Maria, y Padre de Christo, dixo en el Religiosissimo y Real Conuento de las Descalças de Madrid, año de 1644." In *Escvela de Discvrsos Formada de Sermones Varios, excritos por diferentes Autores, Maestros Grandes de la Predicacion* [various authors]. Alcalá de Henares, Spain: Maria Fernandez Viuda, 1645.

Robles, Juan de. *La vida y excelencias y miraglos de Santa Anna y de la gloriosa nuestra señora Santa Maria fasta la edad de quatorze años: Muy deuota y contenplatiua nueuamente copilada.* Seville, Spain: Jacobo Cromberger, 1511.

Rodriguez de Torres, Melchior. *Iornadas de Iosef y su familia Maria y Iesus.* Burgos, Spain: Pedro de Huydobro, 1628.

Roelas, Juan de las. *Hermosura corporal de la Madre de Dios.* Seville, Spain: Diego Perez, 1621.

Sahagún, Bernardino de. *General History of the Things of New Spain: Florentine Codex.* Ed., trans. Arthur J. O. Anderson and Charles E. Dibble. Santa Fe, N.Mex.: School of American Research; Salt Lake City: University of Utah, 1950–82.

———. *Historia general de las cosas de Nueva España.* Ed. Ángel María Garibay. Mexico City: Porrúa, 1981.

Salmerón, Marcos. *El Principe escondido. Meditaciones de la vida oculta de Christo; desde los doze hasta los treinta años. Ilustranse con letras divinas y humanas, politicas, y con noticias chronologicas.* Madrid: Pedro de Horno y Villanueva, 1648.

Sánchez Cantón, F. J., ed. *Fuentes literarias para la historia del arte español.* 5 vols. Madrid: Clásica española, 1923–41.

Sandoval, Pedro de. *Sermon Panegirico del Glorioso Patriarcha, S. Ioseph, Desposado con Maria Santissima, que discurrió, y dixo el dia de su festividad en el Convento de N. P. S. Francisco de la Ciudad de la Puebla.* Mexico City: Doña Maria de Benavides Viuda de Juan de Ribera, 1700.

"Sermon del Patriarca San Iosef, predicose en San Ivan del Mercado Domingo 13. post Pentecoste, en tres de Setiembre, 1645 ajustando el Euangelio de la Dominica con el de la fiesta de san Iosef, y sus alabanças." In *Escvela de Discvrsos Formada de Sermones Varios, excritos por diferentes Autores, Maestros Grandes de la Predicacion* [various authors]. Alcalá de Henares, Spain: Maria Fernandez Viuda, 1645.

Soto, Andres de. *Libro de la vida y excelencias de el glorioso S. Ioseph, Esposo de la Virgen N. Señora.* 1593. Reprint, Brussels: Iuan Mommaerte, 1600.

Strycker, Émile de, ed. and trans. *La forme la plus ancienne du Protévangile de Jacques.* Brussels: Société des Bollandistes, 1961.

Summario de las Indulgencias, y Gracias Perpetuas, Concedidas por Nrô. Smo. Padre Clemente Papa XII. de feliz memoria, â los Cofrades, y Cofradas de la Pia, y devota Esclavitud del Glorioso Patriarcha Señor San Joseph, Fundada canonicamente en la Iglesia del

Monasterio de Religiosas de S. Joseph de Gracia, de esta Ciudad de Mexico, por su Bula expedida en Roma, en Santa Maria la Mayor, debajo del Anillo del Pescador, el dia catorce de Febrero, del año de mil setecientos treinta y cinco, el año quinto de su Pontificado. Mexico City: Viuda de D. Joseph Bernardo de Hogal, 1742.

Teresa de Jesús, Saint [Ahumada y Cepeda, Teresa de]. Libro de la vida. Ed. Dámaso Chicharro. Madrid: Cátedra, 1979.

———. Libro de la Vida. Ed. Otger Steggink. Madrid: Castalia, 1986.

———. The Life of Teresa of Jesus: The Autobiography of Teresa of Avila. Trans., ed. E. Allison Peers. New York: Doubleday, 1991.

Tomay, Ignacio. El Sagrado Corazon del Santissimo Patriarcha Sr. San Joseph, Venerado por todos los dias de la Semana, Con la Consideracion de sus excelencias, y diversidad de afectuosos Coloquios. Mexico City: Viuda de D. Joseph Bernardo de Hogal, 1751.

Tratado del santo sacramento de matrimonio. Lyons, France: Dionisio Gerault, 1677.

Valderrama, Pedro de. Primero, segvnda, y tercera parte de los exercicios espiritvales, para todas las festividades de los santos. Madrid: Alonso Martin, 1608.

Valdes, Joseph Francisco. Vida de la Gloriosísima Madre de la Madre de Dios, y Abuela de Jesuchristo Séñora Santa Ana. Mexico City: Herederos de Don Felipe de Zúñiga y Ontiveros, 1794.

Valdivielso, Ioseph de. Vida, excelencias, y mverte del glorioso Patriarca, y Esposo de N. Señora S. Ioseph. Toledo, Spain: Diego Rodriguez, 1604.

Valdivielso, José de. Vida, excelencias y muerte del gloriosísimo patriarca san Josef, esposo de nuestra señora. In Poemas épicos, ed. Cayetano Rosell. Biblioteca de autores españoles, vol. 29, no. 2. 1603. Reprint, Madrid: Hernando, 1925.

———. La Vida de San Ioseph. Barcelona, Spain: Hieronymo Margarit, 1610.

———. Romancero espiritual. Ed. J. M. Aguirre. Madrid: Espasa-Calpe, 1984.

Vallejo, José Ignacio. Vida del Señor San José, Dignisimo Esposo de la Virgen Maria y Padre Putativo de Jesus. Ed. Juan Rodriguez de San Miguel. 3d rev. ed. from Vallejo's 2d ed. of 1779. Mexico City: J. M. Lara, 1845.

Victoria, Marqués de la. Diccionario de Construccion Naval. Madrid: Museo Naval, manuscript from first half of 18th century.

Villa Sanchez, Juan de. Sermones varios. Mexico City: Rivera, 1738.

Villegas, Alonso de. Flos Sanctorum Quarta y Ultima Parte, y Discursos, ò Sermones, sobre los Euangelios de todas las Dominicas del año, ferias de Quaresma, y de santos principales: en que se contienen exposiciones literales, dotrinas morales, documentos espirituales, auisos y exemplos prouechosos, para todos estados. Madrid: Pedro Machado, 1589.

———. Flos Sanctorvm. Segvnda Parte, y Historia General, en qve se Escrive la vida de la Virgen Sacratissima madre de Dios, y Señora nuestra: y las de los Santos antiguos, que fueron antes de la venida de nuestro Saluador al mundo. Alcalá de Henares, Spain: Iuan Gracian, 1619.

———. Flos Sanctorum. Vida, y Hechos de Jesu-Christo, Dios, y Señor Nuestro, y de Todos los Santos, de que Reza la Iglesia Catholica. Conforme al Breviario Romano, Reformado por Decreto del Santo Concilio Tridentino. Junto con las Vidas de los Santos Propios de España. Barcelona, Spain: Viuda Piferrer, 1787.

Vives, Juan Luis. Instrucción de la mujer cristiana. Trans. Juan Justiniano. Ed., prologue, and notes, Salvador Fernández. Madrid: Signo, 1936.

Voragine, Jacobus de. The Golden Legend of Jacobus de Voragine. 2 vols. Trans., ed. William Granger Ryan and Helmut Ripperger. London and New York: Longmans, Green, 1941.

———. The Golden Legend: Readings on the Saints. 2 vols. Trans. William Granger Ryan. Princeton, N.J.: Princeton University Press, 1993.

Xamarro, Iuan Bautista. Conocimiento de las Diez Aves menores de jaula, su canto, enfermedad, cura y cria. Madrid: Imprenta Real, 1604.

Zamora, Lorenço de. Libro de la Huida de la Virgen nuestra Señora a Egypto. Madrid: Luis Sanchez, 1609.

Zarate, Francisco de. El cordial devoto de San Joseph. Mexico City: Francisco Rodríguez Lupercio, 1674.

Zubiaur, Matheo de. Peso, y fiel contraste de la vida, y de la mverte. avisos, y desengaños, exemplares, morales, y politicos. Con vn tratado, intitvlado, observaciones de palacio y corte. Y vn breve apuntamiento de la llegada de la Reyna N. S. a esta corte. Madrid: Andres Garcia, 1650.

SECONDARY SOURCES

Abou-El-Haj, Barbara. "The Audiences for the Medieval Cult of Saints." Gesta 30 (1991): 3–15.

Aguilar, Gilberto F. Hospitales de antaño: Fundaciones de algunos hospitales de la República. Mexico City: N.p., 1944.

Aguirre, J. M. José de Valdivielso y la poesía religiosa tradicional. Toledo, Spain: Diputación Provincial, 1965.

Alastruey, Gregorio. "Teología de San José." *Estudios josefinos* 1 (1947): 4–23.

Alonso Aguilera, Miguel Ángel. "El culto a San José en la Toscana de Cosme III de Médicis." *Estudios josefinos* 29 (1975): 77–89.

Alpers, Svetlana. "Style Is What You Make It: The Visual Arts Once Again." In *The Concept of Style*, ed. Beral Lang. Philadelphia: University of Pennsylvania Press, 1979.

———. *The Art of Describing: Dutch Art in the Seventeenth Century*. Chicago: University of Chicago Press, 1983.

Álvarez de Morales, Antonio. *Las hermandades, expresión del movimiento comunitario en España*. Valladolid, Spain: Universidad de Valladolid, 1974.

Álvarez Santaló, León Carlos. "La casa de expósitos de Sevilla en el siglo XVII." *Cuadernos de Historia* 7 (1977): 491–532.

———. *Marginación social y mentalidad en Andalucía occidental: Expósitos en Sevilla (1613–1910)*. Seville, Spain: Consejería de Cultura de la Junta de Andalucía, 1980.

Amelang, James. "Society and Culture in Early Modern Spain." *Journal of Modern History* 65 (1993): 357–74.

Ampe, Albert, S.J. "Philippe van Meron, O.F.M., et Jan van Denemarken: Nouveaux aspects sur le développement de la dévotion à Saint Joseph aux Pays-Bas vers 1500." *Estudios josefinos* 31 (1977): 477–99.

Anderson, Arthur J. O. "A Look into Tlalocan." In *Smoke and Mist: Mesoamerican Studies in Memory of Thelma D. Sullivan*, ed. J. Kathryn Josserand and Karen Dakin. Oxford, England: Oxfordshire, 1988.

Anderson, Janet Alice. "Pedro de Mena: Spanish Sculptor, 1628–1680." 2 vols. Ph.D. diss., University of Michigan, 1970.

Angulo Íñiguez, Diego. *Pintura del Renacimiento*. XII. Ars Hispaniae: Historial universal del arte hispánico. Madrid: Plus-Ultra, 1954.

———. *José Antolínez*. Madrid: Instituto Diego Velázquez, del Consejo Superior de Investigaciones Científicas, 1957.

———. *Murillo: Su vida, su arte, su obra*. 3 vols. Madrid: Espasa-Calpe, 1981.

Angulo Íñiguez, Diego, and Alfonso E. Pérez Sánchez. *Historia de la pintura española: Escuela madrileña del primer tercio del siglo XVII*. Madrid: Instituto Diego Velázquez, 1969.

———. *Historia de la pintura española: Pintura toledana de la primera mitad del siglo XVII*. Madrid: Instituto Diego Velázquez, 1972.

———. *Historia de la pintura española: Escuela madrileña del segundo tercio del siglo XVII*. Madrid: Instituto Diego Velázquez, 1983.

Antonio, José, C.D. "La Josefina de Bernardino de Laredo: ¿influyó en Santa Teresa de Jesús?" *Estudios josefinos* 2 (1948): 229–37.

———. "Tres documentos josefinos del Archivo de Simancas." *Estudios josefinos* 2 (1948): 111–24.

———. "Tres documentos josefinos del Archivo de Simancas (Continuación)." *Estudios josefinos* 2 (1948): 217–28.

Arenal, Electa, and Stacey Schlau. *Untold Sisters: Hispanic Nuns in Their Own Works*. Albuquerque: University of New Mexico Press, 1989.

Arens, W. *The Man-Eating Myth. Anthropology and Anthropophagy*. New York: Oxford University Press, 1970.

Arias y Arias, Ricardo. *Spanish Sacramental Plays*. Boston: Twayne, 1980.

Ariès, Philippe. *Centuries of Childhood: A Social History of Family Life*. Trans. Robert Baldick. New York: Vintage Books, 1962.

Armella de Aspe, Virginia, and Mercedes Meade de Angulo. *Tesoros de la Pinacoteca Virreinal*. Mexico City: Fomento Cultural Banamex, 1993.

The Art Museum, Princeton University. *Painting in Spain 1650–1700 from North American Collections*. Exh. cat. Princeton, N.J.: The Art Museum, Princeton University, in association with Princeton University Press, 1982.

Ashe, Geoffrey. *The Virgin*. London: Routledge and Kegan Paul, 1976.

Ashley, Kathleen, and Pamela Sheingorn, eds. *Interpreting Cultural Symbols: Saint Anne in Late Medieval Society*. Athens: University of Georgia Press, 1990.

Astrain, Antonio. *Historia de la Compañía de Jesús en la asistencia de España*. Madrid: Administración de Razón y Fe, 1912.

Atkinson, Clarissa W. *The Oldest Vocation: Christian Motherhood in the Middle Ages*. Ithaca, N.Y.: Cornell University Press, 1991.

Atkinson, William C. *A History of Spain and Portugal*. Baltimore: Penguin, 1960.

Bal, Mieke, and Norman Bryson. "Semiotics and Art History." *Art Bulletin* 73 (1991): 174–208.

Balmori Cinta, Roberto, M.J. "La josefología de Juan José Eguira y Eguren." *Estudios josefinos* 45 (1991): 235–56.

Bantel, Linda, and Marcus B. Burke. *Spain and New Spain: Mexican Colonial Arts in Their European Context.* Corpus Christi: Art Museum of South Texas, 1979.

Barettini Fernández, Jesús. *Juan Carreño: Pintor de cámara de Carlos II.* Madrid: Ministerio de Asuntos Exteriores, 1972.

Barrera y Leirado, Cayetano Alberto de la. *Catálogo bibliográfico y biográfico del teatro antiguo español desde sus orígenes hasta mediados del siglo XVIII.* Madrid: M. Rivadeneyra, 1860.

Bartina, Sebastián, S.J. "Derechos paternos y sucesión davídica según el judaísmo." *Estudios josefinos* 39 (1985): 11–24.

Bataillon, Marcel. *Erasmo y el Erasmismo.* Trans. Carlos Pujol. Barcelona, Spain: Crítica, 1977.

Baticle, Jeannine. *Zurbarán.* Exh. cat. New York: Metropolitan Museum of Art, 1987.

Bavaud, Georges. "La figure de Saint Joseph dans l'oeuvre d'Érasme et de Lefevre d'Étaples." *Estudios josefinos* 31 (1977): 141–55.

Baxandall, Michael. *Giotto and the Orators: Humanist Observers of Painting in Italy and the Discovery of Pictorial Composition, 1350–1450.* Oxford, England: Clarendon, 1971.

———. *Painting and Experience in Fifteenth-Century Italy: A Primer in the Social History of Pictorial Style.* Oxford, England: Clarendon, 1972.

———. *The Limewood Sculptors of Renaissance Germany.* New Haven, Conn., and London: Yale University Press, 1980.

———. *Patterns of Intentions: On the Historical Explanation of Pictures.* New Haven, Conn., and London: Yale University Press, 1985.

Behar, Ruth. "Sexual Witchcraft, Colonialism, and Women's Powers: Views from the Mexican Inquisition." In *Sexuality and Marriage in Colonial Latin America,* ed. Asunción Lavrin. Lincoln: University of Nebraska Press, 1988.

Beltrán, Gabriel, O.C.D. "San Juan de la Cruz y San José." *Estudios josefinos* 46 (January–June 1992): 15–25.

Benito María de la Cruz, O.C.D. "El josefismo de Santa Teresa." *Estudios josefinos* 18 (1963–64): 325–38.

Benito Doménech, Fernando. "Dibujos de José Camarón Boronat sobre la vida de San José." *Archivo español de arte* 60 (1987): 419–45.

———. *The Paintings of Ribalta 1565/1628.* New York: The Spanish Institute, 1988.

Bennassar, Bartolomé. *Valladolid au siècle d'or. Une Ville de Castille et sa campagne au XVIe siècle.* Paris and The Hague: Mouton, 1967.

Bergeron, Henri-Paul, C.S.C. "Saint Joseph selon les prédicateurs français de la Renaissance." *Estudios josefinos* 31 (1977): 371–85.

Bergmann, Emilie. "The Exclusion of the Feminine in the Cultural Discourse of the Golden Age: Juan Luis Vives and Fray Luis de León." In *Religion, Body and Gender in Early Modern Spain,* ed. Alain Saint-Saëns. San Francisco: Mellen Research University Press, 1991.

Bernales Ballesteros, Jorge. *Pedro Roldán: Maestro de Escultura (1624–1699).* Seville, Spain: Diputación Provincial de Sevilla, 1973.

Bertolini, José Antonio, O.S.J. "San Giuseppe nel Brasile durante il XVIII secolo." *Estudios josefinos* 45 (1991): 687–703.

Bilinkoff, Jodi. *The Avila of Saint Teresa: Religious Reform in a Sixteenth-Century City.* Ithaca, N.Y.: Cornell University Press, 1989.

Black, Charlene Villaseñor. "Las imágenes milagrosas de San José en España y Sudamérica, las teorías del arte y el poder de la imagen en el siglo XVIII." *Estudios josefinos* 48 (1994): 27–46.

———. "Saints and Social Welfare in Golden Age Spain: The Imagery of the Cult of Saint Joseph." Ph.D. diss., University of Michigan, 1995.

———. "Trabajo y redención en la España del siglo de oro: Imágenes de San José en el taller de carpintero." Trans. Juan Montero Aparicio. *Estudios josefinos* 101 (1997): 3–23.

———. "Arts." in *American Eras: Early American Civilizations and Exploration to 1600,* ed. Gretchen D. Starr-LeBeau. Detroit: Gale, 1998.

———. "Love and Marriage in the Spanish Empire: Depictions of Holy Matrimony and Gender Discourses in the Seventeenth Century." *Sixteenth Century Journal* 32 (2001): 637–67.

———. "The Moralized Breast in Early Modern Spain." In *The Material Culture of Sex, Procreation, and Marriage in Premodern Europe,* ed. Anne L. McClanan and Karen Rosoff Encarnación. New York: Palgrave, 2002.

———. "St. Anne Imagery and Maternal Archetypes in Spain and Mexico." In *Colonial Saints: Discovering the Holy in the Americas, 1500–1800,* ed. Allan Greer and Jodi Bilinkoff. New York: Routledge, 2002.

———. "The Performativity of Gender in Early Modern Spain: The Case of the Lactating Breast in Spanish Art." In *Sex and Culture in Medieval and*

Early Modern Europe, ed. Philip Soergel. New York: AMS Press, 2005.

Blumenfeld-Kosinski, Renate, and Timea Scell, eds. *Images of Sainthood in Medieval Europe*. Ithaca, N.Y.: Cornell University Press, 1991.

Boone, Elizabeth Hill, ed. *The Art and Iconography of Late Postclassic Central Mexico*. Washington, D.C.: Dumbarton Oaks, 1982.

Boone, Elizabeth Hill, and Walter D. Mignolo, eds. *Writing Without Words: Alternative Literacies in Mesoamerica and the Andes*. Durham, N.C.: Duke University Press, 1994.

Boswell, John. *Same Sex Unions in Premodern Europe*. New York: Villard, 1994.

Bottereau, Georges, S.J. "Saint Joseph et les Jésuites français de la seconde moitié du XVIIe siècle." *Estudios josefinos* 41 (1987): 565–72.

Boyd, E. *Popular Arts of Spanish New Mexico*. Santa Fe: Museum of New Mexico, 1974.

Boyer, Richard. "Women, *La Mala Vida*, and the Politics of Marriage." In *Sexuality and Marriage in Colonial Latin America*, ed. Asunción Lavrin. Lincoln: University of Nebraska Press, 1988.

———. *Lives of the Bigamists: Marriage, Family, and Community in Colonial Mexico*. Albuquerque: University of New Mexico Press, 1995.

Brandes, Stanley. *Metaphors of Masculinity: Sex and Status in Andalusian Folklore*. Philadelphia: University of Pennsylvania Press, 1980.

Branley, Brendan R. "Felipe de Jesús: Images and Devotions." M.A. thesis, University of New Mexico, 2000.

Broderick, Robert C., ed. *New Catholic Encyclopedia*. New York: McGraw-Hill, 1967–79.

———. *The Catholic Encyclopedia*. New York: Thomas Nelson, 1986.

Brooks, Joseph Carter. "The Pasos of Valladolid: A Study in Seventeenth-Century Spanish Sculpture." Ph.D. diss., University of Chicago, 1974.

Broude, Norma, and Mary D. Garrard, eds. *The Expanding Discourse: Feminism and Art History*. New York: HarperCollins, 1992.

Brown, Jonathan. *Murillo and His Drawings*. Princeton, N.J.: Princeton University Press, 1976.

———. *Images and Ideas in Seventeenth-Century Spanish Painting*. Princeton, N.J.: Princeton University Press, 1978.

———. *El Greco of Toledo*. Exh. cat. Toledo, Ohio: Toledo Museum of Art, 1982.

———. "Patronage and Piety: Religious Imagery in the Art of Francisco de Zurbarán." In *Zurbarán*,

ed. Jeannine Baticle. Exh. cat. New York: Metropolitan Museum of Art, 1987.

———. *Francisco de Zurbarán*. New York: Harry N. Abrams, 1991.

———. *The Golden Age of Painting in Spain*. New Haven, Conn., and London: Yale University Press, 1991.

———. *Painting in Spain, 1500–1700*. Pelican History of Art. New Haven, Conn., and London: Yale University Press, 1998.

Brown, Jonathan, and Richard G. Mann. *Spanish Painting of the Fifteenth through Nineteenth Centuries*. Cambridge, England: Cambridge University Press, 1990.

Brown, Peter. *The Cult of the Saints: Its Rise and Function in Latin Christianity*. Chicago: University of Chicago Press, 1981.

Bryson, Norman. *Vision and Painting: The Logic of the Gaze*. New Haven, Conn., and London: MacMillan, 1983.

Burke, Marcus B. *Pintura y escultura en Nueva España: el Barroco*. Mexico City: Grupo Azabache, 1992.

———. *Treasures of Mexican Colonial Painting: The Davenport Museum of Art*. Santa Fe: Museum of New Mexico Press, 1998.

Burke, Peter. *Popular Culture in Early Modern Europe*. New York: Harper and Row, 1978.

Burkhart, Louise M. *Holy Wednesday: A Nahua Drama from Early Colonial Mexico*. Philadelphia: University of Pennsylvania Press, 1996.

———. "Mexica Women on the Home Front: Housework and Religion in Aztec Mexico." In *Indian Women of Early Mexico*, ed. Susan Schroeder, Stephanie Wood, and Robert Hackett. Norman: University of Oklahoma Press, 1997.

Bustamente García, Agustín. "Papeletas de arte castellano. Juan de Porres y Giraldo de Merlo en Avila. El convento de San José." *Universidad de Valladolid boletín del seminario de estudios de arte y arqueología* 36 (1970): 507–13.

Butler, Judith. *Gender Trouble: Feminism and the Subversion of Identity*. 10th anniversary ed. New York: Routledge, 1999.

Buzy, Denis, T.R.P. *Saint Joseph*. Paris: École, 1953.

Bynum, Caroline Walker. *Jesus as Mother: Studies in the Spirituality of the High Middle Ages*. Berkeley and Los Angeles: University of California Press, 1982.

———. "The Body of Christ in the Later Middle Ages: A Reply to Leo Steinberg." *Renaissance Quarterly* 39 (1986): 399–439.

———. *Holy Feast and Holy Fast: The Religious Significance of Food to Medieval Women.* Berkeley and Los Angeles: University of California Press, 1987.

Callaway, Carol H. "Pre-Columbian and Colonial Mexican Images of the Cross: Christ's Sacrifice and the Fertile Earth." *Journal of Latin American Lore* 16 (1990): 199–231.

Calvo, Thomas. "The Warmth of the Hearth: Seventeenth-Century Guadalajara Families." In *Sexuality and Marriage in Colonial Latin America*, ed. Asunción Lavrin. Lincoln: University of Nebraska Press, 1988.

Canal, José María, C.M.F. "Investigación sobre el matrimonio virginal de José y María en la teología de los siglos XIV, XV y XVI." *Estudios josefinos* 8 (1954): 39–43.

———. "San José Corredentor: Estudio positivo. Desde los orígenes hasta el siglo XIII." *Estudios josefinos* 11 (1957): 197–214.

Canal Sánchez, José María. "La devoción a San José en la villa de Gijón." *Estudios josefinos* 24 (1970): 227–33.

———. "Doctrina sobre San José en los autores latinos de los siglos VIII–XII: Desde Beda hasta Pedro Lombardo." *Estudios josefinos* 29 (1975): 15–58.

Canals Vidal, Francisco. "Interpretaciones patrísticas sobre Lucas 3, 23 en el orígen del término 'padre putativo.'" *Estudios josefinos* 43 (1989): 23–66.

Cañedo-Argüelles Gallastegui, Cristina. "La influencia de las normas artísticas de Trento en los tratadistas españoles del siglo XVII." *Revista de ideas estéticas* 32 (1974): 238–39.

Cano Navas, María Luisa. *El Convento de San José del Carmen de Sevilla. Las Teresas. Estudio histórico-artístico.* Seville, Spain: Universidad de Sevilla, 1984.

Carasa Soto, Pedro. *Historia de la beneficiencia en Castilla y León: Poder y pobreza en la sociedad castellana.* Valladolid, Spain: Universidad de Valladolid, 1991.

Carmona García, Juan Ignacio. *El sistema de la hospitalidad pública en la Sevilla del Antiguo Régimen.* Seville, Spain: Diputación Provincial de Sevilla, 1979.

Caro Baroja, Julio. "Honour and Shame: A Historical Account of Several Conflicts." Trans. Mrs. R. Johnson. In *Honour and Shame: The Values of Mediterranean Society*, ed. J. G. Peristiany. Chicago: University of Chicago Press, 1966.

———. *Las formas complejas de la vida religiosa: Religión, sociedad y carácter en la España de los siglos XVI y XVII.* Madrid: Akal, 1978.

Carrasco, José Antonio, O.C.D. "Devociones josefinas no litúrgicas." *Estudios josefinos* 24 (1970): 161–88.

Carrillo Ojeda, José Carlos, M.J. "San José en la Nueva España del siglo XVII." *Estudios josefinos* 41 (1987): 627–53.

———. "Presencia de San José en México en el siglo XVIII." *Estudios josefinos* 45 (1991): 637–64.

———. "Un orgullo de la Catedral de Saltillo, la ciudad josefina del estado de Coahuila (México)." *El Propagador de la devoción al señor San José* 126 (1997): 8–11.

Casey, James. "Le mariage clandestin en Andalousie à l'époque moderne." In *Autour des Parentés en Espagne aux XVIe et XVIIe siècles*, ed. Augustin Redondo. Paris: Publications de la Sorbonne, 1987.

Castro Mantecón, Javier. *Miguel Cabrera, pintor oaxaqueño del siglo XVIII.* Mexico City: Instituto Nacional de Antropología e Historia, 1958.

Catedral de México: Patrimonio artístico y cultural. Mexico City: Secretaría de Desarrollo Urbano y Ecología, 1985.

Chacón Jiménez, Francisco, ed. *Historia social de la familia en España. Aproximación a los problemas de familia, tierra y sociedad en Castilla (ss. XV–XIX).* Alicante, Spain: Instituto de Cultura "Juan Gil-Albert," 1990.

Chacón Jiménez, Francisco, and Juan Hernández Franco, eds. *Poder, familia y consanguinidad en la España del Antiguo Régimen.* Barcelona: Anthropos, 1992.

Chambers, Iain, and Lidia Curtis, eds. *The Post-Colonial Question: Common Skies, Divided Horizons.* London: Routledge, 1996.

Chauvet, Fidel de Jesús. *Los Franciscanos y sus construcciones en Tlaxcala.* Mexico City: Fray Junípero Serra, 1950.

Checa Cremades, Fernando. *Pintura y escultura del Renacimiento en España, 1450–1600.* Madrid: Cátedra, 1983.

Chodorow, Nancy. *The Reproduction of Mothering: Psychoanalysis and the Sociology of Gender.* Berkeley and Los Angeles: University of California Press, 1978.

Chorpenning, Joseph F., ed. *Patron Saint of the New World: Spanish American Colonial Images of St. Joseph.* Philadelphia: Saint Joseph's University Press, 1992.

———. *The Holy Family as Prototype of the Civilization of Love: Images from the Viceregal Americas.* Philadelphia: Saint Joseph's University Press, 1996.

———. *Christopher Blancus' Engravings for Jerónimo Gracián's Summary of the Excellencies of St. Joseph (1597)*, Philadelphia: Saint Joseph's University Press, 1996.

Christian, William A., Jr. *Apparitions in Late Medieval and Renaissance Spain*. Princeton, N.J.: Princeton University Press, 1981.

———. *Local Religion in Sixteenth-Century Spain*. Princeton, N.J.: Princeton University Press, 1981.

Chueca Goitia, Fernando, et al. *La catedral de Sevilla*. Seville, Spain: Guadalquivir, 1985.

Cifuentes, José Antonio, O.F.M. "Influencias franciscanas en la devoción de Santa Teresa de Jesús a San José." *Estudios josefinos* 18 (1963): 251–300.

Clifford, James. *The Predicament of Culture: Twentieth-Century Ethnography, Literature, and Art*. Cambridge, Mass.: Harvard University Press, 1988.

Colegio de San Ildefonso. *Arte y mística del barroco*. Exh. cat. Mexico City: Colegio de San Ildefonso, 1994.

Connell, R. W. *Masculinities*. Berkeley and Los Angeles: University of California Press, 1995.

Contreras, Jaime. "Aldermen and Judaizers: Cryptojudaism, Counter-Reformation, and Local Power." In *Culture and Control in Counter-Reformation Spain*, ed. Anne J. Cruz and Mary Elizabeth Perry. Hispanic Issues, no. 7. Minneapolis: University of Minnesota Press, 1992.

Corella Suárez, María del Pilar. *Arquitectura religiosa de los siglos XVII y XVIII en la provincia de Madrid. Estudio y documentación del partido judicial de Getafe*. Madrid: Consejo Superior de Investigaciones Científicas, Instituto de Estudios Madrileños, 1979.

Cortés Castellanos, Justino. *El catecismo en pictogramas de Fray Pedro de Gante*. Madrid: Fundación Universitaria Española, 1987.

Crow, Thomas E. *Painters and Public Life in Eighteenth-Century Paris*. New Haven, Conn., and London: Yale University Press, 1985.

Cruz, Anne J., and Mary Elizabeth Perry, eds. *Culture and Control in Counter-Reformation Spain*. Hispanic Issues, no. 7. Minneapolis: University of Minnesota Press, 1992.

Cummins, Tom. "Representation in the Sixteenth Century and the Colonial Image of the Inca." In *Writing Without Words: Alternative Literacies in Mesoamerica and the Andes*, ed. Elizabeth Hill Boone and Walter D. Mignolo. Durham, N.C.: Duke University Press, 1994.

———. "From Lies to Truth: Colonial Ekphrasis and the Act of Crosscultural Translation." In *Reframing the Renaissance: Visual Culture in Europe and Latin American 1450–1650*, ed. Claire Farago. New Haven, Conn., and London: Yale University Press, 1995.

———. *Toasts with the Inca: Andean Abstraction and Colonial Images on Quero Vessels*. Ann Arbor: University of Michigan Press, 2002.

Damisch, Hubert. "Semiotics and Iconology." In *The Tell-Tale Sign: A Survey of Semiotics*, ed. Thomas A. Sebeok. Lisse: Peter de Ridder, 1975.

Darby, Delphine Fitz. *Francisco Ribalta and His School*. Cambridge, Mass.: Harvard University Press, 1938.

Davis, Natalie Z. "Some Tasks and Themes in the Study of Popular Religion." In *The Pursuit of Holiness in Late Medieval and Renaissance Religion*, ed. Charles Trinkaux and Heiko A. Oberman. Leiden, The Netherlands: Brill, 1974.

Dean, Carolyn. *Inka Bodies and the Body of Christ: Corpus Christi in Colonial Cuzco, Peru*. Durham, N.C.: Duke University Press, 1999.

Dean, Carolyn, and Dana Leibsohn. "Hybridity and Its Discontents: Considering Visual Culture in Colonial Spanish America." *Colonial Latin American Review* 12:1 (2003): 5–35.

Dedieu, Jean Pierre. "'Christianization' in New Castile: Catechism, Communion, Mass, and Confirmation in the Toledo Archbishopric, 1540–1650." In *Culture and Control in Counter-Reformation Spain*, ed. Anne J. Cruz and Mary Elizabeth Perry. Hispanic Issues, no. 7. Minneapolis: University of Minnesota Press, 1992.

Defourneaux, Marcelin. *Daily Life in Spain in the Golden Age*. Trans. Newton Branch. London: George Allen and Unwin, 1970.

Deleito y Piñuela, José. *La vida religiosa española bajo el cuarto Felipe: Santos y pecadores*. 2d ed. Madrid: Espasa-Calpe, 1963.

———. *La mujer, la casa y la moda*. 3d ed. Madrid: Espasa-Calpe, 1966.

———. *La mala vida en la España de Felipe IV*. Madrid: Espasa-Calpe, 1967.

Delumeau, Jean. *Catholicism between Luther and Voltaire: A New View of the Counter-Reformation*. Trans. Jeremy Moiser. Philadelphia: Westminster, 1977.

Domínguez Ortíz, Antonio. *La sociedad española en el siglo XVII*. Madrid: Instituto Balmes de Sociología, 1963.

———. *Instituciones y sociedad en la España de los Austrias*. Barcelona, Spain: Ariel, 1985.

————. *La sociedad española en el siglo XVII: II. El Testamento eclesiástico*. Granada, Spain: Consejo Superior de Investigaciones Científicas and Universidad de Granada, 1992.

Donahue-Wallace, Kelly. "Print Sources of New Mexican Colonial Hide Paintings." *Anales del Instituto de Investigaciones Estéticas* 68 (1996): 46–64.

————. "Prints and Printmakers in Viceregal Mexico City, 1600–1800." Ph.D. diss., University of New Mexico, 2000.

Dorival, Bernard. *Philippe de Champaigne 1602–1674: La vie, l'œuvre, et le catalogue raisonné de l'œuvre*. Paris: Léonce Laget, 1976.

Duncan, Carol. "Happy Mothers and Other New Ideas in French Art." *Art Bulletin* 55 (1973): 570–83.

Dupont-Bouchat, Marie-Sylvie. "Saint Joseph en Belgique au XVIIe siècle: L'exemple des Carmes Namurois." *Estudios josefinos* 41 (1987): 573–88.

Dupré, Louis, and Donald E. Saliers, eds. *Christian Spirituality: Post-Reformation and Modern*. New York: Crossroads, 1989.

Dusserre, Joseph. "Les origines de la dévotion à Saint Joseph." *Cahiers de Josephologie* 1 (1953): 23–54.

————. "Les origines de la dévotion à Saint Joseph (suite et fin)." *Cahiers de Josephologie* 2 (1954): 5–30.

Efrén de la Madre de Dios, O.C.D., and Otger Steggink, O.C. "Posibles influencias josefinas ambientales en Santa Teresa." *Estudios josefinos* 18 (1963–64): 243–50.

————. *Santa Teresa y su tiempo*. 2 vols. Salamanca, Spain: Universidad Pontificia de Salamanca, 1982–84.

Egido, Teófanes. "Contribución a la historia de la espiritualidad española: San José en los últimos tiempos de la Inquisición." *Estudios josefinos* 22 (1968): 49–61.

————. "La cofradía de San José y los niños expósitos de Valladolid (1540–1757)." *Estudios josefinos* 53 (1973): 77–100.

————. "Religiosidad popular del siglo XVIII: San José en los pliegos de cordel." *Estudios josefinos* 30 (1976): 73–110.

————. "Ambiente josefino en el tiempo de Santa Teresa." *Estudios josefinos* 36 (1982): 5–24.

————. "La devoción a San José en la Ilustración española." *Estudios josefinos* 45 (1991): 437–49.

Elliott, J. H. *Imperial Spain 1469–1716*. New York: New American Library, 1963.

————. *The Count-Duke of Olivares: The Statesman in an Age of Decline*. New Haven, Conn., and London: Yale University Press, [1986] 1988.

————. *Spain and Its World 1500–1700*. New Haven, Conn., and London: Yale University Press, 1989.

Engass, Robert, and Jonathan Brown. *Italy and Spain 1600–1750: Sources and Documents*. Englewood Cliffs, N.J.: Prentice Hall, 1970.

Enrique del Sagrado Corazón, O.C.D. "Estudios de historia josefina: Temas sobre San José en la Inquisición Española." *Estudios josefinos* 7 (1953): 103–11.

————. "Estudio directo del matrimonio de San José y de la Virgen." *Estudios josefinos* 8 (1954): 147–69.

————. "Estudios de historia josefina: Temas sobre San José en la Inquisición española: Juicio Inquisitorial contra una obra de devoción a San José." *Estudios josefinos* 10 (1956): 201–4.

Enrique del Sagrado Corazón, O.C.D., and Pedro de la Inmaculada, O.C.D. "La Doctrina de San Bernardo sobre San José, esposo de María." *Estudios josefinos* 3 (1949): 189–223.

————. "La Doctrina de San Jerónimo sobre San José, esposo de María." *Estudios josefinos* 3 (1949): 46–80.

————. "La Doctrina de San Agustín sobre San José." *Estudios josefinos* 4 (1950): 150–87.

Fane, Diana, ed. *Converging Cultures: Art and Identity in Spanish America*. Exh. cat. New York: The Brooklyn Museum, 1996.

Farago, Claire, ed. *Refiguring the Renaissance: Visual Culture in Europe and Latin America 1450–1650*. New Haven, Conn., and London: Yale University Press, 1995.

Felton, Craig McFayden. "Jusepe de Ribera. A Catalogue Raisonné." Ph.D. diss., University of Pittsburgh, 1971.

Fernández, Simón Tomás, O.C.D. "Las 'Josefinas' de Bernardino de Laredo (1535) y de Andrés de Soto (1593), Franciscanos." *Estudios josefinos* 31 (1977): 223–54.

Fernández Álvarez, Manuel. *La sociedad española del Renacimiento*. Salamanca, Spain: Anaya, 1970.

————. *La sociedad española en el siglo de oro*. Madrid: Nacional, 1983.

Fernández Frontela, Luis J. "San José: arte y catequesis." *Estudios josefinos* 43 (1989): 227–44.

Ferrand, Michel, O.C.D. "L'iconographie de Saint Joseph dans les couvents des Carmes et des Carmélites de France au XVIIe siècle." *Estudios josefinos* 41 (1987): 743–60.

Ferrando Roig, Juan. *Iconografía de los santos*. Barcelona, Spain: Omega, 1950.

Filas, Francis L., S.J. *The Man Nearest to Christ. Nature and Historic Development of the Devotion to St. Joseph.* Milwaukee, Wisc.: Bruce, 1944.

———. *Joseph and Jesus: A Theological Study of Their Relationship.* Milwaukee, Wisc.: Bruce, 1952.

Flynn, Maureen. *Sacred Charity: Confraternities and Social Welfare in Spain, 1400–1700.* Ithaca, N.Y.: Cornell University Press, 1989.

Fombuena, José. *Las fallas de Valencia.* León, Spain: Everest, 1971.

Fortunato de Jesús Sacramentado, O.C.D. "Labor josefina del P. Jerónimo Gracián de la Madre de Dios." *Estudios josefinos* 4 (1950): 188–208.

———. "Santa Teresa de Jesús y su espíritu josefino." *Estudios josefinos* 7 (1953): 9–54.

———. "San José en el Carmen Descalzo español en su primer siglo." *Estudios josefinos* 18 (1963–64): 355–408.

Foster, Marjory Bolger. "The Iconography of St. Joseph in Netherlandish Art, 1400–1500." 2 vols. Ph.D. diss., University of Kansas, 1978.

Foucault, Michel. *Madness and Civilization: A History of Insanity in the Age of Reason.* Trans. Richard Howard. New York: Vintage, 1973; Random House, 1988.

———. *Discipline and Punish: The Birth of the Prison.* New York: Pantheon, 1977.

———. *The History of Sexuality.* Trans. Robert Hurley. New York: Random House, 1978.

Fraenger, Wilhelm. *Hieronymus Bosch.* New York: G. P. Putnam's Sons, 1983.

Fraser, Valerie. *The Architecture of Conquest: Building in the Viceroyalty of Peru 1535–1635.* Cambridge, England: Cambridge University Press, 1990.

Freedberg, David. *The Power of Images: Studies in the History and Theory of Response.* Chicago: University of Chicago Press, 1989.

Friedmann, Herbert. *The Symbolic Goldfinch: Its History and Significance in European Devotional Art.* Washington, D.C.: Pantheon, 1946.

Fuentes Aguirre, J. *La Catedral del Santiago de Saltillo.* Saltillo, Mexico: Amigos del Patrimonio Cultural de Saltillo, 1991.

Gabriel de la Cruz, O.C.D. "Los oficios litúrgicos del Patrocinio de San José para los Carmelitas Descalzos de España; origen, autor y texto." *Estudios josefinos* 11 (1957): 92–115.

Gállego, Julian. *Visión y símbolos en la pintura española del Siglo de Oro.* Madrid: Cátedra, 1972.

García Canclini, Néstor. *Hybrid Cultures: Strategies for Entering and Leaving Modernity.* Minneapolis: University of Minnesota Press, 1995.

García Chico, Esteban. "La Cofradía de San José de los maestros entalladores." *Estudios josefinos* 7 (1953): 235–57.

García Guinea, Miguel Ángel. "La representación de San José a través de la pintura italiana." *Estudios josefinos* 1 (1947): 65–85.

———. "San José en el arte barroco español." *Estudios josefinos* 2 (1948): 187–216.

———. "San José en la vida y en la iconografía medieval." *Estudios josefinos* 2 (1948): 76–110.

———. "Algunas representaciones barrocas de San José: Rubens y Tiepolo." *Estudios josefinos* 3 (1949): 237–60.

———. "San José en la pintura germana gótico-renacentista." *Estudios josefinos* 3 (1949): 81–108.

———. "Algunas representaciones hispano-americanas de San José." *Estudios josefinos* 4 (1950): 209–36.

———. "San José visto por los artistas indios y africanos." *Estudios josefinos* 6 (1952): 196–212.

García Miralles, O.P.M. "Enseñanzas josefinas de los grandes maestros del siglo de oro de la escolástica." *Estudios josefinos* 29 (1975): 59–75.

———. "Enseñanzas josefinas de los grandes maestros del siglo de oro de la escolástica: Conclusión." *Estudios josefinos* 29 (1975): 147–77.

Garrido Bonaño, Manuel, O.S.B. "Himnos y secuencias en honor de San José desde el siglo XIV al siglo XVI." *Estudios josefinos* 33 (1979): 43–57.

Gasca-Queirazza, S.I., Giuliano. "San Giuseppe nelle 'Meditationes Vitae Christi' dell Pseudo-Bonaventura. Loro diffusione nei secoli XV–XVI. Confronto con altri testi in ambito italiano." *Estudios josefinos* 31 (1977): 435–45.

Gauthier, Roland, C.S.C. "Présence de Saint Joseph dans les éditions incunables." *Estudios josefinos* 31 (1977): 79–105.

———. "La proclamation de saint Joseph comme patron de l'Église." *Cahiers de Josephologie* 43 (1995): 189–95.

Gaya Nuño, Juan Antonio. *Claudio Coello.* Madrid: Instituto Diego Velázquez, 1957.

———. *Vida de Acisclo Antonio Palomino.* 2d ed. Córdoba, Spain: Diputación Provincial, 1981.

Geertz, Clifford. *The Interpretation of Cultures: Selected Essays.* New York: Basic Books, 1973.

Gestoso y Pérez, José. *Museo de pinturas de Sevilla.* Barcelona, Spain: Hijos de J. Thomas, 1927.

Giamberardini, Gabriele. *San Giuseppe nella tradizione copta*. Cairo: Centro francescano di studi orientali cristiani, 1966.

Gibson, Gail McMurray. "Saint Anne and the Religion of Childbed: Some East Anglian Texts and Talismans." In *Interpreting Cultural Symbols: Saint Anne in Late Medieval Society*, ed. Kathleen Ashley and Pamela Sheingorn. Athens: University of Georgia Press, 1990.

Goldstein, Carl. "Rhetoric and Art History in the Italian Renaissance and Baroque." *Art Bulletin* 73 (1991): 641–52.

Gómez-Moreno, María Elena. *Alonso Cano: Estudio y catálogo de la exposición celebrada en Granada en junio de 1954*. Exh. cat. Granada, Spain: Museo de Bellas Artes, 1954.

González, Armando. "San José en la devoción neogalaica del siglo XVIII." *Estudios josefinos* 45 (1991): 665–72.

González, Félix Antonio. "San José en el villancico español." *Estudios josefinos* 1 (1947): 24–33.

González Hernández, Vicente. *Jusepe Martínez (1600–1682)*. Zaragoza, Spain: Museo e Instituto de Humanidades "Camón Aznar," 1981.

González Rivas, Severino, S.J. "San José en la teología del P. Francisco Suárez." *Estudios josefinos* 2 (1948): 156–63.

González Zubieta, Rafael. *Vida y obra del artista andaluz Antonio Mohedano de la Gutierra (1563?–1620)*. Córdoba, Spain: Diputación Provincial, 1981.

Goodman, W. L. *The History of Woodworking Tools*. London: G. Bell and Sons, 1964.

Goody, Jack. *The Development of the Family and Marriage in Europe*. Cambridge, England: Cambridge University Press, 1983.

Gottlieb, Beatrice. *The Family in the Western World from the Black Death to the Industrial Age*. Oxford: Oxford University Press, 1993.

Grande, Juan. "Ambiente artístico josefino de Ávila." *Estudios josefinos* 19 (1965): 109–13.

Greer, Allan, and Jodi Bilinkoff, eds. *Colonial Saints: Discovering the Holy in the Americas, 1500–1800*. New York: Routledge, 2002.

Gregorio de Jesús Crucificado, O.C.D. "San José Corredentor (Estudio directo)." *Estudios josefinos* 11 (1957): 215–27.

Grossberg, Lawrence, Cary Nelson, and Paula Treichler, eds. *Cultural Studies*. New York: Routledge, 1992.

Grosz, Elizabeth. *Volatile Bodies: Toward a Corporeal Feminism*. Bloomington: University of Indiana Press, 1994.

Guinard, Paul. "Zurbarán en la exposición de Paris." *Goya* 54 (1963): 355–64.

———. "Aportaciones críticas de obras zurbaranescas." *Archivo español de arte* 37 (1964): 115–28.

Guindon, S.M.M., Henri-M. "Saint Joseph d'après Luther." *Estudios josefinos* 31 (1977): 353–70.

Gutiérrez, Ramón A. *When Jesus Came, the Corn Mothers Went Away: Marriage, Sexuality, and Power in New Mexico, 1500–1846*. Stanford, Calif.: Stanford University Press, 1991.

Gutiérrez Haces, Juana, et al. *Cristóbal de Villalpando: circa 1649–1714*. Mexico City: Instituto de Investigaciones Estéticas, 1997.

Hahn, Cynthia. "Joseph as Ambrose's 'Artisan of the Soul' in the *Holy Family in Egypt* by Albrecht Dürer." *Zeitschrift für Kunstgeschichte* 47 (1984): 515–22.

———. "'Joseph Will Perfect, Mary Enlighten and Jesus Save Thee': The Holy Family as Marriage Model in the Mérode Triptych." *Art Bulletin* 68 (1986): 54–66.

Hall, James. *Dictionary of Subjects and Symbols in Art*. Rev. ed. New York: Harper and Row, 1979.

Hall, Stuart. "When Was the Post-Colonial? Thinking at the Limit." In *The Post-Colonial Question: Common Skies, Divided Horizons*, ed. Iain Chambers and Lidia Curtis. London: Routledge, 1996.

Hamilton, Alistair. *Heresy and Mysticism in Sixteenth-Century Spain: The Alumbrados*. Toronto: University of Toronto Press, 1992.

Hamilton, Earl J. "The Decline of Spain." *Economic History Review* 8 (1938): 168–79.

Hareven, Tamara, and Andrejs Plakans, eds. *Family History at the Crossroads*. Princeton, N.J.: Princeton University Press, 1987.

Hartt, Frederick. *History of Italian Renaissance Art: Painting, Sculpture, Architecture*. 3d ed. New York: Harry N. Abrams, 1987.

Heliodoro Valle, Rafael. *Santiago en América*. 1946. Reprint, Querétaro, Mexico: Gobierno del Estado de Querétaro, 1996.

Herlihy, David. "The Family and Religious Ideologies in Medieval Europe." In *Family History at the Crossroads*, ed. Tamara Hareven and Andrejs Plakans. Princeton, N.J.: Princeton University Press, 1987.

———. "Tuscan Names, 1200–1530." *Renaissance Quarterly* 41 (1988): 561–82.

Hernández Díaz, José. "Juan de Mesa, imaginero andaluz: Interpretaciones iconográficas." *Goya* 111 (1972): 134–45.

———. *Juan Martínez Montañés (1563–1649)*. Seville, Spain: Guadalquivir, 1987.

Herrán, Laurentino María. "El matrimonio de San José y la Virgen anticipo de la Iglesia, bodas del Cordero." *Estudios josefinos* 19 (1965): 99–107.

———. "Aportación de la poesía española a la teología de San José." *Estudios josefinos* 29 (1975): 211–30.

———. "San José en las vidas de Cristo y de María del siglo XVI." *Estudios josefinos* 31 (1977): 447–75.

———. "La infancia de Jesús según San Mateo en el villancico y poesía popular de España." *Estudios josefinos* 32 (1978): 37–59.

———. "El Maestro José de Valdivielso y su poema 'Vida, Excelencias y Muerte del Glorioso Patriarca y Esposo de Nuestra Señora San Josef.'" *Estudios josefinos* 35 (1981): 421–88.

———. "La familia de Jesús y los años que vivió a la sombra de San José hasta su muerte en los poetas y dramaturgos del siglo XVI español." *Estudios josefinos* 37 (1983): 147–214.

———. "Rasgos de la espiritualidad josefina según la obra de Valdivielso "Vida de San José"." *Estudios josefinos* 39 (1985): 67–88.

———. "San José en los sermones de Fray Alonso de la Cruz." *Estudios josefinos* 39 (1985): 163–70.

———. "San José en poetas no estudiados." *Estudios josefinos* 40 (1986): 55–89.

Hibbard, Howard. *Poussin: The Holy Family on the Steps*. New York: Viking, 1974.

———. *Caravaggio*. New York: Harper and Row, 1983.

Higinio de Santa Teresa, O.C.D. "Devoción al Patriarca San José en la Villa de Marquina (Vizcaya)." *Estudios josefinos* 23 (1969): 231–62.

Hospital de los Venerables Sacerdotes. *La pintura sevillana de los siglos de oro*. Exh. cat. Seville, Spain: Ministerio de Cultura, 1991.

Howard, George Elliott. *A History of Matrimonial Institutions*. Vol. 1. Chicago: University of Chicago Press, Callaghan, 1904; London: T. Fisher Unwin, 1904.

d'Hulst, R. A. "*Jordaens Drawings*: Supplement I." *Master Drawings* 18 (1980): 360–69.

Iglesias, Ángel Luis. "Josefología de Francisco de Toledo (1534?–1596)." *Estudios josefinos* 31 (1977): 157–81.

Joaquín de la Sagrada Familia, O.C.D. "Según la tradición, entre San José y la Virgen existió un auténtico y verdadero matrimonio rato." *Estudios josefinos* 8 (1954): 26–38.

John XXIII, Pope. "Juan XXIII: San José, Patrono del Concilio Vaticano II." *Estudios josefinos* 15 (1961): 189–95.

Johnson, Lyman L., and Sonya Lipsett-Rivera, eds. *The Faces of Honor in Colonial Latin America: Sex, Shame, and Violence*. Albuquerque: University of New Mexico Press, 1998.

José Antonio del Niño Jesús, O.C.D. "San José, fundador de la Reforma Teresiana." *Estudios josefinos* 18 (1963–64): 339–53.

———. "Fray Jerónimo Gracián de la Madre de Dios y su 'Summario de las excelencias del glorioso S. Joseph, esposo de la virgen María,' o 'Josefina' (1597)." *Estudios josefinos* 31 (1977): 295–322.

José de Jesús María. "En torno a una encíclica josefina centenaria." *Estudios josefinos* 43 (1989): 175–97.

Josserand, J. Kathryn, and Karen Dakin, eds. *Smoke and Mist: Mesoamerican Studies in Memory of Thelma D. Sullivan*. Oxford: Oxfordshire, 1988.

Juan Bosco de Jesús, O.C.D. "Presencia vivo de San José en el Primitivo Carmelo Español." *Estudios josefinos* 36 (1982): 239–82.

———. "San José en los devocionarios españoles del siglo XVIII." *Estudios josefinos* 45 (1991): 405–35.

Justiniano y Martínez, Manuel. *El Hospital de las Cinco Llagas (Central) de Sevilla*. Seville, Spain: Crónica Oficial de la Provincia, 1963.

Kaftal, George. *Iconography of the Saints in Italian Painting from Its Beginnings to the Early Fifteenth Century*. 4 vols. Florence: Sansoni, 1958–85.

Kamen, Henry. *Spain in the Later Seventeenth Century, 1650–1700*. London: Longman, 1980.

———. *Inquisition and Society in Spain in the Sixteenth and Seventeenth Centuries*. Bloomington: University of Indiana, 1985.

Kellogg, Susan. *Law and the Transformation of Aztec Culture, 1500–1700*. Norman: University of Oklahoma Press, 1995.

———. "From Parallel and Equivalent to Separate but Unequal: Tenochca Mexica Women, 1500–1700." In *Indian Women of Early Mexico*, ed. Susan Schroeder, Stephanie Wood, and Robert Hackett. Norman: University of Oklahoma Press, 1997.

Kertzer, David, and Caroline Brettell. "Advances in Italian and Iberian Family History." In *Family History at the Crossroads*, ed. Tamara Hareven and Andrejs Plakans. Princeton, N.J.: Princeton University Press, 1987.

Kimbell Art Museum. *Jusepe de Ribera lo Spagnoletto*. Exh. cat. Fort Worth, Tex.: Kimbell Art Museum, 1982.

Kinkead, Duncan. "Juan de Valdés Leal (1622–1690): His Life and work." 3 vols. Ph.D. diss. University of Michigan, 1976.

———. "Bartolomé Esteban Murillo: New Documentation." *Burlington Magazine* 121 (1979): 35–37.

Klapisch-Zuber, Christiane. *Women, Family, and Ritual in Renaissance Italy*. Trans. Lydia Cochrane. Chicago and London: University of Chicago Press, 1985.

Klein, Cecelia F. "Who Was Tlaloc?" *Journal of Latin American Lore* 6 (1980): 155–204.

———, ed. *Gender in Pre-Hispanic America: A Symposium at Dumbarton Oaks, 12 and 13 October 1996.* Washington, D.C.: Dumbarton Oaks, 2001.

Knipping, John B. *Iconography of the Counter-Reformation in the Netherlands: Heaven on Earth.* 2 vols. Leiden, The Netherlands: A. W. Sijthoff, 1974.

Kowal, David M. *Ribalta y los Ribaltescos: La evolución del estilo barroco en Valencia.* Trans. Manuel Lloris. Valencia, Spain: Diputación Provincial de Valencia, 1985.

Kristeva, Julia. *Tales of Love.* Trans. Leon S. Roudiez. New York: Columbia University Press, 1987.

Kubler, George. "On the Colonial Extinction of the Motifs of Pre-Columbian Art." In *Essays in Pre-Columbian Art and Archaeology*, ed. S. K. Lothrop et al. Cambridge, Mass: Harvard University Press, 1961.

Kubler, George, and Martin Soria. *Art and Architecture in Spain and Portugal and Their American Dominions 1500–1800.* Pelican History of Art. Baltimore: Penguin, 1959.

Lafaye, Jacques. *The Virgin and Quetzalcóatl: The Formation of Mexican National Consciousness, 1531–1813.* Trans. Benjamin Keen. Chicago: University of Chicago Press, 1976.

Lago, Julio. "Dos panegíricos de Bossuet sobre San José." *Estudios josefinos* 3 (1949): 109–25.

———. "Dos panegíricos de Bossuet sobre San José: Continuación." *Estudios josefinos* 3 (1949): 261–66.

———. "Dos panegíricos de Bossuet sobre San José." *Estudios josefinos* 4 (1950): 110–17.

———. "Dos panegíricos de Bossuet sobre San José: Conclusión." *Estudios josefinos* 4 (1950): 237–50.

Lalonde, Marcel, C.S.C. "La signification mystique du mariage de Joseph et de Marie." *Cahiers de Josephologie* 19 (1971): 548–63.

———. "Deux ouvrages de frères mineurs français sur Saint Joseph: Quentin Rabineau et Olivier Conrard." *Estudios josefinos* 31 (1977): 501–22.

Lang, Beral, ed. *The Concept of Style.* Philadelphia: University of Pennsylvania Press, 1979.

Lara, Jaime. *City, Temple, Stage: Eschatological Architecture and Liturgical Theatrics in New Spain.* Notre Dame, Ind.: University of Notre Dame Press, 2004.

LaRossa, Ralph. *The Modernization of Fatherhood: A Social and Political History.* Chicago: University of Chicago Press, 1997.

Larquié, Claude. "Amours légitimes et amours illégitimes à Madrid au XVIIe siècle." In *Autour des Parentés en Espagne aux XVIe et XVIIe siècles*, ed. Augustin Redondo. Paris: Sorbonne, 1987.

Lavrin, Asunción, ed. *Sexuality and Marriage in Colonial Latin America.* Lincoln: University of Nebraska Press, 1992.

Lees, Clare A., ed. *Medieval Masculinities: Regarding Men in the Middle Ages.* Minneapolis: University of Minnesota Press, 1994.

Leibsohn, Dana. "Colony and Cartography: Shifting Signs on Indigenous Maps of New Spain." In *Refiguring the Renaissance: Visual Culture in Europe and Latin America 1450–1650*, ed. Claire Farago. New Haven, Conn., and London: Yale University Press, 1995.

———. "Mapping Metaphors: Figuring the Ground of Sixteenth-Century New Spain." *Journal of Medieval and Early Modern Studies* 26:3 (1996): 497–523.

León, Imelda de, ed. *Calendario de fiestas populares.* Mexico City: Dirección General de Culturas Populares, 1988.

Levi d'Ancona, Mirella. *The Iconography of the Immaculate Conception in the Middle Ages and the Early Renaissance.* Monographs on Archaeology and the Fine Arts, no. 7. Princeton, N.J.: Princeton University Press, 1957.

Lippy, Charles H., Robert Choquette, and Stafford Poole. *Christianity Comes to the Americas, 1492–1776.* New York: Paragon House, 1992.

Llamas, Enrique, O.C.D. "Pedro de Bivero, S.J. (1572–1656) y su tratado sobre San José." *Estudios josefinos* 39 (1985): 171–97.

———. "La figura de San José en el 'Despertador Cristiano' de José de Barcia y Zambrana." *Estudios josefinos* 45 (1991): 451–76.

Llamas, Román, O.C.D. "San José en los predicadores españoles del siglo XVI." *Estudios josefinos* 31 (1977): 397–434.

———. "La paternidad de San José según el P. Raimundo Lumbier, carmelita." *Estudios josefinos* 39 (1985): 71–104.

———. "San José, patrono de la Iglesia en su tarea evangelizadora." *Estudios josefinos* 44 (1990): 231–44.

———. "San José en los predicadores españoles del siglo XVIII." *Estudios josefinos* 45 (1991): 477–503.

———. "San José evangelizador de América. Tema de un sermón barroco del siglo XVII." *Estudios josefinos* 46 (1992): 27–52.

Llamas-Martínez, Enrique. "Testimonio josefino de un catecismo anti-judío: Mss. en el British Museum (s. XVII)." *Estudios josefinos* 24 (1970): 215–26.

———. "San José en las genealogías de Jesús en la época del renacimiento. Nuevas soluciones." *Estudios josefinos* 31 (1977): 55–77.

Llamera, Bonifacio, O.P. "Singular paternidad de San José." *Estudios josefinos* 3 (1949): 151–88.

Llamera, Felipe G., O.P. "El matrimonio de María y José." *Estudios josefinos* 19 (1965): 53–87.

Lockhart, James. *The Nahuas after the Conquest: A Social and Cultural History of the Indians of Central Mexico, Sixteenth through Eighteenth Centuries.* Stanford, Calif.: Stanford University Press, 1992.

López Grigera, Luisa. "Cuestión de géneros y estilos en dos sonetos de Quevedo." In *Symbolae Pisanae: Studi in onore di Guido Mancini*, ed. Blanca Periñán and Francisco Guazzelli. 2 vols. Pisa, Italy: Giardini, 1989.

———. "Introducción a una lectura retórica de Cervantes: *El Quijote* a la luz de Hermógenes. I." *Salina* 5 (1990): 18–22.

———. "Introducción a una lectura retórica de Cervantes: *El Quijote* a la luz de Hermógenes. II." *Salina* 6 (1991): 34–40.

———. *La rétorica en la España del Siglo de Oro.* Salamanca, Spain: Universidad de Salamanca, 1994.

López Lara, Ramón. *El obispado de Michoacán en el siglo XVII: informe inédito de beneficios, pueblos y lenguas.* Morelia, Mexico: Fímax, 1973.

López Torrijos, Rosa. "Influencia del teatro en la iconografía de San Ildefonso." *Archivo español de arte* 51 (1978): 430–37.

Lozoya, Marqués de. "¿Un precedente de la Sagrada Familia del Pajarito?" *Archivo español de arte* 40 (1967): 83.

Lucinio del Santísimo Sacramento, O.C.D. "San José según cuatro versiones atrevidas del teatro religioso." *Estudios josefinos* 12 (1958): 3–35.

Luis, Ángel, C.S.S.R. "Mt 1–2 en Maldonado." *Estudios josefinos* 30 (1976): 41–70.

———. "Paternidad de San José en Francisco de Toledo y Juan de Maldonado." *Estudios josefinos* 39 (1985): 47–70.

Luján Muñoz, Luis. *Imágenes de Oro.* Guatemala City: G and T, 1993.

Luria, Keith P. "The Counter-Reformation and Popular Spirituality." In *Christian Spirituality: Post-Reformation and Modern*, ed. Louis Dupré and Donald E. Saliers. New York: Crossroads, 1989.

Lynch, John. *The Hispanic World in Crisis and Change, 1598–1700.* Oxford: Blackwell, 1992.

MacKay, Ruth. *The Limits of Royal Authority: Resistance and Obedience in Seventeenth-Century Castile.* Cambridge: Cambridge University Press, 1999.

Mâle, Émile. *L'art religieux de la fin du XVIe siècle, du XVIIe siècle et du XVIIIe siècle: Étude sur l'iconographie après le Concile de Trente.* Paris: Armand Colin, 1951.

———. *Religious Art from the Twelfth to the Eighteenth Century.* New York: Noonday Press, 1959.

———. *L'art religieux après le Concile de Trente.* 3d ed. Paris: Armand Colin, 1984.

Mallory, Nina Ayala. *Bartolomé Esteban Murillo.* Madrid: Alianza, 1983.

———. *El Greco to Murillo. Spanish Painting in the Golden Age, 1556–1700.* New York: HarperCollins, 1990.

Mann, Richard. *El Greco and His Patrons: Three Major Projects.* Cambridge, England: Cambridge University Press, 1986.

Maquívar, María del Consuelo, ed. *El arte en tiempos de Juan Correa.* Mexico City: Museo Nacional del Virreinato and Instituto Nacional de Antropología e Historia, 1994.

———. *El imaginero novohispano y su obra: las esculturas de Tepotzotlán.* Mexico City: Instituto Nacional de Antropología e Historia, 1995.

Maravall, José Antonio. *Culture of the Baroque: Analysis of a Historical Structure.* Trans. Terry Cochran. Minneapolis: University of Minnesota Press, 1986.

Marías, Fernando. "Un retablo de Carbonell atribuido al Greco y una hipótesis sobre los de la capilla de San José." *Archivo español de arte* 50 (1977): 323–26.

Martin, John Rupert. *Baroque.* New York: Harper and Row, 1977.

Martín Abril, Francisco Javier. "San José en la poesía clásica española." *Estudios josefinos* 1 (1947): 121–34.

Martín González, Juan José. *Escultura barroca castellana.* Madrid: Fundación Lázaro Galdiano, 1959.

———. *El escultor Gregorio Fernández.* Madrid: Ministerio de Cultura, 1980.

———. *Escultura barroca en España 1600–1770.* Madrid: Cátedra, 1983.

Martínez, Pedro de Alcántara, O.F.M. "Teología josefina en la predicación franciscana italiana del siglo XV." *Estudios josefinos* 29 (1975): 179–209.

Martínez Caviró, Balbina. "El convento toledano de las benitas, don Francisco de Pisa y El Greco." *Archivo español de arte* 61 (1988): 115–30.

Martínez Gil, Fernando. *Muerte y sociedad en la España de los Austrias*. Mexico City: Siglo XXI, 1997.

Martínez Ripoll, Antonio. *Francisco de Herrera 'el Viejo'*. Seville, Spain: Diputación Provincial, 1978.

Martz, Linda. *Poverty and Welfare in Habsburg Spain: The Example of Toledo*. Cambridge, England: Cambridge University Press, 1983.

Marzolf, Rosemary. "The Life and Work of Juan Carreño de Miranda (1614–1685)." Ph.D. diss., University of Michigan, 1961.

Mason, Peter. *Deconstructing America: Representations of the Other*. New York: Routledge, 1990.

Matías del Niño Jesús, O.C.D. "Primer documento oficial del Patronato de San José sobre la Reforma Teresiana." *Estudios josefinos* 18 (1963–64): 409–14.

Maza, Francisco de la. *El pintor Cristóbal de Villalpando*. Mexico City: Instituto Nacional de Antropología e Historia, 1964.

Maza Zorrilla, Elena. *Pobreza y asistencia social en España, siglos XVI al XX: Aproximación histórica*. Valladolid, Spain: Universidad de Valladolid, 1987.

Mazón de la Torre, María Ángeles. *Jusepe Leonardo y su tiempo*. Zaragoza, Spain: Instituto "Fernando el Católico" del Consejo Superior de Investigaciones Científicas, 1977.

McAndrew, John. *The Open-Air Churches of Sixteenth-Century Mexico: Atrios, Posas, Open Chapels, and Other Studies*. Cambridge, Mass.: Harvard University Press, 1965.

McClanan, Anne L., and Karen Rosoff Encarnación, eds. *The Material Culture of Sex, Procreation, and Marriage in Premodern Europe*. New York: Palgrave, 2002.

Meiss, Millard. "The Madonna of Humility." *Art Bulletin* 18 (1936): 434–64.

———. *Painting in Florence and Siena after the Black Death*. Princeton, N.J.: Princeton University Press, 1951.

Mellinkoff, Ruth. *Outcasts: Signs of Otherness in Northern European Art of the Late Middle Ages*. Berkeley and Los Angeles: University of California Press, 1993.

Mercier, Gérard, O.S.B. "Saint Joseph d'après Jean Geiler et Jacques Wimpheling." *Estudios josefinos* 31 (1977): 579–600.

Metropolitan Museum of Art. *Velázquez*. Exh. cat. New York: Metropolitan Museum of Art, 1989.

———. *Mexico: Splendors of Thirty Centuries*. Exh. cat. New York: Metropolitan Museum of Art, 1990.

Miedema, H. "Realism and Comic Mode: The Peasant." *Simiolus* 9 (1977): 205–19.

Miles, Margaret. "The Virgin's One Bare Breast: Nudity, Gender, and Religious Meaning in Tuscan Early Renaissance Culture." In *The Expanding Discourse: Feminism and Art History*, ed. Norma Broude and Mary D. Garrard. New York: HarperCollins, 1992.

Milone, Giovanni, C.S.I. "Origine e primi sviluppi dell'Arciconfraternità di San Giuseppe dei falegnami in Roma." *Estudios josefinos* 31 (1977): 691–749.

Minott, Charles Ilsley. "The Theme of the Mérode Altarpiece." *Art Bulletin* 51 (1969): 267–71.

Miquel Rosell, Francisco J. "Manuscritos hagiográficos de la Biblioteca Universitaria de Barcelona." *Revista española de teología* 12 (1952): 99–151.

Mirandé, Alfredo. *Hombres y Machos: Masculinity and Latino Culture*. Boulder, Colo: Westview Press, 1997.

Mirimonde, A. P. de. "Les instruments de musique et le symbolisme floral a l'exposition de peinture espagnole et au Louvre." *Revue du Louvre* 13 (1963): 269–82.

Mirrer, Louise. "Representing 'Other' Men: Muslims, Jews, and Masculine Ideals in Medieval Castilian Epic and Ballad." In *Medieval Masculinities: Regarding Men in the Middle Ages*, ed. Clare A. Lees. Minneapolis: University of Minnesota Press, 1994.

Mitterauer, Michael, and Reinhard Sieder. *The European Family: Patriarchy to Partnership from the Middle Ages to the Present*. Trans. Karla Oosterveen and Manfred Hörzinger. Oxford, England: Basil Blackwell, 1982.

Moffit, John F. "Mary as 'Prophetic Seamstress' in Siglo de Oro Sevillian Painting." *Wallraf-Richartz-Jahrbuch* 4 (1993): 141–61.

Montero, Lázaro. *Poesía religiosa española*. Zaragoza, Spain: Ebro, 1950.

Montoto de Sedas, Santiago. *Bartolomé Esteban Murillo: Estudio bibliográfico-crítico*. Seville, Spain: Sobrino de Izquierdo, 1923.

———. "La biblioteca de Murillo." *Bibliografía hispánica* 5 (1946): 465.

———. *Cofradías sevillanas*. Seville, Spain: Universidad de Sevilla, 1976.

Morales, Juan Luis. *El niño en la cultura española*. 2 vols. Madrid: T.P.A., 1960.

Morán, Juan Antonio, M.J. "La Archicofradía de San José y el Propagador de su devoción en México." *Estudios josefinos* 33 (1979): 79–95.

———. "La paternidad de San José en el pueblo cristiano." *Estudios josefinos* 40 (1986): 17–40.

———. "El padre José Ignacio Vallejo y su 'Vida de Señor San José.'" *Estudios josefinos* 45 (1991): 347–74.

Moreno Garrido, Antonio and Miguel Ángel Gamonal. "Contribución al estudio del grabado sevillano en la época de Murillo." *Goya* 181–82 (1984): 30–37.

Mueller, Joseph, S.J. *The Fatherhood of St. Joseph*. Trans. Athanasius Dengler, O.S.B. St. Louis and London: B. Herder, 1952.

Muller, Priscilla E. "Francisco Pacheco as a Painter." *Marsyas* 10 (1961): 34–44.

Mundy, Barbara E. *The Mapping of New Spain: Indigenous Cartography and the Maps of the Relaciones Geográficas*. Chicago: University of Chicago Press, 1996.

Murphy, James J., ed. *Renaissance Eloquence: Studies in the Theory and Practice of Renaissance Rhetoric*. Berkeley and Los Angeles: University of California Press, 1983.

Museo de Artes y Costumbres Populares. *Sevilla en el siglo XVII*. Exh. cat. Seville: Museo de Artes y Costumbres Populares, 1983.

Museo de Bellas Artes, Seville, and Museo del Prado. *Valdés Leal*. Exh. cat. Seville, Spain and Madrid: Museo de Bellas Artes and Museo del Prado, 1991.

Museo Nacional de Arte. *José Juárez: Recursos y discursos del arte de pintar*. Exh. cat. Mexico City: Museo Nacional de Arte, 2002.

Museo del Prado. *Bartolomé Esteban Murillo, 1617–1682*. Exh. cat. Madrid: Museo del Prado, 1982.

———. *Museo del Prado: Inventario general de pinturas*. 2 vols. Madrid: Museo del Prado and Espasa-Calpe, 1990.

———. *Valdés Leal*. Exh. cat. Madrid: Museo del Prado, 1991.

———. *Ribera 1591–1652*. Exh. cat. Madrid: Museo del Prado, 1992.

Museo Español de Arte Contemporáneo. *San José en el arte español*. Exh. cat. Madrid: Ministerio de Educación y Ciencia, 1972.

Museo Nacional de Arte. *Los pinceles de la historia: el origen del reino de la Nueva España, 1680–1750*. Exh. cat. Mexico City: Museo Nacional de Arte, 1999.

Museo Nacional del Virreinato. *Pintura Novohispana*. 3 vols. Tepotzotlán, Mexico: Asociación de Amigos del Museo Nacional del Virreinato and Américo Arte, 1996.

Nader, Helen. *Liberty in Absolutist Spain: The Habsburg Sale of Towns, 1516–1700*. Baltimore: Johns Hopkins University Press, 1990.

Nalle, Sara T. "A Saint for All Seasons: The Cult of San Julián." In *Culture and Control in Counter-Reformation Spain*, ed. Anne J. Cruz and Mary Elizabeth Perry. Hispanic Issues, no. 7. Minneapolis: University of Minnesota Press, 1992.

Neumeyer, Alfred. "The Indian Contribution to Architectural Decoration in Spanish Colonial America." *Art Bulletin* 30 (1948): 104–21.

Nieto Gallo, Gratiniano. "San José en el arte español." *Estudios josefinos* 1 (1947): 219–36.

Nutini, Hugo G. *Todos Santos in Rural Tlaxcala: A Syncretic, Expressive, and Symbolic Analysis of the Cult of the Dead*. Princeton, N.J.: Princeton University Press, 1988.

Olea, Pedro, C.S.J. "Iconografía josefina en el museo diocesano de Sigüenza." *Estudios josefinos* 24 (1970): 63–67.

Orozco Díaz, Emilio. *Pedro Atanasio Bocanegra*. Granada, Spain: Facultad de Letras, 1937.

Orozco Pardo, José Luis. *San José en la escultura granadina. Estudio sobre la historia de una imagen artística*. Granada, Spain: Universidad de Granada, 1974.

Orr, James, ed. *New Testament Apocryphal Writings*. London: J. M. Dent and Sons; Philadelphia: J. B. Lippincott, 1923.

Orso, Steven. *'Los Borrachos' and Painting at the Court of Philip IV*. Cambridge, England: Cambridge University Press, 1994.

Ortega Noriega, Sergio. "Los teólogos y la teología novohispana sobre el matrimonio, la familia y los comportamientos sexuales: De Concilio de Trento al fin de la Colonia." In *Del dicho al hecho . . . Transgresiones y pautas culturales en la Nueva España*, Seminario de Historia de las Mentalidades. Mexico City: Instituto Nacional de Antropología e Historia, 1989.

Orueta y Duarte, Ricardo de. *La vida y obra de Pedro de Mena y Medrano*. Madrid: Blass, 1914.

Ozment, Steven. *When Fathers Ruled: Family Life in Reformation Europe*. Cambridge, Mass.: Harvard University Press, 1983.

Padilla, Carmella, ed. *Conexiones: Connections in Spanish Colonial Art*. Santa Fe: Museum of Spanish Colonial Art, 2002.

Palazzo della Permanente. *L'Europa della pittura nel XVII secolo: 80 capolavori dai musei ungheresi*. Exh. cat. Milan: Palazzo della Permanente, 1993.

Palmer, Gabrielle, and Donna Pierce. *Cambios: The Spirit of Transformation in Spanish Colonial Art.* Santa Barbara, Calif.: Santa Barbara Museum of Art with the University of New Mexico Press, 1992.

Palmero Ramos, Rafael. "Juan Pérez de Cabrera, arcediano de Toledo y el primer culto a San José en la catedral primada." *Estudios josefinos* 31 (1977): 751–58.

Palomero Díaz, Gabriel. "El santo evangelio proporciona datos demostrativos suficientes de que San José y María contrajeron verdadero matrimonio." *Estudios josefinos* 8 (1954): 7–25.

Panofsky, Erwin. "Iconography and Iconology." *Burlington Magazine* 64 (1934): 117–27.

———. "'Et in Arcadia Ego.'" In *Philosophy and History: Essays Presented to Ernst Cassirer*. Oxford: Oxford University Press, 1936.

———. *Studies in Iconology: Humanistic Themes in the Art of the Renaissance*. Oxford: Oxford University Press, 1939.

Páramo, Severiano del, S.J. "Costumbres de Palestina relacionadas con San José." *Estudios josefinos* 1 (1947): 203–13.

———. "Lugares de Palestina relacionados con San José." *Estudios josefinos* 1 (1947): 96–120.

———. "¿Cuando comenzó a darse verdadero matrimonio entre San José y María? ¿La Anunciación y, por consiguiente, la concepción de Jesús tuvieron lugar dentro del verdadero matrimonio?" *Estudios josefinos* 8 (1954): 79–95.

———. "Hasta donde llegó el conocimiento que S. José tuvo de la misión y naturaleza de Jesús." *Estudios josefinos* 19 (1965): 89–98.

———. "San José en la obra de S. Pedro Canisio." *Estudios josefinos* 24 (1970): 53–57.

Pasztory, Esther. "The Aztec Tlaloc: God of Antiquity." In *Smoke and Mist: Mesoamerican Studies in Memory of Thelma D. Sullivan*, ed. Kathryn J. Josserand and Karen Dakin. Oxford: Oxfordshire, 1988.

Payne, Stephen G. *Spanish Catholicism: An Historical Overview*. Madison: University of Wisconsin Press, 1984.

Pedro Tomás de la Sagrada Familia, C.D. "'El mejor esposo S. José'": Comedia bíblica de Guillén de Castro." *Estudios josefinos* 4 (1950): 89–109.

Peers, E. Allison. *Studies of Spanish Mystics*. 3 vols. London: Sheldon; New York and Toronto: Macmillan, 1927.

———. *The Mystics of Spain*. London: Allen and Unwin, 1951.

Pemán, César. "La reconstrucción del retablo de la cartuja de Jerez de la Frontera." *Archivo español de arte* 23 (1950): 203–27.

Pepper, D. Stephen. *Guido Reni: A Complete Catalogue of His Works with an Introductory Text*. Oxford: Phaidon, 1984.

Pérez, Joseph. "La femme et l'amour dans l'Espagne du XVIe siècle." In *Autour des Parentés en Espagne aux XVIe et XVIIe siècles*, ed. Augustin Redondo. Paris: Publications de la Sorbonne, 1987.

Pérez Moreda, Vicente. *Las crisis de mortalidad en la España interior siglos XVI–XIX*. Madrid: Siglo XXI, 1980.

Pérez Moreda, Vicente, and David-Sven Reher, eds. *Demografía histórica en España*. Madrid: Orán, 1988.

Pérez Salazar, Francisco. *Historia de la pintura en Puebla*. 3d ed. Mexico City: Imprenta Universitaria, 1963.

Pérez Sánchez, Alfonso E. *Pintura italiana del siglo XVII en España*. Madrid: Universidad de Madrid y Fundación Valdecilla, 1965.

———. "José Caudí, un olvidado artista, decorador de Calderón." *Goya* 161–62 (1981): 266–73.

———. "On the Reconstruction of El Greco's Dispersed Altarpieces." In *El Greco of Toledo*, Jonathan Brown. Exh. cat. Toledo, Ohio: Toledo Museum of Art, 1982, 149–76.

———. *Juan Carreño de Miranda (1614–1685)*. Madrid: Avilés, 1985.

———. *Pintura barroca en España 1600–1750*. Madrid: Cátedra, 1992.

Periñán, Blanca, and Francisco Guazzelli, eds. *Symbolae Pisanae: Studi in onore di Guido Mancini*. 2 vols. Pisa, Italy: Giardini, 1989.

Peristiany, J. G., ed. *Honour and Shame: The Values of Mediterranean Society*. Chicago: University of Chicago Press, 1966.

Perry, Mary Elizabeth. *Crime and Society in Early Modern Seville*. Hanover, N.H.: University Press of New England, 1980.

———. *Gender and Disorder in Early Modern Seville*. Princeton, N.J.: Princeton University Press, 1990.

Peterson, Jeanette Favrot. "The Virgin of Guadalupe: Symbol of Conquest or Liberation?" *Art Journal* 51 (1992): 39–47.

———. *The Paradise Garden Murals of Malinalco: Utopia and Empire in Sixteenth-Century Mexico*. Austin: University of Texas Press, 1993.

Piccat, Marco. "Iconografie Tardo-Gotiche e Rinascimentali di San Giuseppe nell'Italia

Nordoccidentale." *Estudios josefinos* 31 (1977): 763–85.

Pierce, Donna L. "The Sixteenth-Century Nave Frescoes in the Augustinian Mission Church of Ixmiquilpan, Hidalgo, Mexico." Ph.D. diss., University of New Mexico, 1987.

Pigler, A. *Barockthemen. Eine Auswahl von Verzeichnissen zur Ikonographie des 17. und 18. Jahrhunderts.* 2 vols. Budapest: Akademie der Wissenschaften, 1956.

Pinto Crespo, V. "La actitud de la Inquisición ante la iconografía religiosa." *Hispania Sacra* 31 (1978): 285–322.

Pitt-Rivers, Julian. "Honour and Social Status." In *Honour and Shame: The Values of Mediterranean Society*, ed. J. G. Peristiany. Chicago: University of Chicago Press, 1966.

Pitts, Tom Richardson. "The Origin and Meaning of Some Saint Joseph Figures in Early Christian Art." Ph.D. diss., University of Georgia, 1988.

Pollock, Linda A. "Rethinking Patriarchy and the Family in Seventeenth-Century England." *Journal of Family History* 23 (1998): 3–27.

Poole, Stafford. "Iberian Catholicism Comes to the Americas." Part 1 in *Christianity Comes to the Americas, 1492–1776*, ed. Charles H. Lippy, Robert Choquette, and Stafford Poole. New York: Paragon House, 1992.

———. *The Virgin of Guadalupe.* Tucson: University of Arizona Press, 1995.

Preziosi, Donald. *The Art of Art History: A Critical Anthology.* Oxford History of Art. Oxford: Oxford University Press, 1998.

Proske, Beatrice Gilman. *Juan Martínez Montañes: Sevillian Sculptor.* New York: Hispanic Society of America, 1967.

Purtle, Carol J. *The Marian Paintings of Jan van Eyck.* Princeton, N.J.: Princeton University Press, 1982.

Ramírez, Hermengildo, M.J. "San José en la evangelización de América Latina." *Estudios josefinos* 45 (1991): 611–35.

Ramírez Godoy, Guillermo, and Arturo Camacho Becerra. *Cuatro siglos de pintura jalisciense.* Guadalajara, Mexico: Cámara Nacional de Comercio de Guadalajara, 1997.

Réau, Louis. *Iconographie de l'art chrétien.* 3 vols. Paris: Presses Universitaires de France, 1958.

Redigonda, L. A., O.P. "La 'Summa de Donis Sancti Ioseph' di Isidoro Isolani." *Estudios josefinos* 31 (1977): 203–21.

Redondo, Augustin, ed. *Autour des Parentés en Espagne aux XVIe et XVIIe siècles*, ed. Augustin Redondo. Paris: Sorbonne, 1987.

Rennert, Hugo Albert. *The Spanish Stage in the Time of Lope de Vega.* New York: Hispanic Society of America, 1909.

Rey, José Ignacio, O.C.D. "Presencia de San José en el Museo de Arte de Ponce (Puerto Rico)." *Estudios josefinos* 33 (1979): 73–78.

———. "San José en la pintura colonial de Las Antillas." *Estudios josefinos* 33 (1979): 59–71.

———. "San José en el folklore de Puerto Rico." *Estudios josefinos* 34 (1980): 95–107.

Ridderbos, Bernhard. *Saint and Symbol: Images of Saint Jerome in Early Italian Art.* Groningen, The Netherlands: Bouma's Boekhuis, 1984.

Río, Ignacio del. *Guía del Archivo Franciscano de la Biblioteca Nacional de México.* Vol. 1. Mexico City: Universidad Nacional Autónoma de México and Instituto de Investigaciones Bibliográficas, 1975.

Rodas Estrada, Juan Haroldo. "La devoción a San José en el siglo XVIII en Guatemala." *Estudios josefinos* 45 (1991): 673–86.

Rodríguez, Juan Luis, O.C.D. "San José en la escultura barroca española del siglo XVII." *Estudios josefinos* 35 (1981): 134–51.

Rodríguez Gutiérrez de Ceballos, Alfonso. "Exposición de Santa Teresa y su Tiempo." *Archivo español de arte* 64 (1971): 229–31.

———. "Crónica: San José en el arte español." *Archivo español de arte* 45 (1972): 247–49.

Rodríguez Marín, Francisco. *Francisco Pacheco: Maestro de Velázquez.* Madrid: Revista de Archivos, Bibliotecas y Museos, 1923.

Rodríguez Martínez, Juan Luis, O.C.D. "'El Hermosísimo Sol de los Santos' del P. Gaspar de San Nicolás de Tolentino (Agustino)." *Estudios josefinos* 45 (1991): 277–97.

Rodríguez Martínez, Luis, and Teófanes Egido. "La devoción popular a San José en el Antiguo Régimen." *Estudios josefinos* 38 (1984): 225–49.

Rodríguez Parra, María Eugenia, and Mario Ríos Villegas. *Catálogo de pintura colonial en edificios religiosos del Municipio de Toluca.* Toluca, Mexico: Universidad Autónoma del Estado de México, 1984.

Romero Quiroz, Javier. *El convento hospital de Nuestra Señora de Guadalupe y del Señor San José: Recolección de Nuestro Padre San Juan de Dios. El teatro de los hospitalarios.* Mexico City: Gobierno de Estado de México, 1976.

Romeu, J., ed. *Teatre hagiogràfic.* 3 vols. Barcelona, Spain: Barcino, 1957.

Rondet, Henri. *Saint Joseph*. Trans. and ed. Donald Attwater. New York: P. J. Kennedy and Sons, 1956.

Ros García, Salvador. "San José en la vivencia teresiana." *Estudios josefinos* 36 (1982): 25–64.

Rosenberg, Charles E., ed. *The Family in History*. Philadelphia: University of Pennsylvania Press, 1975.

Ruano, Lucinio. "Carisma josefino de Santa Teresa de Jesús." *Estudios josefinos* 71 (1982): 65–112.

Rubén Sanabria, José, M.J. "¿Inmaculada concepción de San José?" *Estudios josefinos* 12 (1958): 63–120.

———. "La devoción a San José en México en el siglo XVI." *Estudios josefinos* 31 (1977): 663–76.

Rubial García, Antonio. *La santidad controvertida: hagiografía y conciencia criolla alrededor de los venerables no canonizados de Nueva España*. Mexico City: Universidad Nacional Autónoma de México and Fondo de Cultura Económica, 1999.

Ruiz Gomar, Rogelio. *El pintor Luis Juárez: su vida y su obra*. Mexico City: Universidad Nacional Autónoma de México, 1987.

Sacred Congregation of Rites. "Decreto de la Sagrada Congregación de Ritos sobre la inserción del nombre de San José en el Canon de la Misa (1962)." *Estudios josefinos* 17–18 (1963–64): 128–208.

Saint-Saëns, Alain, ed. *Religion, Body and Gender in Early Modern Spain*. San Francisco: Mellen Research University Press, 1991.

Salerno, Luigi. *I Dipinti dei Guercino*. Rome: Ugo Bozzi, 1988.

Sánchez Camargo, Manuel. *La muerte y la pintura española*. Madrid: Nacional, 1944.

Sánchez Cantón, F. J. *Nacimiento e infancia de Cristo*. Madrid: Biblioteca de Autores Cristianos, 1948.

Sánchez Céspedes, P., S.J. "El principio de asociación aplicado a la teología de San José." *Estudios josefinos* 22 (1968): 63–68.

Sánchez Lora, José Luis. *Mujeres, conventos y formas de la religiosidad barroca*. Madrid: Fundación Universitaria Española, 1988.

Sánchez Pérez, José Augusto. *El culto mariano en España*. Madrid: Consejo Superior de Investigaciones Científicas, Instituto "Antonio de Nebrija," 1943.

Sautman, Francesca. "Saint Anne in Folk Tradition: Late Medieval France." In *Interpreting Cultural Symbols: Saint Anne in Late Medieval Society*, ed. Kathleen Ashley and Pamela Sheingorn. Athens: University of Georgia Press, 1990.

Schofield, R., D. Reher, and A. Bideau, eds. *The Decline of Mortality in Europe*. Oxford: Clarendon Press and Oxford University Press, 1991.

Schroeder, Susan, Stephanie Wood, and Robert Haskett, eds. *Indian Women of Early Mexico*. Norman: University of Oklahoma Press, 1997.

Schwartz, Sheila. "The Iconography of the Rest on the Flight into Egypt." Ph.D. diss., New York University, 1975.

Scott, Joan W. "Gender: A Useful Category of Analysis." *American Historical Review* 91 (1986): 1053–75.

Sebastián, Santiago. *Contrarreforma y barocco: Lecturas iconográficas e iconológicas*. 2d ed. Madrid: Alianza, 1989.

———. *Iconografía e iconología del arte novohispano*. Mexico City: Grupo Azabache, 1992.

Sebastián, Santiago, Mariano Monterrosa, and José Antonio Terán. *Iconografía del arte del siglo XVI en México*. Zacatecas, Mexico: Universidad Autónoma de Zacatecas, 1995.

Seed, Patricia. *To Love, Honor, and Obey in Colonial Mexico: Conflicts over Marriage Choice, 1574–1821*. Stanford, Calif.: Stanford University Press, 1988.

Seitz, Joseph. *Die Verehrung des hl. Joseph in ihrer geschichtlichen Entwichlung bis zum Konzil von Trient dargestellt*. Freiburg im Breisgau, Germany: Herder, 1908.

Seminario de Historia de las Mentalidades. *Del dicho al hecho . . . Transgresiones y pautas culturales en la Nueva España*. Mexico City: Instituto Nacional de Antropología e Historia, 1989.

Sheingorn, Pamela. "Appropriating the Holy Kinship: Gender and Family History." In *Interpreting Cultural Symbols: Saint Anne in Late Medieval Society*, ed. Kathleen Ashley and Pamela Sheingorn. Athens: University of Georgia Press, 1990.

Shergold, Norman D. *A History of the Spanish Stage from Medieval Times until the End of the Seventeenth Century*. Oxford: Clarendon Press, 1967.

Sherwood, Joan. *Poverty in Eighteenth-Century Spain: The Women and Children of the Inclusa*. Toronto: University of Toronto Press, 1988.

———. "The Ideology of Breast-feeding: Deconstructing Spanish Medical Texts Concerning Nursing Women at the End of the Eighteenth Century." In *Religion, Body and Gender in Early Modern Spain*, ed. Alain Saint-Saëns. San Francisco: Mellen Research University Press, 1991.

Simons, Patricia. "Alert and Erect: Masculinity in Some Italian Renaissance Portraits of Fathers and Sons." In *Gender Rhetorics: Postures of Dominance and Submission in History*, ed. Richard C. Trexler. Binghamton, N.Y.: Center for Medieval and Early Renaissance Studies, State University of New York Press, 1994.

Sinding-Larsen, Staale. *Iconography and Ritual: A Study of Analytical Perspectives*. Oslo: Universitetsforlaget, 1984.

Smith, Hilary D. *Preaching in the Spanish Golden Age*. Oxford: Oxford University Press, 1978.

Snyder, James. *Northern Renaissance Art: Painting, Sculpture, the Graphic Arts from 1350 to 1575*. Englewood Cliffs, N.J.: Prentice-Hall; New York: Harry N. Abrams, 1985.

Soehner, Halldor. *Una obra maestra del Greco, la Capilla de San José en Toledo*. Madrid: Hauser y Manet, 1961.

Solá, Francisco de P., S.J. "La predestinación de San José." *Estudios josefinos* 20 (1965): 165–86.

———. "Devoción y culto a San José en la Diócesis de Barcelona." *Estudios josefinos* 38 (1984): 193–224.

———. "La paternidad de San José en San Agustín (354–430)." *Estudios josefinos* 39 (1985): 25–46.

———. "Josefología del P. Tomás Muniesa S.J., insigne teólogo y predicador († 1696)." *Estudios josefinos* 43 (1989): 201–25.

Solomon-Godeau, Abigail. *Male Trouble: A Crisis in Representation*. London: Thames and Hudson, 1997.

Soria, Fernando, O.P. "Conocimiento y consentimiento de San José a los misterios de la Encarnación y Redención." *Estudios josefinos* 11 (1957): 172–96.

———. "San José en el Beato Angélico." *Estudios josefinos* 39 (1985): 147–62.

Sousa, Lisa Mary. "Women and Crime in Colonial Oaxaca: Evidence of Complementary Gender Roles in Mixtec and Zapotec Societies." In *Indian Women of Early Mexico*, ed. Susan Schroeder, Stephanie Wood, and Robert Hackett. Norman: University of Oklahoma Press, 1997.

Sparks, Timothy M., O.P. "Cajetan on Saint Joseph." *Estudios josefinos* 31 (1977): 255–82.

Steinberg, Leo. *The Sexuality of Christ in Renaissance Art and in Modern Oblivion*. New York: Pantheon, 1983.

Stern, Steve J. *The Secret History of Gender: Women, Men, and Power in Late Colonial Mexico*. Chapel Hill: University of North Carolina Press, 1995.

Stirling-Maxwell, Sir William. *Annals of the Artists of Spain*. 3 vols. London: J. C. Nimmo, 1891.

Stoichita, Victor. *Visionary Experience in the Golden Age of Spanish Art*. London: Reaktion, 1995.

Stone, David M. *Guercino: Catalogo completo dei dipinti*. Florence: Cantini, 1991.

Stone, Lawrence. "The Rise of the Nuclear Family in Early Modern England: The Patriarchal Stage." In *The Family in History*, ed. Charles E. Rosenberg. Philadelphia: University of Pennsylvania Press, 1975.

Stramare, Tarcisio, O.S.J. "Las congregaciones tituladas de San José." *Estudios josefinos* 37 (1983): 9–23.

———. "La circuncisión de Jesús: Significado exegético y teológico." *Estudios josefinos* 40 (1986): 3–15.

Stratton, Suzanne L. *Spanish Polychrome Sculpture 1500–1800 in United States Collections*. Exh. cat. Dallas: Meadows Museum, 1993.

———. *The Immaculate Conception in Spanish Art*. Cambridge, England: Cambridge University Press, 1994.

Suárez, Pablo Luis, C.M.F. "Matrimonio de María y José a la luz del Antiguo Testamento." *Estudios josefinos* 20 (1965): 187–202.

Subías Galter, Juan. *Imágenes españolas de la Virgen*. Barcelona, Spain: Selecta, 1941.

Suleiman, Susan R. *The Female Body in Western Culture: Contemporary Perspectives*. Cambridge, Mass.: Harvard University Press, 1986.

Sullivan, Edward J. *Baroque Painting in Madrid: The Contribution of Claudio Coello with a Catalogue Raisonné of His Works*. Columbia: University of Missouri Press, 1986.

Sullivan, Thelma D. "Tlazolteotl-Ixcuina: The Great Spinner and Weaver." In *The Art and Iconography of Late Postclassic Central Mexico*, ed. Elizabeth Hill Boone. Washington, D.C.: Dumbarton Oaks, 1982.

Suñe Blanco, Beatriz. "Religiosidad popular en Andalucía y América (siglo XVII)." In *Andalucía y América en el siglo XVII. Actas de las III jornadas de Andalucía y América*, ed. Bibiano Torres Ramírez and José Jesús Hernández Palomo. 2 vols. 1983. Reprint, Seville, Spain: Escuela de Estudios Hispano-Americanos de Sevilla, Consejo Superior de Investigaciones Científicas, 1985.

Sutton, Peter C. *The Age of Rubens*. Exh. cat. Boston: Museum of Fine Arts, 1993.

Taggard, Mindy Nancarrow. "Narrative Meaning in Antonio del Castillo's *The Life of Joseph*." *Gazette des Beaux-Arts* 116 (1990): 116–28.

———. *Murillo's Allegories of Salvation and Triumph: The Parable of the Prodigal Son and The Life of Jacob*. Columbia: University of Missouri Press, 1992.

Tentler, Thomas N. *Sin and Confession on the Eve of the Reformation*. Princeton, N.J.: Princeton University Press, 1977.

Thacher, John S. "The Paintings of Francisco de Herrera, the Elder." *Art Bulletin* 19 (1937): 325–80.

Toschi, Larry M., O.S.J. "St. Joseph, Father of the Birth of Christianity in Alta California." *Estudios josefinos* 45 (1991): 705–24.

Toussaint, Manuel. "Proceso y denuncias contra Simón Pereyns en la Inquisición de México." *Anales del Instituto de Investigaciones Estéticas* (1938), Supplement.

———. *Colonial Art in Mexico*. Trans. and ed. Elizabeth Wilder Weismann. Austin: University of Texas Press, 1967.

Townsend, Richard F. *The Aztecs*. London: Thames and Hudson, 1992.

Trapier, Elizabeth du Gué. *Catalogue of Paintings in the Collection of the Hispanic Society of America: 16th, 17th and 18th Centuries*. New York: Hispanic Society of America, 1929.

———. *Ribera*. New York: Hispanic Society of America, 1952.

———. *Valdés Leal: Spanish Baroque Painter*. New York: Hispanic Society of America, 1960.

Trens, Manuel. *María, iconografía de la Virgen en el arte español*. Madrid: Plus-Ultra, 1947.

Trexler, Richard C., ed. *Gender Rhetorics: Postures of Dominance and Submission in History*. Binghamton, N.Y.: Center for Medieval and Early Renaissance Studies, State University of New York Press, 1994.

———. *The Journey of the Magi: Meanings in the History of a Christian Story*. Princeton, N.J.: Princeton University Press, 1997.

———. *Sex and Conquest: Gendered Violence, Political Order, and the European Conquest of the Americas*. Ithaca, N.Y.: Cornell University Press, 1995.

Trottier, Aimé, C. S. C. *Essai de bibliographie sur Saint Joseph*. 3d ed. Montreal: Centre de Recherche et de Documentation Oratoire Saint-Joseph, 1962.

———. "Saint Joseph dans le drame réligieux de langue française au moyen age et durant la renaissance." *Estudios josefinos* 31 (1977): 633–52.

Turner, James Grantham, ed. *Sexuality and Gender in Early Modern Europe. Institutions, Texts, Images*. Cambridge, England: Cambridge University Press, 1993.

Twinan, Ann. "Honor, Sexuality, and Illegitimacy in Colonial Spanish America." In *Sexuality and Marriage in Colonial Latin America*, ed. Asunción Lavrin. Lincoln: University of Nebraska Press, 1988.

Urmeneta, Fermín de. "Directrices teológicas ante el arte sagrado y las teorías de Pacheco." *Revista de ideas estéticas* 18 (1960): 47–59.

Urrea, Jesús. "Dos San Josés ignorados de Gregorio Fernández." *Estudios josefinos* 30 (1976): 71–74.

Valbuena Prat, Ángel. "La escenografía de una comedia de Calderón." *Archivo español de arte y arqueología* 1 (1925): 1–25.

Valdivieso González, Enrique. *La pintura en Valladolid en el siglo XVII*. Valladolid, Spain: Diputación Provincial, 1971.

———. *Catálogo de las pinturas de la Catedral de Sevilla*. Seville, Spain: Diputación Provincial, 1978.

———. "La pintura en la Catedral de Sevilla. Siglos XVII al XX." In *La Catedral de Sevilla*, Fernando Chueca Goitia et al. Seville, Spain: Guadalquivir, 1984.

Valdivieso González, Enrique, and Juan Miguel Serrera. *Historia de la pintura española: Escuela sevillana del primer tercio del siglo XVII*. Madrid: Instituto Diego Velázquez, 1985.

Vauchez, André. *La sainteté en Occident aux derniers siècles du moyan âge, d'après les procès de canonisation et les documents hagiographiques*. Rome: École française; and Paris: Boccard, 1981.

Velasco Bayón, Balbino, O.C. "El tratado sobre las grandezas de San José y su patrocinio, del P. José de Diego." *Estudios josefinos* 43 (1989): 109–21.

———. "La devoción a San José entre los carmelitas de los siglos XVII y XVIII." *Estudios josefinos* 46 (1992): 53–56.

Vergara Vergara, José. "La parroquia de La Asunción de Pachuca y Juan Correa." In *El arte en tiempos de Juan Correa*, ed. María del Consuelo Maquívar. Mexico City: Museo Nacional del Virreinato and Instituto Nacional de Antropología e Historia, 1994.

Verri, Franco, C.S.I. "San Giuseppe nella pittura veneta del Rinascimento." *Estudios josefinos* 31 (1977): 787–98.

Villafuerte García, María de Lourdes. "Casar y compadrar cada uno con su igual: casos de

oposición al matrimonio en la ciudad de México, 1628–1634." In *Del dicho al hecho. . . Transgresiones y pautas culturales en la Nueva España*, Seminario de Historia de las Mentalidades. Mexico City: Instituto Nacional de Antropología e Historia, 1989.

Volk, Mary Crawford. *Vicencio Carducho and Seventeenth-Century Castilian Painting*. New York: Garland Outstanding Dissertations in the Fine Arts, 1977 [Yale University, 1973].

Warner, Marina. *Alone of All Her Sex: The Myth and the Cult of the Virgin Mary*. New York: Vintage, 1983.

Wattenberg, Federico. *Museo Nacional de Escultura de Valladolid*. 2d ed. Madrid: N.p., 1964.

Weber, Alison. *Teresa of Avila and the Rhetoric of Femininity*. Princeton, N.J.: Princeton University Press, 1990.

Webster, Susan Verdi. *Art and Ritual in Golden Age Spain: Sevillian Confraternities and the Processional Sculpture of Holy Week*. Princeton, N.J.: Princeton University Press, 1998.

Weinstein, Donald, and Rudolph M. Bell. *Saints and Society. The Two Worlds of Western Christendom, 1000–1700*. Chicago: University of Chicago Press, 1982.

Weisbach, Werner. *Spanish Baroque Art*. Cambridge, England: Cambridge University Press, 1941.

Wethey, Harold E. *Alonso Cano: Painter, Sculptor, Architect*. Princeton, N.J.: Princeton University Press, 1955.

———. *El Greco and His School*. 2 vols. Princeton, N.J.: Princeton University Press, 1962.

Wilk, Richard W., and Wendy Ashmore, eds. *Household and Community in the Mesoamerican Past*. Albuquerque: University of New Mexico Press, 1985.

Wilson, Carolyn C. *St. Joseph in Italian Renaissance Society and Art: New Directions and Intepretations*. Philadelpia: Saint Joseph's University Press, 2001.

Wilson, Christopher Dean. "Mother, Missionary, Martyr: St. Teresa of Avila in Mexican Colonial Art." Ph.D. diss. The George Washington University, 1998.

Wilson, Stephen, ed. *Saints and Their Cults: Studies in Religious Sociology, Folklore and History*. Cambridge, England: Cambridge University Press, 1983.

Wind, Barry. *'A Foul and Pestilent Congregation': Ribera and Images of 'Freaks' in Baroque Art*. Aldershot, England: Ashgate, 1997.

Woodward, Kenneth L. *Making Saints: How the Catholic Church Determines Who Becomes a Saint, Who Doesn't, and Why*. New York: Simon and Schuster, 1990.

Wright, Christopher. *The French Painters of the Seventeenth Century*. Boston: Little, Brown, 1985.

Wyschogrod, Edith. *Saints and Postmodernism: Revisioning Moral Philosophy*. Chicago: University of Chicago Press, 1990.

Xiberta, Bartolomé María, O.C. "Flores josefinas en la liturgía carmelitana antigua." *Estudios josefinos* 18 (1963–64): 301–19.

Zueras Torres, Francisco. *Antonio del Castillo: Un gran pintor del barroco*. Córdoba, Spain: Diputación Provincial, 1982.

INDEX

Note: Page numbers in *italic* type indicate illustrations.

PHOTOGRAPHY CREDITS

The sources of visual material other than those indicated in the captions are as follows (numerals refer to figures).

Photo courtesy Archivo Fotográfico Manuel Toussaint, Instituto de Investigaciones Estéticas, Universidad Nacional Autónoma de México (plate 5; 3, 10–12, 15, 18, 21, 29, 30, 31–33, 37–41, 43–45, 49, 52, 55, 58, 69, 70, 73, 76, 78, 82, 83, 84)

Photo courtesy Art Resource, New York (6)

Photo courtesy Bibliothèque national de France, Paris (plate 2)

Photo courtesy El Paso Museum of Art, El Paso, Texas (plate 7)

Photo courtesy Gemäldegalerie, Berlin (2)

Photos courtesy Institut Amatller d'Art Hispànic (Arxiu Mas) (plates 3, 4, 8; 1, 5, 7–9, 13, 14, 16, 17, 19, 20, 22–25, 27, 28, 35, 42, 46–48, 50, 51, 53, 54, 56, 57, 59–61, 63, 64, 68, 71, 72, 74, 75, 77, 79, 80)

Photo courtesy Museo de las Américas, Madrid (plate 1)

Photo courtesy Museo Nacional del Virreinato, Tepotzotlán, Mexico (66)

Photo courtesy Museum of International Folk Art, Santa Fe, New Mexico (4)

Photo courtesy Ringling Museum of Art, Sarasota, Florida (26, 67)

Photo courtesy The Art Institute of Chicago, Illinois (36)

Photo courtesy The Cleveland Museum of Art, Ohio (65)

Photo courtesy Toledo Museum of Art, Toledo, Ohio (34)

Photo courtesy Washington University Gallery of Art, St. Louis, Missouri (plate 6)

Reproduction authorized by the Instituto Nacional de Antropología e Historia (62, 81)